D1662941

# GRANDMOTHERHOOD

# GRANDMOTHERHOOD

*The Evolutionary Significance of the Second Half of Female Life*

Edited by Eckart Voland, Athanasios Chasiotis, and Wulf Schiefenhövel

RUTGERS UNIVERSITY PRESS
New Brunswick, New Jersey, and London

Library of Congress Cataloging-in-Publication Data

Grandmotherhood : the evolutionary significance of the second half of female life / edited by Eckart Voland, Athanasios Chasiotis, and Wulf Schiefenhövel.
    p.  cm.
  Includes bibliographical references and index.
  ISBN 0-8135-3609-X (hardcover : alk. paper)
  1. Matriarchy.  2. Grandmothers.  3. Older women—Social conditions.
4. Women—Evolution.  5. Fertility, Human.  6. Human reproduction—Age factors.
7. Social evolution.  I. Voland, Eckart, 1949–  II. Chasiotis, Athanasios.
III. Schiefenhövel, Wulf, 1943–
  GN479.6.G36 2005
  306.874′5—dc22

                                          2004021376

A British Cataloging-in-Publication record for this book is available from the British Library.

This collection copyright © 2005 by Rutgers, The State University
Individual chapters copyright © 2005 in the names of their authors unless otherwise noted below

Portions of "Menopause: Adaptation and Epiphenomenon" by Jocelyn Scott Peccei were originally published in *Evolutionary Anthropology* 10, no. 2 (2001): 43–57. © 2001 Wiley-Liss, Inc. This material is used by permission of Wiley-Liss, Inc., a subsidiary of John Wiley and Sons, Inc.

All rights reserved
No part of this book may be reproduced or utilized in any form or by any means, electronic or mechanical, or by any information storage and retrieval system, without written permission from the publisher. Please contact Rutgers University Press, 100 Joyce Kilmer Avenue, Piscataway, NJ 08854-8099. The only exception to this prohibition is "fair use" as defined by U.S. copyright law.

Manufactured in the United States of America

# Contents

Preface and Acknowledgments     vii

INTRODUCTION  Grandmotherhood: A Short Overview of Three Fields of Research on the Evolutionary Significance of Postgenerative Female Life
Eckart Voland, Athanasios Chasiotis, and Wulf Schiefenhövel     1

PART I  LIFE HISTORY: *The Evolutionary Route to Grandmothers*

CHAPTER 1  Primate Predispositions for Human Grandmaternal Behavior
Andreas Paul     21

CHAPTER 2  Menopause: Adaptation and Epiphenomenon
Jocelyn Scott Peccei     38

CHAPTER 3  Human Longevity and Reproduction: An Evolutionary Perspective
Natalia S. Gavrilova and Leonid A. Gavrilov     59

CHAPTER 4  Grandmothers, Politics, and Getting Back to Science
Chris Knight and Camilla Power     81

CHAPTER 5  Human Female Longevity: How Important Is Being a Grandmother?
Cheryl Sorenson Jamison, Paul L. Jamison, and Laurel L. Cornell     99

CHAPTER 6  Human Age Structures, Paleodemography, and the Grandmother Hypothesis
Kristen Hawkes and Nicholas Blurton Jones     118

PART II  BEHAVIOR: *Modern Outcomes of Past Adaptations*

CHAPTER 7  Are Humans Cooperative Breeders?
Ruth Mace and Rebecca Sear     143

CHAPTER 8  Hadza Grandmothers as Helpers: Residence Data
Nicholas Blurton Jones, Kristen Hawkes, and James O'Connell     160

CHAPTER 9  The Role of Maternal Grandmothers in Trobriand Adoptions
Wulf Schiefenhövel and Andreas Grabolle   177

CHAPTER 10  Kinship Organization and the Impact of Grandmothers on Reproductive Success among the Matrilineal Khasi and Patrilineal Bengali of Northeast India
Donna L. Leonetti, Dilip C. Nath, Natabar S. Hemam, and Dawn B. Neill   194

CHAPTER 11  The *Helping* and the *Helpful* Grandmother: The Role of Maternal and Paternal Grandmothers in Child Mortality in the Seventeenth- and Eighteenth-Century Population of French Settlers in Québec, Canada
Jan Beise   215

CHAPTER 12  "The Husband's Mother Is the Devil in House": Data on the Impact of the Mother-in-Law on Stillbirth Mortality in Historical Krummhörn (1750–1874) and Some Thoughts on the Evolution of Postgenerative Female Life
Eckart Voland and Jan Beise   239

CHAPTER 13  Exploring the Variation in Intergenerational Relationships among Germans and Turkish Immigrants: An Evolutionary Perspective of Behavior in a Modern Social Setting
Akiko Nosaka and Athanasios Chasiotis   256

CHAPTER 14  Variability of Grandmothers' Roles
Axel Schölmerich, Birgit Leyendecker, Banu Citlak, Amy Miller, and Robin Harwood   277

PART III  SYNTHESIS: *The Evolutionary Significance of Grandmothers*

CHAPTER 15  Cooperative Breeders with an Ace in the Hole
Sarah Blaffer Hrdy   295

Contributors   319
Name Index   325
Subject Index   339

# Preface and Acknowledgments

In the year 2030, the average life expectancy of women in industrialized countries could well be around ninety and, thereby, exceed that of men by about ten years. This means that the "feminization of age," which is already taking place, will increase further. At the present time, two-thirds of all persons over sixty and three-fourths of those over seventy are women. At present, postmenopausal women represent 15 percent of the world population. Impressed by these demographic changes as well as by the increasing interest in the second half of human life expressed by the scientific community and by society as a whole, the Institute of Advanced Studies Hanse Wissenschaftskolleg (HWK) in Delmenhorst, Germany, convened a conference in September 2002 during which experts discussed the evolutionary bases for this development. Perspectives from disciplines such as life history theory, paleoanthropology, anthropology, sociobiology, and evolutionary psychology were presented and put in discourse with each other. The present volume is the result of this meeting. We cordially thank Gerhard Roth, the director of HWK, for his interest in the topic and his sturdy support of the endeavor and for providing such a very hospitable atmosphere for the meeting. In the same way, cordial thanks are due to Uwe Opolka, the scientific manager of HWK, for his very active and efficient role in putting everything in place. We owe thanks also to the German Research Foundation (DFG) and the HWK for their financial support of the conference. Audra Wolfe and her team at Rutgers University Press as well as Lee Cronk, anthropology department of Rutgers University, and the anonymous reviewers have been encouraging and critical in a very helpful mixture. We would also like to thank Kai Willführ of Giessen University for his manifold and efficient technical support.

<div style="text-align: right;">Eckart Voland, Athanasios Chasiotis, Wulf Schiefenhövel</div>

# GRANDMOTHERHOOD

INTRODUCTION

# Grandmotherhood
## A Short Overview of Three Fields of Research on the Evolutionary Significance of Postgenerative Female Life

Eckart Voland, Athanasios Chasiotis, and Wulf Schiefenhövel

En olle Fro un'n olle Kuh, dor kummt een noch wat van to;
man'n ollen Kerl un'n old Perd, de sünt geen Bohne wert.

(From an old woman and an old cow you can still expect something;
but an old man and an old horse aren't worth anything.)
—East Frisian proverb

Along the way towards hominization, something has happened that is still puzzling anthropologists: a significantly prolonged life span has placed the helping grandmother on the stage of life. One can assume that our hominoid ancestors—comparable to present-day big apes—could reach a maximum age of forty to fifty years, provided their living conditions were favorable (Hill et al. 2001, Nishida et al. 2003); we, however, were provided by evolution with roughly twice as many years. Obviously, in the Plio-Pleistocene milieu of hominization, there must have been clear advantages in becoming older than one's ancestors, otherwise natural selection would not have pushed lives to last so long.

The doubling of life span surely would not pose any insurmountable problem for anthropological theory if it were not tied to the obligatory sterility of postmenopausal women, a pattern rarely found in the animal kingdom. The process of aging progresses in all human organs with the same speed—with the exception of reproductive female physiology, which ages much faster and has remained uninfluenced by increased life spans. One could say that the female reproductive system, by losing its function in the fifth decade after birth, is evolutionarily frozen in the chimpanzee stage (Gould, Flint, and Graham 1981; Leidy 1999; Wood et al. 2001). Whereas all female primates experience reduced fertility at an older age (Paul this volume) and whereas evidence for menopause in nonhuman primates is growing (Bellino and Wise 2003), it is clear that among primates only human females experience a significant postmenopausal life span. This needs ex-

planation because according to Darwinian logic evolutionary advantages are reproductive advantages. But as Blikslager (1910) highlights by repeating the proverb quoted above, ability to reproduce is not the whole story. Why has evolution prolonged life as a whole but not the fertile period in women? Why has evolution betted instead on sterile grandmothers?

In his classic paper, George Williams (1957) suggested that menopause is a biological adaptation. To be fertile until the end of female life would not be beneficial for humans because maternal risks increase with the number of births as well as with age. After a certain number of deliveries, an enlargement of the uterus and weakening of the abdominal muscles can cause irregular positions of the fetus and problems in further deliveries; the incidence of placenta previa is much increased, too, mainly because local atrophies of the endometrium (especially when pregnancies follow each other quickly) prevent the insertion of the placenta in the proper place. Evidence suggests that the human uterus is designed to carry up to seven pregnancies to term. Higher fertility would be beyond the adaptive optimum (Pschyrembel, Bretscher, and Hofmann 1973). Also, there is a marked increase in chromosomal aberrations in the fetus once the mother has reached a certain age (for example, for a woman of forty-five years of age, the risk of giving birth to a child with trisomia 21 is 1: 23, for a thirty-five-year-old women it is 1: 356 [Nikolaides, Sebire, and Snijders 2000]). Furthermore, obstetric risks accruing from advanced maternal age are well-known (Kirchengast and Hartmann 2003). Therefore it would be better to forsake reproduction completely at this stage and invest life energy into the well-being of adult children and possibly their offspring. By helping and supporting adult daughters in the pursuit of their reproductive chances, older women would increase the number of successfully raised grandchildren and thereby increase their genetic fitness to a larger extent than would be possible by continuously having children of their own.

This "stopping-early hypothesis," now well-integrated into the scientific literature, is intuitively appealing, yet doubts have been raised as to whether this evolutionary calculation can work. According to all models and data sets, reproduction seems to be more advantageous than helping others reproduce (Grainger and Beise n.d.; Hill and Hurtado 1996; Hrdy 1999; Rogers 1993; Shanley and Kirkwood 2001). Following the models and theories of behavioral ecology, increased fertility will increase reproductive fitness only under specific life conditions. Maximal fertility was and is not at all the absolute target of natural selection. A larger number of children can, for instance, cause additional costs when the offspring compete for parental resources. Siblings can compete for wealth, food, territories, status, mating opportunities, kin support, and other goals. When an increase of the

number of children follows the law of diminishing returns, one can easily envisage situations in which the costs of menopause approach zero (Mace 2000). Reproductive fitness, the ultimate currency of biological evolution, is known to have several components; fertility is just one of them.

In light of the facts available today, weighty arguments can be brought forward to challenge the hypothesis formulated by Williams that ending one's fertility in the middle of one's life does not represent a strategic adaptation for higher reproductive success but is, instead, the outcome of an evolutionary constraint that could not, for reasons that need further examination, be reconstructed in the course of phylogeny. As is well known, girls are born with their whole stock of approximately 2 million follicles of which about 300,000 remain by the age of seven, and the number is gradually reduced to zero until the age of menopause; this phenomenon is called "semelgametogenesis." Menopause happens because the egg stock is used up and can't be replaced. New insights from study of the mouse ovary, however, establish the existence of proliferative germ cells that sustain oocyte and follicle production in the postnatal mammalian ovary (Johnson et al. 2004). At present, it remains unclear whether these results bear any significance for a better understanding of the human menopause. In the conventional view, if natural selection would favor prolonging the fertile years of women, this stock would have had to be increased enormously, and it seems doubtful whether a corresponding evolutionary redesigning of the human ovary would be possible in early ontogeny without prohibitive costs for the organism. According to the antagonistic pleiotropy hypothesis, senescence is caused by effects of genes that enhance reproduction in early life but impede survival later in life (Charlesworth 1980). Following the logic of antagonistic pleiotropy, menopause could be the result of an optimal physiological trade-off: selection for efficient early reproduction at the cost of late infecundity and eventual sterility increases lifetime reproductive success more than selection for prolonged reproduction. In this scenario, menopause is not the feature that needs to be explained but rather age-specific fecundity and why it decreases relatively early in life, having reached its reproductive peak in the mid-twenties (Peccei this volume).

The "follicular depletion system," on the other hand, is not specific only to humans, but characterizes all mammals (Leidy 1999; Wood et al. 2001). Chimpanzee and human females have similar features of this system. Both have a large stock of follicles, approximately the same rate of follicle atresia, and both undergo irrevocable follicular exhaustion around the age of fifty. Why does this happen? At the center of the problem is the question of exactly how much additive genetic variance the features of the follicular depletion system possess. Did natural selection, in the course of hominization,

have a chance at all to evaluate variants of female reproductive biology? If so, then the similarity between chimpanzees and humans would represent the outcome of a stabilizing selection, and one would have to conclude that a prolongation of the fertile life span would not have resulted in a net gain. Twin studies and family correlations suggest a moderate to high heritability of age of menopause (De Bruin et al. 2001; Kirk et al. 2001; Peccei 1999; Snieder, MacGregor, and Spector 1998), so one can indeed assume that a sufficient window of opportunity existed for a directed selection towards a postponed menopause. That this opportunity apparently remained unused corroborates the assumption that net costs would have been the consequence of prolonged fertility.

To support this hypothesis, some authors (for example, Peccei this volume) have pointed at the seemingly biphasic process of follicular atresia: it first appeared that it accelerates at an age of about forty, as if an early menopause was to be initiated in this way. This appears to be the work of evolutionary design: without this acceleration of the rate of atresia, the stock of follicles would last nearly thirty more years. Yet there are doubts as to the validity of these findings. Specifically, the rate of atresia is said not to exhibit any special features, which would support the argument that the process represents an adaptation (Leidy, Godfrey, and Sutherland 1998).

If follicular atresia and the age at which menopause occurs are largely genetically fixed features with only weak heritability, they would have to be seen as unchangeable constraints in human evolution. This could explain why socioeconomic factors have very little influence on the mean age at menopause yet have a significant influence on the mean age of menarche (Leidy Sievert 2001; Thomas et al. 2001). Reported differences in mean age at natural menopause between women in industrialized countries versus those in developing countries turns out to be largely due to methodological artifacts (Reynolds and Obermeyer 2001). Apart from this, a diachronic comparison of the mean age at menopause from antiquity to modernity (notwithstanding sketchy data sets) reveals that there has been practically no change (Peccei this volume). Even nutrition does not play a significant role in influencing the onset of menopause (Thomas et al. 2001; Wood 1994). In contrast to the beginning of fecundity, the end of it does not appear to be especially sensitive to such environmental factors. It shows little leeway for conditional variability. This rigidity suggests that a prolongation of fecundity, even given that it would have contributed to an increase in lifetime fitness, was outside the window of opportunity for natural selection. Menopause, then, would not represent a functional adaptation but rather a dysfunctional and unchangeable inheritance resulting from the phylogeny of mammals.

# Longevity

What constitutes evolutionary advantage for women who reach old age if obligatory infertility excludes them from continuing childbearing (table I.1)? Whether this question is well founded has been repeatedly challenged. One would argue, based on paleodemographic finds that seem to indicate that postmenopausal survival was a relatively rare event (for example, Kennedy 2003, Weiss 1981), that only modern times with more or less ad libitum food intake, medicine, and hygiene has made this section of life possible. Older adulthood is, according to this line of reasoning, of recent origin, no older than the Neolithic or even the Industrial Revolution and thus in no need of an evolutionary explanation. Yet demographic data gathered in contemporary hunter-gather societies of the Ache (in the rain forest of eastern Paraguay), Hadza[1] (in the arid tropics of Tanzania), and

**Table I.1** Hypotheses pertaining to the evolution of human longevity

| Hypothesis | Logic | Key reference |
|---|---|---|
| Stopping early hypothesis or altriciality life span hypothesis or good mother hypothesis | Due to the extreme altriciality of human infants, selection favors mothers who live beyond their childbearing years and continue investment in their last-born child (this hypothesis may also explain the evolution of menopause) | Williams 1957 Peccei this volume Sherman 1998 |
| Modern artifact hypothesis | Longevity is a recent phenomenon due to improved nourishment, medicine, and hygiene and thus needs no evolutionary interpretation | Weiss 1981 |
| By-product hypothesis | Longevity is the nonfunctional by-product of selection for premenopausal vitality | Wood et al. 2001 |
| Embodied capital hypothesis | Older males produce caloric surplus that they barter for mating and/or maternal investment; female longevity evolves in tow of the male advantage of increasing life span | Kaplan et al. 2000 |
| Grandmother hypothesis | Prolonged female postgenerative longevity is an evolutionary consequence of grandmotherly investment in kin | Hawkes & Blurton Jones this volume |
| Cooperative breeding hypothesis | Cooperative breeding came first in the evolutionary sequence, before selection for prolonged postgenerative life spans could occur | Hrdy this volume |

!Kung (Kalahari desert, Botswana) reveal that women at the age forty-five can expect to live for another twenty years. These societies are not completely free of Western influence, but in a critical appraisal of possible outside interference, Blurton Jones, Hawkes, and O'Connell (2002) conclude that these twenty years of life after menopause cannot be seen as artifact brought about by civilization but rather are a part of the evolved life history of *Homo sapiens* (cf. Hawkes and Blurton Jones this volume). Among the Eipo, a society of newly contacted horticulturists and gatherers in highland West New Guinea, Schiefenhövel (1988) found a similar extended life span in women who consequently outlived men—a pattern that is typical worldwide for all but very few societies (United Nations Statistics Division 2000) and accentuates the theoretical problem human menopause poses: Why do women of our species live longer yet cease to be fertile at an earlier age than men? The interpretation of Blurton Jones, Hawkes, and O'Connell (2002) is, furthermore, congruent with estimates of the typical human life span based on interspecies regressions to body height and brain volume (Hammer and Foley 1996; Judge and Carey 2000). Their interpretation is also congruent with the observation that differential longevity is under genetic control (for example, Cournil, Legay, and Schächter 2000; Hershkind et al. 1996) as well as with mammalian life-history models (Hawkes and Blurton Jones this volume).

However, indications that postmenopausal survival can be explained in evolutionary terms does not mean that it constitutes an adaptation. Based on Vaupel (1997; Vaupel et al. 1998), Wood et al. (2001) interpret the postgenerational life span instead as a nonfunctional by-product of a selection for increased premenopausal vitality: those selected to have a good chance of reaching fifty in order to fully use one's fertile life span stood a good chance of living beyond this age, and therefore beyond fertility. To exemplify the argument, the authors use the nonbiological metaphor of a cosmic probe: once it has fulfilled its designed function, it will speed far off into space. In other words, to include a self-destructing mechanism would be costlier than to have it simply leave its galactic destiny. In this light, postmenopausal survival would be a "fly-by" phenomenon, a kind of waste product of a selection that favored premenopausal survival. Such nonfunctional interpretation includes the possibility that life span thus gained could be co-opted by adaptive behavioral strategies, for example, in the form of kin investment. The authors only doubt that the adaptive opportunity that arose as a consequence of an increased life span was the evolutionary motor of living longer. Longevity, so typical for humans, would thus represent, in the term of Gould and Lewontin (1979), a "spandrel": a by-product of evolution, in itself without adaptive function, gaining evolutionary significance through the implementation of grandmotherhood.

There are, on the other hand, models that do ascribe adaptive advantage to the evolution of longevity. Higher somatic cost—what organisms have to pay for maintenance and repair in order to live longer—would be reimbursed through higher direct and indirect fitness so that "genes for longevity" would spread in the population. Whether there exists a trade-off between longevity and fertility—in other words, whether longevity creates reproductive costs as life history predicts—is still under debate (Doblhammer and Oeppen 2003; Helle, Lummaa, and Jokela 2002; Le Bourg 2001; Lycett, Dunbar, and Voland 2000). In any case, female longevity does not require childlessness (Gavrilova and Gavrilov this volume). As menopause bars continuous childbearing, the explanation of longevity requires evolutionary scenarios that could have resulted in a net gain through kin support. What scenario was favored is still debated, however. Was prolonged life span predominantly a male- or a female-driven phenomenon? Which work productivity in older age could have been transformed into fitness gains—that of male hunters (Kaplan et al. 2000) or that of women gatherers (Hawkes and Blurton Jones this volume)? Was this kin support for the young by the older generation directed primarily to the last-born children because they were not yet fully independent and their chances in life would be much reduced without investment by their parents? This hypothesis is subsumed under the term "good mother hypothesis" (Sherman 1998) or "altriciality life span hypothesis" (Peccei 1995) and finds substantial support (Sorenson Jamison, Jamison, and Cornell this volume). Or was support for adult and actively reproducing offspring the evolutionary motor for longevity as encapsulated in the "grandmother hypothesis" in the narrower sense postulated by Hawkes et al. (1989, 1998, 2000)? Or, phrased differently, is human longevity caused by the benefits of prolonged investment of parents into their children or by the "invention" of grandmothers as "helpers at the nest"? This hypothesis is supported by a growing body of evidence that shows that grandmothers enhance the reproductive success of their offspring (Beise and Voland 2002; Jamison et al. 2002; Lahdenperä et al. 2004; Sear, Mace, and McGregor 2000, 2003; Sear et al. 2002; Voland and Beise 2002). Or perhaps the "good mother" and the "grandmother" hypotheses are simply different sides of the same coin, since both are about stopping reproduction early (Hrdy this volume; Peccei 2001).

When older women, though still vital, could no longer bear their own children but could relieve their adult daughters with respect to subsistence efforts, this would have resulted in higher fertility of the latter, as they could wean their infants considerably earlier than their hominoid ancestors. For comparison: the typical birth interval in chimpanzees is five to six years, whereas in tropical hunter-gatherer societies it is only three to four years. Do we thus owe the increase of our life span to those elderly women who

spread their "genes for longevity" through effective material and emotional as well as cognitive support of their adult offspring plus their grandchildren? Data collected among the Hadza hunter-gatherers in Tanzania support this hypothesis, as older women produce surplus calories that increase the fertility of their daughters (Hawkes, O'Connell, and Blurton Jones 1989). This happens in the following way: the foraging returns of a Hadza woman are the lower the younger her last child is. This leads to prolonged nursing and consequently a later ending of lactational amenorrhea. Therefore, the next child is born later and total fertility is reduced; being provisioned can decrease the interval between births, of course. While Hawkes et al. (1989, 1998, 2000) emphasize the provisioning by the mother's mother, thus deemphasizing the role of husbands as providers, new data show that men do invest in their genetic children, especially during the nursing period (Marlowe 2003). So it seems that in the cooperative breeding system of the Hadza, both grandmothers and husbands play their part.

Grandmothers in Ache and Hiwi cultures produce, on average, no nutritional surplus (Kaplan et al. 2000), so it is doubtful whether the case of the Hadza describes the evolutionary scenario leading to grandmotherhood well. Of course, kin support could have been realized through other channels than food supply, for example, through food processing and, especially, child care, which cannot be expressed in caloric terms. Elderly women could have accumulated valuable knowledge regarding coping with disease, knowing medical plants, taking care of toddlers at the critical period of weaning, and last but not least, acting as competent birth attendants. Recently it was reported that an experienced gorilla mother in the San Diego Wild Animal Park encouraged her daughter to behave in an adequately nurturing way towards her newborn (Nakamichi et al. 2003). Clearly this is an anecdote that should not be overinterpreted; yet it inspires the hypothesis that teaching maternal care was, in evolutionary terms, a decisive channel of grandmotherly kin support. Whereas men, in historical times, might have been the most important calorie providers, women might have contributed socioemotional and other vital support at critical times in the children's lives. Yet, when the effects of investment are measured in "offspring equivalents per year," Hill and Hurtado (1996) document only marginal benefits coming from Ache grandmothers in regard to the family's reproduction. Quantifying grandmother effects in this way, however, is a difficult enterprise, as grandmothers 'help could be channeled according to respective needs of the infants and distributed unevenly to different recipients. It would be necessary to compare the reproductive fitness of different kin networks while simultaneously taking into account which other persons took over supportive roles—an analytically challenging endeavor, indeed.

Theory and empirical data in grandmother research apparently do not

mesh in yet another facet. It is generally assumed in anthropological textbooks that Pleistocene hunter-gatherers typically had a virilocal residence rule and were thereby organized in patrilocal groups, which were thus unified through genetically related males while women were the mobile sex and left the group at the onset of fecundity. The majority of contemporary hunter-gatherer societies, in remarkable continuity with chimpanzees and bonobos, favor male philopatry and female dispersal. Kayser et al. (2003) have shown the same pattern for Papuan populations in Melanesia: the diversity of Y chromosomes is very much reduced while that of mitochondrial DNA is not. Historically speaking, a limited number of genetically related men have been the fathers whereas the mothers came into clan-exogamous, virilocal groups from outside (but see Hage and Marck 2003). In such social systems, however, it is rare but not impossible that many elderly women lived in the same house or settlement as their adult daughters or other kin. Paleolithic women, therefore, shared their lives with their mothers-in-law rather than with their own mothers. These were probably unfavorable preconditions for the helping grandmother to evolve as the motor of longevity. If, on the other hand, evolutionary success was effectuated not via grandmothering but via prolonged mothering, as postulated by the altricial life span hypothesis, then the prevailing dispersal patterns did not play a role (Peccei 2001). Therefore, the high incidence of male philopatry within human and nonhuman hominoids would not constitute a stumbling block for an evolutionary explanation of postgenerative life span. Perhaps grandmothers are just "making the best of a bad job." Life may have become prolonged in the course of phylogeny due to completely different reasons, but, if one gets old anyway and can no longer bear children, one can assume the role of "helper at the nest" and assist one's own children and their offspring. This is better than having one's hands in one's lap.

However, a critical assessment of the anthropological database shows that the assumption of virilocality and patriarchy as the predominant social characteristics of Paleolithic societies may not be easy to defend (Knight and Power this volume). An unbiased interpretation of the findings is difficult as the matriarchy/patriarchy issue has always been ideologically instrumentalized beyond the scientific disciplines. The predominant views of the nineteenth and twentieth centuries saw patriarchic rather than matriarchic structures to be the base of early human societies (Knight and Power this volume). A reanalysis of the existing ethnographic literature does not exclude at all the possibility that matrilocality was an important constituting element of early human social structure. This possibility is also suggested by the study of Holden and Mace (2003). Based upon ethnographies from Africa, these authors suggest that matrilineal descent is lost with the cultivation of resources (for example, livestock) that serve men's reproductive

interests more than women's. Hence it seems that during the environment of evolutionary adaptedness, or EEA, with its lack of heritable resources, matrilineal descent was more likely, and patrilineal descent gained importance with the opportunity to accumulate resources, that is, especially with the Neolithic revolution.

## Behavioral Strategies

In any case, one should expect helping grandmothers. Evolved strategies are, as a general rule, conditional strategies. This is why evolution most likely did not bring about helping grandmothers unconditionally. But as the prehistory of grandmothers can't be observed it must be painstakingly reconstructed, and the only road available is the admittedly risky one of drawing conclusions about evolutionary scenarios from the observation of modern humans. Notwithstanding this limitation, the study of the socioecological variability of the effects of grandmothers can contribute to a proper assessment of their evolutionary role as a helpers (see, in this volume, Beise; Blurton Jones, Hawkes, and O'Connell; Hawkes and Blurton Jones; Hrdy; Leonetti et al.; Mace and Sear; Nosaka and Chasiotis; Schiefenhövel and Grabolle; Schölmerich et al.; Sorenson Jamison, Jamison, and Cornell). To pursue this research, one needs to know under which personal, cultural, and ecological conditions a form of support is given to whom in what degree. A good knowledge of such behavioral patterns should, according to Darwinian heuristics, facilitate the formulation of plausible hypotheses concerning the evolutionary scenarios that lead to grandmotherhood.

A first task will be to ask in which channels the newly evolved opportunity for grandmotherly kin support materialized. What exactly is it that makes grandmothers persist in an evolutionary perspective? Is it their contribution to family subsistence? Or does their political influence enhance the success of their offspring? Perhaps the advantage is their rich knowledge and wisdom accumulated during long lives, which can be tapped to solve their children's and grandchildren's problems, as we know occurs among elephants (McComb et al. 2001). We can assume that, depending on the ethnohistoric situation and on the type of subsistence and ecological niche, grandmotherly help will probably come to bear in very different channels.

The center of research on the evolutionary significance of grandmothers is their potential for kin support. This focus may have obstructed the fact that grandmothers are, of course, also enmeshed in competitive intrafamilial interactions and may, therefore, develop exploitative tendencies. Grandmothers are not related to the wives of their sons. Their interest in their daughters-in-law, therefore, only stretches as far as the latter contribute to

the former dynastic interest. It is part of the strategic differentiation of the helping grandmother that she obviously and primarily supports her own daughters and their children (Beise this volume; Beise and Voland 2002; Bereczkei and Dunbar 1997; Schiefenhövel and Grabolle this volume; Jamison et al. 2002; Mace and Sear this volume; Ragsdale 2004; Sear, Mace, and McGregor 2000; Voland and Beise this volume). The adaptive logic in this asymmetry possibly stems from the fact that fatherhood is uncertain (Jamison et al. 2002). As there can be no doubt about motherhood outside hospital conditions, elderly women can be absolutely sure that they are the genetic grandmothers of their daughters 'children. With regard to their sons' children, this security does not exist. It is well known that this basic difference deeply influences relationships in families (Euler, Hoier, and Rohde 2001; Gaulin, McBurney, and Brakeman-Wartell 1997).

Besides uncertain paternity, there are at least two further areas of conflict in which mothers-in-law and daughters-in-law can clash. Mothers-in-law could increase the reproductive success of their sons by increasing their opportunities to mate, whereas the daughters-in-law would have an interest to continue supporting dependent children between births. The genetic interests of mothers-in-law would be directed at weakening the bond between their sons and their daughters-in-law and at finally pushing them out of the family or to a less important position in order to create additional reproductive opportunities for their sons. Of course, the success of such strategy would be subject to specific demographic and socioecological conditions.

Another conflict centers around the contribution the daughter-in-law is expected to make to the economy of the family. A mother-in-law would, provided her intrafamilial power position is strong enough, tend to pressure her daughter-in-law to do more work than her own daughter. To be generous and nurturing towards the daughter-in-law during her pregnancy or puerperium was not necessarily (for example, under agrarian subsistence conditions) an optimal strategy of the mother-in-law. Even considering that economic exploitation of the daughter-in-law would harm her health or even cost the life of a grandchild, this strategy would have prevailed if the productivity of the daughter-in-law was significant. Under conditions of high fertility, an infant who died early could be replaced quickly. Furthermore, a deceased daughter-in-law could be replaced (although polygyny and preferential female infanticide, which are not uncommon in traditional societies, may cause a scarcity of younger women). Daughters-in-law thus faced a twofold exploitation: reproduction and productivity. The demands on them may have conflicted with their self-interests. These kinds of hypotheses need further systematic corroboration, yet they warn us of a "blind spot" in evolutionary grandmother research. Because it is primarily the ef-

fect of kin support of elderly women that is extensively studied, possible negative influences on familial reproduction, which are likely to occur, could slip from view.

Biological adaptations are known to persist beyond the conditions under which they evolved. It is, therefore, an open question whether those fitness advantages that were the reason for grandmotherly support strategies to develop in the Plio-Pleistocene environment of evolutionary adaptedness would come to bear in other environments. The motivational system of the strategically supporting grandmother is most likely an anthropological constant. Under which socioecological conditions this tendency to help contributes to increased fitness of senior women is still largely unknown. The transformation of kin support into fitness is tied to the inevitable condition that everyday life presents sufficient opportunity for this transformation.

And what about societies in which the original channels of grandmotherly investment are practically "dried up" because infant mortality is reduced drastically and grandmothers can hardly reduce it further? Or because reproductive decisions are geared toward reducing fertility rather than increasing it and grandmothers as "weaning devices" would be outright counterproductive? Interestingly enough, even under modern circumstances, the helping grandmother can be found in a variety of cultural settings (Nosaka and Chasiotis this volume; Schölmerich et al. this volume). Moreover, analyses of intergenerational wealth flow indicate that in traditional (Kaplan 1994) as well as in modern societies (Kohli 1999; Lee 1997), the net flow within families moves from the older to the younger generation. On the national level of modern societies, however, the net flow is reversed, and resources are transferred from the younger to the older generation. Fitting with sociobiological theory, benefits coming from the elderly are privatized with the kin group whereas their costs (pensions, health care) become the burden of the whole community.

Could it be that the respect one pays to seniors is a function of their realized evolutionary utility? This question is not unjustified if one keeps in mind that there are three conditions necessary for the evolution of grandmotherhood (Hrdy this volume). First, there had to be, of course, a motivational tendency for kin support. This tendency is primate heritage and therefore can safely be assumed to exist. Second, the elder women must have had a chance to benefit their family, and third, the survival of the older individuals must not have caused costs that would have neutralized or even exceeded the support they were able to give. If resources are shared within the family, as, for example, Helle, Käär, and Jokela (2002) report from the Sami in northern Finland, intrafamilial allocation conflicts arise. It may not pay to begin with reproduction early in life. Postponing childbearing to a later age minimizes the time grandparents and their grandchildren live to-

gether. Hence, lengthening generation time can lead to a reduction of intrafamilial competition and thus reduce the costs for the elderly. If getting old uses more resources than the elderly can produce themselves, if, in other words, the resource flow of kin support would have gone from the young to the old, then it would not have paid, in evolutionary terms, to have a grandmother around.

Even though she might have done her utmost to help her kin, if this self-sacrificial tendency did not pay in overall terms, relatives would have had, on average, little sympathy for a grandmother who became more a hindrance than a help. It is quite possible in light of this cost-benefit matrix that a specific emotionality towards grandmothers evolved that tied affect towards the elderly to the balance of the costs old women represent to their kin group and the contributions they make (Amoss and Harrell 1981). The findings from the Hadza and !Kung, where older women take over important subsistence work and are well respected, and from the Inuit and the Ache, who both rely on hunting, seem to support this; events of gerontocide are legitimized by a lack of productivity of older women (Hill and Hurtado 1996). All these manifold angles exemplify that the evolution of postgenerative life span and the behavioral ecology shaping this period of human life can only be examined and understood in the context of social and family structures.

## Note

1. A newer version of this ethnonym is Hadzabe, the plural of Hadza (which is singular or adjective), which seems to be preferred by the indigenous people themselves (Power, personal communication).

## References

Amoss, P. T., and S. Harrell. 1981. "An anthropological perspective on aging." In *Other Ways of Growing Old: Anthropological Perspectives*, ed. P. T. Amoss and S. Harrell. Stanford, CA: Stanford University Press, 1–24.
Beise, J., and E. Voland. 2002. "A multilevel event history analysis of the effects of grandmothers on child mortality in a historical German population (Krummhörn, Ostfriesland, 1720–1874)." *Demographic Research* 7: 469–97.
Bellino, F. L., and P. M. Wise. 2003. "Nonhuman primate models of menopause workshop." *Biology of Reproduction* 68:10–18.
Bereczkei, T., and R. I. M. Dunbar. 1997. "Female-biased reproductive strategies in a Hungarian Gypsy population." *Proceedings of the Royal Society of London.B* 264:17–22.
Blikslager, G. 1910. *Der Ostfriese in seinen Sprichwörtern und Redensarten*. Emden: Haynel.
Blurton Jones, N. G., K. Hawkes, and J. F. O'Connell. 2002. "Antiquity of postre-

productive life: Are there modern impacts on hunter-gatherer postreproductive life spans?" *American Journal of Human Biology* 14:184–205.

Charlesworth, B. 1980. *Evolution in Age-Structured Populations.* Cambridge: Cambridge University Press.

Cournil, A., J.-M. Legay, and F. Schächter. 2000. "Evidence of sex-linked effects on the inheritance of human longevity: A population-based study in the Valserine valley (French Jura), 18–20th centuries." *Proceedings of the Royal Society of London.B* 267:1021–25.

De Bruin, J. P., H. Bovenhuis, P. A. H. Van Noord, P. L. Pearson, J. A. M. Van Arendonk, E. R. Te Velde, W. W. Kuurman, and M. Dorland. 2001. "The role of genetic factors in age at natural menopause." *Human Reproduction* 16:2014–18.

Doblhammer, G., and J. Oeppen. 2003. "Reproduction and longevity among the British peerage: The effect of frailty and health selection." *Proceedings of the Royal Society London.B* 270:1541–47.

Euler, H. A., S. Hoier, and P. A. Rohde. 2001. "Relationship-specific closeness of intergenerational family ties: Findings from evolutionary psychology and implications for models of cultural transmission." *Journal of Cross-cultural Psychology* 32:147–58.

Gaulin, S. J. C., D. H. McBurney, and S. L. Brakeman-Wartell. 1997. "Matrilateral biases in the investment of aunts and uncles: A consequence and measure of paternity uncertainty." *Human Nature* 8:139–51.

Gould, K. G., M. Flint, and C. E. Graham. 1981. "Chimpanzee reproductive senescence: A possible model for evolution of the menopause." *Maturitas* 3:157–66.

Gould, S. J., and R. C. Lewontin. 1979. "The spandrels of San Marco and the Panglossian program: A critique of the adaptationist programme." *Proceedings of the Royal Society of London.B* 250:281–88.

Grainger, S., and J. Beise. (n.d.) "Menopause and post-generative longevity: Testing the 'stopping-early' and 'grandmother' hypotheses."

Hage, P., and J. Marck. 2003. "Matrilineality and the Melanesian origin of Polynesian Y chromosomes." *Current Anthropology* 44 (Suppl.): S121–S127.

Hammer, M. L. A., and R. A. Foley. 1996. "Longevity and life history in hominid evolution." *Human Evolution* 11:61–66.

Hawkes, K., J. F. O'Connell, and N. G. Blurton Jones. 1989. "Hardworking Hadza grandmothers." In *Comparative Socioecology: The Behavioral Ecology of Humans and Other Mammals,* ed. V. Standen and R. A. Foley. Oxford: Blackwell, 341–66.

Hawkes, K., J. F. O'Connell, N. G. Blurton Jones, H. Alvarez, and E. L. Charnov. 1998. "Grandmothering, menopause, and the evolution of human life histories." *Proceedings of the National Academy of Sciences (USA)* 95:1336–39.

———. 2000. "The grandmother hypothesis and human evolution." In *Adaptation and Human Behavior: An Anthropological Perspective,* ed. L. Cronk, N. Chagnon, and W. Irons. Hawthorne, NY: Aldine de Gruyter, 237–58.

Helle, S., P. Käär, and J. Jokela. 2002. "Human longevity and early reproduction in pre-industrial Sami populations." *Journal of Evolutionary Biology* 15:803–7.

Helle, S., V. Lummaa, and J. Jokela. 2002. "Sons' reduced maternal longevity in preindustrial humans." *Science* 296:1085.

Herskind, A. M., M. McGue, N. V. Holm, T. I. A. Sorensen, B. Harvald, and J. W. Vaupel. 1996. "The heritability of human longevity: A population-based study of 2,872 Danish twin pairs born 1870–1900." *Human Genetics* 97:319–23.

Hill, K., C. Boesch, J. Goodall, A. Pusey, J. Williams, and R. Wrangham. 2001. "Mortality rates among wild chimpanzees." *Journal of Human Evolution* 39:1–14.

Hill, K., and A. M. Hurtado. 1996. *Ache Life History: The Ecology and Demography of a Foraging People.* Hawthorne: Aldine de Gruyter.

Holden, C. J., and R. Mace. 2003. "Spread of cattle led to the loss of matrilineal descent in Africa: A coevolutionary analysis." *Proceedings of the Royal Society London.B* 270:2425–33.

Hrdy, S. B. 1999. *Mother Nature: A History of Mothers, Infants, and Natural Selection.* New York: Pantheon.

Jamison, C. S., L. L. Cornell, P. L. Jamison, and H. Nakazato. 2002. "Are all grandmothers equal? A review and a preliminary test of the 'grandmother hypothesis' in Tokugawa, Japan." *American Journal of Physical Anthropology* 119:67–76.

Johnson, J., J. Canning, T. Kaneko, J. K. Pru, and J. L. Tilly. 2004. "Germline stem cells and follicular renewal in the postnatal mammalian ovary." *Nature* 428:145–50.

Judge, D. S., and J. R. Carey. 2000. "Postreproductive life predicted by primate patterns." *Journal of Gerontology: Biological Sciences* 55A:B201–B209.

Kaplan, H. 1994. "Evolutionary and wealth flows theories of fertility: Empirical tests and new models." *Population and Development Review* 20:753–91.

Kaplan, H., K. Hill, J. Lancaster, and A. M. Hurtado. 2000. "A theory of human life history evolution: Diet, intelligence, and longevity." *Evolutionary Anthropology* 9:156–85.

Kayser, M., S. Brauer, G. Weiss, W. Schiefenhövel, P. Underhill, S. Peidong, P. Oefner, M. Tommaseo-Ponzetta, and M. Stoneking. 2003. "Reduced Y-chromosome, but not mitochondrial DNA, diversity in human populations from West New Guinea." *American Journal of Human Genetics* 72:281–302.

Kennedy, G. E. 2003. "Palaeolithic grandmothers? Life history theory and early Homo" *Journal of the Royal Anthropological Institute* (n.s.) 9:549–72.

Kirchengast, S., and B. Hartmann. 2003. "Advanced maternal age is not only associated with newborn somato-metrics but also with the mode of delivery." *Annals of Human Biology* 30:1–12.

Kirk, K. M., S. P. Blomberg, D. L. Duffy, A. C. Heath, I. P. F. Owens, and N. G. Martin. 2001. "Natural selection and quantitative genetics of life-history traits in western women: A twin study." *Evolution* 55:423–35.

Kohli, M. 1999. "Private and public transfers between generations: Linking the family and the state." *European Societies* 1:81–104.

Lahdenperä, M., V. Lummaa, S. Helle, M. Tremblay, and A. F. Russell. 2004. "Fitness benefits of prolonged post-reproductive lifespan in women." *Nature* 428:178–81.

Le Bourg, E. 2001. "A mini-review of the evolutionary theories of aging. Is it the time to accept them?" *Demographic Research* 4, article 1.

Lee, R. D. 1997. "Intergenerational relations and the elderly." In *Between Zeus and*

*the Salmon: The Biodemography of Longevity,* ed. K. W. Wachter and C. E. Finch. Washington, DC: National Academy, 212–33.

Leidy, L. E. 1999. "Menopause in evolutionary perspective." In *Evolutionary Medicine,* ed. W. R. Trevathan, E. O. Smith, and J. McKenna. New York: Oxford University Press, 407–27.

Leidy, L. E., L. R. Godfrey, and M. R. Sutherland. 1998. "Is follicular atresia biphasic?" *Fertility and Sterility* 70:851–59.

Leidy Sievert, L. 2001. "Aging and reproductive senescence." In *Reproductive Ecology and Human Evolution,* ed. P. T. Ellison. New York: Aldine de Gruyter, 267–92.

Lycett, J. E., R. I. M. Dunbar, and E. Voland. 2000. "Longevity and the costs of reproduction in a historical human population." *Proceedings of the Royal Society London B* 267:31–35.

Mace, R. 2000. "Evolutionary ecology of the human female life history." In *Sex and Longevity: Sexuality, Gender, Reproduction, Parenthood,* ed. J.-M. Robine, T. B. L. Kirkwood, and M. Allard. Berlin: Springer, 59–73.

Marlowe, F. W. 2003. "A critical period for provisioning by Hadza men: Implications for pair bonding." *Evolution of Human Behavior* 24:217–29.

McComb, K., C. Moss, S. M. Durant, L. Baker, and S. Sayialel. 2001. "Matriarchs as repositories of social knowledge in African elephants." *Science* 292:491–94.

Nakamichi, M., A. Silldorff, C. Bringham, and P. Sexton. 2003. "Baby-transfer and other interactions between its mother and grandmother in a captive social group of lowland gorillas." *Primates* 45:73–77.

Nishida, T., N. Corp, M. Hamai, T. Hasegawa, M. Hiraiwa-Hasegawa, K. Hosaka, K. D. Hunt, N. Itoh, K. Kawanaka, A. Matsumoto-Oda, J. C. Mitani, M. Nakamura, K. Norokoshi, T. Sakamaki, L. Turner, S. Uehara, and K. Zamma. 2003. "Demography, female life history, and reproductive profiles among the chimpanzees of Mahale." *American Journal of Primatology* 59:99–121.

Nikolaides, K. H., N. J. Sebire, and R. J. M. Snijders. 2000. *Die Ultraschalluntersuchung der 11–14 Schwangerschaftswoche. Diagnose fetaler Fehlbildungen.* New York: Parthenon.

Peccei, J. S. 1995. "The origin and evolution of menopause: The altriciality-lifespan hypothesis." *Ethology and Sociobiology* 16:425–49.

———. 1999. "First estimates of heritability in the age of menopause. *Current Anthropology* 40:553–58.

———. 2001. "Menopause: Adaptation or epiphenomenon?" *Evolutionary Anthropology* 10:43–57.

Pschyrembel, W., J. Bretscher, and D. Hofmann. 1973. *Praktische Geburtshilfe und Geburtshilfliche Operationen.* Berlin: De Gruyter.

Ragsdale, G. 2004. "Grandmothering in Cambridgeshire, 1770–1861." *Human Nature* 15:301–17.

Reynolds, R., and C. M. Obermeyer. 2001. "Age at natural menopause in Beirut, Lebanon: The role of reproductive and lifestyle factors." *Annals of Human Biology* 28:21–29.

Rogers, A. R. 1993. "Why menopause?" *Evolutionary Ecology* 7:406–20.

Schiefenhövel, W. 1988. *Geburtsverhalten und Reproduktive Strategien der Eipo: Ergebnisse Humanethologischer und Ethnomedizinischer Untersuchungen im Zentralen Bergland von Irian Jaya (West-Neuguinea), Indonesien.* Berlin: Reimer.

Sear, R., R. Mace, and I. A. McGregor. 2000. "Maternal grandmothers improve nutritional status and survival of children in rural Gambia." *Proceedings of the Royal Society London. B* 267:1641–47.

———. 2003. "The effects of kin on female fertility in rural Gambia." *Evolution and Human Behavior* 24:25–42.

Sear, R., R. F. Steele, I. A. McGregor, and R. Mace. 2002. "The effects of kin on child mortality in rural Gambia." *Demography* 39:43–63.

Shanley, D. P., and T. B. L. Kirkwood. 2001. "Evolution of the human menopause." *BioEssays* 23:282–87.

Sherman, P. W. 1998. "The evolution of menopause." *Nature* 392:759–61.

Snieder, H., A. J. MacGregor, and T. D. Spector. 1998. "Genes control the cessation of a woman's reproductive life: A twin study of hysterectomy and age at menopause." *Journal of Clinical Endocrinology and Metabolism* 83:1875–80.

Thomas, F., F. Renaud, E. Benefice, T. De Meeüs, and J.-F. Guegan. 2001. "International variability of ages at menarche and menopause: Patterns and main determinants." *Human Biology* 73:271–90.

United Nations Statistics Division. 2000. *The World's Women 2000: Trends and Statistics.* New York: United Nations Publications.

Vaupel, J. W. 1997. "The remarkable improvements in survival at older ages." *Philosophical Transactions of the Royal Society London. B* 352:1799–1804.

Vaupel, J. W., J. R. Carey, K. Christensen, T. E. Johnson, A. I. Yashin, N. V. Holm, I. A. Iachine, V. Kannisto, A. A. Khazaeli, P. Liedo, V. D. Longo, Y. Zeng, K. G. Manton, and J. W. Curtsinger. 1998. "Biodemographic trajectories of longevity." *Science* 280:855–60.

Voland, E., and J. Beise. 2002. "Opposite effects of maternal and paternal grandmothers on infant survival in historical Krummhörn." *Behavioral Ecology and Sociobiology* 52:435–443.

Weiss, K. 1981. "Evolutionary perspectives on human aging." In *Other Ways of Growing Old,* ed. P. Amoss and S. Harrell. Stanford, CA: Stanford University Press, 25–58.

Williams, G. C. 1957. "Pleiotropy, natural selection, and the evolution of senescence." *Evolution* 11:398–411.

Wood, J. W. 1994. *Dynamics of Human Reproduction: Biology, Biometry, Demography.* Hawthorne, NY: Aldine de Gruyter.

Wood, J. W., K. A. O'Connor, D. J. Holman, E. Brindle, S. H. Barsom, and M. A. Grimes. 2001. "The evolution of menopause by antagonistic pleiotropy." *Center for Studies in Demography and Ecology: Working Papers* 1–4. Seattle, WA.

# PART I
# LIFE HISTORY
*The Evolutionary Route to Grandmothers*

# CHAPTER 1

# Primate Predispositions for Human Grandmaternal Behavior

Andreas Paul

Nearly thirty years ago, Sarah Hrdy was among the first to challenge the long-held view that menopause is a uniquely human trait. "Accumulating evidence," she wrote in 1976, "indicate that women are not the only primates who cease to reproduce with age" (Hrdy 1981, 61). Based on the ideas of Williams (1957), Hamilton (1966), and Alexander (1974), as well as on her own observations (and those of others) on the behavior of female primates, Hrdy went on to note that this comes "as no surprise to evolutionary biologists." Given the extended care primate offspring require for their survival and successful reproduction, she argued that Williams' (1957) suggestion that it might have become advantageous for women eventually to stop producing new offspring and concentrate on the promotion of extant ones "applies to nonhuman primates as well" (Hrdy 1981, 72). Specifically, Hrdy proposed that "from an evolutionary perspective post-reproductive females have more to gain defending their genetic investment, *grandchildren*" (Hrdy 1981, 67: italics mine).

Hrdy frankly acknowledged that some of her ideas were "speculative," but she also presented evidence in support of her "grandmother hypothesis." Firstly, she showed that among various species of monkeys and apes, fertility not only declines with age but that at least some females stopped reproducing well before death. Moreover, the fact that postreproductive females were not only found among captive or provisioned primates, but also in populations living under natural conditions (for example, Dittus 1975; Waser 1978; see also Hamilton, Busse, and Smith 1982; Nishida, Takasaki, and Takahata 1990; Robinson 1988), clearly raised the possibility that postreproductive survival in nonhuman primates may be not a simple—and recent—result of an artificially extended life span, but an evolved trait. If so, menopause could be indeed an old part of our primate legacy. Secondly, in her search for an adaptive explanation, Hrdy drew on her own observations of wild langurs and those of Jennifer Partch (1978) of free-ranging but provisioned rhesus monkeys. In both studies, it was observed that old and supposedly postreproductive females vigorously defended infants from their own matrilines against infanticidal males or other threats. Moreover, these old females appeared to be even more protective and courageous

than breeding ones. "Old age among at least some primate species," Hrdy concluded, "is the product of evolutionary forces that favor the genes of animals who survive past their own reproductive periods to foster, support, and protect their younger kin" (Hrdy 1981, 75).

While the grandmother hypothesis eventually received considerable attention from evolutionary anthropologists (for example, Hill and Hurtado 1991; Hawkes et al. 1998; Peccei 2001), many of Hrdy's primatologist colleagues remained skeptical about her claims. In fact, both the existence of menopause (or the adaptive termination of reproduction) in nonhuman primates and the strong commitment of grandmothers or old females to young relatives have been questioned. Mary Pavelka and Linda Fedigan (1991), for example, in a critical review about menopause from a comparative life history perspective, argued that "menopause is fundamentally distinct from the reproductive senescence that has been described for a very small number of very old individual allo-primates" (that is, nonhuman primates). Since the majority of nonhuman primate females described in the physiological literature continue to cycle until death, changes in the reproductive system of some aged females that resemble the changes associated with menopause in humans were regarded as "idiosyncratic" (Pavelka and Fedigan 1991, 33). Moreover, in a study on the "social role" of old female Japanese macaques, Pavelka concluded that "there is little evidence that old females behave differently from adult females in general" (Pavelka 1990, 369). Hrdy's and Partch's observations were dismissed since "whether or not these females were post-reproductive, it has been widely reported in the primatological literature that female macaques defend kin in agonistic encounters with non-kin, and this is not a proven age-related pattern" (Pavelka 1990, 370).

Finally, even proponents of the idea that menopause is not restricted to human females but can and occasionally does occur in some nonhuman species such as chimpanzees remain skeptical about the grandmother hypothesis since "the male philopatry of the chimpanzee-human clade appears to make it difficult for a female to help her daughter to raise the latter's offspring" (Nishida 1997, 568). Other researchers doubt whether aged nonhuman primate females "possess the physical where-withal to confer any meaningful fitness benefits to their already-born offspring" (Johnson and Kapsalis 1998, 763).

According to these views there appears to be little, if anything, we can learn about the evolutionary significance of grandmotherhood from our closest living relatives, the nonhuman primates. However, while there are undoubtedly differences in the life histories of humans and other primates, some recent findings are likely to change the view about nonhuman primate grandmothers. The aim of the present review is to evaluate the grand-

mother hypothesis from three different dimensions: life history, behavior, and fitness.

## The Life-History Perspective: Do Primate Females Terminate Reproduction before Death?

While it is widely accepted that in female mammals fertility declines at an advanced age (for example, Hill and Hurtado 1991; Packer, Tatar, and Collins 1998), there is little agreement about whether or not mammals other than humans experience "true" menopause. If menopause is defined as the "universal midlife termination of reproduction" (Pavelka, Fedigan, and Zohar 2002), there appears indeed little evidence that any other species than humans experience menopause. But cessation of reproduction at some stage of the female's life span has been documented for several nonhuman species, including primates. Free-ranging but provisioned Japanese macaques, for example, whose maximum life span is about thirty-three years, invariably cease to reproduce at the age of twenty-five years (Pavelka and Fedigan 1999), and by and large the same appears to be true for other Old World monkeys (for macaques and baboons, see Johnson and Kapsalis 1998; Packer, Tatar, and Collins 1998; Paul, Kuester, and Podzuweit 1993; Takahata, Koyama, and Suzuki 1995; Walker 1995; see also Sommer, Srivastava, and Borries 1992 for langurs). Furthermore, endocrinological investigations of aged captive rhesus macaques and histological examinations of their ovaries revealed changes similar to those associated with menopause in human females, such as elevated LH concentrations and atretic follicles (Walker 1995; see also Nozaki, Yamashita, and Shimuzu 1997 for Japanese macaques). Cessation of menstruation (historically the technical definition of menopause) in rhesus monkeys, whose maximum life span is about thirty-five years (Tigges et al. 1988), occurs by approximately twenty-seven years of age, and all females ranging in age from twenty-seven to thirty-four years were "clearly postmenopausal" (Walker 1995, 69).

Among the New World monkeys, the relatively small-bodied capuchins are known for their extraordinarily long maximum life span (at least forty-seven years in captivity). Termination of reproduction appears to occur a few years later than among the macaques, but has been observed among wild females ranging in age from approximately twenty-six to thirty-six years (Robinson 1988; see also figure 2.29 in Fleagle 1999). Among the great apes, maximum life span is even longer than in capuchins (at least fifty-five years in common chimpanzees, Hill et al. 2001), yet female chimpanzees typically produce their last offspring in their late thirties to early forties (Nishida, Takasaki, and Takahata 1990). Curiously, although field studies of wild chimpanzees provide compelling evidence for the cessation of cycling

among aged females (presumably in their early or mid forties, Nishida, Takasaki, and Takahata 1990), physiological studies of captive females (Graham, Kling, and Steiner 1979; Gould, Flint, and Graham 1981) revealed no unequivocal evidence for menopause (Pavelka and Fedigan 1991). This is even more curious in light of the fact that Gould and his coworkers (1981) found clear evidence for menopause in an at least forty-year-old bonobo female. While it may be argued that data from one single bonobo hardly confirms menopause for an entire species, especially given that several closely related common chimpanzees failed to show clear signs of menopause (Pavelka and Fedigan 1991), taken together these data suggest that menopause in primates is not an idiosyncratic but a regular and age-specific phenomenon, as it is in the case of human females.

Despite these findings, from a life-history perspective two critical questions are in order: How many females actually reach a postreproductive stage, and how long is the postreproductive life span of individual females? If, as it is widely held, few individuals survive into old age, especially in the wild, postmenopausal monkeys and apes would be indeed unusual, and in this sense "idiosyncratic."

Data from captive colonies reveal a mixed picture. In their examination of demographic records from thirteen primate species (and one historical human population), Caro et al. (1995) found that in seven colonies less than 50 percent of females survived into "old age" (operationally defined as the last quartile of life experienced by the oldest individual in the population), while in six other colonies (and the human population) more than 50 percent of females lived to old age. Environmental conditions appeared to influence these differences in survivorship much more than taxonomic relationships since in both categories species belonging to New World monkeys, Old World monkeys, and great apes were present. This fact is further highlighted by differences in survivorship between different populations of the same species: While Takahata, Koyama, and Suzuki (1995) found that among the provisioned but free-ranging Japanese macaques of the Arashiyama B troop in Japan 41 percent of all females born survived to the age of twenty years, only 8 percent of females born in the Arashiyama West troop, translocated to an outdoor enclosure in Texas in 1972, survived to this age (Pavelka and Fedigan 1999). Maximum life span was similar in both populations (thirty-three years in Arashiyama B, thirty-two years in Arashiyama West), but, not surprisingly, only a few of the females born in Arashiyama West (2.9 percent) could expect to live to the age of population-wide reproductive termination (twenty-five years).

Low survivorship values were also reported for two rhesus macaque colonies living on small islands off the cost of Florida (Johnson and Kapsalis 1998), where 24 percent of the juvenile females could expect to survive

to the age of twenty-five years, and only about 10 percent were expected to eventually experience menopause. In contrast, life-table statistics for a provisioned Barbary macaque population living in an outdoor enclosure in southern Germany revealed that 60 percent of all females born in this colony could expect to survive to the age of twenty years (Paul and Kuester 1988). Similarly, life-table statistics for a wild capuchin monkey *(Cebus olivaceus)* population revealed that about 50 percent of all females born entered the old-age category (at age twenty-six), and that at the end of the last age category (age thirty-six) nearly 10 percent were still alive (Robinson 1988).

According to Pavelka and Fedigan, "the vast majority (of the small sample) of old primates described in the literature, mostly based on laboratory studies, had continued to cycle and even produce infants until the end of their lives" (Pavelka and Fedigan 1999, 456). Indeed, a value of less than 3 percent of all females born reaching menopausal age, as Pavelka and Fedigan's (1999) data indicate, hardly sounds very impressive. But among those females who lived to reproductive age, the picture changes considerably: 28.5 percent of these females terminated reproduction before death (some of them under the age of twenty-five; if these are excluded, the value was still 17 percent). This value fells well within the range found by Caro et al. (1995), who reported that, among females who had survived to middle age, the proportion of those terminating reproduction before death is commonly more than 20 percent (up to 60 percent in common chimpanzees). Although limited, data from some field studies reveal a similar picture: Sommer, Srivastava, and Borries (1992) reported that among wild (but partly provisioned) langurs of Jodhpur, 13.9 percent of a total of seventy-nine female years fell into the postreproductive life span, White and Churchill (1997) considered 17 percent of the adult female bonobos at Lomako postreproductive, and life-table data for wild chimpanzees indicate that 18 percent of females are expected to survive from age fifteen to age forty (Hill et al. 2001). Finally, among wild olive baboons living in the Gombe National Park, fertility decreases at twenty-three years of age and essentially ceases at twenty-four, yet the females' life expectancy at twenty-one years is still an additional five years (Packer, Tatar, and Collins 1998). Taken together, these data indicate that female primates who had reached reproductive age have some real chance to become eventually postreproductive.

Yet evidence for cessation of reproduction in primates has been questioned because usually "the time lag between last parturition and death of the mother (LP-D) is treated as postreproductive, when indeed these females may be dying within a normal birth interval" (Pavelka and Fedigan 1999, 456). Indeed, as noted by Pavelka and Fedigan (1991), the median length of the postreproductive life span reported for the Mahale chim-

panzees (4.2 years, based on a sample of females who did not become pregnant during the period from the death of their last offspring to their own death [Nishida, Takasaki, and Takahata 1990]) was even shorter than the mean length of interbirth intervals in this population (six years). To circumvent this problem, Caro et al. (1995) used an operational criterion for defining reproductive termination: A female was treated as showing termination of reproduction if the time lag between her last parturition and her own death exceeded the length of her own average interbirth interval over her lifetime plus two standard deviations (LP-D/[$\bar{X}$ IBI + 2 SD] > 1). While this procedure certainly minimizes the probability that an apparent cessation of reproduction is simply an overly long interbirth interval, it is still untenable to assume that the postreproductive chimpanzees observed by Nishida, Takasaki, and Takahata (1990) simply died during overly long, or even normal interbirth intervals: When females lost their infants (Nishida's criterion for the onset of the postreproductive period was the death of the females' last offspring!), they usually resumed cycling within two months, and gave birth to their next offspring twelve months later, resulting in a mean interbirth interval of 14.4 months (Nishida, Takasaki, and Takahata 1990, 84).

Average postreproductive life spans (LP-D) among captive species reported by Caro et al. (1995) ranged in length between 2.1 years (among common marmosets, whose maximum life span is about twelve years) and 9.3 years (common chimpanzees). Prolonged postreproductive life spans have also been observed among primates living under more natural conditions. For semi-free-ranging (provisioned) Barbary macaques, for example, Paul, Kuester, and Podzuweit (1993) reported an average postreproductive life span of 5.7 years (range 3 to 8 years). Takahata, Koyama, and Suzuki (1995) reported similar data for both provisioned (mean = 6.0 years, range 1 to 10 years) and unprovisioned Japanese macaques (mean = 5.1 years, range 3 to 6 years). Among free-ranging female langurs, Sommer, Srivastava, and Borries (1992) found postreproductive life spans between 3.0 and 9.0 years, and among the wild capuchin monkeys observed by Robinson (1988), eight females lived at least four years without producing an infant, and two of them at least seven years. While none of these authors applied the Caro et al. criterion for the termination of reproduction, there is little reason to suspect that these females simply died during normal, or overly long, interbirth intervals. Postreproductive life spans among the female Barbary macaques observed by Paul, Kuester, and Podzuweit (1993), for example, were clearly longer than their mean interbirth intervals plus two standard deviations (population mean = 414.2 days, SD = 121.39). Based on these data, therefore, the number of years spent in a postreproductive state among primates can account for approximately 16 to 25 percent of the females' maximum life span. Even if one does not consider the total time

lag between the female's last parturition and her own death as postreproductive, but subtracts the time until an infant is able to survive without maternal care, as Takahata, Koyama, and Suzuki (1995) did, the time spent in a postreproductive state (4.5 years among provisioned Japanese macaques) may still account for 16 percent of the females' average life span (27.3 years; see Takahata, Koyama, and Suzuki 1995). In contrast, Pavelka and Fedigan (1999) reached a much lower value (2.08 years spent postreproductive, or 8.7 percent of the females' life span). This difference appeared mainly due to the fact that Pavelka and Fedigan applied the Caro et al. criterion not only for calculation of the proportion of females who terminated reproduction, but also for their calculation of the length of the postreproductive life span (that is, PRLS = LP-D $- [\bar{X}$ IBI $+ 2$ SD]). While such a procedure is, of course, reasonable, the same criterion must be applied to humans, too.

Finally, given that female primates approaching menopause are, in marked contrast to women, typically considered to be "extremely old" (Pavelka and Fedigan 1990), and in a poor physical condition (Johnson and Kapsalis 1998), it may be argued that reproductive senescence is not temporally distinct from the overall aging process in primates (Pavelka and Fedigan 1990; Johnson and Kapsalis 1998). In fact, Johnson and Kapsalis found that among female rhesus macaques the proportion of underweight individuals steadily increased, and that most females considered postmenopausal were indeed underweight. Among the twenty-five- to twenty-seven-year-old females, however, the proportion of normal weight individuals was still highest, suggesting that reproductive senescence is not necessarily causally related to poor physical condition. Similarly, according to Nishida, Takasaki, and Takahata (1990), at least some wild, postreproductive chimpanzees were still in "good health," and such a characterization might also apply to the postreproductive Barbary macaques observed by Paul, Kuester, and Podzuweit (1993), who typically survived several harsh winters. Moreover, although the deteriorating physical condition of these females was obvious both from their appearance and from the fact that they sooner or later lost their former rank positions, their reproductive performance did not decline gradually, as might be expected if the reproductive system follows a process similar to that of other organ systems, but ceased abruptly.

## The Behavioral Perspective: What Do Primate Grandmothers Actually Do?

Aged female monkeys and apes are generally described as being less active and socially much more disengaged than younger females (for example, Hauser and Tyrrell 1984; Huffman 1990; Nakamichi 1991; Ratnayeke 1994),

a point also largely acknowledged by Hrdy (1981). For example, in Barbary macaques, who live, like most Old World monkeys, in matrifocal social groups with overlapping generations of females, postreproductive matriarchs spent significantly more time alone than their adult, and reproductively still active, daughters (Grieger 1984). While such findings scarcely corroborate the grandmother hypothesis, evidence in favor of it, including Hrdy's and Partch's observations (Hrdy 1981; Partch 1978, published only as an abstract), was largely considered anecdotal or inconclusive at best. For example, while there are a few reports of orphaned infant macaques adopted by their grandmothers (reviewed by Thierry and Anderson 1986), in a study of more than 40 orphaned immature Japanese macaques no such case was reported (although several of the orphans received care from adult males or older siblings, Hasegawa and Hiraiwa 1980). In fact, Japanese macaque grandmothers were not observed to care for their infant grandoffspring, whether orphaned or not, *but rather pushed them off* when approached (Hiraiwa 1981).

Similarly, in a detailed case study on the behavior of two postreproductive female hanuman langurs—a species where females are known for exceptionally strong involvement in allomaternal care—Borries (1988) reported that allomothering, as well as other and contact behavior with infants either occurred "only sporadically" or that its frequency was "extremely low" (see also Kurland 1977 for Japanese macaques; Paul and Kuester 1996 for Barbary macaques; and Ratnayeke 1994 for toque macaques). Borries nevertheless found some evidence for "grandmothering," since interactions of one of the females (but not the other), including high levels of contact with and interventions on behalf of her grandoffspring, were indicative of a distinctive relationship. Similarly, one anecdotal observation of a Japanese macaque grandmother who spent two hours near her infant grandoffspring while it was temporarily separated from its mother suggests that grandmothers in this species are not always as indifferent towards their grandoffspring as adult females generally appear to be towards other females' infants (Hiraiwa 1981; see also below). Finally, vigorous grandmaternal defense of infants against infanticidal males has not only been observed in langurs. Collins, Busse, and Goodall (1984) described such a case in wild savanna baboons, where a grandmother harassed a male who had attacked her infant grandoffspring "with particular persistence," despite the fact that the male also attacked her, inflicting a deep cut on the crown of her head. Similarly, in a study of captive sooty mangabeys, Busse and Gordon (1983) observed a grandmother vigorously supporting her daughter and newborn grandoffspring against a male attacking the mother and her newborn.

Evidence for grandmaternal commitment is not restricted to anecdotal observations, however. Some of the most convincing systematically recorded

behavioral data supporting the grandmother hypothesis (or one of its versions) result from Lynn Fairbanks' longitudinal research on mother-offspring relationships in captive vervet monkeys (reviewed by Fairbanks 1993, 2000). During that research, Fairbanks noticed that mother-infant dyads with (maternal) grandmothers were consistently different from dyads where no grandmother was present. In dyads with grandmothers, mothers were less protective, spent less time in contact with their infants, and were much less restrictive of their infants' movements. Moreover, infants with grandmothers not only spent significantly more time away from their mothers, but also actively approached and left their mothers at an earlier age compared to infants without grandmothers (Fairbanks 1988a). Thus, when grandmothers were available, the mothers appeared to be able to reduce the time and energy they devoted to infant care without jeopardizing the health and safety of their offspring (Fairbanks 1993).

While Fairbanks' (1988a) study provided no information about the actual behavior of grandmothers, her results strongly suggested that it was not merely the *presence* of a grandmother that influenced mother-offspring relationships, but her *behavior*. This was confirmed by further observations on the behavior of thirty infants and their maternal grandmothers (Fairbanks 1988b). In this study, it was shown that grandmothers and grandoffspring formed affiliative relationships with one another, and that these relationships were, in many cases, stronger than the infants' relationships with other adult female kin. The intensity of the grandmother-grandinfant relationship varied according to factors associated with the relative benefits that infants could expect to receive, such as the infant's vulnerability to mortality, or the grandmother's ability to provide effective social support: grandmothers spent almost twice as much time near their daughter's first surviving infant than near later-born infants, and when grandmothers had more than one adult daughter, they spent more time near the infant of the younger daughter. Moreover, high-ranking grandmothers played a much more active part in establishing and maintaining relationships with their infant grandoffspring than lower-ranking grandmothers did, spending more time near them, grooming them more often, and initiating more allomaternal care (touching, holding, and carrying them).

Observations by Fairbanks and MacGuire (1986) provide further evidence for the significance of vervet monkey grandmothers. Grandmothers continued to associate preferentially with their adult daughters, and during agonistic interactions with other group members, young mothers were three times more likely to be supported by their own mothers than by other females. As a consequence, young mothers who lost their own mothers received twice as much aggression from nonkin adult females than adult females whose mothers were present and were less likely to challenge the rank

of other adult females. Two high-born females dropped in rank after the death of their mothers and never tried to reassert their former rank position.

Fairbanks also noted, however, that there was "no reason to believe that the grandmothers were sacrificing their ability to invest in other offspring" (Fairbanks 1988a, 186). In fact, while the grandmothers in this study were older than other female kin, and most of them were already beginning the decline in fertility associated with old age, none of them terminated reproduction before death (see Caro et al. 1995). Nevertheless, taken together, Fairbanks' data not only provide strong support for the hypothesis that primate grandmothers are actively contributing to the survival and reproductive success of their progeny, but the study also underscores the particular effect that grandmothers have in influencing their daughters' behavior and reproduction (for fitness consequences, see the next section).

Data on allomaternal care (or "infant handling") in Barbary macaques (Paul and Kuester 1996) replicate Fairbanks' finding that infants receive more care from their grandmothers than from most other females, whether kin or nonkin. Indeed, in this study, infants received far more care from their maternal grandmothers than from all other kin categories except the infants' older sisters—despite the fact that (as in many other species) young adolescent females showed much higher rates of allomaternal care than older females, and old, postreproductive females completely refrained from allomaternal care.

Experimental studies on captive Japanese macaques provide further evidence for the particular role primate grandmothers play in the life of their grandoffspring (Belisle and Chapais 2001; Chapais, Savard, and Gauthier 2001). Observations by Kurland (1977) had already shown that grandmothers spent not only more time near their grandoffspring than most other kin categories, but that they (and the mothers) also aided their grandoffspring much more frequently during agonistic bouts with other group members than was expected by chance. The work by Chapais and his coworkers replicated and extended this finding by showing several points:

(1) Grandmothers were much more tolerant toward their lower-ranking adult granddaughters at a monopolizable feeding site than was observed in all other kin dyads except mothers and daughters (Belisle and Chapais 2001).
(2) During conflicts with dominant peers, juvenile males received much more support from their grandmothers and even their great-grandmothers (both were aged twenty-four years during the time of the experiments, and had their tubes cut when they were twenty-one years old [B. Chapais, personal communication]) than from other kin, including the juveniles' mothers!

(3) These juveniles were always able to outrank their peers in the presence their mothers, older sisters, or (great-) grandmothers, but almost never in the presence of other kin (Chapais, Savard, and Gauthier 2001).

## The Fitness Perspective: Do Primate Grandmothers Promote the Survival and Reproductive Success of Their Progeny?

Since dominance rank in primates often (though not always) correlates with reproductive success (for example, Paul 1998), the experiments done by Chapais and his coworkers, as well as the findings by Fairbanks and MacGuire (1986) provide indirect support for the hypothesis that the behavior of primate grandmothers promotes the fitness of their existing progeny. Similarly, allomaternal care by grandmothers may affect their daughters' reproduction if, as is widely believed, it allows the mother to reduce the length of her interbirth intervals (for example, Ross and MacLarnon 2000; but see Paul and Kuester 1996). Among slowly reproducing species such as primates, such direct evidence is, of course, much more difficult to obtain, but at least some studies provide data essential to test the hypothesis that termination of reproduction among primates is an evolved trait.

Long-term investigations on the survival and reproduction of wild savanna baboons and lions provide little evidence that grandmothers enhance the survival or reproductive success of their progeny (Packer, Tatar, and Collins 1998). Neither the presence of a baboon grandmother nor her reproductive state ("reproductive" or "inactive") affected the survival of her infant grandoffspring or her daughter's reproductive performance (measured by her age at puberty, length of interbirth intervals, and rates of successful pregnancy). The only significant effect was found in lions, where infant grandoffspring of reproductively active grandmothers enjoyed higher survival, apparently because lions—unlike baboons—nurse other females' offspring while tending their own cubs.

In contrast, Hasegawa and Hiraiwa's (1980) study on orphaned Japanese macaques provides data indicating that the presence of a grandmother promotes the survival of her grandoffspring. Among seven firstborn offspring of orphaned females, only two survived the first six months of their lives, while five other non-orphaned primiparous females all succeeded in keeping their infants alive to at least one year. Among older, multiparous females, no such effect was apparent, although two of the four multiparous orphans (and their offspring) disappeared during the course of the study. Since it was not clear from this study whether the mothers of non-orphaned

females were still living when they produced their first (or later-born) offspring (orphans were defined as having lost their mothers as infants or young juveniles), and since the observed effect could be due to the fact that these females had lost their mothers at an early age, these data are inconclusive, however. Nevertheless, a positive effect of grandmothers on the survival of their grandoffspring has been found by Fairbanks and McGuire (1986). Here too, young mothers suffered a much higher infant mortality rate (73 percent) when their own mothers were dead than when they were still present in the mothers' group (32 percent). Moreover, females without mothers had a slightly lower fecundity rate compared to females with mothers. Removal experiments confirmed the influence of matriarchs on their daughters' reproductive success under controlled conditions (Fairbanks 2000). After removal of the matriarch, there was a dramatic decline in fertility and offspring survival among their young adult daughters (age four to six years). However, the effect was a temporary one: only one year after grandmaternal absence, these vervet monkey mothers reproduced nearly as well as during the period before the removal of the matriarch. Thus, both the data reported by Hasegawa and Hiraiwa (1980) and Fairbanks (2000) suggest that young mothers can cope with the absence of their mothers, but at the cost of temporarily reduced reproductive success.

Recent research on the impact of postreproductive grandmothers on their daughters' reproductive performance among Japanese monkeys from the Arashiyama West population by Pavelka, Fedigan, and Zohar (2002) revealed an even stronger effect. Although, as noted above, in this population the proportion of females living past the age of last birth was quite small, with only five out of 175 females having a postreproductive mother alive at the time they gave first birth, grandoffspring with a postreproductive grandmother available were significantly more likely to survive to weaning age than those without a living grandmother, or with a grandmother who was still reproducing. Moreover, the presence of a postreproductive mother was associated with a three-month shortening of the daughters' interbirth intervals and an earlier age of first reproduction.

Finally, data from the Arashiyama West macaques also provide some support for Williams' (1957) suggestion that reproductive cessation might have evolved as an adaptive response to prolonged offspring dependency on maternal care. According to this "good mother" version of the grandmother hypothesis, an aging mother who terminates child bearing and devotes her reproductive effort to insuring the survival of already existing offspring would leave more descendants than another one who continues to produce offspring who are unlikely to survive their mother's death. Sherman (1998) considered this hypothesis to be supported by research done by Packer, Tatar, and Collins (1998), who found that postreproductive females did not

improve their daughters' reproductive performance, whereas the females' life expectancy at the end of their reproductive careers (5.0 years in baboons, and 1.8 years in lions) was related to offspring vulnerability when orphaned. Packer, Tatar, and Collins remained skeptical because in this baboon population, infant survival declined rapidly when their mothers reached twenty-one years. Whether such a decline is typical for primates in general, however, remains to be shown: there are also studies reporting the opposite trend (Paul, Kuester, and Podzuweit 1993). Fedigan and Pavelka's (2001) study on Japanese macaques currently provides the best direct evidence in favor of the good mother hypothesis. In that study, final infants of postreproductive females were significantly more likely to survive than final infants of females that reproduced until death were. As a consequence, there was a highly significant positive relationship between length of maternal care and survivorship of final infants in this population.

## Summary and Conclusions

The purpose of this review is not to imply that there are no differences in the life histories of humans and other primates. In fact, it is quite obvious that there are some striking differences (see, for example, Hawkes et al. 1998; Hawkes, O'Connell, and Blurton Jones 2002): humans have longer life spans than even their closest living primate relatives, their period of juvenile dependency is remarkably long, sexual maturity is attained at a later age, and they produce, in contrast to all other primates, altricial offspring (although none of the other primates' young are precocial in the sense that they are able to follow their mothers from birth). Yet human mothers wean their offspring at an earlier age than other great apes, enabling them to produce offspring at a faster rate.

Furthermore, while the evidence reviewed here suggests that menopause per se is not a uniquely human trait, midlife termination of reproduction certainly is. Although the postreproductive life span in nonhuman primates may account for several years (and a substantial proportion of their total life span), none experiences a further life expectancy of twenty or more years after their last birth, as is the case even in preindustrialized human populations (Hawkes, O'Connell, and Blurton Jones 2002). Moreover, while the percentage of nonhuman primate females who, having reached maturity, live past the age of last birth is often higher than usually acknowledged, it is also clear that this percentage is still much lower than in contemporary human hunter-gatherer populations, where up to 80 percent of all sexually mature women can expect to live past childbearing age (Hawkes, O'Connell, and Blurton Jones 2002). This fact alone suggests that selective forces favoring delayed senescence and an extended life span were much weaker

among the extant nonhuman primates and their ancestors than they have been during human evolution. Whether this, in turn, also implies that reproductive cessation in female nonhuman primates is a nonadaptive byproduct of overall senescence (Packer, Tatar, and Collins 1998) and invocation of the grandmother hypothesis, or any of its variants, is unnecessary (Johnson and Kapsalis 1998) is not as clear, however. The data reviewed here show that primate grandmothers, whether reproductively still active or not, tolerate, support, and care for their grandoffspring at unexpectedly high rates, and there is also evidence that this is translated into evolutionary currency: fitness. Whether these fitness benefits were strong enough to select for an extended postreproductive life span, is, at present, uncertain, although both the observed fitness effects and the differences in postmenopausal life expectancy and offspring vulnerability between lions and baboons suggest that this may be the case. Finally, it remains to be shown whether the main targets of postmenopausal nepotism are last-born offspring or grandoffspring. Apart from these uncertainties, however, it seems safe to conclude that there are primate predispositions for human grandmaternal behavior, or, in the words of Peccei (2001, 46), that "there is plenty of variation and raw material for selection to work on if a postreproductive life span were to become advantageous." Our primate cousins have already set the ground.

## Acknowledgments

I am grateful to Eckart Voland, Athanasios Chasiotis, and Wulf Schiefenhövel for inviting me to the "grandmother conference," to Kristen Hawkes for helpful advice, and to Bernard Chapais for providing unpublished information.

## References

Alexander, R. D. 1974. "The evolution of social behavior." *Annual Review of Ecology and Systematics* 5:325–83.

Belisle, P., and B. Chapais. 2001. "Tolerated co-feeding in relation to degree of kinship in Japanese macaques." *Behaviour* 138:487–509.

Borries, C. 1988. "Patterns of grandmaternal behaviour in free-ranging Hanuman langurs (*Presbytis entellus*)." *Human Evolution* 3:239–60.

Busse, C. D., and T. P. Gordon. 1983. "Attacks on neonates by a male mangabey (*Cercocebus atys*)." *American Journal of Primatology* 5:345–56.

Caro, T. M., D. W. Sellen, A. Parish, R. Frank, D. M. Brown, E. Voland, and M. Borgerhoff Mulder. 1995. "Termination of reproduction in nonhuman and human female primates." *International Journal of Primatology* 16:205–20.

Chapais, B., L. Savard, and C. Gauthier. 2001. "Kin selection and the distribution of altruism in relation to degree of kinship in Japanese macaques (*Macaca fuscata*)." *Behavioral Ecology and Sociobiology* 49:493–502.

Collins, D. A., C. D. Busse, and J. Goodall. 1984. "Infanticide in two populations of savanna baboons." In *Infanticide: Comparative and Evolutionary Perspectives*, ed. G. Hausfater and S. B. Hrdy. Hawthorne, NY: Aldine, 193–215.

Dittus, W. P. J. 1975. "Population dynamics of the toque monkey, *Macaca sinica.*" In *Socioecology and Psychology in Primates*, ed. R. H. Tuttle. The Hague: Mouton, 125–54.

Fairbanks, L. A. 1988a. "Vervet monkey grandmothers: Effects on mother-infant relationships." *Behaviour* 104:176–88.

———. 1988b. "Vervet monkey grandmothers: Interactions with infant grandoffspring." *International Journal of Primatology* 9:425–41.

———. 1993. "What is a good mother? Adaptive variation in maternal behavior in primates." *Current Directions in Psychological Science* 2:179–83.

———. 2000. "Maternal investment throughout the life span in Old World monkeys." In *Old World Monkeys*, ed. P. F. Whitehead and C. J. Jolly. Cambridge: Cambridge University Press, 341–67.

Fairbanks, L. A., and M. T. McGuire. 1986. "Age, reproductive value, and dominance-related behaviour in vervet monkey females: Cross-generational influences on social relationships and reproduction." *Animal Behaviour* 34:1710–21.

Fedigan, L. M., and M. S. M. Pavelka. 2001. "Is there adaptive value to reproductive termination in Japanese macaques? A test of maternal investment hypotheses." *International Journal of Primatology* 22:109–25.

Fleagle, J. G. 1999. *Primate Adaptation and Evolution*. San Diego: Academic Press.

Gould, K. G., M. Flint, and C. E. Graham. 1981. "Chimpanzee reproductive senescence: A possible model for evolution of the menopause." *Maturitas* 3:157–66.

Graham, C. E., O. R. Kling, and R. A. Steiner. 1979. "Reproductive senescence in female nonhuman primates." In *Aging in Nonhuman Primates*, ed. D. M. Bowden. New York: Van Nostrand Reinhold, 183–202.

Grieger, M. 1984. "Verhalten alter Berberaffenweibchen (Macaca sylvanus LINNE, 1758). Ein Vergleich zwischen alten Berberaffenweibchen und ihren adulten Töchtern." Diploma thesis, Göttingen: Universität Göttingen.

Hamilton, W. D. 1966. "The moulding of senescence by natural selection." *Journal of Theoretical Biology* 12:12–45.

Hamilton, W. J., III, C. Busse, and K. S. Smith. 1982. "Adoption of infant orphan chacma baboons." *Animal Behaviour* 30:29–34.

Hasegawa, T., and M. Hiraiwa. 1980. "Social interactions of orphans observed in a free-ranging troop of Japanese monkeys." *Folia Primatologica* 33:129–58.

Hauser, M. D., and G. T. Tyrrell. 1984. "Old age and its behavioral manifestations: A study of two species of macaque." *Folia Primatologica* 43:24–35.

Hawkes, K., J. F. O'Connell, N. G. Blurton Jones, H. Alvarez, and E. L. Charnov. 1998. "Grandmothering, menopause, and the evolution of human life histories." *Proceedings of the National Academy of Sciences (USA)* 95:1336–39.

Hawkes, K., J. F. O'Connell, and N. G. Blurton Jones. 2002. "Human life histories:

Primate trade-offs, grandmothering socioecology, and the fossil record." In *Primate Life Histories and Socioecology*, ed. P. M. Kappeler and M. E. Pereira. Chicago: University of Chicago Press, 204–27.

Hill, K., C. Boesch, J. Goodall, A. Pusey, J. Williams, and R. Wrangham. 2001. "Mortality rates among wild chimpanzees." *Journal of Human Evolution* 40:437–50.

Hill, K., and A. M. Hurtado. 1991. "The evolution of premature reproductive senescence and menopause in human females: An evaluation of the 'grandmother hypothesis.'" *Human Nature* 2:313–50.

Hiraiwa, M. 1981. "Maternal and alloparental care in a troop of free-ranging Japanese monkeys." *Primates* 22:309–29.

Hrdy, S. B. 1981. "'Nepotists' and 'altruists': The behavior of old females among macaques and langur monkeys." In *Other Ways of Growing Old*, ed. P. T. Amoss and S. Harrell. Stanford, CA: Stanford University Press, 59–76.

Huffman, M. A. 1990. "Some socio-behavioral manifestations of old age." In *The Chimpanzees of the Mahale Mountains: Sexual and Life History Strategies*, ed. T. Nishida. Tokyo: University of Tokyo Press, 237–55.

Johnson, R. L., and E. Kapsalis. 1998. "Menopause in free-ranging rhesus macaques: Estimated incidence, relation to body condition, and adaptive significance." *International Journal of Primatology* 19:751–65.

Kano, T. 1997. "Comment." *Current Anthropology* 38:568.

Kurland, J. A. 1977. "Kin selection in the Japanese monkey." *Contributions to Primatology* 12:1–145.

Nakamichi, M. 1991. "Behavior of old females: Comparisons of Japanese monkeys in the Arashiyama East and West groups." In *The Monkeys of Arashiyama: Thirty-Five Years of Research in Japan and the West*, ed. L. M. Fedigan and P. J. Asquith. Albany: State University of New York Press, 175–93.

Nishida, T. 1997. "Comment." *Current Anthropology* 38:568–69.

Nishida, T., H. Takasaki, and Y. Takahata. 1990. "Demography and reproductive profiles." In *The Chimpanzees of the Mahale Mountains: Sexual and Life History Strategies*, ed. T. Nishida. Tokyo: University of Tokyo Press, 63–97.

Nozaki, M., K. Yamashita, and K. Shimuzu. 1997. "Age-related changes in ovarian morphology from birth to menopause in the Japanese monkey, *Macaca fuscata fuscata.*" *Primates* 38:89–100.

Packer, C., M. Tatar, and A. Collins. 1998. "Reproductive cessation in female mammals." *Nature* 392:807–11.

Partch, J. 1978. "The socializing role of post-reproductive rhesus macaque females." *American Journal of Physical Anthropology* 48:425.

Paul, A. 1998. *Von Affen und Menschen: Verhaltensbiologie der Primaten*. Darmstadt: Wissenschaftliche Buchgesellschaft.

Paul, A., and J. Kuester. 1988. "Life-history patterns of Barbary macaques (*Macaca sylvanus*) at Affenberg Salem." In *Ecology and Behavior of Food-Enhanced Primate Groups*, ed. J. E. Fa and C. H. Southwick. New York: Alan R. Liss, 199–228.

———. 1996. "Infant handling by female Barbary macaques (*Macaca sylvanus*) at Affenberg Salem: Testing functional and evolutionary hypotheses." *Behavioral Ecology and Sociobiology* 39:133–45.

Paul, A., J. Kuester, and D. Podzuweit. 1993. "Reproductive senescence and terminal investment in female Barbary macaques (*Macaca sylvanus*) at Salem." *International Journal of Primatology* 14:105–24.

Pavelka, M. S. M. 1990. "Do old female monkeys have a specific social role?" *Primates* 31:363–73.

Pavelka, M. S. M., and L. M. Fedigan. 1991. "Menopause: A comparative life history perspective." *Yearbook of Physical Anthropology* 34:13–38.

———. 1999. "Reproductive termination in female Japanese monkeys: A comparative life history perspective." *American Journal of Physical Anthropology* 109:455–64.

Pavelka, M. S. M., L. M. Fedigan, and S. Zohar. 2002. "Availability and adaptive value of reproductive and postreproductive Japanese macaque mothers and grandmothers." *Animal Behaviour* 64:407–14.

Peccei, J. S. 2001. "Menopause: Adaptation or epiphenomenon?" *Evolutionary Anthropology* 10:43–57.

Ratnayeke, S. 1994. "The behavior of postreproductive females in a wild population of toque macaques (*Macaca sinica*) in Sri Lanka." *International Journal of Primatology* 15:445–69.

Robinson, J. G. 1988. "Demography and group structure in wedge-capped capuchin monkeys, *Cebus olivaceus*." *Behaviour* 104:202–32.

Ross, C., and A. MacLarnon. 2000. "The evolution of non-maternal care in anthropoid primates: A test of hypotheses." *Folia Primatologica* 71:93–113.

Sherman, P. W. 1998. "The evolution of menopause." *Nature* 392:759–61.

Sommer, V., A. Srivastava, and C. Borries. 1992. "Cycles, sexuality, and conception in free-ranging langurs (*Presbytis entellus*)." *American Journal of Primatology* 28:1–27.

Takahata, Y., N. Koyama, and S. Suzuki. 1995. "Do the old aged females experience a long postreproductive life span? The cases of Japanese macaques and chimpanzees." *Primates* 36:169–80.

Thierry, B., and J. R. Anderson. 1986. "Adoption in anthropoid primates." *International Journal of Primatology* 7:191–216.

Tigges, J., T. P. Gordon, H. M. McClure, E. C. Hall, and A. Peters. 1988. "Survival rate and life span of rhesus monkeys at the Yerkes Regional Primate Research Center." *American Journal of Primatology* 15:263–73.

Walker, M. L. 1995. "Menopause in female rhesus monkeys." *American Journal of Primatology* 35:59–71.

Waser, P. M. 1978. "Postreproductive survival and behavior in a free-ranging female mangabey." *Folia Primatologica* 29:142–60.

White, F. J., and S. E. Churchill. 1997. "Comment." *Current Anthropology* 38:569–70.

Williams, G. C. 1957. "Pleiotropy, natural selection, and the evolution of senescence." *Evolution* 11:398–411.

**CHAPTER 2**

# Menopause
## *Adaptation and Epiphenomenon*
Jocelyn Scott Peccei

---

Human females are virtually unique in experiencing a nonfacultative and irreversible cessation of fertility well before senescence of other somatic systems and end of average adult life span. Many evolutionary biologists and anthropologists suggest that menopause is a hominine adaptation: the result of selection for a postreproductive life span to permit increased maternal investment in existing progeny. Others hypothesize that premature reproductive senescence is an epiphenomenon: either the result of a physiological trade-off favoring efficient early reproduction, or merely an artifact of increases in life span and life expectancies. Neither of the epiphenomenon hypotheses attempts to justify in fitness terms the postreproductive life span in human females. However, this too requires an adaptationist explanation, given that evolutionary theory predicts there should be no selection for postreproductive individuals.

In writing *Menopause: Adaptation or Epiphenomenon?*[1] my purpose was to provide cogent arguments for and against each of these three hypotheses (Peccei 2001b). Here my goal is to present a more integrated and conclusive view of why human females have menopause by showing how the hypotheses are complementary. Hence I concentrate on areas where the adaptation and epiphenomenon explanations are mutually supportive. I begin with a brief review of the hypotheses.

## The Adaptation Hypothesis

The adaptation hypothesis for menopause is a quality vs. quantity trade-off explanation. At some point in human evolution, females who ceased reproducing before the end of their lives gained a fitness advantage because they could direct their remaining reproductive effort more profitably toward enhancing the reproductive success of existing progeny (Diamond 1997; Hamilton 1964; Hawkes, O'Connell, and Blurton Jones 1989; Hill and Hurtado 1991; Lancaster and Lancaster 1983; Peccei 1995; Trevathan 1987; Williams 1957).

Researchers have speculated that menopause is an ancestral trait that may have arisen during the Plio-Pleistocene 1.9–1.7 million years ago

(mya), following a time of substantial climatic change that required hominids to have increased foraging flexibility and larger home ranges (Foley 1987; Foley and Lee 1991; Hill 1982; Sikes 1994; Vrba 1985). This was also a time in hominid evolution of increasing bipedality and rapid encephalization (McHenry 1994; Martin 1983). Initially, the rapid prenatal brain growth needed to attain greater adult brain size was limited only by the metabolic cost of gestation. Eventually, due to increases in fetal head size and changes in pelvic anatomy for more efficient bipedal locomotion, the birth process became so torturous that further rapid infant brain growth had to continue postpartum (Martin 1983; McHenry 1994; Trevathan 1987). With much organizational development in addition to rapid growth still to take place postnatally, hominid infants were born in a state of *secondary* altriciality, requiring intensified and prolonged investment in infants and juveniles (Bogin and Smith 1996; Trevathan 1987) ("secondary" refers to the reversal of a phylogenetic trend toward increased precociality). With the difficulty of childbirth and the need for greater and more prolonged maternal investment, each successive offspring imposed increased risk to mother—and her existing offspring should she die in childbirth—and greater costs in terms of reduction of her physical reserves (Lancaster and Lancaster 1983; Merchant, Martorell, and Haas 1990). With her own survival in question and the future of her existing offspring at stake, producing late babies with low survival probability could lead to reproductive failure. In this scenario, menopause results from selection for premature reproductive cessation.

When these life-history changes occurred is unknown. We can assume that the transformation from australopithecine to humanlike life histories was complete by the time anatomically modern *H. sapiens* appeared roughly 150 thousand years ago. However, given that studies agree that maximum life span of late *H. erectus* exceeded fifty years, it is possible that menopause has been around for more than a million years (Bogin and Smith 1996; Hammer and Foley 1996).

There are two adaptation hypotheses. The grandmother hypothesis is about inclusive fitness; the benefit of menopause derives from increasing fertility of one's adult female kin and survival of their offspring (Hawkes, O'Connell, Blurton Jones 1989; Hill and Hurtado 1991). The mother hypothesis is about increasing survival and potential fertility of one's own subadult offspring (Gaulin 1980; Lancaster and Lancaster 1983; Peccei 1995; Williams 1957). The grandmother hypothesis misses the point that increased infant helplessness and prolonged juvenile dependence required a change in the reproductive strategies of young females (Peccei 1995, 2001a). It was not possible to solve the problem of prolonged offspring dependence by increasing interbirth intervals. The period of dependence

was too long relative to life expectancies of mothers (Gage et al. 1989). The fitness-enhancing strategy was to switch from serial to overlapping child care, leaving some postreproductive time to finish raising the last born (Kaplan 1997; Peccei 2001b).

## The Epiphenomenon Explanations

The epiphenomenon explanations are the physiological trade-off favoring efficient early reproduction and the by-product of increased longevity hypotheses. The underlying assumption in both is that evolution is constrained by phylogenetic history, developmental limitations, and genetic correlations (Stearns 1992). In both hypotheses, menopause is the product of negative genetic correlations (antagonistic pleiotropy) that result in intertemporal physiological trade-offs. Such time-delayed antagonistic pleiotropy, in which pleiotropic genes produce positive effects at younger ages and negative effects later in life, can exist because selection against fitness-reducing traits weakens with age (Williams 1957).

### The Physiological Trade-off Hypothesis

Given semelgametogenesis, the trait of producing one's gametes at one time, a physiological trade-off favoring efficient early reproduction allows human females to maximize reproductive output early in life before the dwindling supply of oocytes jeopardizes hormonal support for ovulation and to terminate fertility before the negative consequences of old eggs predominate (Gosden and Faddy 1994; Leidy 1999; O'Rourke and Ellison 1993; Wood, O'Connor, and Holman 1999). Selection might favor a longer reproductive life span, but efficient early fertility, which results in decreasing fertility and eventual sterility, provides greater reproductive success. At issue is the intensity of reproduction early in the fertile life span, not how early reproduction begins. Here, as in the adaptation hypothesis, menopause is about stopping early. I have argued that selection for efficient early reproduction is part of the fitness-enhancing strategy of overlapping child care and the possibility of postreproductive life (Peccei 2001b).

### Artifact of Longer Life Spans, or Life Expectancies Hypothesis

An alternative explanation is that, given the physiological constraints of semelgametogenesis, menopause is simply the result of human life spans and life expectancies increasing beyond females' supply of eggs or ability to sustain ovulatory cycles (Gosden and Telfer 1987; Marlowe 2000; Pavelka and Fedigan 1991; Washburn 1981; Weiss 1981; Wood 1994).

As an explanation for the origin of menopause, we can dismiss the notion that postreproductive life is the result of recent increases in life expectancies due to improved sanitation and medical care. We know from Genesis that women have lived past menopause for at least three thousand years, and during most of this time living conditions were certainly not benign. Nor is the postreproductive life span solely the result of increases in maximum life span in humans. Many investigators agree that hominid maximum life span exceeded the current age of menopause well before the appearance of *H. sapiens* (Bogin and Smith 1996; Hammer and Foley 1996; Judge and Carey 2000).

Reproductive senescence may be equivalent to death according to evolutionary theory, but no one is truly postreproductive if one can influence the fitness of biological relatives (Diamond 1997; Williams 1957). The premise that there should be no selection for postreproductive individuals overlooks this fact. Especially in preliterate foraging societies, older people are valued for their ability to share their vast store of knowledge on matters concerning survival (Diamond 1997). It is not inconceivable that postreproductive hominid females maintained reproductive value (RV) in a similar manner (Peccei 2001b).

## Links and Differences between the Hypotheses

All complex design features of organisms are ultimately the result of natural selection, such that menopause can always be considered an adaptation. However, adaptations are always morphologically, physiologically, and developmentally constrained by phylogenetic heritage (Stearns 1992). The question is whether menopause is primarily an adaptation to provide a postreproductive life span in humans, or whether it is the cost of selection for efficient early reproduction or simply the result of physiological constraints preventing prolongation of fertility along with increases in human longevity. The distinction between adaptations, fitness trade-offs, and phylogenetic constraints is the level of explanation. Trade-offs and constraints without evolutionary justification are proximate explanations. Clearly, the question of menopause cannot be isolated from the question of human longevity, and all three explanations are relevant. In all three cases, selection favors early termination of reproduction relative to life span.

The difference between the adaptation and physiological trade-off hypotheses is that the former seeks to explain menopause and the postreproductive life span, and the latter why age-specific fertility begins decreasing decades before menopause. However, these explanations are not mutually exclusive. Apart from the fact that a physiological trade-off resulting from

selection for efficient early fertility to accommodate overlapping child care constitutes an adaptation in its own right, antagonistic pleiotropy could be the proximate mechanism creating a postreproductive life span if that were favored. If the expedience of overlapping child care is the driving force behind the reproductive strategies of human females, these two explanations are inextricably co-involved. In fact, reduced fertility cannot be adduced both as the result of selection for a postreproductive life span and the proximate reason for reproductive cessation unless one invokes selection for rapid early reproduction and antagonistic pleiotropy to explain why fertility declines as a function of age (Hill and Hurtado 1991).

The physiological trade-off and artifact explanations are not mutually exclusive either. First, antagonistic pleiotropy would be the proximate mechanism preventing increases in reproductive life span in the presence of selection for increased longevity. Second, increases in life span and life expectancies may be partly the result of selection for early fertility if reproductive cessation releases energy for increased somatic repair or if the cessation of childbirth increases life expectancies for mothers and offspring. However, there is no clear evidence for a trade-off between longevity and high fertility (see Gavrilov and Gavrilova [1999] and references therein).

## Predictions Shared by the Adaptation and Physiological Trade-Off Hypotheses

If a period of postreproductive maternal investment is the response to a unique set of socioecological, anatomical, and physiological pressures, and is also of critical importance to how we evolved, menopause should be rare in other species. We should also find historical and cross-populational evidence of high early fertility in humans to accommodate prolonged offspring dependence and the expedience of overlapping child care and a different pattern of fertility in other female mammals and human males. The evidence supporting these two predictions is strong. Further, we should find costs to prolonged fertility and benefits to reproductive cessation. For these predictions support is somewhat weaker.

### Menopause Virtually Unique to Human Females

All iteroparous organisms can be expected to exhibit declining fertility as a function of general senescence (Wilson 1975). However, in contrast to human females, nonhuman primates and even longer-lived species such as elephants and whales retain reproductive capacity until very old age relative to their maximum life spans (Caro et al.1995; Croze, Hillman, and Lang 1981; Diamond 1997; Hill and Hurtado 1996; Laws, Parker, and Johnstone 1975; Mizroch 1981). This is true for human males, as well (Harman and

Talbert 1984). For example, East African female elephants with a life span of about sixty years still retain 50 percent of their reproductive capacity at age fifty-five, an age that only 5 percent of the population reaches (Croze, Hillman, and Lang 1981; Laws, Parker, and Johnstone 1975). The only real exception to this general mammalian pattern are short-finned pilot whales *(Globicephala macrorynchus)* (Marsh and Kasuya 1984). In this species, females have a mean postreproductive life span of fourteen years.

It is particularly important to understand how the fertility profiles of nonhuman primates and human males differ from those of human females from a comparative life-history perspective. In both field and captive studies, researchers have reported menopause-like physiological phenomena in monkeys and apes (Caro et al. 1995; Pavelka and Fedigan 1991, 1999). However, close scrutiny of these reports reveals that the reproductive changes observed in nonhuman primates represent something different from human menopause. The reproductive changes are idiosyncratic and generally far from species-wide, while age at reproductive cessation is extremely variable and postreproductive life spans are relatively short (Pavelka and Fedigan 1991, 1999). In field studies, the majority of the oldest individuals in all species investigated show no signs of ovarian failure (Pavelka and Fedigan 1991). In captive primate species, where extrinsic sources of mortality are minimal, on average about 67 percent of old females continue to reproduce throughout their lives, and in all species postreproductive life spans are short (Caro et al. 1995).

Hill and Hurtado's (1996) comparative life-history diagram for Ache women, former foragers from eastern Paraguay, and *Pan troglodytes* illustrates how different the human female fertility pattern is from that of other primates (figure 2.1). Approximately half of all chimpanzee mothers never outlive their reproductive capacity, whereas approximately half of all reproductive-age Ache women live at least eighteen years after reproductive cessation. Postreproductive life may be part of our phylogenetic legacy, as Judge and Carey (2000) suggest, but it appears to be rare in nonhuman primates. (See Andreas Paul in this volume for a more thorough discussion.)

Although human males usually exhibit an age-related decline in fertility, in most cases this is a function of sociocultural and economic factors, ill health, or advanced overall senescence (Harman and Talbert 1985). For women, the estimated hazard rates of reproductive cessation due strictly to reproductive physiology rises sharply from less than 0.1 to 1.0 between ages forty and fifty. For men, the hazard rate of reproductive cessation due to impotence rises gradually after age fifty, reaching only 0.3 at age eighty (Wood 1994). This is not premature reproductive senescence. Most human males are physically capable of siring offspring until quite old age, and it is in their interest to do so.

**Figure 2.1** Comparative reproductive life histories of Ache women and female chimpanzees (redrawn from Hill and Hurtado 1996). *Evolutionary Anthropology* © 2001 Wiley-Liss, Inc.

## *Historical and Cross-populational Evidence of High Early Fertility*

We also find historical and cross-populational evidence of selection for high early fertility in humans. In extant and historical natural-fertility populations, total fertility rates vary enormously, as do nutritional status and mortality rates (Bongaarts 1980; Frisch 1978; Hill and Hurtado 1996; Wood 1994). Despite these differences, the pattern of age-specific marital fertility is remarkably consistent across time and geographical boundaries, peaking at around age twenty-five, then decreasing monotonically, with cessation of fertility generally preceding menopause by several years (Wood 1989). Notwithstanding considerable variation in median ages of menopause, mean age at last birth for a large number of natural-fertility populations—including well-nourished Hutterite women—is forty years (Bongaarts 1983). Average onset of sterility is estimated to occur one year later (Henry 1961). This universal pattern suggests a biological explanation for reproductive cessation before menopause and is consistent with selection for efficient early fertility via antagonistic pleiotropy (Peccei 2001b). It also suggests greater selection on the end of fertility than on the end of menstruation.

Additional indication that the causes of premenopausal cessation of fertility are physiological comes from Wood and Weinstein's (1988) analysis of

age-specific apparent fecundabilities (monthly probabilities of a recognized conception) and coital rates. After age thirty-five, declining coital rates cease to be the major cause of yearly decreases in apparent fecundability and biological causes take over. The biological portion of the decline stems principally from increasing risk of early fetal loss.

## Fertility Patterns in Other Mammals

The fact that biological factors appear to be largely responsible for the *front-loaded* reproductive pattern of human females strongly suggests selection for efficient early fertility. The fact that human females are unique among mammals in their early peak, subsequent decline in fertility, and long postreproductive life spans provides further evidence. Fertility patterns for semi-provisioned Barbary macaques, nonprovisioned olive baboons, lions, and East African elephants are different from the human pattern (Laws, Parker, and Johnstone 1975; Packer, Tatar, and Collins 1998; Paul, Kuester, and Podzuweit 1993; Robinson 1986). As figure 2.2 illustrates, instead of resembling a left-skewed triangle with fertility starting to decrease when women are in their mid-twenties, age-specific fertility functions of macaques and elephants are box-like, with fertility remaining relatively constant over a period of time, then terminating relatively abruptly only a few years before maximum age at death.[2]

## Fitness Costs of Prolonged Fertility

The best evidence of fitness costs of prolonged fertility are elevated fetal and infant mortality associated with late pregnancies. There is also evidence of increased maternal mortality as a function of age.

Data collected in Europe and North America that go back to 1650 indicate that maternal mortality rates (MMR) increase with age, independent of parity (Knodel 1988; Loudon 1992). From 1700 to 1899, MMRs averaged roughly 1 percent, increasing from 0.6 percent at age twenty-five to 2.3 percent at age forty-nine (Knodel 1988; Loudon 1992). With an average chance of dying each time she gave birth of 1 percent, a woman's cumulative risk of dying in childbirth grew as a function of parity. Knodel observes that until the 1930s everybody knew someone who died as a result of giving birth. By 1940 in New York State, despite a persisting rise in MMR with maternal age, MMR for women age forty and above had fallen to 0.8 percent (Loudon 1992). Still, if a woman died in childbirth, the risk of her infant dying within the first year increased more than fivefold. My guess is that maternal mortality loomed as a considerable personal—though perhaps demographically insignificant—risk until relatively recently, particularly for older women.

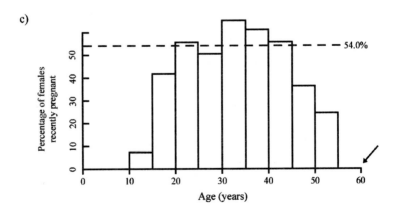

**Figure 2.2** Age-specific fertility functions: a) normalized average natural fertility rates from seven human populations (Robinson 1986); b) semi-free-ranging Barbary macaques (Paul, Kuester, and Podzuweit 1993); c) East African elephants (Laws, Parker, and Johnstone 1975). Arrows indicate maximum age at death. *Evolutionary Anthropology* © 2001 Wiley-Liss, Inc.

Knodel's (1988) analysis of eighteenth- and nineteenth-century genealogies from fourteen German villages shows that neonatal, post-neonatal, infant, and early childhood mortality rates all increased with maternal age and parity, with the most dramatic increases occurring in neonatal and infant mortality rates. For example, at parity 3, average neonatal mortality rate (NMR) increased from 10 percent at age twenty-five to 15 percent at age forty. By 1940, NMRs had fallen considerably, but—like MMRs—still remained higher for older mothers (Loudon 1992). In the New York population, average NMR rose from 2.5 percent at age twenty-five to 4 percent at age forty.

If older mothers are no longer at much risk of dying in childbirth and mortality of their infants is greatly reduced, late pregnancy still carries high risk for fetuses in modern industrialized societies (Berkowitz et al. 1990; Fretts et al. 1995; Gaulden 1992; Naeye 1983). The risks include increased probability of fetal loss, stillbirth, and birth defects. The overall risk of fetal loss for women over forty is 50 percent. Of these abortuses, 85 percent have some detectable chromosomal abnormality, with Down syndrome representing the most dramatic example of this trend (Wood 1994).

## Fitness Benefits Associated with Reproductive Cessation

As a corollary to the fitness costs of prolonged reproduction, we expect to find fitness benefits associated with cessation of reproduction before death. To discover these benefits, researchers have relied on studies of work performed by postreproductive women in extant foraging and horticultural populations. Evidence of work-related benefits is mixed, as well as variable with regard to the gender of the beneficiaries, but it is evident that postreproductive women—especially maternal grandmothers—can have a positive effect on grandoffspring survival.

Sear, Mace, and McGregor (2000) demonstrated that maternal grandmothers in rural Gambia not only increase nutritional status but also survival of grandchildren they provision. They also found that children whose grandmothers were still reproductive were less well nourished, and by inference perhaps less likely to survive than children with postreproductive grandmothers. This suggests a cost to continued reproduction and a benefit to postreproductive investment. Additional evidence of the positive effect maternal grandmothers have on the survival of grandoffspring is found in demographic data from historical populations. Using historical church records from Germany and census records from Tokugawa Japan, respectively, Voland and Beise (2002) and Jamison et al. (2002) found that the mere presence of maternal grandmothers increases grandoffspring survival, whereas paternal grandmother effects are generally negative. Studies of

other traditional societies also suggest that by providing material goods and services, postreproductive women enable their daughters to raise more offspring and thereby increase their own fitness (Biesele and Howell 1981; Hames 1988; Hawkes, O'Connell, and Blurton Jones 1989; Turke 1988). The best evidence comes from the Hadza, where postreproductive grandmothers spend the greatest amount of time foraging and their foraging time is correlated with grandchildren's weight (Hawkes, O'Connell, and Blurton Jones 1997). Whether grandmothers' efforts translated into an inclusive fitness advantage was not demonstrated in these studies. Hill and Hurtado's (1991, 1995) mathematical models designed to test the grandmother hypothesis with Ache data did not show significantly positive grandmother effects.

In their comparative study of production in hunter-gatherer societies, Kaplan et al. (2000) found that juveniles and reproductive-age women do not meet their own energy requirements and grandmothers like Hadza women aged forty-five to sixty, who bring in approximately 1,000 more calories on a daily basis than the average person consumes, are exceptional. Ache and Hiwi women never produce surplus calories. Moreover, even Hadza grandmothers provide less than 6 percent of the average daily protein intake and far fewer calories and protein through foraging than do Hadza male hunters of all ages. These findings led Kaplan et al. to conclude that men, not postreproductive women, support women's reproduction. In contrast, in the Gambian population, apart from mothers, only maternal grandmothers have a consistently positive influence on the nutritional status of children of all ages, whereas male kin have a negligible impact (Sear, Mace, and McGregor 2000). Still, with new evidence of meat consumption during the Plio-Pleistocene, it is difficult to dismiss the evolutionary importance of male investment in human reproduction (de Heinzelin et al. 1999).

## Reproductive Physiology and Heritability in Menopause

Additional support for the adaptation and physiological trade-off explanations comes from the dynamics of human female reproductive physiology and the implications of estimates of heritability in age of menopause.

Across mammal species, females' supply of oocytes at puberty scales allometrically with body size and life span (Gosden and Telfer 1987). At maturity, human females have approximately 400,000 oocytes, the number predicted by their body weight. However, all women who survive long enough will become depleted of oocytes around age fifty, long before generalized senescence and end of life, whereas in other species senescence and death usually precede depletion of oocytes (Finch and Gosden 1986). To understand why human females run out of oocytes and why fertility starts to de-

crease when women are in their mid-twenties and terminates around age forty, we need to consider the reproductive physiology of women, along with their reproductive strategies.

Human females produce all of their oocytes by the fifth month of gestation. Surrounded by follicles in the ovaries, these oocytes remain inactive in an arrested phase of meiosis until they either succumb to atresia—a programmed process of cell death—or become part of an ovulatory cohort (Gosden and Spears 1997). Normally, one oocyte in a follicular cohort is *chosen* to complete meiosis; the rest provide hormonal support for development of this primary oocyte, after which they too become atretic. As the follicle pool shrinks, it becomes increasingly difficult to recruit a large enough cohort of follicles to produce ovulation. In addition, as human females age, the *chosen* oocytes become increasingly susceptible to malfunction during completion of meiosis, producing chromosomally abnormal ova (Gosden 1985).

Physiological sources of variation in age of menopause include the original number of oocytes and the rates of atresia (Leidy 1994). Histological investigation of ovaries removed from human females indicates an acceleration in the rate of atresia around age forty (Block 1952; Faddy and Gosden 1996; Gosden and Faddy 1994; Gougeon, Ecochard, and Thalabard 1994; Richardson, Senikas, and Nelson 1987; see Leidy, Godfrey, and Sutherland 1998 for a contrasting interpretation of the data). This acceleration is thought to be functionally related to menopause, hastening its occurrence. Without the acceleration, which begins when some threshold number of oocytes remain (for example, 25,000), women would have enough oocytes to last about seventy years (Faddy et al. 1992). Although it is still unclear why the rate of atresia increases, such an acceleration is consistent with selection for efficient early reproduction.

Further support for a physiological trade-off comes from Wood, O'Connor and Holman's finding that throughout their menstruating life spans women experience periods of ovarian inactivity during which regular cycling and ovulation do not occur (O'Connor, Holman, and Wood 1998; Wood, O'Connor, and Holman 1999). These inactive phases, which increase in frequency and duration as menopause is approached, are predictable from the age pattern of follicular depletion. To Wood and coinvestigators, this suggests that the dynamics of the follicular depletion system determine the distribution of inactive phases and hence the probability of ovulatory cycles. Hence they hypothesize that menopause is the negative pleiotropic result of selection acting on the follicular depletion system to maintain regular ovarian cycles in young women.

Support for both the adaptation and physiological trade-off hypotheses is provided by estimates of heritability in age of menopause, which contain

information about the history of selection on the trait (Falconer 1989; Roff 1997). With these heritability estimates, we can infer something about the maintenance of menopause in the relatively recent past—say, the last two thousand years—from the stability of the mean age of menopause. We learn about the long-term maintenance of the trait from the amount of additive genetic variance (Houle 1992).

The evidence, though not conclusive, suggests that the age of menopause has remained roughly constant for a few thousand years throughout the world, despite tremendous socioeconomic and demographic change (Amundsen and Diers 1970, 1973; Flint 1978, 1997; Gray 1976; McKinlay, Bifano, and McKinlay 1985; Post 1971). With heritabilities as large as 40 to 60 percent (Peccei 1999; Snieder, MacGregor, and Spector 1998) and no appreciable upward movement in the mean age of menopause, there are three possible explanations: (1) age of menopause has in fact experienced an upward secular trend that has not been detected, (2) age of menopause is selectively neutral, (3) age of menopause is under some degree of stabilizing selection.

High heritability and no discernible upward movement in the mean age of menopause in the presence of improving socioeconomic conditions supports stabilizing selection, which in turn suggests costs to prolonging fertility, and by inference benefits to reproductive cessation, in modern industrialized and traditional agricultural societies (Peccei 1999). This finding is significant because it changes the menopause debate with respect to both its origin and maintenance. Previous investigation has focused on the socioecology of hunter-gatherers in an attempt to understand the selection pressures acting on female reproductive strategies in the environment of evolutionary adaptedness (EEA). The fact that there are presently costs and benefits means that there is nothing exclusive to the foraging way of life that makes premature reproductive senescence adaptive. This should not be surprising, given the evidence suggesting that reproductive patterns in human females are remarkably consistent across populations and time, regardless of mode of subsistence. Finding stabilizing selection on age of menopause is also important because it bolsters the relatively weak evidence of the costs and benefits associated with menopause presented in the previous section.

High heritabilities are usually associated with weak stabilizing selection because strong selection generally reduces additive genetic variation (Falconer 1989; Roff 1997). Weak stabilizing selection on age of menopause suggests that, over a broad intermediate range, age of menopause could be considered a neutral trait. The relatively large amount of variation in median age of menopause both within and between populations is consistent with this notion. Weak stabilizing selection on age of menopause could be

the consequence of selection for some other trait that results in menopause, such as selection for early fertility or a postreproductive life span. The universal mean age at last birth of approximately forty years is consistent with both of the above. Indeed, with the latency between last birth and menopause, selection for efficient early fertility implies a built-in postreproductive period—albeit a short one. Even an initially modest postreproductive period could have afforded a fitness advantage if it increased offspring survival. To me this strongly suggests that menopause is both the result of selection for intensive reproduction early in the fertile period to accommodate prolonged offspring dependence through overlapping child care and an adaptation for more effective maternal investment, which included some period of postreproductive life.

## Conclusions

In all societies, historically and cross-culturally, women undergo menopause if they live long enough. If premature reproductive senescence is the result of certain conditions in the EEA, the universality of menopause implies that those conditions must still be present today. Menopause, or the postreproductive life span, must be the response to some unvarying constellation of pressures. In my view, infant altriciality, prolonged offspring dependence, and the expedience of overlapping child care are major components of that constellation. Supporting this notion is the strong evidence from historical and modern populations of front-loaded fertility and an average mean age at last birth of forty years, which provides a short postreproductive life span before menopause. Additional evidence of the continuing importance of efficient early fertility is provided by recent heritability estimates of 40 to 60 percent for age of menopause and the apparent lack of upward secular movement, which imply there are still costs to prolonging fertility as well as benefits associated with premature reproductive cessation. The fact that loss of oocytes accelerates when women are in their late thirties provides the proximate physiological reason for premature reproductive cessation.

If menopause is the result of selection for efficient early fertility to accommodate overlapping child care, it is also the result of changes in the reproductive strategies of young females, which provides compelling support for the mother hypothesis. To me the notion that menopause originated for grandmothering makes less sense, given low life expectancies in the EEA and the fact that females had more to gain from investing in the survival and potential fertility of their own subadult offspring than in grandchildren. The evidence of variability in grandmothers' reproductive effort further weakens the grandmother hypothesis. Finally, there is the logical and incon-

trovertible inference that when menopause first appeared, fertile women would have had subadult dependents.

In the presence of selection for efficient early reproduction, subsequent increases in life span or life expectancies would have resulted in longer postreproductive life spans for human females. These further increases could have had nothing to do with menopause. As long as females retained some RV once there was selection for postreproductive life, any reasons for increases in life span or life expectancies would have been sufficient to increase female postreproductive life spans. However, it is quite likely that increases in female life span or life expectancies resulted from a positive feedback generated by the fitness benefits of maternal, and subsequently grandmaternal, postreproductive investment. Given the reproductive physiology of males and their contribution to the energetics of human reproduction, longer-lived males would have increased their own fitness; there is no need to invoke a correlated response. The very prolonged postreproductive life span now enjoyed by virtually all human females who reach reproductive age is the result of large recent increases in life expectancies.

## Summary

Figure 2.3 shows schematically how menopause is both an epiphenomenon and an adaptation. The universal front-loaded fertility function in human females with the average woman terminating reproduction by age forty indicates a fitness advantage to efficient early reproduction and shows, by the cessation of fertility before menopause, the epiphenomenal origin of the postreproductive life span. This short built-in postreproductive life span suggests that the average ancestral woman who lived until menopause would have had the opportunity to provide prolonged care to her existing subadult offspring, increasing their survival and potential fertility and her own fitness (mothering). The model also shows how as life span or life expectancies increased and postreproductive life spans kept pace—possibly as a result of mothering—grandmothers eventually gained the opportunity to increase the fertility of their adult offspring and the survival of their grandchildren. Grandmothering could then in turn have played a role in further increases in life span or life expectancies.

## Notes

1. J. S. Peccei, "Menopause: Adaptation or Epiphenomenon?" *Evolutionary Anthropology* 10 (2001): 43–57. This material is used by permission of Wiley-Liss, Inc., a subsidiary of John Wiley and Sons, Inc.
2. Nishida et al.'s (1990, 83) data on age of mother at previous birth and length

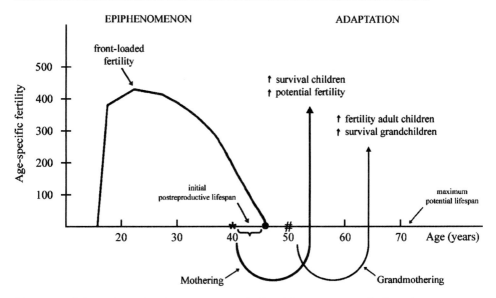

**Figure 2.3** Schematic model of menopause as both epiphenomenon and adaptation. Universal front-loaded fertility with termination of reproduction before menopause shows the epiphenomenal origin of postreproductive life that provides the fitness-enhancing opportunity for mothering. As postreproductive life spans increased, grandmothering became possible. Maximum predicted life span based on body size and brain mass of catarrhine comparison group (Judge and Carey 2000). (∗) Average mean age at last birth in historical and natural-fertility contemporary populations (Bongaarts 1985). (•) Median age of menopause for the Gainj of Papua New Guinea based on hormonal assessment of current status (Wood, Johnson, and Campbell 1985). (#) Median age of menopause for Caucasian women (Wood 1994).

of interbirth interval for Mahale chimpanzees show no correlation, suggesting that noncaptive chimpanzees have a similar box-like fertility pattern ($r = 0.09 \pm 8.66$, n = 19).

## References

Amundsen, D. W., and C. J. Diers. 1970. "The age of menopause in classical Greece and Rome." *Human Biology* 42:79–86.

———. 1973. "The age of menopause in medieval Europe." *Human Biology* 45: 605–12.

Berkowitz, G. S., M. L. Skovron, R. H. Lapinski, and R. L. Berkowitz. 1990. "Delayed childbearing and the outcome of pregnancy." *New England Journal of Medicine* 322:659–64.

Biesele, M., and N. Howell. 1981."The old people give you life: Aging among !Kung hunter-gatherers." In *Other Ways of Growing Old,* ed. P. T. Amoss and S. Harrell. Stanford, CA: Stanford University Press, 77–98.

Block, E. 1952. "Quantitative morphological investigations of the follicular system in women: Variations at different ages." *Acta Anatomica* 14 (suppl. 16): 108–23.

Bogin, B, and B. H. Smith. 1996. "Evolution and the human life cycle." *American Journal of Human Biology* 8:703–16.

Bongaarts, J. 1980. "Does malnutrition affect fecundity? A summary of evidence." *Science* 208:564–69.

———. 1983. "The proximate determinants of natural marital fertility." In *Determinants of Fertility in Developing Countries*, ed. R. A. Bulatao and R. D. Lee. New York: Academic Press, 103–38.

Caro, T. M., D. W. Sellen, A. Parish, R. Frank, D.M. Brown, E. Voland, and M. Borgerhoff Mulder. 1995. "Termination of reproduction in nonhuman and human primate females." *International Journal of Primatology* 16:205–20.

Croze, H., A. K. K. Hillman, and E. M. Lang. 1981. "Elephants and their habitats." In *Dynamics of Large Mammal Populations*, ed. C. W. Fowler and T. D. Smith. New York: John Wiley and Sons, 297–316.

De Heinzelin, J., D. Clark, T. White, W. Hart, P. Renne, G. WoldeGabriel, Y. Beyene, and E. Vrba. 1999. "Environment and behavior of 2.5-million-year-old Bouri hominids." *Science* 284, no. 5414: 625–29.

Diamond, J. 1997. "Making more by making less: The evolution of female menopause." In *Why Is Sex Fun?* New York: Basic Books, 103–25.

Faddy, M. J., and R. G. Gosden. 1996. "A model conforming the decline in follicle numbers to the age of menopause in women." *Human Reproduction* 11: 1484–86.

Faddy, M. J., R. G. Gosden, A. Gougeon, S. J. Richardson, and J. F. Nelson. 1992. "Accelerated disappearance of ovarian follicles in mid-life: Implications for forecasting menopause." *Human Reproduction* 7: 1342–46.

Falconer, D. S. 1989. *Introduction to Quantitative Genetics*, 3rd ed. New York: Longman Scientific.

Finch, C. E., and R. G. Gosden. 1986. "Animal models for the human menopause." In *Aging, Reproduction, and the Climacteric*, ed. L. Mastroianni and C. A. Paulsen. London: Plenum Press, 3–34.

Flint, M. 1978. "Is there a secular trend in age of menopause?" *Maturitas* 1:133–39.

———. 1997. "Secular trends in menopause age." *Journal of Psychosomatic Obstetrics and Gynecology* 18:65–72.

Foley, R. A. 1987. *Another Unique Species*. New York: Longman Scientific and Technical.

Foley, R. A., and P. C. Lee. 1991. "Ecology and energetics of encephalization in hominid evolution." *Philosophical Transactions of the Royal Society of London Series.B* 334:223–32.

Fretts, R. C., J. Schmittdiel, F. H. McLean, R. H. Usher, M. B. Goldman. 1995. "Increased maternal age and the risk of fetal death." *New England Journal of Medicine* 333: 953–57.

Frisch, R. E. 1978. "Population, food intake, and fertility." *Science* 199: 22–30.

Gage, T. B., J. M. McCullough, C. A. Weitz, J. S. Dutt, A. Abelson. 1989. "Demographic studies and human population biology." In *Human Population Biology: A*

*Transdisciplinary Science,* ed. M. A. Little and J. D. Haas. New York: Oxford University Press, 45–65.
Gaulden, M. E. 1992. "Maternal age effect: The enigma of Down syndrome and other trisomic conditions." *Mutation Research* 296:69–88.
Gaulin, S. J. C. 1980. "Sexual dimorphism in the human post-reproductive lifespan: Possible causes." *Journal of Human Evolution* 9:227–32.
Gavrilov, L. A., and N. S. Gavrilova. 1999. "Is there a reproductive cost for human longevity?" *Journal of Anti-Aging Medicine* 2:121–23.
Gosden, R. G. 1985. *Biology of Menopause: The Causes and Consequences of Ovarian Ageing.* London: Academic Press.
Gosden, R. G., and M. J. Faddy. 1994. "Ovarian aging, follicular depletion, and steroidogenesis." *Experimental Gerontology* 29:265–74.
Gosden, R. G., and N. Spears. 1997. "Programmed cell death in the reproductive system." *British Medical Bulletin* 52:644–61.
Gosden, R. G., and E. Telfer. 1987. "Number of follicles and oocytes in mammalian ovaries and their allometric relationships." *Journal of Zoology London* 211:169–75.
Gougeon, A., R. Ecochard, and J. C. Thalabard. 1994. "Age-related changes of the population of human ovarian follicles." *Biology of Reproduction* 50:653–63.
Gray, R. H. 1976. "The menopause: Epidemiological and demographic considerations." In *The Menopause: A Guide to Current Research and Practice,* ed. R. J. Beard. Lancaster, UK: MTP Press, 25–40.
Hames, R. B. 1988. "The allocation of parental care among the Ye'kwana." In *Human Reproductive Behavior,* ed. L. Betzig, M. Borgerhoff Mulder, and P. Turke. Cambridge: Cambridge University Press, 237–51.
Hamilton, W. D. 1964. "The genetical evolution of social behaviour I, II." *Journal of Theoretical Biology* 7:1–52.
Hammer, M. L. A., and R. A. Foley. 1996. "Longevity and life history in hominid evolution." *Human Evolution* 11:61–66.
Harman, S. M., and G. B. Talbert. 1985. "Reproductive aging." In *The Biology of Aging,* ed. C. E. Finch and E. L. Schneider. New York: Van Nostrand Reinhold, 475–510.
Hawkes, K., J. F. O'Connell, and N. G. Blurton Jones. 1989. "Hardworking Hadza grandmothers." In *Comparative Socioecology,* ed. V. Standen and R. A. Foley. Oxford: Blackwell Scientific, 341–66.
———. 1997. "Hadza women's time allocation, offspring provisioning, and the evolution of long post-menopausal lifespans." *Current Anthropology* 38:551–77.
Henry, L. 1961. "Some data on natural fertility." *Eugenics Quarterly* 8:81–91.
Hill, K. 1982. "Hunting and human evolution." *Journal of Human Evolution* 11:521–44.
Hill, K., and A. M. Hurtado. 1991. "The evolution of premature reproductive senescence and menopause in human females: An evaluation of the grandmother hypothesis." *Human Nature* 2:313–50.
———. 1995. "How much does Grandma help?" In *Human Nature: A Critical Reader,* ed. L. Betzig. New York: Oxford University Press, 140–43.

———. 1996. *Ache Life History: The Ecology and Demography of a Foraging People.* New York: Aldine de Gruyter.
Houle, D. 1992. "Comparing the evolvability and variability of quantitative traits." *Genetics* 130:195–204.
Jamison, C. S., L. L. Cornell, P. L. Jamison, and H. akazato. 2002. "Are all grandmothers equal? A review and a preliminary test of the grandmother hypothesis in Tokugawa Japan." *American Journal of Physical Anthropology* 119:67–76.
Judge, D., and J. Carey. 2000. "Postreproductive life predicted by primate patterns." *Journal of Gerontology* 55A:B201–9.
Kaplan, H. 1997. "The evolution of the human life course." In *The Biodemography of Aging,* ed. K. Wachter and C. Finch. Washington, DC: National Academy of Sciences, 175–211.
Kaplan, H., K. Hill, J. Lancaster, and A. M. Hurtado. 2000. "The evolution of intelligence and the human life history." *Evolutionary Anthropology* 89:156–84.
Knodel, J. E. 1988. *Demographic Behavior in the Past.* Cambridge: Cambridge University Press.
Lancaster, J. B., and C. S. Lancaster. 1983. "Parental investment: The hominid adaptation." In *How Humans Adapt: A Biocultural Odyssey,* ed. D. Ortner. Washington, DC: Smithsonian Institution Press, 33–66.
Laws, R. M., I. S. C. Parker, and R. C. B. Johnstone. 1975. "Reproduction." In *Elephants and Their Habitats.* Oxford: Clarendon Press, 204–27.
Leidy, L. E. 1994. "Biological aspects of menopause: Across the lifespan." *Annual Review of Anthropology* 23:231–53.
———. 1999. "Menopause in evolutionary perspective." In *Evolutionary Medicine,* ed. W. Trevathan, J. McKenna, and E. O. Smith. New York: Oxford University Press, chap. 16.
Leidy, L. E., L. R. Godfrey, and M. R. Sutherland. 1998. "Is follicular atresia biphasic?" *Fertility and Sterility* 79:851–59.
Loudon, I. 1992. *Death in Childbirth.* Oxford: Clarendon Press.
Marlow, F. 2000. "The patriarch hypothesis: An alternative explanation of menopause." *Human Nature* 11:27–42.
Marsh, H., and T. Kasuya. 1984. "Changes in the ovaries of the short-finned pilot whale, *Globicephala macrorhychus,* with age and reproductive activity." In *Reproduction in Whales, Dolphins, and Porpoises,* ed. W. F. Perrin, R. L. Brownell Jr., and D. P. DeMaster. Cambridge, MA: Report of the International Whaling Commission. 311–35.
Martin, R. D. 1983. "Human brain evolution in an ecological context." *Fifty-second James Arthur Lecture on the Evolution of the Human Brain.* New York: American Museum of Natural History.
McHenry, H. M. 1994. "Behavioral ecological implications of early hominid body size." *Journal of Human Evolution* 27:77–87.
McKinlay, S. M., N. L. Bifano, and J. B. McKinlay. 1985. "Smoking and age at menopause in women." *Annals of Internal Medicine* 103:350–56.
Merchant, K., R. Martorell, and J. D. Haas. 1990. "Consequences for maternal nu-

trition of reproductive stress across consecutive pregnancies." *American Journal of Clinical Nutrition* 52:616–20.

Mizroch, S. A. 1981. "Analyses of some biological parameters of the Antarctic fin whale (*Balaenoptera physalus*)." *Report of the International Whaling Commission* 31:425–34.

Naeye, R. L. 1983. "Maternal age, obstetric complications, and the outcome of pregnancy." *Obstetrics and Gynecology* 61:210–16.

Nishida, T., H. Takasaki, and Y. Takahata. 1990. "Demography and reproductive profiles." In *The Chimpanzees of the Mahale Mountains: Sexual and Life History Strategies*, ed. T. Nishida. Tokyo: Tokyo University Press, 63–97.

O'Connor, K. A., D. J. Holman, and J. W. Wood. 1998. "Declining fecundity and ovarian ageing in natural fertility populations." *Maturitas* 30:127–36.

O'Rourke, M. T., and P. T. Ellison. 1993. "Menopause and ovarian senescence in human females." *American Journal of Physical Anthropology* suppl. 16: 154.

Packer, C., M. Tatar, and A. Collins. 1998. "Reproductive cessation in female mammals." *Nature* 392:807–11.

Paul, A., J. Kuester, and D. Podzuweit. 1993. "Reproductive senescence and terminal investment in female Barbary macaques (*Macaca sylvanus*) at Salem." *International Journal of Primatology* 14:105–24.

Pavelka, M. S. M., and L. M. Fedigan. 1991. "Menopause: A comparative life-history perspective." *Yearbook of Physical Anthropology* 34:13–38.

———. 1999. "Reproductive termination in female Japanese monkeys: A comparative life-history perspective." *American Journal of Physical Anthropology* 109: 455–64.

Peccei, J. S. 1995. "The origin and evolution of menopause: The altriciality-lifespan hypothesis." *Ethology and Sociobiology* 16:425–49.

———. 1999. "First estimates of heritability in the age of menopause." *Current Anthropology* 40:553–58.

———. 2001a. "The grandmother hypotheses: Old and new." *American Journal of Human Biology* 13:434–52.

———. 2001b. "Menopause: Adaptation or epiphenomenon?" *Evolutionary Anthropology* 10:43–57.

Post, J. B. 1971. "Ages at menarche and menopause: Some mediaeval authorities." *Population Studies* 25:83–87.

Richardson, S. J., V. Senikas, and J. F. Nelson. 1987. "Follicular depletion during the menopausal transition: Evidence for accelerated loss and ultimate exhaustion." *Journal of Clinical Endocrinology and Metabolism* 65:1231–37.

Robinson, W. C. 1986. "Another look at the Hutterites and natural fertility." *Social Biology* 33:65–76.

Roff, D. A. 1997. *Evolutionary Quantitative Genetics*. New York: Chapman Hall.

Sear, R., R. Mace, and I. A. McGregor. 2000. "Maternal grandmothers improve nutritional status and survival of children in rural Gambia." *Proceedings of the Royal Society of London* 267:1641–47.

Sikes, N. E. 1994. "Early hominid habitat preferences in East Africa: Paleosol carbon isotopic evidence." *Journal of Human Evolution* 27:25–45.

Snieder, H., A. J. MacGregor, and T. D. Spector. 1998. "Genes control the cessation of a woman's reproductive life: A twin study of hysterectomy and age at menopause." *Journal of Clinical Endocrinology and Metabolism* 83:1875–80.

Stearns, S. C. 1992. *The Evolution of Life Histories*. New York: Oxford University Press.

Takahata, Y., N. Koyama, and S. Suzuki. 1995. "Do the old aged females experience a long postreproductive lifespan? The cases of Japanese macaques and chimpanzees." *Primates* 36:169–80.

Trevathan, W. R. 1987. *Human Birth: An Evolutionary Perspective*. New York: Aldine de Gruyter.

Turke, P. W. 1988. "Helpers at the nest: Childcare networks of Ifaluk." In *Human Reproductive Behavior*, ed. L. Betzig, M. Borgerhoff Mulder, and P. Turke. Cambridge: Cambridge University Press, 173–88.

Voland, E., and J. Beise. 2002. "Opposite effects of maternal and paternal grandmothers on infant survival in historical Krummhörn." *Behavioural Ecology and Sociobiology* 52:435–43.

Vrba, E. S. 1985. "Ecological and adaptive changes associated with early hominid evolution." In *Ancestors: The Hard Evidence*, ed. E. Delson. New York: Alan R Liss, Inc., 63–71.

Washburn, S. L. 1981. "Longevity in primates." In *Aging, Biology, and Behavior*, ed. J. March and J. McGaugh. New York: Academic Press, 11–29.

Weiss, K. M. 1981. "Evolutionary perspectives on human aging." In *Other Ways of Growing Old*, ed. P. T. Amoss and S. Harrell. Stanford, CA: Stanford University Press, 25–28.

Williams, G. C. 1957. "Pleiotropy, natural selection, and the evolution of senescence." *Evolution* 11:398–411.

Wilson, E. O. 1975. "The relevant principles of population biology." In *Sociobiology*. Cambridge, MA: Belknap Press, 2–47.

Wood, J. W. 1989. "Fecundity and natural fertility in humans." In *Oxford Reviews of Reproductive Biology*, vol. 2, ed. S. R. Milligan. Oxford: Oxford University Press, 61–102.

———. 1994. *Dynamics of Human Reproduction: Biology, Biometry, Demography*. New York: Aldine de Gruyter.

Wood, J. W, P. L. Johnson, and K. L. Campbell. 1985. "Demographic and endocrinological aspects of low natural fertility in Highland New Guinea." *Journal of Biosocial Science* 17:57–79.

Wood, J. W., K. A. O'Connor, and D. J. Holman. 1999. "Biodemographic models of menopause." *Human Biology Association Abstracts* 182:133.

Wood, J. W., and M. Weinstein. 1988. "A model of age-specific fecundability." *Population Studies* 42:85–113.

# CHAPTER 3

# Human Longevity and Reproduction
## *An Evolutionary Perspective*
Natalia S. Gavrilova and Leonid A. Gavrilov

---

Evolutionary considerations of the significance of grandmaternal effects discussed in this book bring us to a more general question: What does evolutionary theory tell us about the links between human longevity and reproduction? The purpose of this chapter is to review the ideas and facts on longevity-reproduction studies in evolutionary context and to present some new findings on this issue. The idea that human longevity and reproduction are linked to each other, and that this relationship could have a fundamental evolutionary explanation, has deep historical roots (Beeton, Yule, and Pearson 1900). Dozens of comprehensive studies on this topic have been published in the past (to mention a few, see Powys 1905; Bell 1918; Freeman 1935; Henry 1956; Gautier and Henry 1958; Bideau 1986; Knodel 1988). Yet the topic continues to be a matter of intensive study (Le Bourg et al. 1993; Westendorp and Kirkwood 1998; Korpelainen 2000, 2003; Lycett, Dunbar, and Voland 2000; Gavrilov and Gavrilova 2002; Müller et al. 2002; Doblhammer and Oeppen 2003) and debate (Ligtenberg and Brand 1998; Gavrilov and Gavrilova 1999; Westendorp and Kirkwood 1999).

The nature of the longevity-reproduction relationship is not just one scientific problem but a set of problems (which have used an identical terminology), and how longevity and reproduction will interact depends on the context of a particular study. For example, studies of human populations practicing birth control and family planning address fundamentally different question(s) on the link between longevity and reproduction than studies of populations with natural fertility. The studies of modern contraceptive-using populations address questions about modulating effects of socioeconomic status and personal health/reproductive choices, while the studies of natural fertility populations come closer to addressing fundamentals of human biology and evolution. Such a distinction may sound trivial, but these two very different types of studies are often confused with each other because they use an identical terminology (terms "reproduction" and "longevity").

The next issue of critical importance is related to how human longevity is defined. Those studies that include deaths at reproductive ages into analysis address fundamentally different question(s) than studies focused

on postreproductive survival only. The former studies consider anticipated effects of premature deaths on reproductive output, while the latter studies are more relevant to the studies of human longevity and its possible nontrivial link to reproduction. Again these two very different research approaches are often confused with each other because they use a similar terminology.

Finally it is particularly important to distinguish how reproductive success is measured. Straightforward studies on the numbers of children will reveal the "direct costs" of reproduction related to the potentially debilitating effects of excessive childbearing in natural fertility populations. Although this research approach addresses an important problem of the physiological and economic costs of reproduction, this ecological problem is different from a genetic problem posed by evolutionary theory, which is focused on heritable genetic components of reproductive costs, not just trivial environmental trade-offs.

Specifically, some evolutionary theories predict that genes enhancing human longevity should impair human reproduction because they divert resources from reproduction to body maintenance and repair (Kirkwood and Holliday 1979; Westendorp and Kirkwood 1998). If this theory is correct, then people with exceptional longevity should be infertile more frequently because they have a higher frequency of longevity gene(s) suppressing reproduction. Indeed, one study found that almost a half of long-lived women were allegedly childless (Westendorp and Kirkwood 1998). Moreover, it was found that this reported effect of exceptional longevity on reproductive output (numbers of children) was determined exclusively by increased proportion of childless women (Ligtenberg and Brand 1998). Thus the dependence of infertility rate instead of number of children on human life span at extremely old post-reproductive ages could be more informative for testing specific predictions of evolutionary theories on the links between longevity and reproduction.

Surprisingly, such an important and informative variable as childlessness/infertility rate has not received much attention in the studies of longevity-reproduction links. Most studies continue to operate with the numbers of children, a variable whose causes may have a trivial explanation (health exhaustion through excessive childbearing). Also, the number of children is strongly affected by family planning and reproductive habits (by frequency of sexual intercourse, for example). In contrast to the numbers of children, the childlessness rate is a more robust variable, because only a few couples remain childless voluntarily (Glass 1963; Toulemon 1996). Thus studies of childlessness rates among long-lived people may be particularly interesting and informative for testing evolutionary theories of aging. In this study, we try to fill this gap and present new findings regarding a pos-

sible link between human longevity and childlessness rate. We also provide a historical review of the relevant studies and discuss methodological issues related to the longevity-reproduction problem.

## Historical Review of the Studies on Fertility and Longevity

Studies of the relationship between reproduction and longevity have a long and interesting history with many useful lessons to learn.

One of the first systematic studies on this topic was conducted by famous statisticians Karl Pearson and George Yule with the assistance of Mary Beeton in 1900 (Beeton, Yule, and Pearson 1900). The authors tried to test one of predictions of the Darwinian evolutionary theory that the fittest individuals should leave more offspring. These researchers studied the dependence of the number of children on parental life span after age fifty (at postreproductive ages). The authors found a slightly *positive* relationship between life span of both mothers and fathers and the number of offspring in four different sets of genealogical data (English Quaker records and Whitney family of Connecticut records for females and American Whitney family and Burke's *Landed Gentry* for males). Interestingly, this positive relationship was stronger when American data were analyzed. They also tried to use data on the British peerage but had to discard them because the data for women proved to be incomplete (many birth dates were missing) and because of indications that British peerage practiced some artificial restriction of births. They came to the conclusions that "fertility is correlated with longevity even after the fecund period is passed" (Beeton, Yule, and Pearson 1900, 163) and that "selective mortality reduces the numbers of the offspring of the less fit relatively to the fitter" (1900, 170). They also suggested that "in the case of life under wild conditions, the correlation between fertility and power of surviving would probably be far greater." (1900, 170).

Powys (1905) analyzed longevity of married women in post-reproductive period using vital statistics of the New South Wales for the years 1898 to 1902. He found that mothers of "moderate" sized families of about six children live on the average longer than those with smaller or larger families, and that extreme fecundity is unfavorable to extreme longevity in females but not males. The author explained the latter observation by "incessant strain upon the physique of women who bear large families during the periods of gestation, parturition and lactation" (Powys 1905, 244). It should be noted, however, that these results were obtained using cross-sectional data subjected to biases due to population structure and secular effects.

Another important study of fertility and longevity was conducted by the famous telephone inventor, Alexander Graham Bell, who analyzed genealo-

gies of the Hyde family in New England. He found that *"The longer lived parents were the most fertile"* (Bell 1918, 52; emphasis added).

In 1935 Bettie Freeman conducted a thorough study on the fertility and longevity of married women living beyond the reproductive period. She correctly criticized previous studies on this topic for not taking into account such important confounding variables as the age at marriage, and she emphasized the importance of avoiding right truncation of life span data, which occurs when data for nonextinct birth cohorts are used in the analysis. Freeman carefully selected for analysis eleven of the most complete and accurate American genealogies with data on 2,614 married women born from 1625 to 1825, who lived beyond age forty-five and had living husbands at the end of their reproductive period. The advantage of this study is the use of nontruncated data for the extinct birth cohort. The author also took into account calendar years of birth (control for changes over time), duration of marriage (control for exposure to childbirth) and the woman's age at marriage using a stratification approach. As a result of this careful study, the author found weak *positive* correlations between the duration of postreproductive life in women and the number of offspring borne, although this dependence was statistically significant only for women married before age twenty (Freeman 1935). This is an interesting observation, because the early-married women have the longest exposure to childbearing "risk." These early-married women also start to reproduce earlier, which may be protective against certain diseases like breast cancer (Bernier et al. 2000; Meister and Morgan 2000). Freeman came to the following conclusion on the link between reproduction and longevity: "this study gives no evidence that the association between the two variables is of sufficient moment to play a significant part in affecting population movements" (1935, 418).

After Freeman's comprehensive analyses, researchers of human evolution apparently considered this topic to be completely explored and left further studies of longevity and reproduction to historical demographers. Studies of historical populations revealed either no relationship (Henry 1956; Gautier and Henry 1958; Knodel 1988) or a positive relationship (Bideau 1986) between reproduction and longevity.

In 1993 Eric Le Bourg and colleagues returned to evolutionary studies of human longevity and reproduction using historical data for Québec. The authors tried to test Williams' (1957) evolutionary theory of senescence (antagonistic pleiotropy theory), which predicts the existence of a trade-off between early fecundity and longevity. They used population registers of French immigrants to Québec in the seventeenth century and of the first Canadians in the seventeenth and eighteenth centuries, a noncontraceptive human population living at a time when longevity had not been extended by advanced medical care and was not artificially shortened by wars, epi-

demics, or other external causes. The authors did not find any trade-off between longevity and reproduction in this historical population (Le Bourg et al. 1993).

In 1998 Westendorp and Kirkwood tested the predictions of the antagonistic pleiotropy theory in general and a disposable soma theory in particular (Kirkwood and Holliday 1979). Using genealogical data for British (actually European) aristocracy for a historical period when it was believed no birth control was practiced, the authors of this study reported that long-lived women are especially unsuccessful in reproduction. In particular, as many as 50 percent of the married long-lived women were reported to be childless. The long-lived women had, according to this study, less than two children on average, and they had their first child at a later age—by the age of twenty-seven years. The authors came to the conclusion that human longevity is achieved at the cost of reproductive success because of a genetic trade-off between longevity and reproduction predicted by the disposable soma theory of aging (Westendorp and Kirkwood 1998).

The authors apparently were not aware that their conclusions were in conflict with many previous findings on the relationship between reproduction and longevity. They did not quote and discuss the inconsistency of their results with findings from numerous previous studies on the same topic, where not only were any strong trade-offs between human longevity and fertility *not* observed, but even the opposite trend was often found (Beeton, Yule, and Pearson 1900; Freeman 1935; Henry 1956, 1963; Bideau 1986; Knodel 1988; Le Bourg et al. 1993). Thus an impression was created that their strong trade-off between longevity and reproduction is a well-documented observation, consistent with previous research. Now an impaired fertility of long-lived women is often presented in the scientific literature and mass media as an established fact (Kirkwood 2002; Westendorp 2002; Glannon 2002; Perls et al. 2002). Confirmation of this trade-off has become an appealing task for subsequent researchers because it seemed to be endorsed both by evolutionary theory and by publication in the prestigious scientific journal *Nature* (Westendorp and Kirkwood 1998). As a result, subsequent researchers began to seek trade-offs between fertility and longevity and report them, even though these trade-offs were not directly observable from their data (Lycett, Dunbar, and Voland 2000; Doblhammer and Oeppen 2003).

For example, Lycett, Dunbar, and Voland studied a historical population of northwest Germany (1720–1870) and found no difference in life span between married childless and parous women. Then the authors studied the relationship between residual longevity and residual number of children and found a *positive* correlation between these variables for farmers and smallholders, which is opposite to Westendorp and Kirkwood's findings but

is consistent with many earlier publications. The authors also found a weak negative relationship for particularly poor landless persons. The authors concluded, "while our data do not at first appear to provide support for the disposable soma theory for the evolution of human ageing, our subsequent analyses of social groups within the Krummhörn suggest that, at least for the poorest social group, there is a trade-off between reproduction and longevity" (Lycett, Dunbar, and Voland 2000). Ironically, this study, published 100 years after Karl Pearson's paper (Beeton, Yule, and Pearson 1900) in the same journal (*Proceedings of the Royal Society of London*), came to the opposite conclusion, but somehow each of these studies reported support for the evolutionary theory. Recently Dribe (2004) found a positive relationship between mortality and number of children among poor landless women but not among women from other social groups in preindustrial Sweden, which he believes is caused by economic rather than biological factors.

Doblhammer and Oeppen also sought a trade-off between reproduction and longevity using Hollingsworth's database on British peerage. This database is more complete compared to the Bloore's database used by Westendorp and Kirkwood (1998), although it represents a British peerage that seemed to practice artificial restriction of births as noted by Karl Pearson and coauthors (Beeton, Yule, and Pearson 1900). Initially, Doblhammer and Oeppen did not find any trade-off between postreproductive life span and fertility when they analyzed the data in a conventional way. Then they introduced an additional unobserved variable (without any justification) into the analysis, which was interpreted as "unobserved health"—and after excluding childless women and women with one child from the analysis, they finally got the anticipated trade-off: a positive correlation between relative mortality risk and parity (Doblhammer and Oeppen 2003). It is not clear, however, why the important and informative cases of childless women have to be excluded from the analysis in order to get a statistically significant trade-off between reproduction and longevity.

There was one more study that reported a diminished fertility among long-lived women (Korpelainen 2000). The author studied historical data on European aristocrats and rural Finns and did not find any significant increase in the childlessness among long-lived women (80+ years). She explained this apparent contradiction with the trade-off paradigm by insufficient data quality: "childless families are more easily overlooked in historical genealogical data" (Korpelainen 2000, 1769). The author, however, surmised lower number of progeny among long-lived women, although this observation was not statistically significant. This conclusion is likely to be an artifact of not taking into account a dramatic historical increase in life span accompanied by significant historical decline in fertility (the data were not controlled for time changes over two centuries).

Thus the studies of reproduction and longevity produced controversial conclusions on the relationship between number of offspring and postreproductive life span. It looks like in populations with natural fertility there is a positive relation between postreproductive longevity and number of offspring. This relationship was observed for some historical populations with natural fertility (Beeton, Yule, and Pearson 1900; Freeman 1935; Bideau 1986), supporting the idea of Karl Pearson that the fittest individuals leave more offspring. It appears that in the same context we may interpret the results that demonstrated higher longevity of women who had late children (Perls et al. 1997; Müller et al. 2003). It was shown that age at menopause is negatively correlated with mortality (Jacobsen, Heuch, and Kvale 2003), so women that have late children and reproduce longer are healthier than women who stop reproducing earlier because of early menopause.

In populations practicing birth control, a positive relationship between reproduction and longevity is replaced by a curve with the optimum when the lowest risk of death is observed for women having three (Kumle and Lund 2000) to six (Powys 1905) children. It seems that European aristocrats started to use birth control relatively early in history, as noted by Karl Pearson and colleagues more than a century ago. Interestingly, these researchers found strong *positive* correlation between life span and reproduction for American women, which continued up to ninety years of age at death (Beeton, Yule, and Pearson 1900). However, for the English data the positive relationship between life span and number of offspring only holds until age seventy-five years, and beyond this age at death there appeared to be a slight decrease in numbers of children. One possible explanation of this phenomenon may be that more educated English women started taking measures for birth control earlier in history than Americans, thereby decreasing the debilitating effects of excessive childbearing on health. In populations with natural fertility, most married women achieve their reproductive potential, so both the longevity and the number of offspring reflect an organism's fitness. In populations practicing birth control, the number of children is no longer related to fitness alone, so physically robust women having fewer children may live longer due to smaller exposure to the debilitating effects of excessive childbearing.

It is known that number of children borne is modulated by the age of marriage, which was particularly late among the British aristocracy (Hollingsworth 1964). As a result, the observed number of offspring is not a good measure of their biological reproductive potential. The situation becomes even more complicated if we take into account artificial restriction of fertility, which British aristocrats started to practice after the eighteenth century (Hollingsworth 1964). For example, the mean number of children among the British peerage (4.84, see Doblhammer and Oeppen 2003) is much

lower than among the early New England settlers (5.7 to 7.2, see Freeman 1935). The most likely explanation of this difference is the late age at marriage and partial birth control among the British peerage (Hollingsworth 1964). On the other hand, childlessness is much less affected by restrictions of birth control because the majority of married couples agree to have at least one child; voluntary childlessness is extremely rare (Glass 1963; Toulemon 1996). This makes studies on links between childlessness and longevity particularly promising. In our study, we present data on the relationship between reproduction and longevity using childlessness as a proxy for biological infertility (there is further justification of this assumption below). Another reason for studying childlessness comes from an observation published by Ligtenberg and Brand (1998) that alleges that an inverse relationship between longevity and reproduction was caused by changes in the proportions of reported childless women. As those authors concluded, "it is not a matter of reduced fertility, but a case of 'to have or have not'" (Ligtenberg and Brand 1998). Still, a study of childlessness using genealogical data requires a high quality and completeness of the data set to be used in the analyses.

There is no question that genealogical data and historical demographic data might be of great interest for evolutionary studies on human longevity and reproduction. However, this specific area of research requires extremely careful data handling (data quality control and adjustment for important predictor variables) described in the classical books on historical demography (Knodel 1988). We believe, therefore, that the relationship between human longevity and childlessness should be explored again with these methodological caveats in mind.

## Are Longevious Women Infertile? Validation Study of Infertility Rates as a Function of Life Span

### Data and Methods

#### MAIN DATA SOURCE

This study applies the database on European royal and noble families that was developed and used in our previous studies. This family-linked database was developed as a result of more than ten years of continued efforts that proved to be both labor-intensive and time-consuming because of extensive data cross-checking and data quality control. We used earlier intermediate versions of this database in previous studies (Gavrilov and Gavrilova 1997, 1999b, 2000, 2001, 2003, 2004; Gavrilov et al. 1997, 2002; Gavrilova and Gavrilov 2001; Gavrilova et al. 1998, 2003, 2004). To develop this database, we have chosen one of the best professional sources of genealogical data

available: the famous German edition of the *Genealogisches Handbuch des Adels* (called also the *New Gotha Almanac*), edited by W. Van Hueck, as well as several other reputable data sources described elsewhere (Gavrilova and Gavrilov 1999).

A detailed description of this database and issues of quality control for this historical dataset are available in previous publications (Gavrilov and Gavrilova 2001; Gavrilova and Gavrilov 2001). The main feature of this data source (compared to other genealogical resources) is its very high quality achieved through cross-checking of each record with multiple data sources. Also, this wealthy population is reasonably homogeneous regarding socioeconomic characteristics, and it did not suffer from undernutrition, starvation, or poor living conditions. Thus, although the sample analyzed in this study does not represent the whole human population (as laboratory animals do not represent species in the wild), it is one of the best possible samples to test biological hypotheses because the effects of population heterogeneity are minimized with regard to social status.

Data quality control was an important part of our effort to develop a high-quality family-linked database and use it for scientific research. In particular, we checked data for completeness, accuracy, and representativeness.

The *completeness* in birth and death dates reporting in the *New Gotha Almanac* was very high: dates of all vital events were reported for nearly 95 percent of all persons. Such high completeness is not common for other genealogical data sources. For example, the British peerage data published by Burke's almanac often lack information on birth dates for women, making the calculation of female life span impossible. This problem with British aristocratic women was first noticed by Karl Pearson and Mary Beeton a century ago (Beeton and Pearson 1899, 1901). The authors used British peerage data to study longevity inheritance and had to exclude women from their consideration for the following reason: "The limitation to the male line was enforced upon us partly by the practice of tracing pedigrees only through the male line, partly by the habitual reticence as to the age of women, even at death, observed by the compilers of peerages and family histories" (Beeton and Pearson 1901, 50–51). Our own experience revealed much lower quality of British genealogies compared to German and Scandinavian genealogies, particularly in the case of female birth-date recording. For example, the proportion of female birth dates with an unknown month of birth was 16 percent in British genealogies versus 1.6 percent in German genealogies.

The accuracy of data published in the *New Gotha Almanac* is also very high: the frequency of inconsistent records is less than 1 per 1,000 records while for many other genealogical data sources it falls within 1 per 300 to 400 records.

As for representativeness, the comparison of our data with Hollingsworth's analysis of the British peerage (Hollingsworth 1964) revealed close agreement between his findings and ours on mortality patterns, including the male/female gap in life expectancy (seven to ten years of female advantage in life span).

Another important advantage of this dataset is that the data are not spoiled by selective emigration (a common problem for data collected through local registers) because in this dataset every person is traced until his or her death. It was possible to trace the destiny of almost every person, including even those relatively rare cases when a person left Europe and eventually died in another part of the world (United States, Canada, Australia, South Africa, India, Latin America, and so on).

We also used extinct (noncensored) birth cohorts in our study. For this purpose, only those birth cohorts were used in the study that were born at least 100 years before the year of data publication (to be sure that the birth cohort under study is almost extinct).

## CHARACTERISTICS OF THE DATA SAMPLE
## USED FOR THE CHILDLESSNESS STUDY

Selection of data for this particular study was conditioned by the necessity of obtaining reliable information on women's fertility, date of marriage, and husband characteristics. Therefore, data on 3,723 married women born from 1500 to 1875 and belonging to the upper European nobility were used for the analysis. Although data for women born before 1500 were also available, we found that completeness of these old data is not satisfactory because of obvious underreporting of children who died in infancy and underreporting of family size compared to post-1500 data (even for royal lines). Thus we decided to discard these data in order to ensure a high quality of data selected for the analyses. Also, the most accurate information on the number of children is available in genealogies compiled for upper European nobility: royal, princely, and ducal lines as well as German mediatized houses. To ensure higher accuracy of the data, we excluded all non-royal lines of Russian nobility since they have lower quality compared to other European upper nobility genuses. We would like to emphasize the importance of selecting upper nobility genealogies for studying fertility with genealogical data. It turned out that in published genealogies, the number of reported children and proportion of childless women often are inversely related to the nobility rank of the studied family. For example, in the Bloore's database used by Westendorp and Kirkwood (1998), the percentage of allegedly childless long-lived women (life span above 80 years, born before 1800) dropped from 43 percent in poorly documented families of low nobility rank to 23 percent in better-studied families (where husbands

belonged to nobility ranks higher than barons and baronets). Note that the latter estimate of childlessness better agrees with published data (Knodel 1988; Lycett, Dunbar, and Voland 2000) while the former estimate looks unrealistically high. To avoid this problem, we excluded families with low nobility rank from the analyses.

Women with two or more marriages (5 percent) were excluded from the analysis in order to simplify the interpretation of results (to ensure continuity of exposure to childbearing).

The most difficult issue was to prove that women with no recorded children were really childless. To ensure the accuracy of this judgment, every case of childlessness has been checked using at least two different genealogical sources. Although most records in our dataset belong to continental European nobility, it has approximately 65 percent overlap with Bloore's dataset used by Westendorp and Kirkwood (1998) regarding the studied families. This significant data overlap occurred because a considerable number of records for the British peerage in Bloore's database lacked information about female birth dates and therefore were useless for further analysis. As a result, 60 to 65 percent of the records with a known female life span in Bloore's database belonged to the continental European (mostly German) ruling lines rather than to the British peerage.

## ANALYTICAL METHODS

The statistical analyses were performed using the multivariate logistic regression model (Breslow and Day 1980; Aldrich and Nelson 1984; Hosmer and Lemeshow 1989).

Suppose $Y$ is a binary variable indicating the fact of being childless and $x$ is a vector of explanatory variables. Then probability $p = Pr(Y = 1|x)$ of being childless can be modeled by linear logistic regression:

$$\log\left(\frac{p}{1-p}\right) = \alpha + \beta x$$

where $\alpha$ is the intercept parameter, $\beta$ is the vector of slope parameters, and $x$ is a vector of predictor variables.

Childlessness was considered as a dependent outcome variable in multivariate logistic regression with dummy (0–1) predictor variables using the SAS statistical package (procedure LOGISTIC). The independent predictor variables included six sets of binary variables:

1. calendar year of birth (to control for historical increase in life expectancy as well as for fluctuations in life span over time). The whole birth-year period of 1500 to 1875 was split into four fifty-year intervals

(for 1500 to 1700), five twenty-five-year intervals (1700 to 1825) and ten five-year intervals (after 1825) presented by binary (0–1) variables with the reference level set at 1870–1874 birth years.

2. female life span (the key variable of this study aimed to explore the effects of female life span on childlessness). The female life span data were grouped into eight ten-year intervals with the exception of the first (< 20 years) and the last (≥ 90 years) intervals, which had a small number of observations. The data were coded as dummy variables with the reference level set at 50 to 59 years for female life span.

3. female (wife's) age at marriage. This variable is used to control for possible confounding effects of female age on probability of being childless. Age at marriage is the most important explanatory variable both for the number of progeny and for the age at first childbirth (Knodel 1988). For example, it is well known in historical demography that the mean number of progeny in the past was about eight children for women married at age 20 to 24, and only two children for women married at age 35 to 39 (Knodel 1988). For this reason, if the data are not adjusted for the age at marriage (age when the births of legitimate children start), the analysis of the number of progeny in humans can be seriously compromised. In our study, the female age-at-marriage data were grouped into six five-year intervals with the exception of the first (< 20 years) and the last (≥ 40 years) intervals, which had a small number of observations. The data were coded as dummy variables with the reference level set at 20 to 24 years old for wife's age at marriage.

4. male (husband's) age at marriage. This is a second fundamental predictor variable for the number of offspring (a proxy for husband's fertility). If the husband is ten or more years older than the wife, the number of births may be twice as low compared to a situation where the husband is younger than the wife (Knodel 1988). This variable is used to control for possible confounding effects of the husband's age on the probability of being childless. The husband's age-at-marriage data were grouped into seven five-year intervals with the exception of the first (< 20 years) and the last (≥ 45 years) intervals, which had a small number of observations. The data were coded as dummy variables with the reference level set at 20 to 24 years old for husband's age at marriage.

5. male (husband's) life span. This variable controls for duration of marriage dependent on spousal death. The data were grouped and coded in the same way as female (wife's) life span.

6. nationality. The nationality of the individual is represented by three categories: British, French, and other European nationalities. The group of "other'" nationalities (mostly Germans) was the reference group.

## Results and Discussion

The results of the univariate analyses of childlessness are presented in tables 3.1 and 3.2. Table 3.1 shows the historical distribution of childless women in our sample of women belonging to the European upper nobility. The data demonstrate a gradual decline of childlessness over time among aristocratic women. Similar trends were observed in the eighteenth and nineteenth century for the British peerage (Hollingsworth 1957, 1964) and during the first half of the twentieth century in France (Toulemon 1996); these trends may reflect an improvement of reproductive health over time.

Table 3.2 presents the distribution of childlessness as a function of female life span. Data obtained by other researchers are presented in the same table for comparison. Note the unrealistically high proportion of childless women in the data published by Westendorp and Kirkwood (1998). On the other hand, data by Lycett, Dunbar, and Voland (2000) as well as our data for aristocratic women are consistent with each other and do not demonstrate any increase in childlessness for long-lived women.

The results presented so far were obtained using univariate analyses, which do not take into account important confounding variables described earlier. In order to study the "true" relationship between childlessness and longevity, we need to take into account these other confounding variables. We applied multivariate logistic regression with childlessness as a dependent

**Table 3.1** Reproductive and lifespan characteristics of married women in a historical dataset used in this study. Data on European aristocratic women with high nobility rank born in 1500–1875.

| Birth cohort (Birth-year range) | Average number of progeny | Proportion of childless women | Mean age at death, years | Sample size, number of cases |
|---|---|---|---|---|
| 1501–1550 | 6.00 ± 0.48 | 0.24 | 52.58 ± 1.62 | 111 |
| 1551–1600 | 5.21 ± 0.34 | 0.21 | 51.10 ± 1.21 | 185 |
| 1601–1650 | 5.19 ± 0.33 | 0.16 | 52.52 ± 1.11 | 220 |
| 1651–1700 | 4.53 ± 0.25 | 0.20 | 53.21 ± 1.09 | 302 |
| 1701–1725 | 5.07 ± 0.33 | 0.13 | 53.21 ± 1.41 | 165 |
| 1726–1750 | 5.07 ± 0.31 | 0.13 | 57.85 ± 1.52 | 171 |
| 1751–1775 | 4.50 ± 0.23 | 0.13 | 56.23 ± 1.23 | 234 |
| 1776–1800 | 4.12 ± 0.17 | 0.14 | 60.41 ± 1.09 | 346 |
| 1801–1825 | 3.88 ± 0.14 | 0.11 | 63.52 ± 0.89 | 475 |
| 1826–1850 | 3.85 ± 0.11 | 0.07 | 66.50 ± 0.71 | 666 |
| 1851–1875 | 3.48 ± 0.09 | 0.10 | 69.80 ± 0.61 | 848 |
| Total | 4.25 ± 0.06 | 0.13 | 61.59 ± 0.32 | 3,723 |

**Table 3.2** Proportion of childlessness by women's age at death. Comparison of our data set with similar data for the historical German population (Lycett et al. 2000) and data for the British aristocracy (Westendorp and Kirkwood 1998).

| Age at death, years | Proportion of childless women in different datasets | | |
|---|---|---|---|
| | Gavrilovs dataset on European upper nobility | Lycett et al. (2000), German data | Westendorp and Kirkwood (1998), British aristocracy |
| 20–29 | 0.17 | 0.15 | 0.39 |
| 30–39 | 0.10 | 0.08 | 0.26 |
| 40–49 | 0.14 | 0.08 | 0.31 |
| 50–59 | 0.13 | 0.11 | 0.28 |
| 60–69 | 0.12 | 0.09 | 0.33 |
| 70–79 | 0.10 | 0.09 | 0.31 |
| 80–89 | 0.15 | 0.10 | 0.45 |
| 90+ | 0.12 | — | 0.49 |

binary variable and calendar year of birth, female age at marriage, male age at marriage, female life span, and male life span as predictor variables.

The main result of our study is shown in figure 3.1. This figure presents the odds of being childless as a function of female life span, adjusted for other important confounding variables. The odds of childlessness are particularly high when women's life span is short (< 30 years), which is not surprising. What is important is that the chances of being childless do not demonstrate a statistically significant increase among long-lived women (life span > 90 years). This result confirms the findings from our univariate analyses (table 3.2) as well as from other studies (Lycett, Dunbar, and Voland 2000; Korpelainen 2000) that demonstrated that long-lived women do not have a higher rate of childlessness even when controlling for other important confounding variables.

Figure 3.2 demonstrates the chances of a married couple being childless as a function of the husband's life span. As in the previous case, the chances for a couple to be childless are particularly high when husband's life span is short (< 40 years), which again is not surprising. What is interesting is that the odds of childlessness do not increase for longer-lived males, including nonagenarians (life span > 90 years). Thus, both males and females with high longevity do not demonstrate any signs of impaired fertility, contrary to some previous reports (Westendorp and Kirkwood 1998).

We also found the women's age at marriage to be a significant predictor of childlessness. The odds ratio for childlessness is five times higher for women married at ages 35 to 40 years compared to early-married women

**Figure 3.1** Childlessness odds ratio as a function of female life span. Net effects are adjusted for female calendar year of birth, female age at marriage, husband's life span, and husband's age at marriage. Multivariate regression analysis of 3,723 European aristocratic families.

**Figure 3.2** Childlessness odds ratio as a function of husband's life span. Net effects are adjusted for female calendar year of birth, female life span, female age at marriage, and husband's age at marriage. Multivariate regression analysis of 3,723 European aristocratic families.

(ages 20 to 25 years). Our results also demonstrate the importance of the husband's age at marriage as a significant predictor of couple childlessness. In particular, the trend of rising infertility with age of husband starts as early as at 25 years old for men. The odds ratio for childlessness is twice as high when the husband's age at marriage is 35 to 40 years compared to early-married husbands (at ages 20 to 25 years). These data demonstrate that a husband's age of marriage cannot be ignored in studies of human fertility.

The finding that a woman's age at marriage has a tremendous effect on the chances of being childless is in accord with common sense and many other observations. The importance of a husband's age at marriage is less obvious, and it is particularly intriguing that some loss of fertility starts so early in men's life—at age 25 years. In early studies of human reproduction, the husband's age at marriage was considered an unimportant variable in fertility determination (Freeman 1935). However, our results demonstrate that a decline in fertility with husband's age starts very early and progresses rapidly. It is known that mutation rates in male germ cells are much higher than in female ova cells (Crow 1997, 2000; Gavrilov and Gavrilova 2000), and this rapid accumulation of mutation load with age may contribute to an age-related increase in male infertility. It is clear that ignoring such important variables as the age at marriage for each spouse would compromise any scientific study of human fertility no matter how carefully planned and analyzed are other aspects of the study.

Our study does not support the concept that human longevity comes at the cost of infertility. This conclusion may have both theoretical significance (testing some evolutionary theories of aging) as well as practical implications for the future of life extension. It helps relax concerns over the question of whether it is morally acceptable to extend human longevity at the cost of infertility. Specifically, our findings do not support the prediction that "the next generations of *Homo sapiens* will have even longer life spans but at the cost of impaired fertility" (Westendorp 2004). Some authors have already raised concerns on the unintended consequences of life span extension: "increasing longevity through genetic manipulation of the mechanisms of aging raises deep biological and moral questions. These questions should give us pause before we embark on the enterprise of extending our lives" (Glannon 2002). This study helps alleviate some concerns on these issues.

## Conclusions

We have tested the prediction of some evolutionary theories of aging that exceptional human longevity should come with a high cost of infertility. To this aim, we collected particularly accurate genealogical data for the upper

European nobility that were cross-checked against multiple data sources. We found no increase in the proportion of childlessness among long-lived women and men. Thus our study does not support the concept that human longevity comes at a high cost of infertility. Previous reports of high rates of childlessness among long-lived women (Westendorp and Kirkwood 1998) are likely to be an artifact of data incompleteness caused by underreporting of children in the analyzed data set, as revealed in previous studies (see Gavrilova and Gavrilov 1999; Gavrilov and Gavrilova 2002; Doblhammer and Oeppen 2003; Gavrilova et al. 2004). Our finding is also consistent with the results of earlier studies (Beeton, Yule, and Pearson 1900; Freeman 1935; Henry 1956, 1963; Bideau 1986; Knodel 1988; Le Bourg et al. 1993) as well as recent publications (Costa, Luzza, and Mattace 2000; Gudmundsson et al. 2000; Müller et al. 2002) that demonstrated that exceptional human longevity is not associated with impaired fertility.

It is important now to revise a highly publicized scientific concept of heavy reproductive costs for human longevity and to make corrections in related teaching curriculums for students. It is also important to disavow the concerns over further extension of human life span that were recently voiced in biomedical ethics because of acceptance of the idea of harmful side effects of life span extension, including infertility (Glannon 2002).

There is little doubt that the number of children can affect human longevity through complications of pregnancy and childbearing, through economic costs of childbearing and changes in socioeconomic status, and so forth. However, the concept of heavy infertility cost in exchange for human longevity is not supported by data, when these data are carefully cleaned and cross-checked to ensure their completeness and accuracy. Our finding that there is no infertility cost for human longevity makes it easier to study and interpret the grandmaternal effects on offspring survival and reproduction because these effects are not confounded by longevity-infertility relationships for individuals. This helps to straighten out the interpretation of numerous important studies on the effects of grandmothers on grandchildren survival and reproductive success (Voland 1998; Hawkes 1998, 2004; Sear, Mace, and McGregor 2000; Voland and Beise 2002; Lahdenperä et al. 2004).

## Acknowledgments

This study was inspired by scientific discussion of our presentation at the international conference "Grandmothers: The Psychological, Social, and Reproductive Significance of the Second Half of Life" (Hanse Institute for Advanced Science, Delmenhorst, Germany, September 19–21, 2002). We are grateful to Drs. Eckart Voland, Athanasios Chasiotis, Wulf Schiefenhövel,

Gerhard Roth, and other participants in this conference for encouraging and useful discussion of presented ideas and findings. We are most grateful to Victoria G. Semyonova and Galina N. Evdokushkina for their assistance in computerization of the genealogical data for this study. This study was made possible thanks to partial support from the National Institute on Aging (NIH, USA) and a stimulating working environment at the Center on Aging, NORC/University of Chicago.

## References

Abbott, A. 2004. "Ageing: Growing old gracefully." *Nature* 428:116–18.

Aldrich, J. H., and F. D. Nelson. 1984. *Linear Probability, Logit, and Probit Models.* Beverly Hills: Sage.

Beeton, M., and K. Pearson. 1899. "Data for the problem of evolution in man, II: A first study of the inheritance of longevity and the selective death rate in man." *Proceedings of the Royal Society of London* 65: 290–305.

———. 1901. "On the inheritance of the duration of life and the intensity of natural selection in man." *Biometrika* 1:50–89.

Beeton, M., G. U. Yule, and K. Pearson. 1900. "Data for the problem of evolution in man. V. On the correlation between duration of life and the number of offspring." *Proceedings of the Royal Society of London* 67:159–79.

Bell, A. G. 1918.*The Duration of Life and Conditions Associated with Longevity: A Study of the Hyde Genealogy.* Washington, DC: Genealogical Records Office.

Bernier, M. O., G. Plu-Bureau, N. Bossard, L. Ayzac, and J. C. Thalabard. 2000. "Breastfeeding and risk of breast cancer: a meta-analysis of published studies." *Human Reproduction Update* 6:374–86.

Bideau, A. 1986. "Fécondité et mortalité après 45 ans. L'apport des recherches en démographie historique." *Population* 41:59–72.

Breslow, N. E., and N. E. Day. 1980. *Statistical Methods in Cancer Research*, vol. 1, *The Analysis of Case-Control Studies.* IARC Scientific Publ. No. 32. Lyon, France: IARC.

Costa, M.C., F. Luzza, and R. Mattace. 2000. "Centenarians at no cost of reproductive success." *Age and Ageing* 29:373–74.

Crow, J. F. 1997. "The high spontaneous mutation rate: Is it a health risk?" *Proceedings of the National Academy of Sciences, USA* 94:8380–86.

———. 2000. "The origins, patterns, and implications of human spontaneous mutation." *Nature Review Genetics* 1:40–47.

Doblhammer, G., and J. Oeppen. 2003. "Reproduction and longevity among the British peerage: The effect of frailty and health selection." *Proceedings of the Royal Society of London* 270:1541–47.

Dribe, M. 2004. "Long-term effects of childbearing on mortality: Evidence from pre-industrial Sweden." *Population Studies* 58:297–310.

Fogel, R. W. 1993. "New sources and new techniques for the study of secular trends

in nutritional status, health, mortality, and the process of aging." *Historical Methods* 26:5–43.

Freeman, B. C. 1935. "Fertility and longevity in married women dying after the end of the reproductive period." *Human Biology* 7:392–418.

Gautier, E., and L. Henry. 1958. "La population de Crulai paroisse normande: Étude historique." *Travaux et documents, Cahier n° 33*. Paris: INED.

Gavrilov, L. A., and N. S. Gavrilova. 1991. *The Biology of Life Span: A Quantitative Approach.* New York: Harwood Academic Publishers.

———. 1997. "When fatherhood should stop?" *Science* 277:17–18.

———. 1998. "Inventory of Data Resources on Familial Aggregation of Human Longevity That Can Be Used in Secondary Analysis in Biodemography of Aging." Bethesda: National Institute on Aging. NIA Professional Service Contract #263 SDN74858.

———. 1999a. "Is there a reproductive cost for human longevity?" *Journal of Anti-Aging Medicine* 2: 121–23.

———. 1999b. "Season of birth and human longevity." *Journal of Anti-Aging Medicine* 2:365–66.

———. 2000. "Human longevity and parental age at conception." In *Sex and Longevity: Sexuality, Gender, Reproduction, Parenthood,* ed. J.-M. Robine, T. B. L. Kirkwood, and M. Allard. Berlin: Springer-Verlag, 7–31.

———. 2001. "Biodemographic study of familial determinants of human longevity." *Population, English Selection* 13:197–222.

———. 2002. "Evolutionary theories of aging and longevity." *Scientific World Journal* 2:339–56. http://www.thescientificworld.com/.

———. 2003. "Early-life factors modulating lifespan." In *Modulating Aging and Longevity,* ed. S. I. S. Rattan. Dordrecht, Netherlands: Kluwer Academic Publishers, 27–50.

———. 2004. "Early-life programming of aging and longevity: The idea of high initial damage load (the HIDL hypothesis)." *Annals of the New York Academy of Sciences* 1019:496–501.

Gavrilov, L. A., N. S. Gavrilova, V. N. Kroutko, G. N. Evdokushkina, V. G. Semyonova, A. L. Gavrilova, E. V. Lapshin, N. N. Evdokushkina, and Yu E. Kushnareva. 1997. "Mutation load and human longevity." *Mutation Research* 377:61–62.

Gavrilov, L. A., N. S. Gavrilova, S. J. Olshansky, and B. A. Carnes. 2002. "Genealogical data and biodemography of human longevity." *Social Biology* 49:160–73.

Gavrilova, N. S., and L. A. Gavrilov. 1999. "Data resources for biodemographic studies on familial clustering of human longevity." *Demographic Research* [Online] 1:1–48. http://www.demographic-research.org/Volumes/Vol1/4/default.htm.

———. 2001. "When does human longevity start? Demarcation of the boundaries for human longevity." *Journal of Anti-Aging Medicine* 4:115–24.

Gavrilova, N. S., L. A. Gavrilov, G. N. Evdokushkina, and V. G. Semyonova. 2003. "Early-life predictors of human longevity: Analysis of the nineteenth century birth cohorts." *Annales de Démographie Historique* 2:177–98.

Gavrilova, N. S., L. A. Gavrilov, G. N. Evdokushkina, V. G. Semyonova, A. L. Gavrilova, N. N. Evdokushkina, Yu E. Kushnareva, V. N. Kroutko, and A. Y. Andreyev. 1998. "Evolution, mutations and human longevity: European royal and noble families." *Human Biology* 70:799–804.

Gavrilova, N. S., L. A. Gavrilov, V. G. Semyonova, and G. N. Evdokushkina. 2004. "Does exceptional human longevity come with high cost of infertility? Testing the evolutionary theories of aging." *Annals of the New York Academy of Sciences* 1019:513–17.

Glannon, W. 2002. "Extending the human life span." *Journal of Medicine and Philosophy* 27:339–54.

Glass, D. V. 1963. "Aspects biologiques de la fecondite: Discussion." *Proceedings of the Royal Society of London* 159:89–93.

Gudmundsson, H., D. F. Gudbjartsson, A. Kong, H. Gudbjartsson, M. Frigge, J. R. Gulcher, and K. Stefansson. 2000. "Inheritance of human longevity in Iceland." *European Journal of Human Genetics* 8:743–749.

Hawkes, K. 1998. "Grandmothers and the evolution of human longevity." *American Journal of Human Biology* 15:380–400.

———. 2004. "Human longevity: the grandmother effect." *Nature* 428: 128–29.

Henry, L. 1956. "Anciennes familles genovoises: Étude démographique, XVIe–XXe siècle." *Travaux et documents, Cahier n° 26*. Paris: INED.

———. 1963. "Aspects biologiques de la fecondité." *Proceedings of the Royal Society of London* 159:81–89.

Hollingsworth, T. H. 1957. "A demographic study of the British ducal families." *Population Studies* 11:4–26.

———. 1964. "The demography of the British peerage." *Population Studies* (suppl.) 18: 3–107.

———. 1969. *Historical Demography*. Ithaca, NY: Cornell University Press.

Hosmer, D. W., and S. Lemeshow. 1989. *Applied Logistic Regression*. New York: Wiley and Sons.

Jacobsen, B. K., I. Heuch, and G. Kvale. 2003. "Age at natural menopause and all-cause mortality: A thirty-seven-year follow-up of 19,731 Norwegian women." *American Journal of Epidemiology* 157:923–29.

Kasakoff, A. B., and J. W. Adams. 1995. "The effect of migration on ages at vital events: A critique of family reconstitution in historical demography." *European Journal of Population* 11:199–242.

Kirkwood, T. B. L. 2002. "Evolution of aging." *Mechanisms of Ageing Development* 123:737–45.

Kirkwood, T. B. L., and R. Holliday. 1979. "The evolution of ageing and longevity." *Proceedings of the Royal Society of London.B* 205:531–46.

Knodel, J. E. 1988. *Demographic Behavior in the Past*. New York: Cambridge University Press.

Korpelainen, H. 2000. "Fitness, reproduction, and longevity among European aristocrats and rural Finnish families in the 1700s and 1800s." *Proceedings of the Royal Society of London.B* 267:1765–70.

———. 2003. "Human life histories and the demographic transition: A case study from Finland, 1870–1949." *American Journal of Physical Anthropology* 120: 384–90.
Kumle, M., and E. Lund. 2000. "Patterns of childbearing and mortality in Norwegian women: A twenty-year follow-up of women aged 40–96 in the 1970 Norwegian census." In *Sex and Longevity: Sexuality, Gender, Reproduction, Parenthood*, ed. J.-M. Robine et al. Berlin: Springer-Verlag, 117–28.
Lahdenperä, M., V. Lummaa, S. Helle, M. Tremblay, and A. F. Russell. 2004. "Fitness benefits of prolonged post-reproductive lifespan in women." *Nature* 428: 178–81.
Le Bourg, E., B. Thon, J. Legare, B. Desjardins, and H. Charbonneau. 1993. "Reproductive life of French-Canadians in the 17–18th centuries: A search for a trade-off between early fecundity and longevity." *Experimental Gerontology* 28: 217–32.
Ligtenberg, T., and H. Brand. 1998. "Longevity: Does family size matter?" *Nature* 396: 743–46.
Lummaa, V. 2003. "Early developmental conditions and reproductive success in humans: Downstream effects of prenatal famine, birthweight, and timing of birth." *American Journal Human Biology* 15: 370–79.
Lycett, J. E., R. I. M. Dunbar, and E. Voland. 2000. "Longevity and the cost of reproduction in a historical human population." *Proceedings of the Royal Society of London* 267: 31–35.
Meister, K., and J. Morgan. 2000. *Risk Factors for Breast Cancer*. New York: American Council on Science and Health.
Müller, H. G., J. M. Chiou, J. R. Carey, and J. L. Wang. 2002. "Fertility and life span: Late children enhance female longevity." *Journals of Gerontology Series A: Biological Sciences and Medical Sciences* 57: B202–B206.
Perls, T. T., L. Alpert, and R. C. Fretts. 1997. "Middle-aged mothers live longer." *Nature* 389: 133.
Perls, T., R. Levenson, M. Regan, and A. A. Puca. 2002. "What does it take to live to 100?" *Mechanisms of Ageing Development* 123: 231–42.
Pope, C. L. 1992. "Adult mortality in America before 1900: A view from family histories." In *Strategic Factors in Nineteenth Century American Economic History. A Volume to Honor Robert W. Fogel*, ed. C. Goldin and H. Rockoff. Chicago: University of Chicago Press, 267–96.
Post, W., F. Van Poppel, E. Van Imhoff, and E. Kruse. 1997. "Reconstructing the extended kin-network in the Netherlands with genealogical data: Methods, problems, and results." *Population Studies* 51: 263–78.
Powys, A. O. 1905. "Data for the problem of evolution in man: On fertility, duration of life, and reproductive selection." *Biometrika* 4: 233–85.
Sear R., R. Mace, and I. A. McGregor. 2000. "Maternal grandmothers improve nutritional status and survival of children in rural Gambia." *Proceedings of the Royal Society of London.B* 267: 1641–47.
Skolnick, M., L. L. Bean, S. M. Dintelman, and G. Mineau. 1979. "A computerized family history data base system." *Sociology and Social Research* 63: 506–23.

Toulemon, L. 1996. "Very few couples remain voluntarily childless." *Population: An English Selection* 8:1–27.

Van Hueck W., ed. 1951–1991. *Genealogisches Handbuch der Fürstlichen Häuser*, vol. 1 of *Genealogisches Handbuch des Adels*. Limburg an der Lahn, Germany: C. A. Starke Verlag.

———. 1952–1993. *Genealogisches Handbuch der Gräflichen Häuser*, vol. 2 of *Genealogisches Handbuch des Adels*. Limburg an der Lahn, Germany: C. A. Starke Verlag.

———. 1954–1994. *Genealogisches Handbuch der Freiherrlichen Häuser*, vol. 4 of *Genealogisches Handbuch des Adels*. Limburg an der Lahn, Germany: C. A. Starke Verlag.

———. 1953–1992. *Genealogisches Handbuch der Adeligen Häuser*, vol. 5 of *Genealogisches Handbuch des Adels*. Limburg an der Lahn, Germany: C. A. Starke Verlag.

Voland, E. 1998. "Evolutionary ecology of human reproduction." *Annual Review of Anthropology* 27:347–74.

Voland, E., and J. Beise. 2002. "Opposite effects of maternal and paternal grandmothers on infant survival in historical Krummhörn." *Behaviour Ecology and Sociobiology* 52: 435–43.

Westendorp, R. G. J. 2002. "Leiden research program on aging." *Experimental Gerontology* 37:609–14.

———. 2004. "Are we becoming less disposable?" *EMBO Reports* 5:2–6.

Westendorp, R. G. J., and T. B. L. Kirkwood. 1998. "Human longevity at the cost of reproductive success." *Nature* 396:743–46.

———. 1999. "Longevity: Does family size matter? Reply." *Nature* 399:522–22.

Williams, G. C. 1957. "Pleiotropy, natural selection, and the evolution of senescence." *Evolution* 11: 398–411.

# CHAPTER 4

# Grandmothers, Politics, and Getting Back to Science
Chris Knight and Camilla Power

Nineteenth-century anthropologists widely agreed that early human society was not based on the nuclear family. Instead, Lewis Henry Morgan argued for the priority of the matrilineal clan—a view that came to be shared by E. B. Tylor, Friedrich Engels, A. C. Haddon, W. H. R. Rivers, Emile Durkheim, and Sigmund Freud. For several decades, most scholars accepted a "stages" view of the evolution of kinship, in which descent through females universally preceded patrilineal inheritance.

Early in the twentieth century, Morgan's evolutionist paradigm came under vehement attack. The modern schools of cultural anthropology in the United States and of social anthropology in Britain were formed out of this process. We can document the extent to which pro-family, anti-communist ideology overrode scholarship in determining the outcome of these debates. This political intervention was historically significant, since it lies at the root of the division between the social/cultural and evolutionary branches of anthropology. Throughout most of the twentieth century, evolutionary processes were disallowed as legitimate areas of study by social and cultural anthropologists. This has led to our present position of divorce in the discipline, with anthropologists on either side of the divide knowing lamentably little of one another's work.

Recent work in evolutionary anthropology has produced two models of the evolution of human life history—the "grandmother" hypothesis (O'Connell, Hawkes, and Blurton Jones 1999) and the "diet, intelligence, and longevity" model (Kaplan et al. 2000). In the second part of our chapter, we evaluate these in historical and political perspective. The recent emergence of the grandmother hypothesis compels us to return to the issue of "matrilineal priority." Critics of the grandmother model (for example, Kennedy 2003) routinely attack it on the basis that it presupposes female philopatry, in contrast to the male philopatry still dogmatically accepted as the prevailing situation throughout human evolution (for example, Foley and Lee 1989; Rodseth et al. 1991). Are these opponents merely revisiting old ideological battlegrounds, respectively debunking and defending the evolutionary centrality of the nuclear family? Or do they offer us the pros-

pect of reintegrating the split discipline of anthropology on a basis that owes more to science than to politics?

## The Discovery of Matriliny: Bachofen, Morgan, and Mother-Right

Matrilineal exogamy was first accurately described in print by an early English adventurer, John Lederer, who published an account of his travels in eastern North America in 1672 (Lederer 1672, 4–5). Fifty-two years later, Father Lafitau (1724, 1:71–72) described in glowing terms the honored status of women among the matrilineally organized Iroquois. Scottish historian Adam Ferguson (1819 [1767], 126) remarked of "savage nations" in general that the "children are considered as pertaining to the mother, with little regard to descent on the father's side."

The Swiss jurist and historian Johann Jakob Bachofen drew on ancient Greek sources to argue that "mother right is not confined to any particular people but marks a cultural stage" (1973 [1861], 71). The legal historian J. F. McLennan read Bachofen's book in 1866, after publishing his *Primitive Marriage*, which independently proposed "kinship through females" as the "more archaic system" (1865, 123). Most prominent in supporting Bachofen, however, was American business lawyer Lewis Henry Morgan, who researched matriliny among the Iroquois and other Native Americans. Describing an Iroquois longhouse, Morgan wrote of the common stores and "the matron in each household, who made a division of the food from the kettle to each family according to their needs." Here, he commented, "was communism in living carried out in practical life." In such households, he concluded, "was laid the foundation for that 'mother-power' which was even more conspicuous in the tribes of the Old World, and which Professor Bachofen was the first to discuss under the name of gyneocracy and mother-right" (1881, 126–28).

Engels elaborated Morgan's findings in *The Origin of the Family, Private Property, and the State* (1972 [1884]). "The rediscovery of the original mother-right gens," he wrote, ". . . has the same significance for the history of primitive society as the theory of evolution has for biology, and Marx's theory of surplus value for political economy." He continues, "The mother-right gens has become the pivot around which this entire science turns" (1972 [1884], 36). This was no hasty judgement. From their earliest days in revolutionary struggle, Marx and Engels had been wrestling with questions about sex as well as class. In 1844, Marx wrote that the "immediate, natural and necessary relationship of human being to human being is the relationship of man to woman," adding that "from this relationship the whole cultural level of man can be judged" (2000 [1844], 96). Marx took Morgan's

work on the matrilineal clan as confirmation that primitive communism preceded property-based class society and that its secret had been sexual equality. In *The German Ideology,* Marx and Engels contrasted this with the subsequent dominance of "property, the nucleus, the first form, of which lies in the family, where wife and children are the slaves of the husband" (2000 [1846], 185).

Morgan recognized that the transition to patriliny rested on the isolation of women from one another in the husband's home, reversing "the position of the wife and mother in the household" (1881, 128). Engels added political impact to this idea: "The overthrow of mother right was the *world-historic defeat of the female sex.* The man seized the reins in the house also, the woman was degraded, enthralled, the slave of the man's lust, a mere instrument for breeding children" (1972 [1884], 68; emphasis in original). He continued, "The first class antagonism which appears in history coincides with the development of the antagonism between man and woman in monogamian marriage, and the first class oppression with that of the female sex by the male" (1972 [1884], 75).

## Revolution and Counterrevolution in Evolutionary Science

Around the turn of the century, virtually all those who had helped found the discipline of anthropology converged around the fundamentals of the Bachofen-Morgan theory. As G. P. Murdock subsequently observed, the "extremely plausible" arguments in its favor included inferences about paternity uncertainty, the biological inevitability of the mother-child bond, and, above all, numerous apparent survivals of matrilineal traditions in patrilineal societies. The logic of the hypothesis was so compelling, wrote Murdock, "that from its pioneer formulation by Bachofen in 1861 to nearly the end of the nineteenth century it was accepted by social scientists practically without exception" (1949, 185).

What, then, changed everyone's mind? Once Engels' inflammatory formulations in *The Origins of the Family* had become a manifesto of proletarian struggle, no one could write neutrally on these subjects any more. Today, social anthropologists assume that the matriliny hypothesis was falsified on scholarly grounds. The evidence is that politics played the decisive role. Morgan's *Ancient Society* (1877), as Robert Lowie documents in his history of the period, "attracted the notice of Marx and Engels, who accepted and popularized its evolutionary doctrines as being in harmony with their own philosophy. As a result it was promptly translated into various European tongues, and German workingmen would sometimes reveal an uncanny familiarity with the Hawaiian and Iroquois mode of designating kin, matters not obviously connected with a proletarian revolution" (1937, 54–55).

Thanks to Engels' endorsement, Morgan's theory was destined to become a casualty of the central conflict of the age. Twentieth-century social and cultural anthropologists often imagine their discipline to have been shaped in its modern form quite independently of Marxism. It would be more accurate to describe it as shaped in reaction against Marxism. "With Morgan's scheme incorporated into Communist doctrine," observes Marvin Harris, "the struggling science of anthropology crossed the threshold of the twentieth century with a clear mandate for its own survival and well-being: expose Morgan's scheme and destroy the method on which it was based" (1969, 249).

A widespread consensus developed on both sides of the Atlantic that whether or not Morgan's paradigm was wrong, it was too dangerous to be allowed. An early 1930s radio broadcast by Bronislaw Malinowski revealed his state of mind:

> A whole school of anthropologists, from Bachofen on, have maintained that the maternal clan was the primitive domestic institution.... In my opinion, as you know, this is entirely incorrect. But an idea like that, once it is taken seriously and applied to modern conditions, becomes positively dangerous. I believe that the most disruptive element in the modern revolutionary tendencies is the idea that parenthood can be made collective. If once we came to the point of doing away with the individual family as the pivotal element of our society, we should be faced with a social catastrophe compared with which the political upheaval of the French revolution and the economic changes of Bolshevism are insignificant. The question, therefore, as to whether group motherhood is an institution which ever existed, whether it is an arrangement which is compatible with human nature and social order, is of considerable practical interest. (1956, 76)

Malinowski declared, "I would rather discountenance any speculation about the 'origins' of marriage or anything else than contribute to them even indirectly" (1932: xxiii–xxiv). Despite this, Malinowski's mission statement was to "prove to the best of my ability that marriage and the family have been, are, and will remain the foundations of human society" (1956, 28). He argued that "marriage in single pairs—monogamy in the sense in which Westermarck and I are using it—is primeval" (1956, 42). Note Malinowski's tactic of denouncing origins research while specifying in advance its outcome.

In the United States, Franz Boas and his students were worried by Social Darwinism as much as by Bolshevism, launching a trend in American liberal circles in which these threats were deliberately linked. According to Lowie (1960 [1946], 418), Boas had initially supported matrilineal priority. This was understandable since, as Murdock later explained, there was a "complete lack of historically attested, or even inferentially probable, cases of a direct transition from patrilineal to matrilineal descent" (1949, 190). In

Murdock's opinion, this was the most difficult obstacle to destroying the matrilineal priority theory. A single exception was needed to undermine Morgan's scheme.

Boas came up with the Kwakiutl. This group had once been patrilineal, he claimed, but had adopted matriliny from coastal neighbors, disproving Morgan's understanding of the necessary directionality (Boas 1897, 334–35). Subsequently, Boas's student Robert Lowie admitted that although "the Kwakiutl facts are very interesting, it is highly doubtful whether they have the theoretical significance ascribed to them" (1960 [1914], 28). The Kwakiutl *numaym* discussed by Boas were neither exogamous nor matrilineal. However, Lowie's admission did not prevent Boas and his students from disseminating the myth. As Marvin Harris summed up the episode: "On the basis of this one drastically deficient case, there gradually diffused out of Schermerhorn Hall at Columbia, through lecture, word of mouth, article and text, the unquestioned dogma that Boas had proved that it was just as likely that patrilineality succeeded matrilineality as the reverse" (1969, 305).

Lowie's seminal books *Primitive Society* (1920) and *The Origin of the State* (1927) were written with the express purpose of discrediting the notion of "primitive communism," claiming private property and the state to be universals of all human societies. Another student of Boas, John Swanton (1905) actually inverted Morgan's stages, arguing that bilateral (nuclear family) and patrilineal forms of social organization were more primitive than matrilineal ones. This became established dogma within American anthropology (Murdock 1949, 189).

Across the Atlantic, a parallel assault on Morgan was launched when A. R. Radcliffe-Brown (1924) published his celebrated article on the "mother's brother." His target was a comprehensive monograph on the Thonga of Mozambique (Junod 1912). Details of the avunculate in this culture had led Junod to conclude that the Thonga were neither simply matrilineal nor patrilineal—they were in a transitional stage. Radcliffe-Brown proposed an alternative explanation. Brother-sister unity, he argued, has no necessary connection with matriliny. It is just a universal sociological principle. This led him to his punch line: given emotional solidarity between brother and sister, it is psychologically inevitable that any "sentiments" felt by a child toward its mother will be "extended" to her brother as well.

Radcliffe-Brown's sleight of hand was to invoke brother-sister solidarity as if this could be dissociated from matriliny. Schneider (1961) reiterated the central logical insight that Radcliffe-Brown's circumlocutions were designed to obfuscate. Feelings of mutual solidarity may indeed characterize the brother-sister relationship. But that does not make the unit of brother and sister central to social structure. Sibling solidarity of an intensity sufficient to survive the rival pressure of marital obligation is by no means a "univer-

sal sociological principle." On the contrary, these are variables—choices between alternative strategies. When a woman marries, any new loyalty to her husband can only be at the expense of her former loyalty to natal kin. Where the husband wins out, a wife must in effect surrender her reproductive future to him and his kin—her children will belong to them. Let us suppose, however, that after marriage, a woman continues to prioritize her brother and other kin at her husband's expense. To follow that principle consistently would be to assert the primacy of matrilineal as opposed to patrilineal descent.

Murdock's (1959, 378) research on the Thonga confirmed they were indeed in the throes of transition from matriliny to patriliny—as Junod had originally claimed. In essential conformity with Morgan's scheme, the rise of alienable property may be the crucial factor cementing marital bonds at the expense of brother-sister solidarity throughout much of sub-Saharan Africa. As David Aberle (1961, 680) put it, "the cow is the enemy of matriliny." Following in the footsteps of Murdock's cross-cultural comparative work, Mace and Holden's (1999) phylogenetically controlled analysis confirmed a negative correlation between African matriliny and cattle owning. In their most recent analysis of matriliny as daughter-biased investment, Holden, Sear, and Mace comment, "the two factors Morgan identified, heritable wealth and paternity uncertainty, remain central to our understanding of variation in matriliny and patriliny in human social organisation" (2003, 110).

## The Effect on Paleoanthropology in the Twentieth Century

Subsequent to the fraudulent claims of the leaders of American cultural and British social anthropology, theories based on evolutionary stages were held to be "dead as mutton" (Evans-Pritchard 1965, 100). Except in the Soviet Union (where it became incorporated into state dogma), matrilineal priority was effectively suppressed. By the mid-1930s, it had become institutionally impossible to reopen the debate.

So where did this leave palaeoanthropology and evolutionary theory? Morgan's work on the matrilineal clan had led such influential thinkers as Engels, Freud, and Durkheim to argue for fundamental discontinuity between primate and human social organization. Classificatory kinship, exogamy, totemic avoidances—these things needed explanation in any account of human origins. The main effect of the suppression of Morgan's work was to sideline social anthropology's distinctive scholarly contribution to evolutionary science. From this point on, the two branches of anthropology were hardly on speaking terms. As a result, Darwinians were handicapped with profound ignorance of variability in kinship systems around the world and their historic development.

By default, as a gradualist theory, Darwinism assumes continuity between primate and human life. Drawing on the primatology of his day, Darwin himself had pictured primeval man as a sexual tyrant jealously guarding his hard-won harem of females to the exclusion of local male rivals (1871, 2:362). After World War II, populist writers on human evolution felt licensed to weave narratives free of all ethnographic constraint. "Naked ape" theory (Morris 1967) connected extant primates directly to the pair-bonding preoccupations of contemporary Western culture. Eurocentrism was the inevitable result, as middle-class English family values became scientifically naturalized and projected into the evolutionary past. This trend continues today as U.S. college campus lifestyles are reflected in the literature produced by evolutionary psychology (for example, Ellis and Symons 1990; Kenrick et al. 1990). Even where surveys of sexual preferences have aimed to collect cross-cultural data (for example, Buss 1989), propertied societies have been overwhelmingly represented to the virtual exclusion of hunter-gatherers.

From the 1930s, Leslie A. White and his students had attempted to salvage much of Morgan's evolutionist program, with the major difference that the bilateral-patrilineal-matrilineal sequence of Boas's disciples was now taken for granted. Against this background, Sherwood Washburn and associates launched palaeoanthropology in its modern form. Central to their preoccupations was what they termed "the human family," attributed to the hunting way of life, deep in the evolutionary past. This "human family" was simply assumed to be a male-female pair sharing a complementary division of labor to raise offspring (Washburn and Lancaster 1968, 301). Despite abundant primate evidence for the significance of matrilineal bonds (for example, Kummer 1971), female strategies had no place in this paradigm. Although the "patrilocal band" model (Service 1962) was heavily criticized by social anthropologists (Lee and DeVore 1968; Woodburn 1968), subsequent origins narratives countenanced male but not female bonding. Patrilocality but not matrilocality, paternity certainty but not the alternative of paternity confusion—no one seemed to notice how their choice of narrative was being systematically constrained.

## New Models for Old Arguments

When evolutionary psychology came onto the scene in the 1980s, it inherited this default set of assumptions. The major challenge to this legacy has arisen with the development of the "grandmother" hypothesis (O'Connell, Hawkes, and Blurton Jones 1999), deriving from work on the Hadzabe of Tanzania. This group of big-game hunter-gatherers lives in the East African savanna environment that produced modern humans. Kristen Hawkes

(1991; 1993) observed that, contrary to the assumptions of the nuclear family model, Hadza men did not provide meat to their own families, but instead hunted large game that was distributed throughout the entire camp (Hawkes, O'Connell, and Blurton Jones 1991). If men are not trading provisioning for pair bonds and paternity certainty, we need different models for the emergence of a social division of labor and may even ask Why pair bonds at all? (Hawkes, O'Connell, and Blurton Jones 2001).

Having observed the relative rarity of success for each individual Hadza hunter (amounting to one big kill each month), Hawkes and colleagues went on to document the more reliable daily gains of women's labor (Hawkes, O'Connell, and Blurton Jones 1997). This research focused on the economics of female foraging strategies, especially foraging for roots and tubers (most commonly //*ekwa*), which provide the staple of the Hadza bush diet. To this day, Hadza women tend to live with their mothers and sisters. The work of older women, particularly matriline relatives (Hawkes, O'Connell, and Blurton Jones 1997, 554), proves important in subsidizing weaning mothers. Viewing these findings in the light of general mammalian life-history theory (Charnov 1993), the Hawkes team offered an account of the evolution of human life-history characteristics, dubbed the grandmother hypothesis, which was discussed in the context of the palaeoclimate, fossil, and archaeological records.

The grandmother hypothesis provides an elegant account of the evolution of those life-history characters distinguishing humans from chimpanzees—menopause, increased fertility rates, delay in sexual maturity, and reduced weanling and overall mortality rates. It does not address encephalization, a critical issue discussed further below. O'Connell, Hawkes, and Blurton Jones (1999) specify an evolutionary context of change in climate and foraging strategies that triggered new social strategies. With the increasing aridity of the Lower Pleistocene, it became harder for weanlings to find accessible resources. Roots and tubers became widely available in this climate but could only be processed by adults. They argue that the mother's mother was the most reliable candidate for doing work to feed weanling children. A female with a long-lived, vigorous mother would be able to shorten her interbirth intervals and increase reproductive output relative to other females. This sets up selection directly for longer life span and greater allocation of somatic effort to maintaining the body after reproduction. The consequent reduction of mortality rates allows delay in sexual maturity.

Aside from empirical observation, this challenge to the "Man the hunter" paradigm arises as a matter of principle from modern Darwinian theory. Because the sexes get genes into the next generation by different means, they have different calculations about fitness. For females, high levels of parental investment are inevitable; for males, investment in an offspring

may come at a high opportunity cost if there are chances of mating elsewhere (Trivers 1985). While it is likely that some form of male care or paternal solicitude is ancient in primates as a guard against infanticide, this differs from male parental investment (MPI) involving provision of energy to mother or offspring. The latter is not seen among nonhuman primates, and we have to explain its evolution in terms of fitness benefits and costs to males.

The old "Man the hunter" stories may have dissolved away in the acid of selfish genes, but the camp aligned with nuclear family orthodoxy has now responded to the grandmother hypothesis with an updated version of Washburn's earlier model (Kaplan et al. 2000). Similarly sophisticated in its use of life-history theory, the "diet, intelligence, and longevity" model is grounded in fine-grained evolutionary ecological comparative work on chimpanzee and human hunter-gatherer foraging strategies, broken down by age and sex. The model takes encephalization into account—a strong point—but is notably weak in contextualizing the argument in terms of archaeological and paleontological data. The authors demonstrate that among contemporary hunter-gatherers, the energy produced by males between the ages of twenty and fifty effectively subsidizes female reproduction. Yet the energy production of hunters with modern weapons is a different story from that of males in a Pleistocene scavenging economy, lacking spears or bows and arrows. Blithely ignoring two decades of archaeological debate about whether hominins of the Plio-Pleistocene were hunting or scavenging (cf. O'Connell et al. 2002, 838), Kaplan et al. (2000) argue that a dietary shift towards high-quality, difficult-to-acquire foods required increasing skill and knowledge. Because individuals became more productive at later ages, and needed longer periods to learn the skills needed for acquiring these foods, this led to coevolution of intelligence with longer life span. Kaplan et al. (2000, 173–74) hitch their model to MPI, with skillful, older males fuelling the process by providing difficult-to-acquire resources to juvenile dependents (their offspring). The authors have been vague about a specific time period for the initial stages of the model, linking it indifferently to the first phase of encephalization (over 2 mya, associated with early *Homo* culminating in *H. ergaster*) or the second phase (from c. 600,000 BP, associated with *H. heidelbergensis,* culminating in modern humans and Neanderthals).

## When Did Humanlike Life Histories Start?

These two life-history models stand as the modern sparring partners in the old matriliny vs. nuclear family controversy. Kaplan et al. (2000, 181) avoid specifying dates, places, or even species in outlining their model. But does

the fossil record constrain the time period of major changes in hominin life history? If it does, we can propose a timetable for the onset of life-history changes in *Homo,* and then ask how well the two models fit this timetable.

What can evolutionary anthropology say about the evolution of human forms of kinship? We need to investigate the main pathways of natural selection that would produce early forms of social cooperation, including divisions of labor. Critical here are the energetic costs of reproduction for each sex. These have altered during the course of human evolution particularly because of increases in brain size and body size, which require extra energy for maintenance (Key 2000). Across species, brain and body size are closely related to life-history variables such as age at first reproduction and life span. Fossil remains can therefore provide important evidence about the life history of fossil taxa.

Among earlier hominins—australopiths prior to 2 mya who retained significant climbing abilities—brains and bodies were relatively small, with high size dimorphism between the sexes. From about 2.5 mya, some of these species began to encephalize while bodies remained quite small and apparently still highly dimorphic (McHenry 1996; Wood and Collard 1999). These species led after 2 mya to the emergence of *Homo ergaster,* the first hominin with body proportions like ours—bodies that were bigger and designed for walking not climbing (Wood and Collard 1999). Their brains were twice the size of chimpanzee/australopithecine brains. Sex size dimorphism had reduced, largely because *H. ergaster* females increased body size proportionately more than males (McHenry 1996). Why the strong selection pressure on females? According to the expensive tissue hypothesis (Aiello and Wheeler 1995), it is possible for an organism to run a larger brain without increasing basal metabolic rate if expensive tissue from another part of the body is reduced. The gut is the part that can be most readily reduced, but only if the animal finds a higher-quality diet. To find such a diet requires larger foraging areas. To travel further, *H. ergaster* females needed larger bodies of the right shape to give them more efficient bipedality and thermoregulation in increasingly arid environments. In addition, larger body size aided females who had to carry offspring that were helpless for longer. A further benefit is that the bigger the mother in relation to her offspring, the more efficient lactation per unit body weight (Lee and Bowman 1995).

Cathy Key (2000) models the effects of body size on reproductive costs for hominin species. For females, energetic costs of producing a single offspring are calculated by breaking down a single interbirth interval (IBI) in terms of costs of gestation, costs of lactation, and costs while cycling after weaning (Key 2000, 337). Among anthropoid primates, daily energy expenditure is closely related to body mass. During gestation, this may be increased by some 25 percent; during lactation by 50 percent. Key (2000, 338–

39) applies chimpanzee life-history parameters, with relatively long lactation/IBI, and human parameters, with shorter lactation/IBI, to a range of hominin species, drawing body mass estimates from McHenry (1992). If the same parameters, whether chimp or human, are applied across all species, there is a 50 percent increase in energy expenditure for females across the australopith-*Homo* transition due to the increase in body size. Alternatively, if costs are calculated for the australopiths using long chimp-style IBI, and for *Homo* with shorter human-style IBI, then costs level off across the transition (Key 2000, 340). Fossil evidence of pattern and rate of dental development in australopithecines strongly supports ape-like life-histories in these species (Smith 1991). While one recent study of dental development in *H. ergaster* (Dean et al. 2001) points to australopith growth rates, a number of other studies place this species closer to the modern human range of variation (for example, Clegg and Aiello 1999; Smith 1993).

By Charnov's life-history model (1993), large body size in *Homo ergaster* implies reduction in mortality and delay in maturity. Key's simple model shows that female *H. ergaster* could not have evolved her larger body unless she had considerably reduced IBI relative to chimps. Shortening lactation greatly reduces reproductive costs. But this is only possible if the weanling can fend for itself, or if someone other than the mother can support it. According to Key's model, human-like life histories must begin to emerge from 2 mya, associated with the increase in body size following the initial phase of encephalization. Yet that first phase of encephalization involved incipient development of secondary altriciality (Shipman and Walker 1989). This refers to the extreme helplessness of a human infant, owing to the rapidity of brain development in the first year and corresponding retardation of motor skills or digestive function. This retardation makes sense for the mother because she has significantly more energy to find than a chimp mother and so slows the whole process down. But the key contradiction of human evolution is this: how, given the pressures of encephalization, did human mothers end up with shorter, rather than longer IBIs? If *H. ergaster* mothers reduced their IBIs, their weanlings, as a result of encephalization, would have been relatively immature. They would have needed other individuals to help find food, leading to the onset of another novelty of human life history—childhood. Unlike primate juveniles, human children, once weaned, are still dependent on adult help.

## Who Could Have Helped?

We have outlined two competing accounts of the evolution of human life history. Do they work in the time frame outlined by energetics modeling? The grandmother hypothesis fits well. It directly associates the onset of hu-

manlike life history with the emergence of *H. ergaster/erectus*. It allows for the necessary reduction of IBI in conjunction with the increase of female body size through female social cooperation. It points to the evidence of palaeoclimate change that drove novel female foraging strategies, enabling provisioning of children. The one thing left out of the argument is encephalization (see Blurton Jones, Hawkes, and O'Connell 1999, 157–58). Yet stress of encephalization on top of climate change can promote grandmother strategies. *Homo* mothers experienced the heaviest costs of growing brains in the first two years of infancy (Foley and Lee 1991); it is for this reason that weaning of underdeveloped juveniles required a novel social solution. Without allocarers, *Homo* females would have had to extend their IBIs, resulting in prohibitive reproductive costs; with grandmothers, they could raise birth rates.

The "diet, longevity, and intelligence" argument compares chimpanzee patterns of energy production and consumption with those of modern hunter-gatherers. Yet the comparison critical for this life-history argument is between chimps and hominins of the Plio-Pleistocene boundary. Two key questions arise. Firstly, could males in a Lower Pleistocene scavenging economy be productive enough on a regular basis to underwrite life-history changes (see O'Connell et al. 2002, 853–59)? Secondly, if males could be so productive, why would they channel hard-won resources into MPI rather than into attracting extra fertile females? We are asked to believe that, over 2 million years ago, when *Homo* mothers critically required allocare for newly weaned children, they turned first to mates, who were liable to rove, instead of to female kin. Partly because Hadza scavenging returns were highly variable and intermittent, O'Connell, Hawkes, and Blurton Jones (1988) were prompted to investigate "grandmothering" as an alternative, since returns would be far more reliable on a day-to-day basis. Because females share similar trade-offs while males must engage in mating competition, there is little doubt which sex is going to provide the most dependable energy income.

If we remove the insistence on MPI at this early stage, we could salvage aspects of Kaplan and colleagues' argument. It is not clear why, apart from ideological considerations, MPI is necessary to coevolution of complex foraging skills, intelligence, and longer life span. For *Homo* females coming under increasing stress from encephalization and climate change, senior female kin offer the most reliable option for daily allocare, setting up incipient selection for longer postreproductive life span, shorter IBIs, reduced mortality rates and delayed onset of reproduction. In modeling the effects of body size on reproductive costs, Key and Aiello (2000) investigated how the relative reproductive costs of the sexes affected their likelihood of co-

operation, both within each sex and between the sexes. Where males had similarly high costs to females, because they needed much bigger bodies to succeed in reproductive competition, they were unlikely to be cooperative. Wherever female costs of reproduction were high—as would be the case in *H. ergaster* with increased brain and body size—female-female cooperation was strongly selected. When female costs rise relative to males, males become much more likely to cooperate with females. With the evolution of *H. ergaster,* female costs did rise relative to males because of the reduction in sexual size dimorphism. Already in Lower Pleistocene scavenging economies, males may have been giving females significant benefits—but such male-female cooperation emerged on a basis of prior interfemale cooperation. The reduction of sexual size dimorphism is driven originally by females meeting their own costs—becoming larger bodied—not by changes in behavior between the sexes. By Key's model, increasing male-female cooperation is an outcome of change in body size, not a cause.

Which females precisely will males be inclined to help? Males will choose those who are most frequently fertile, that is, those with reduced IBIs. In other words, females with older female kin who take the weaned children off their hands will attract more male help. Micronutrients in meat are especially valuable for children (Milton 1999). Females who get meat gifts from males will be able to reduce their IBIs even further and/or their children will survive better. So "Grandmother" and "Man the cooperative scavenger" become mutually reinforcing. Males will actively choose females who have senior female kin support. We can dispense with MPI since male investment can start and proceed on the basis of mating effort with fertile females.

The combination of "Grandmother" with "Man the Lower Pleistocene scavenger" yields a more complete argument for the emergence of specifically human life histories. Complex scavenging strategies could then set up selection pressures for investment in intelligence and longer life span in males, as argued by Kaplan et al. (2000). As it stands at present, without the grandmother model as necessary precursor, the diet, intelligence, and longevity model is silent on menopause.

In the final phase of encephalization, from 600,000 BP among *H. heidelbergensis* (the ancestor of moderns and Neanderthals), female costs again rose steeply (Aiello 1996). In line with Hawkes, we argue that female coalitions adopted strategies to promote male competition in big-game "show-off" hunting. Males became more productive from the Middle to Upper Pleistocene, attaining the levels seen among modern hunter-gatherers, and effectively subsidizing female reproduction of larger-brained offspring (cf. Kaplan et al. 2000). None of this requires assumptions about MPI; it can

all be driven by males seeking matings with fertile females. We have argued elsewhere that such female coalitionary strategies led to the emergence of ritual and symbolism (Knight 1991; Knight, Power, and Watts 1995; Power and Aiello 1997). Because female-female cooperation remained central, there is little reason to suppose that prior structures of female kin-bonding would have been altered at this stage. We conclude that our ancestors, from *H. ergaster* through *H. heidelbergensis* up to early modern humans, were biased to matrilocality—tipping the scales towards matriliny as and when unilineal descent groups evolved.

## Conclusion

Seeking to explain variation in marriage and family systems, Morgan and Engels anticipated the discipline of evolutionary ecology. Modern Darwinians may well object that the grandmother hypothesis is not an argument about matrilineal clans or "group motherhood"—it implies female kin-bonded coalitions and a strong (but variable) tendency to female philopatry. We do not imagine *Homo ergaster* coalitions were unilineal descent groups with classificatory kinship. But, as Murdock (1949) established long ago, the pragmatics of residence, affiliation, and mating on the ground must precede and constrain the emergence of formal systems of kinship and descent. If the evolution of menopause is evidence for ancestral female philopatry in genus *Homo*, this necessarily constrains the ways in which kinship arose with the beginnings of symbolic culture in modern humans. Our picture of the world history of kinship then reverts to Morgan's perspective of matrilineal priority with classificatory kinship.

In exposing the politically motivated grounds for discarding Morgan's legacy, we are not trying to reinstate the Morgan/Engels scheme of universal stages of cultural evolution. Nevertheless, Morgan successfully identified key factors underlying variation in residence and descent. Bird (1999) has argued that we can understand the sexual division of labor as the product of variable outcomes to strategic conflict between the sexes in differing environments. Instead of assuming cooperation between the sexes, kinship systems can likewise be viewed as variable outcomes to sexual strategic conflict, with factors such as paternity uncertainty and heritable wealth altering trade-offs (Holden, Sear, and Mace 2003). Understanding variability is preferable to any view of fixity in species patterns. Some do not accept that menopause is an adaptation. Even they will surely acknowledge that a century's unhealthy preoccupation with paternity certainty and the nuclear family has blinkered our vision of the full range of strategies available to our ancestors (cf. Beckermann and Valentine 2002; Marlowe 2004; Hrdy, this volume).

## References

Aberle, D. F. 1961. "Matrilineal descent in cross-cultural comparison." In *Matrilineal Kinship*, ed. D. Schneider and K. Gough. Berkeley: University of California Press, 655–727.

Aiello, L. C. 1996. "Hominine preadaptations for language and cognition." In *Modelling the Early Human Mind*, ed. P. Mellars and K. Gibson. Cambridge: McDonald Institute Monograph Series, 89–99.

Aiello, L. C., and P. Wheeler. 1995. "The expensive tissue hypothesis: The brain and the digestive system in human and primate evolution." *Current Anthropology* 36:199–221.

Bachofen, J. J. 1973 [1861]. *Myth, Religion, and Mother-Right: Selected Writings*. Princeton: Princeton University Press.

Beckerman, S., and P. Valentine. 2002. *Cultures of Multiple Fathers*. Gainesville: University of Florida Press.

Bird, R. 1999. "Cooperation and conflict: The behavioral ecology of the sexual division of labor." *Evolutionary Anthropology* 8:65–75.

Blurton Jones, N. G., K. Hawkes, and J. F. O'Connell. 1999. "Some current ideas about the evolution of human life history." In *Comparative Primate Socioecology*, ed. P. C. Lee. Cambridge: Cambridge University Press, 140–66.

Boas, F. 1897. *The Social Organization and the Secret Societies of the Kwakiutl Indians*. Report of the U.S. National Museum, 1895. Washington, DC.

Buss, D. M. 1989. "Sex differences in human mate preferences: Evolutionary hypotheses tested in thirty-seven cultures." *Behavioral and Brain Sciences* 12:1–14.

Charnov, E. L. 1993. *Life History Invariants*. Oxford: Oxford University Press.

Clegg, M., and L. C. Aiello. 1999. "A comparison of the Nariokotome *Homo erectus* with juveniles from a modern human population." *American Journal of Physical Anthropology* 110:81–93.

Darwin, C. 1871. *The Descent of Man, and Selection in Relation to Sex*. 2 vols. London: Murray.

Dean, M. C., M. G. Leakey, D. Reid, F. Schrenk, G. T. Schwartz, C. Stringer, and A. Walker. 2001. "Growth processes in teeth distinguish modern humans from *Homo erectus* and earlier hominins." *Nature* 414:628–31.

Ellis, B. J., and D. Symons. 1990. "Sex differences in sexual fantasy: An evolutionary psychological approach." *Journal of Sex Research* 27:527–55.

Engels, F. 1972 [1884]. *The Origin of the Family, Private Property, and the State*. New York: Pathfinder Press.

Evans-Pritchard, E. E. 1965. *Theories of Primitive Religion*. Oxford: Oxford University Press.

Ferguson, A. 1819 [1767]. *An Essay on the History of Civil Society*. Philadelphia: A. Finley.

Foley, R. A., and P. C. Lee. 1989. "Finite social space, evolutionary pathways, and reconstructing hominid behaviour." *Science* 243:901–6.

———. 1991. "Ecology and energetics of encephalization in hominid evolution." *Philosophical Transactions of the Royal Society, London.B* 334:223–32.

Harris, M. 1969. *The Rise of Anthropological Theory*. London: Routledge.
Hawkes, K. 1991. "Showing off: Tests of an hypothesis about men's foraging goals." *Ethology and Sociobiology* 12:29–54.
———. 1993. "Why hunter-gatherers work: An ancient version of the problem of public goods." *Current Anthropology* 34:341–61.
Hawkes, K., J. F. O'Connell, and N. G. Blurton Jones. 1991. "Hunting income patterns among the Hadza: Big game, common goods, foraging goals, and the evolution of the human diet." *Philosophical Transactions of the Royal Society, London.B* 334:243–51.
———. 1997. "Hadza women's time allocation, offspring production, and the evolution of long postmenopausal lifespans." *Current Anthropology* 38:551–77.
———. 2001. "Hunting and nuclear families: Some lessons from the Hadza about men's work." *Current Anthropology* 42:681–709.
Holden, C. J., R. Sear, and R. Mace. 2003. "Matriliny as daughter-biased investment." *Evolution and Human Behavior* 24:99–112.
Junod, H. 1912. *The Life of a South African Tribe*, vol. 1. Neuchâtel: Imprimerie Attinger Frères.
Kaplan, H., K. Hill, J. Lancaster, and A. M. Hurtado. 2000. "A theory of human life history evolution: Diet, intelligence, and longevity." *Evolutionary Anthropology* 9:156–85.
Kennedy, G. 2003. "Paleolithic grandmothers? Life history theory and early *Homo*." *Journal of the Royal Anthropological Institute (n. s.)* 9:549–72.
Kenrick, D. T., E. K. Sadalla, G. Groth, and M. R. Trost. 1990. "Evolution, traits, and the stages of human courtship: Qualifying the parental investment model." *Journal of Personality* 58:97–116.
Key, C. A. 2000. "The evolution of human life history." *World Archaeology* 31:329–50.
Key, C. A., and L. C. Aiello. 2000. "A prisoner's dilemma model of the evolution of paternal care." *Folia Primatologica* 71:77–92.
Knight, C. 1991. *Blood Relations*. London: Yale University Press.
Knight, C., C. Power, and I. Watts. 1995. "The human symbolic revolution: a Darwinian account." *Cambridge Archaeological Journal* 5:75–114.
Kummer, H. 1971. *Primate Societies*. Chicago: Aldine Atherton.
Lafitau, J. T. 1724. *Moeurs des Sauvages Amériquaines, Comparées aux Moeurs des Premiers Temps*. Paris: Saugrain l'aîné.
Lederer, J. 1672. *The Discoveries of John Lederer, in Three Several Marches from Virginia, to the West of Carolina and Other Parts of the Continent. Begun in March 1669, and ended in September 1670*. London: Samuel Heyrick.
Lee, P. C., and J. E. Bowman. 1995. "Influence of ecology and energetics on primate mothers and infants." In *Motherhood in Human and Nonhuman Primates*, ed. C. R. Pryce, R. D. Martin, and D. Skuse. Third Schultz-Biegert Symposium, Kartause-Ittingen, 1994. Basel: Karger, 47–58.
Lee, R. B., and I. DeVore. 1968. "Problems in the study of hunters and gatherers." In *Man the Hunter*, ed. R. B. Lee and I. DeVore. Chicago: Aldine, 3–12.

Lowie, R. H. 1920. *Primitive Society*. New York: Harper.
———. 1927. *The Origin of the State*. New York: Harcourt, Brace.
———. 1937. *The History of Ethnological Theory*. New York: Holt, Rinehart and Winston.
———. 1960 [1914]. "Social Organization." *American Journal of Sociology* 20:68–167. Reprinted in *Lowie's Selected Papers in Anthropology*, ed. C. du Bois. Berkeley: University of California Press.
———. 1960 [1946]. "Evolution in cultural anthropology: a reply to Leslie White." *American Anthropologist* 58:223–33. Reprinted in *Lowie's Selected Papers in Anthropology*, ed. C. du Bois. Berkeley: University of California Press.
Mace, R., and C. Holden. 1999. "Evolutionary ecology and cross-cultural comparison: The case of matrilineal descent in sub-Saharan Africa." In *Comparative Primate Socioecology*, ed. P. C. Lee. Cambridge: Cambridge University Press, 387–405.
Malinowski, B. 1932. *The Sexual Life of Savages in North-Western Melanesia*, 3rd ed. London: Routledge.
———. 1956. *Marriage: Past and Present. A Debate between Robert Briffault and Bronislaw Malinowski*, ed. M. F. Ashley Montagu. Boston: Porter Sargent.
Marlowe, F. W. 2004. "Marital residence among foragers." *Current Anthropology* 45:277–84.
Marx, K. 2000 [1844]. "Economic and philosophical manuscripts." In *Karl Marx: Selected Writings*, ed. D. McLellan, 2nd ed. Oxford: Oxford University Press, 83–121.
Marx, K., and F. Engels. 2000 [1846]. "The German Ideology." In *Karl Marx: Selected Writings*, ed. D. McLellan, 2nd ed. Oxford: Oxford University Press, 175–208.
McHenry, H. M. 1992. "Body size and proportion in the early hominids." *American Journal of Physical Anthropology* 86:407–31.
———. 1996. "Sexual dimorphism in fossil hominids and its socioecological implications." In *The Archaeology of Human Ancestry*, ed. J. Steele and S. Shennan. London: Routledge, 91–109.
McLennan, J. F. 1865. *Primitive Marriage*. Edinburgh: Adam and Charles Black.
Milton, K. 1999. "A hypothesis to explain the role of meat-eating in human evolution." *Evolutionary Anthropology* 8:11–21.
Morgan, L. H. 1877. *Ancient Society*. London: MacMillan.
———. 1881. *Houses and House-Life of the American Aborigines*. Chicago: University of Chicago Press.
Morris, D. 1967. *The Naked Ape*. London: Cape.
Murdock, G. P. 1949. *Social Structure*. New York: Macmillan.
———. 1959. *Africa, Its Peoples, and Their Culture History*. New York: McGraw-Hill.
O'Connell, J. F., K. Hawkes, and N. G. Blurton Jones. 1988. "Hadza scavenging: Implications for Plio-Pleistocene hominid subsistence." *Current Anthropology* 29:356–63.
———. 1999. "Grandmothering and the evolution of *Homo erectus*." *Journal of Human Evolution* 36:461–85.

O'Connell, J. F., K. Hawkes, K. D. Lupo, and N. G. Blurton Jones. 2002. "Male strategies and Plio-Pleistocene archaeology." *Journal of Human Evolution* 43: 0831–72.

Power, C., and L. C. Aiello. 1997. "Female proto-symbolic strategies." In *Women in Human Evolution*, ed. L. D. Hager. New York: Routledge, 153–71.

Radcliffe-Brown, A. R. 1924. "The mother's brother in South Africa." *South African Journal of Science* 21:542–55.

Rodseth, L., R. W. Wrangham, A. M. Harrigan, and B. B. Smuts. 1991. "The human community as primate society." *Current Anthropology* 32:221–54.

Schneider, D. M. 1961. Introduction to *Matrilineal Kinship*, ed. D. M. Schneider and K. Gough. Berkeley: University of California Press, 1–29.

Service, E. R. 1962. *Primitive Social Organization*. New York: Random House.

Shipman, P., and A. Walker. 1989. "The costs of becoming a predator." *Journal of Human Evolution* 18:373–92.

Smith, B. H. 1991. "Dental development and the evolution of life history in hominidae." *American Journal of Physical Anthropology* 86:157–74.

———. 1993. "The physiological age of KNM-WT 15000." In *The Nariokotome Homo erectus skeleton*, ed. A. Walker and R. Leakey. Cambridge, MA: Harvard University Press, 195–220.

Swanton, J. 1905. "The social organization of American tribes." *American Anthropologist* 7:663–73.

Trivers, R. 1985. *Social Evolution*. Menlo Park, CA: Benjamin/Cummings.

Washburn, S. L., and C. Lancaster. 1968. "The evolution of hunting." In *Man the Hunter*, ed. R. B. Lee and I. DeVore. Chicago: Aldine, 293–303.

Wood, B. A., and M. Collard. 1999. "The human genus." *Science* 284:65–71.

Woodburn, J. 1968. "Stability and flexibility in Hadza residential groupings." In *Man the Hunter*, ed. R. B. Lee and I. DeVore. Chicago: Aldine, 103–10.

## CHAPTER 5

# Human Female Longevity
## *How Important Is Being a Grandmother?*

Cheryl Sorenson Jamison, Paul L. Jamison,
and Laurel L. Cornell

---

Ever since 1957 when George Williams posed the question of whether menopause might be an evolutionary adaptation, researchers have been attempting to find evidence either supporting (for example, Beise and Voland 2002; Hrdy 1999; Hill and Hurtado 1996; Mace 2000; Peccei 1995; Rogers 1993; Sear, Mace, and McGregor 2000; Sear et al. 2002; Shanley and Kirkwood 2001; Sorenson Jamison et al. 2002; Turke 1997; Voland and Beise 2002) or discounting the suggestion (for example, Blurton Jones, Hawkes, and O'Connell 1999; Holmes 2002).

Human female postreproductive longevity has been equally controversial. On average, human females live roughly one-third of their lives following menopause, a very unusual circumstance for animals in general and for primates in particular (Austad 1994, 1997; Graham 1979; Nishida, Takasaki, and Takahata 1990). While the life expectancy of *Homo sapiens* in Western societies has increased during the past 100 years, our maximum life span has not changed for at least the past 100,000 years (Cutler 1975). In addition, investigations of longevity among traditional foraging societies have demonstrated that postreproductive longevity is not simply a characteristic of western culture (Blurton Jones, Hawkes, and O'Connell 2002; Hawkes, O'Connell, and Blurton Jones 1997; Hawkes et al. 1998; Kaplan 1997).

Arguments in favor of postreproductive longevity as an evolutionary adaptation have typically centered on one or another version of what has come to be known as the grandmother hypothesis. The suggestion is that menopause evolved so that a woman would have time to care for her offspring long enough for each child to reach adulthood and then to help children rear their own offspring (Williams 1957). However, it is not menopause that requires an evolutionary explanation—menopause is a result of the finite number of ova with which a female is born, and their inevitable deterioration over time. Other primates have been known to live long enough to cease cycling as well, but they usually die within a few years (Hrdy 1981; Graham 1979). The trait that does require explanation because of its rarity is human female postmenopausal longevity, which is different from both other mammalian females who typically die soon after they stop

cycling and also from human males who can reproduce until they die at an advanced age (Harmon and Talbert 1985; Wood et al. 1994).

As originally presented, the grandmother hypothesis was actually two hypotheses that have since been divided into separate propositions differing specifically with regard to the primary beneficiary. The good mother hypothesis (Sherman 1998) emphasizes that she will stop producing more babies after her reproductive deterioration has begun and concentrate instead on making sure that those children already born are able to mature to adulthood (see also Alexander 1974; Nesse and Williams 1996).

The second version of the hypothesis is the more narrowly defined grandmother hypothesis (Beise and Voland 2002; Hawkes, O'Connell, and Blurton Jones 1989; Hawkes et al. 1998; Sorenson Jamison et al. 2002; Voland and Beise 2002). The central idea behind this hypothesis is that when older women no longer have their own immature offspring to care for, if they are still strong and capable, they can focus their time and energy on helping to care for their grandchildren. While some researchers have not separated maternal from paternal grandmothers and thus have not found support for the hypothesis (for example, Hill and Hurtado 1996), others have emphasized the importance of the maternal grandmother over the paternal grandmother and have found support for their position (Beise and Voland 2002; Hawkes, O'Connell, and Blurton Jones 1989; Hawkes et al. 1998; Sear, Mace, and McGregor 2000, 2003; Sorenson Jamison et al. 2002; Voland and Beise 2002). The logic of separating the effects of maternal from paternal grandmothers is based on the concepts of kin selection (Hamilton 1964) and paternal uncertainty (for example, Kurland 1979). Whereas a woman can be 100 percent assured of her relationship to her daughter's children and thus any benefit she gives to her daughter's children will definitely be aiding her own kin, she cannot be as positive that the help she gives to her son's children will benefit her genetic kin.

Sarah Blaffer Hrdy suggests an intriguing way of combining the two versions of the grandmother hypothesis into a proposal that she calls the grandmother's clock hypothesis (1999). This idea emphasizes the uniquely human stages of the *Homo sapiens* life span: we have both a long period of childhood dependency and a lengthy period of female postreproductivity. She argues that these two stages are not only species-specific but that they are also interdependent—one could not have evolved without the other. Near the beginning of our life span we have childhood, a period that is unique to our genus *Homo* if not to our own species (Bogin 1999), and at the other end we have a long period following menopause in which a woman is fully functional even though she is no longer producing offspring. Hrdy argues that this latter period is also not only unique to our species but that it is at least as evolutionarily old as the period of childhood.

Many authors explicitly or implicitly support the importance of the relationship between these two human life span periods (Bogin and Smith 1996; Hawkes 2003; Kaplan 1997; Kaplan et al. 2000; Peccei 1995). "The keys to the evolutionary puzzles of menopause and old age may thus lie in the survival risks faced by infants and children" (Ellison 2001, 242–43) and human life span extension is self-reinforcing in its positive effect on the young (Carey and Judge 2001).

While evidence supporting the narrower version of the grandmother hypothesis has recently been reported (see Sorenson Jamison et al. 2002 for a review), attempts to find evidence supporting the good mother hypothesis have not been so successful (for example, Hill and Hurtado 1996; Rogers 1993). It is possible that one of the reasons for the failure of the latter investigations is the fact that they used a woman's fertility as a measure of success. Evolutionary success isn't determined only by the number of offspring, however; it relates to offspring quality and ensuring that those offspring who are born are able to reach reproductive age (see the excellent review by Hrdy 1999).

We suggest that a better way to test the good mother hypothesis is to look at the relationship of the survival of women to the age of their youngest child: if she can live long enough to ensure this child reaches adulthood, then of course, the older children would already likely be able to live independently. Additionally, we suggest that a test of the grandmother's clock hypothesis would be to establish a relationship between longevity and grandmotherhood. Among women who are beyond their child-bearing years (beyond fifty), if women who are grandmothers live longer than those who are not, this finding can be taken as support for the idea that grandmotherhood in itself is self-reinforcing. The intention of this paper is to provide evidence supporting these two suggestions. Accordingly, we make the following two predictions concerning a data set of women who were at least fifty years old at the time of their death: (1) women who were older at the birth of their last child should live longer than those who had their last child at a younger age, and (2) women who are grandmothers should live to an older age than those who are not.

## Materials and Methods

Data for the present research originate from the annual population registers (*Shūmon Aratame Chō,* or SAC) compiled during the Tokugawa Period (1603–1867) for a centrally located Japanese peasant village in the modern prefecture of Nagano (Cornell 1983). We refer to this village as the SRP Village #1. The basic unit of registration for the SAC was the household, or *ie,* which in many cases included not only the nuclear family but also other re-

lated and unrelated individuals as well as servants. Local government officials gathered the information for the registers once a year on a predetermined date.

Akira Hayami and his associates transcribed the SACs from a number of villages into modern Japanese (Cornell and Hayami 1986; Hayami 1973). The specific annual enumeration information generally includes name, age, sex, and relationship to the household head for each individual. Additionally, events such as births, deaths, and marriages are recorded. According to the Japanese custom at that time, a child was considered to be one year old at the time of birth and became a year older each New Year's Day. Children were not entered in the census if they were born and died between enumerations, and we therefore have little information concerning perinatal and infant mortality. Data from the registers from SRP Village #1 were entered into an electronic database under the direction of one of the authors (LLC). The basic table was arranged by person-year within household. Additional tables included other relevant individual and household variables as well as events occurring each year. The combination of these tables allows the use of discrete time event history analysis using the person-year as the unique record (Allison 1984, 1995).

Registers from SRP Village #1 were originally recorded for 144 of the years between 1671 and 1871. Data pertaining to 217 separate households (not all of which existed for the entire time period), and 3,290 individuals were combined into a time-varying table of 57,661 person-years. From the full database, we extracted a person-year data set consisting of 5,737 postreproductive aged women (fifty years of age and older). This data set included the woman's age and marital status as well as variables related to the composition of her household, her offspring, and whether or not there had been a famine in the preceding year (data from Saito 1966).

Next, to examine the relationship of age at death with grandmother status, we created life tables for the data set of postreproductive women, first for all of the women together, and then separately by grandmother status. We then used logistic regression to test the relationship of the likelihood of a woman's death to our two predictor variables, namely, whether or not she had grandchildren and her age when her last child was born. In this analysis, we controlled for the following variables: year, age, marital status, number of household members, age and sex (male = 1) of the household head, the number of years the household had been in existence, whether there had been a famine in the preceding year (yes = 1), and the age at which a woman's first child had been born. For the marital status variable, since at this age, most women were either married or widowed, we created a new variable, with currently married coded as 1, and widowed, divorced, or never married as 0.

# Results

Descriptive statistics for SRP Village #1 summary data, number of children, and person-year combinations of offspring, parents, and grandparents can be found in Sorenson Jamison et al. (2002). Table 5.1 provides summary statistics for the 463 women who are included in the postreproductive analyses in the present study.

Table 5.2 presents a combined, abridged life table by five-year age groups for the data set of postreproductive women separated by grandmother status. The most important difference between grandmothers and

**Table 5.1** Descriptive and person-year statistics for women age 50 and older (N = 463) in SRP Village #1, 1671–1871

| Variable | Range | Mean | Std. dev. |
|---|---|---|---|
| Age in years | 50–95 | 62.36 | 8.94 |
| At birth of first child | 13–48 | 22.92 | 5.65 |
| At birth of youngest child | 19–51 | 37.13 | 6.10 |
| Number of children ever born | 0–10 | 3.83 | 2.59 |
| Number of grandchildren ever born | 0–37 | 5.44 | 6.91 |
| Number of household members | 1–23 | 5.94 | 2.83 |
| Marital status in person-years | | Frequency | Percent |
| Married | | 2425 | 42.3 |
| Widow | | 2659 | 46.3 |
| Divorced | | 72 | 1.3 |
| Never married | | 28 | 0.5 |
| Information missing | | 553 | 9.6 |
| Total | | 5737 | 100.0 |

**Table 5.2** Abridged life tables for postreproductive women in SRP Village #1, 1671–1871 (life expectancy in years)

| Age group | Women with grandchildren n = 308 | Women w/o grandchildren n = 155 |
|---|---|---|
| 50–54 | 19.43 | 15.85 |
| 55–59 | 15.49 | 13.14 |
| 60–64 | 12.24 | 10.93 |
| 65–69 | 9.49 | 10.02 |
| 70–74 | 7.58 | 8.40 |
| 75–79 | 5.73 | 5.38 |
| 80–84 | 4.16 | 4.78 |
| 85+ | 3.00 | 5.00 |

nongrandmothers can be seen in life expectancy at age fifty: women who are grandmothers can expect to live almost four more years than those who are not grandmothers. But also note that this advantage decreases with each advancing five-year age group, and is totally lost by age group sixty-five to sixty nine.

To clarify our finding favoring grandmothers, we extracted a single-record data set of postreproductive women who died and ran a t-test with age at death as the dependent variable and grandmother status as the grouping variable (261 grandmothers, 94 nongrandmothers, data not in tables). We found that grandmothers lived on average 4.75 years longer than nongrandmothers (mean for grandmothers = 71.05, mean for non-grandmothers = 66.30; t = −4.065, p = .000).

Table 5.3 presents the results for the logistic regression analysis. As a result of our finding that the benefit of grandmotherhood decreases with age (see table 5.2), we computed an interaction variable between age and grandmotherhood that was included in the analysis (coded 1 if age was greater than or equal to sixty-five and if the woman had one or more grandchild). Due to missing data, the analysis was based upon 4,401 person-years rather than 5,737. With regard to the control variables, the most noteworthy result is that if a famine occurred in the preceding year, the likelihood of a woman's death increased by more than 263 percent! Year of the data and age of the woman are also highly significant but not surprising—the older a woman is, the more likely she is to die, and time towards modernity decreases the likelihood of death. Two of the other control variables that come close to reaching significance should be mentioned: the larger the household and the longer the household has been in existence, the less likely a woman is to die in a given year. Both of these variables probably reflect the fact that larger and longer lasting households were more stable and affluent. But the rest of the control variables, including marital status, age and sex of the household head, the age of woman when her first child is born, and the variable measuring the interaction between age and grandmother status, all fail to demonstrate a significant relationship to whether or not a woman is likely to die in a given year.

The two predictor variables, however, are both clearly demonstrated to be significantly related to the likelihood of a woman's death. The importance of the woman's age when her last child is born is best illustrated by the odds ratio: while a ratio of .971 does not appear to be substantial at first glance, when it is realized that the variable is continuous rather than a dummy indicator, its importance is magnified. This finding means that a one-year increase in age at the youngest child's birth reduces the odds of death by a modest 3 percent. But the effect accumulates exponentially with each additional year in age. For a five-year increase in the age of the mother

**Table 5.3** Logistic regression odds ratios using death of a postreproductive woman (person-year n = 4,401) as the dependent variable[a]

| Variable | Odds ratio | Confid. interval | Sig. |
|---|---|---|---|
| Year of data | 0.996 | 0.993–0.999 | .003 |
| Age | 1.112 | 1.087–1.137 | .000 |
| Household | | | |
|   Number of members | 0.949 | 0.900–1.001 | .056 |
|   Age of head | 0.995 | 0.985–1.004 | .282 |
|   Sex of head (male = 1) | 1.369 | .673–2.784 | .385 |
|   Years in existence | 0.997 | 0.994–1.000 | .069 |
| Married? (yes = 1) | 1.131 | 0.815–1.570 | .462 |
| Famine in preceding year? | 2.654 | 1.444–4.878 | .002 |
| Age at birth of first child | 0.982 | 0.957–1.009 | .190 |
| Age when youngest child born | 0.971 | 0.949–0.993 | .012 |
| Grandchildren? (yes = 1) | 0.589 | 0.354–0.981 | .042 |
| Interaction: age and grandchildren | 1.076 | 0.689–1.679 | .747 |

[a] −2LL = 1753.789
Nagelkerke (pseudo) $R^2$ = .136
Model $X^2$ = 221.570; p = .0000

at the birth of her youngest child, there is a corresponding decrease of over 14 percent in the likelihood of her death. For a ten-year increase in age at the youngest child's birth, the likelihood of death is decreased by 25 percent! While there is a significant correlation between the age of a woman at the birth of her youngest child and her age at the birth of her first child (r = .22, p < .01, data not in table) the correlation is not high enough to suggest that if a woman has her first child at an older age than another woman, she will routinely also have her last child at an older age than the other woman.

We can also see in table 5.3 that our other predictor, being a grandmother, decreases the chances of death in a given year by more than 40 percent. This is a very dramatic effect considering that its significance occurs after the effects of the other variables are controlled for. In addition, it is especially strong considering that the interaction effect of this variable with age is not significant, even though we can see that the advantage of grandmotherhood disappears by age sixty-five.

## Discussion

What do these results mean with regard to female postreproductive longevity? We need to emphasize that the results of this study must be seen in the context of an association or correlation between grandmotherhood and longevity. From these data alone, causality can be suggested but not clearly

demonstrated. Our first finding, that the older a postreproductive woman was at the birth of her last child the less likely she was to die, provides clear support for the good mother hypothesis. Mothers need to survive long enough to see that their youngest child reaches adulthood. Though this concept may seem to be a trivial one, our research has demonstrated its importance and the relevance of the presence of postreproductive women for children's survival. A child is certainly dependent upon a mother's presence, but since this dependence decreases as the child ages, it is the youngest child who at all ages is most vulnerable. It may well be that there is some type of a "longevity clock" that is reset in a woman with the birth of each child.

Our finding might be related to that of Perls, Alpert, and Fretts (1997) comparing two cohorts of women who were born in the same area in 1896, one group of whom bore children into their forties and the other who did not. These researchers found that the former group was four times more likely to live to age 100 than the latter. The present study also lends support to the broader version of the grandmother hypothesis (and thus to the grandmother's clock hypothesis) in that if the woman is still alive when her youngest child is having children, most if not all of her grandchildren will also benefit by her presence (Holliday 1996).

Our second finding, that grandmothers are less likely to die in a given year than postreproductive aged women who are not grandmothers, is not as intuitively obvious, particularly when it is paired with the fact that the advantage is lost after age sixty-five. We argue that the explanations for our findings are biocultural in nature and will discuss the cultural aspects first. The idea that the presence of older people in a group provides valuable assistance to younger members is not new. Older people help supply food and labor (Blurton Jones, Hawkes, and O'Connell 1996, 1999; Hawkes, O'Connell, and Blurton Jones 1997; Hurtado et al. 1992; Kaplan et al. 2000; Sear, Mace, and McGregor 2003) as well as caring and solicitude (Euler and Weitzel 1995; Gaulin, McBurney, and Brakeman-Wartell 1997) and are the source of significant additional capital resources (Judge 1995; Judge and Hrdy 1992; Kaplan 1996; Lee 2003). In preliterate societies, old people served a crucial role for the entire group as the repositories of knowledge and wisdom, most particularly regarding the means to survive infrequent dangers (Diamond 2001).

If grandmothers are taking care of children, including being responsible for their food, then they are more likely to be nutritionally advantaged as well since caretakers who are responsible for making sure the children are fed have additional food available for themselves, too (for example, Pawloski 1999). Thus, if both the young and the old are benefiting, the process can be seen as one of positive feedback: the more the lives of the old are benefited, the more available they are to help the younger members of

the group, and the cycle continues. Carey and Judge argue that intergenerational transfer of resources can flow in both directions and that this interactional benefit can form a basis for selection: "If investment from older to younger individuals decreases mortality, then selection for increased longevity results and that investment can flow for a longer period" (2001, 417). Thus, there is a mutual benefit between grandmothers and the community.

Skinner (1977) offers yet another culturally based explanation for longevity—he found that women who optimally spaced their children and produced them in the expected sex order lived longer than those who did not. The potential relevance of this finding to ours might be whether these women were also more likely to be grandmothers, something that perhaps could be investigated in the future.

It is not too surprising that older people who feel that they are making a useful contribution to the welfare of others not only feel better themselves, they feel better about themselves and live longer (for example, Maruta et al. 2000; Rowe and Kahn 1987). So older women living in households in which they have important responsibilities, including taking care of their grandchildren, supplying food and wisdom, and helping with chores and official duties as the Tokugawa women did (Cornell 1991; Uno 1991), feel better about themselves. A side effect may be that they remain healthier and thus live longer than women who do not have these important responsibilities. And, we would argue, it is more likely to be women who are grandmothers who have these important roles to fill (Cornell 1991).

The most intriguing finding coming from the present study is that the advantage of being a grandmother ceases after age sixty-five. Why would this be the case? Here is where we look to Hrdy's (1999) three conditions for postreproductive longevity: (1) there must be increasing altruism with age, that is, there must be evidence that postreproductive women do help their grandchildren, (2) there must be something that older women can do that is clearly beneficial to their grandchildren, and (3) the cost of having older women around must be offset by the help she contributes. There is ample evidence for the first two conditions from the literature (Beise and Voland 2002; Cornell 1991; Sear, Mace, and McGregor 2000; Sear et al. 2002; Sorenson Jamison et al. 2002; Uno 1991; Voland and Beise 2002). We believe that the third condition is the explanation for our finding that the advantage of being a grandmother decreases after age sixty-five.

By age sixty-five, not only is it likely that a woman's youngest child, as well as her other children, are all fully grown adults, but there are now likely plenty of other caretakers ready and able to help with growing grandchildren. It is only the first fifteen years following menopause that are most critical for a postreproductive woman to be available to help her own children and grandchildren. After this point, several other factors can enter into her

continued survival since her children are independent and her health is likely to be deteriorating perhaps to the point at which her contributions to the care of her grandchildren no longer outweigh the cost of having her there. Thus our finding that the advantage ceases after age sixty-five is supportive of both the good mother hypothesis (because her youngest child is now likely to be old enough to survive without her) and the grandmother's clock hypothesis (because it meets Hrdy's three conditions for longevity).

The biological part of our biocultural argument for postreproductive female longevity is based both upon evolutionary theory and the recent literature on aging. The former has already been alluded to, that is, for the trait to have been selected for in our ancestors, there must first have been genetic variation in postreproductive longevity (evidenced in the difference between us and our closest primate relatives) and second, there must have been a fitness advantage for those having the trait. If postreproductive women who are grandmothers behave in ways that not only benefit their children and grandchildren as well as themselves, and if there is a genetic basis for this behavior, this behavior will be selected for. We recognize the preceding explanation is speculation about a causal link that goes beyond the strictly associational results in our study.

This paper and other research on the survival advantage to grandchildren living with grandparents provide ample evidence of increased fitness associated with postreproductive longevity. As mentioned earlier, female postreproductive longevity is nearly unique to our species, while within our species it is a universal trait. Menopause occurs in all populations at approximately the same age (Leidy Sievert 2001; Wood et al. 1994), and the age at which it occurs is highly heritable and demonstrates little evidence of a secular trend (de Bruin et al. 2001; Leidy Sievert 2001; Peccei 1999; Snieder, McGregor, and Spector 1998). Human females spend approximately one-third of their lifetimes postreproductively, and since this trait is not a function of modern medicine (Cutler 1975; Hayflick 2000; Smith, Falsetti, and Donelly 1989), it would seem that the evidence of the genetic basis of the trait combined with the altruistic benefits supplied by these women to both their children and grandchildren provides support for the evolutionary argument. Indeed, Shanley and Kirkwood (2001) provide a model demonstrating how menopause might have evolved. It supports the grandmother's clock hypothesis in that neither the model of the good mother hypothesis nor the broader grandmother hypothesis alone can explain female postreproductive longevity, but taken together, they do.

If there is a genetic basis for our longevity, what might be the mechanics underlying it? Although the answer(s) to this question must be very theoretical at this stage, there has been a great deal of recent research in the area of aging, and a few tantalizing possibilities exist that we will briefly mention.

In a study of 444 centenarian families in the United States, Perls et al. concluded that there are probably two classes of genes primarily responsible for longevity: (1) the absence of alleles in genetic polymorphisms that predispose to premature mortality and (2) "longevity enabling genes" that slow aging and also confer resistance to age-related diseases (2002, 8447). One longevity-enhancing gene candidate might be a region on chromosome 4 identified as D4S1564 (Puca et al. 2001).

It has long been known that a primary factor leading to aging is the damaging effects of oxidation on DNA repair mechanisms (de Boer et al. 2002; Finkel and Holbrook 2000; Johnson, Sinclair, and Guarente 1999). Since oxidative stress is so strong a factor in cell senescence, factors associated with stress resistance should be significant in increasing life span in humans as already demonstrated in *Drosophilia*, mice, and *C. elegans*.

Other research has demonstrated the relationship between telomere dysfunctioning and/or shortening and aging. Baird et al.'s finding is especially intriguing because they found considerable telomere allelic variation, even in the same cell, suggesting that, "a difference between maternal and paternal alleles is maintained from the zygote throughout development. This in turn implies a previously unexpected large-scale variance in starting telomere length in the human population" (2003, 206). Takahashi, Kuro-o, and Ishikawa (2000) suggest that the *klotho* mouse mutant gene (which leads to premature aging possibly due to rapid telomere shortening) indicates the potential existence of a mammalian anti-aging hormone.

Tatar (2003) discusses Simon et al.'s (2003) finding that flies heterozygous for the receptor for ecdysone, the major steroid hormone, were more likely to live longer, and furthermore, they showed no decrease in fertility or differential behavior with age. Tatar ties this finding to those of insulin receptors and insulin-like growth factor (Holtzenberger et al. 2003; Hsu, Murphy, and Kenyon 2003; Kenyon 2001) in suggesting that control of the aging process has been strongly evolutionarily conserved and that the role of steroid hormones is central to the process.

Last, but far from least, one of the most interesting lines of investigation from the point of view of the present research has looked at the role of genetic variation in mitochondrial DNA (mtDNA) in aging. Mitochondria generate most of a cell's energy primarily through a process called oxidative phosphorylation (Saraste 1999), and mtDNA defects have been associated with a number of developmental and degenerative diseases (Dillin et al. 2002; Wallace 1999). MtDNA accumulates mutations throughout the life span, perhaps due to increasing damage from oxygen free radicals, and the mutations may make the mitochondria less efficient in energy generation (Michikawa et al. 1999; Pennisi 1999; Wallace 1999). Such findings have led to the supposition that mtDNA is an aging clock (Coskun, Ruiz-Pesini, and

Wallace 2003). Thus one route to increased longevity might be in finding mtDNA genomes that are more resistant to mutation, or conversely, ones that have more efficient mechanisms to recognize copying errors and repair them.

On the other hand, there might be specific mtDNA mutations that are advantageous to the individual, and the research of Zhang et al. (2003) suggests such a tantalizing possibility. They found significantly higher frequencies of a particular homoplasmic mtDNA (C150T) in centenarians (ages 99–106) than in younger individuals (p = .0035). These authors argue that since these older individuals have survived the health-related risks that those who died earlier succumbed to, "selection for a remodeled replication origin, inherited or somatically acquired, provides a survival advantage" (2003, 1116). This mutation was found both in skin fibroblasts and in lymphocytes. While other researchers have found high proportions of clonal mutant mtDNA, even to the point of homoplasy (for example, Nekhaeva et al. 2002) associated with disease, Zhang et al.'s research is the first to actually suggest a selective advantage to a specific mutation leading to an increased life span rather than a limitation on life span. How would the mutation have a selective advantage? Coskun, Ruiz-Pesini, and Wallace (2003) suggest that the C150T mutation might affect the immune system or that it might be linked to other mtDNA variants and work conjointly to promote longevity.

Though the mtDNA research regarding longevity is only tentative, we find it to be the most exciting with regard to our speculation about causal factors because it identifies a specific mechanism whereby longevity is enhanced through the female lineage given that mtDNA is inherited only from the mother (Wallace 1999). But mtDNA is passed directly from a mother to all her offspring (males as well as females). In sum, if a mutation such as C150T were to exist in a woman who behaved in what we have come to describe as a grandmotherly fashion, and thus the gene were transmitted to both her own children and then her daughter's children, and additionally, her grandmotherly behavior were a factor in the survival of her grandchildren, then longevity would be selected for, both postreproductively for females and in overall life span for males.

Thus, we can now see that the positive feedback cycle is truly biocultural, with a potential genetic basis that is accentuated through cultural interaction. The hereditary component (perhaps found in mtDNA) allowing increased postreproductive longevity led to women living long enough to help their youngest child reach adulthood and women behaving in "grandmotherly" ways not only to help their children but also their grandchildren survive. In so doing, they are passing on their genes to succeeding generations, but in turn, they are being rewarded not only by feeling better about them-

selves but also with tangible cultural rewards, and thus are more likely to reach their full longevity potential. And it is in this point that we see that the main difference between grandmothers and nongrandmothers is primarily a cultural one—the lives of the latter are shortened perhaps because they are less likely to behave "grandmotherly" but also perhaps because they do not receive the rewards and benefits associated with such status and behavior.

## Summary

The human life span includes two periods that are both unique and prolonged—childhood and female postreproductive longevity. The possibility that these two periods are interdependent as suggested by Hrdy (1999), Hawkes (2003), and Kaplan et al. (2000) has provided the impetus to the study of grandmothers and postreproductive female longevity. This paper, based upon a sample of women from Tokugawa, Japan, who were at least fifty years old at the time of their death, combined with results of earlier studies, presents evidence for Hrdy's grandmother's clock hypothesis. Where earlier studies found support for increased postreproductive longevity benefiting grandchildren (one end of the life span), the present research supports the benefit to individuals living at the other end of the life span. Among postreproductive women, grandmothers live longer than nongrandmothers, and women who are older when their last child is born are more likely to die at an older age than other postreproductive women whose last child was born when they were younger. This latter finding also supports the good mother hypothesis in that it suggests that mothers need to live long enough for their youngest child to reach adulthood. Comparison of life tables of grandmothers versus nongrandmothers in our study further supports this idea, because the life expectancy advantage of grandmothers is greatest at age fifty, and gradually diminishes until there is no difference by age sixty-five. If a woman had her last child close to age fifty, that child would be almost an adult by her age sixty-five, and would be able to fend for him or herself (at least in the environment in which we evolved, if not necessarily today's world). We argue that there is a biocultural positive feedback relationship between grandmotherhood and postreproductive longevity: if there is a genetic basis for longevity in women that also behave in "grandmotherly" ways, they will be valued members of the community and be treated accordingly, and they will feel better about themselves, and thus also be happier and healthier—and be more likely to live longer, even longer than they would if they did not behave "grandmotherly."

We speculate that an increased female postreproductive life span was selected for because it benefited three generations: the grandmother, her children, and her grandchildren (principally her daughter's children). We

further speculate that the genetic mechanism through which this selection occurred was most likely to be in mitochondrial DNA, because of its method of inheritance through the maternal line.

## Note

This manuscript was originally submitted August 13, 2003, revised and resubmitted October 26, 2003, and accepted November 4, 2003. A paper by M. Lahdenperä et al., which appeared in the March 11, 2004, issue of *Nature*, demonstrated significant support for the grandmother hypothesis. In addition, they confirmed the finding in our study that there is an age beyond which being a grandmother is no longer positively associated with greater age at death.

## References

Alexander, R. D. 1974. "The evolution of social behavior." *Annual Review of Ecology and Systematics* 5:325–83.

Allison, P. D. 1984. *Event History Analysis: Regression for Longitudinal Event Data.* Newbury Park, CA: Sage Publications.

———. 1995. *Survival Analysis Using the SAS System: A Practical Guide.* Cary, NC: SAS Institute, Inc.

Austad, S. N. 1994. "Menopause: An evolutionary perspective." *Experimental Gerontology* 29:255–63.

———. 1997. "Postreproductive survival." In *Between Zeus and the Salmon: The Biodemography of Longevity*, ed. K. W. Wachter and C. E. Finch. Washington, DC: National Academy Press, 161–74.

Baird, D. M., J. Rowson, D. Wynford-Thomas, and D. Kipling. 2003. "Extensive allelic variation and ultrashort telomeres in senescent human cells." *Nature Genetics* 33:203–7.

Beise, J., and E. Voland. 2002. "A multilevel event history analysis of the effects of grandmothers on child mortality in a historical German population." *Demographic Research* 7:469–98.

Blurton Jones, N. G., K. Hawkes, and J. F. O'Connell. 1996. "The global process and local ecology: How should we explain differences between the Hadza and the !Kung?" In *Cultural Diversity among Twentieth-Century Foragers*, ed. S. Kent. Cambridge: Cambridge University Press, 159–87.

———. 1999. "Some current ideas about the evolution of human life history." In *Comparative Primate Socioecology*, ed. P.C. Lee. Cambridge: Cambridge University Press, 140–66.

———. 2002. "Antiquity of postreproductive life: Are there modern impacts on hunter-gatherer postreproductive life spans?" *American Journal of Human Biology* 14:184–205.

Bogin, B. 1999. *Patterns of Human Growth*, 2nd ed. Cambridge: Cambridge University Press.

Bogin, B., and B. H. Smith. 1996. "Evolution of the human life cycle." *American Journal of Human Biology* 8:703–16.
Carey, J. R., and D. S. Judge. 2001. "Lifespan extension in humans is self-reinforcing: A general theory of longevity." *Population and Development Review* 27: 411–36.
Cornell, L. L. 1983. "Retirement, inheritance, and intergenerational conflict in preindustrial Japan." *Journal of Family History* 8:55–69.
———. 1991. "The deaths of old women: Folklore and differential mortality in nineteenth-century Japan." In *Recreating Japanese Women, 1600–1945*, ed. G. L. Bernstein. Berekely: University of California Press, 71–87.
Cornell, L. L., and A. Hayami. 1986. "The Shūmon Aratame Chō: Japan's population registers." *Journal of Family History* 11:311–28.
Coskun, P.E., E. Ruiz-Pesini, and D. Wallace. 2003. "Control region mtDNA variants: Longevity, climatic adaptation, and a forensic conundrum." *Proceedings of the National Academy of Sciences* 100:2174–76.
Cutler, R. G. 1975. "Evolution of human longevity and the genetic complexity governing aging rate." *Proceedings of the National Academy of Sciences* 72:4664–68.
De Boer, J., J. O. Andresson, J. de Wit, J. Huijmans, R. B. Beems, H. van Steeg, G. Weeda, G. T. J. van der Horst, W. van Leeuwen, A. P. N. Themmen, M. Meradji, and J. H. J. Hoeijmakers. 2002. "Premature aging in mice deficient in DNA repair and transcription." *Science* 296:1276–79.
De Bruin, J. P., H. Bovenhuis, P. A. H. van Noord, P. L. Pearson, J. A. M. van Arendonk, E. R. te Velde, W. W. Kuurman, and M. Dorland. 2001. "The role of genetic factors in age at natural menopause." *Human Reproduction* 16:2014–18.
Diamond, J. 2001. "Unwritten knowledge." *Nature* 410:521.
Dillin, A., A.-L. Hsu, N. Arantes-Oliveira, J. Lehrer-Graiwer, H. Hsin, A. G. Fraser, R. S. Kamath, J. Ahrinter, and C. Kenyon. 2002. "Rates of behavior and aging specified by mitochondrial function during development." *Science* 298: 2398–2401.
Ellison, P. T. 2001. *On Fertile Ground*. Cambridge: Harvard University Press.
Euler, H. A., and B. Weitzel. 1995. "Discriminative grandparental solicitude as reproductive strategy." *Human Nature* 7:39–59.
Finkel, T., and N. J. Holbrook. 2000. "Oxidants, oxidative stress, and the biology of ageing." *Nature* 408:239–47.
Gaulin, S. J. C., D. H. McBurney, and S. L. Brakeman-Wartell. 1997. "Matrilateral biases in the investment of aunts and uncles." *Human Nature* 8:139–51.
Graham, C. E. 1979. "Reproductive function in aged female chimpanzees." *American Journal of Physical Anthropology* 50:291–300.
Hamilton, W. D. 1964. "The genetical evolution of social behavior, parts 1 and 2." *Journal of Theoretical Biology* 7:1–52.
Harmon, S. M., and G. B. Talbert. 1985. "Reproductive aging." In *Handbook of the Biology of Aging*, 2nd ed., ed. C. E. Finch and E. L. Schneider. New York: Van Nostrand Reinhold, 341–510.
Hawkes, K. 2003. "Grandmothers and the evolution of human longevity." *American Journal of Human Biology* 15:380–400.

Hawkes, K., J. F. O'Connell, and N. G. Blurton Jones. 1989. "Hardworking Hadza grandmothers." In *Comparative Socioecology: The Behavioral Ecology of Humans and Other Mammals,* ed. V. Standon and R. A. Foley. London: Blackwell, 341–66.

———. 1997. "Hadza women's time allocation, offspring provisioning and the evolution of long menopausal life spans." *Current Anthropology* 38:551–77.

Hawkes, K., J. F. O'Connell, N. G. Blurton Jones, and H. Alvarez. 1998. "Grandmothering, menopause, and the evolution of life histories." *Proceedings of the National Academy of Sciences* 95:1336–39.

Hayami, A. 1973. *Kensei, Noson no Rekishi Jinkogakuteki Kenkyu* (The Historical Demographic Study of Villages in Tokugawa, Japan). Tokyo: Tokyo Keizai Shinposha.

Hayflick, L. 2000. "The future of ageing." *Nature* 408:267–69.

Hill, K., and A. M. Hurtado. 1996. *Ache Life History.* Hawthorne, NY: AldinedeGruyter.

Holliday, R. 1996. "The evolution of human longevity." *Perspectives in Biology and Medicine* 40:100–107.

Holmes, D. J. 2002. "Is postmenopausal life-span a gift of modern health or a product of natural selection?" http://sageke.sciencemag.org/cgi/content/full/sageke;2002/7/pe3.

Holzenberger, M., J. Dupont, B. Ducos, P. Leneuve, A. Geloen, P. C. Even, P. Cervera, and Y. LeBouc. 2003. "IGF-1 receptor regulates lifespan and resistance to oxidative stress in mice." *Nature* 421:182–86.

Hrdy, S. B. 1981. "'Nepotists' and 'altruists': The behavior of old females among macaques and langur monkeys." In *Other Ways of Growing Old,* ed. P. T. Amoss and S. Harrell. Stanford, CA: Stanford University Press, 59–76.

———. 1999. *Mother Nature: A History of Mothers, Infants, and Natural Selection.* New York: Pantheon.

Hsu, A-L., C. T. Murphy, and C. Kenyon. 2003. "Regulation of aging and age-related disease by DAF-16 and heat-shock factor." *Science* 300:1142–45.

Hurtado, A. M., K. Hill, H. Kaplan, and I. Hurtado. 1992. "Trade-offs between female food acquisition and child care among Hiwi and Ache foragers." *Human Nature* 3:185–216.

Johnson, F. B., D. A. Sinclair, and L. Guarente. 1999. "Molecular biology of aging." *Cell* 96:291–302.

Judge, D. S. 1995. "American legacies and the variable life histories of women and men." *Human Nature* 6:291–323.

Judge, D. S., and S. B. Hrdy. 1992. "Allocation of accumulated resources among close kin: Inheritance in Sacramento, California, 1890–1984." *Ethology and Sociobiology* 13:495–522.

Kaplan, H. 1996. "A theory of fertility and parental investment in traditional and modern human societies." *Yearbook of Physical Anthropology* 39:91–135.

———. 1997. "The evolution of the human life course." In *Between Zeus and the Salmon: The Biodemography of Longevity,* ed. K. W. Wachter and C. E. Finch. Washington, DC: National Academy Press, 175–211.

Kaplan, H., K. Hill, J. Lancaster, and A. M. Hurtado. 2000. "A theory of human life history evolution: Diet, intelligence, and longevity." *Evolutionary Anthropology* 9:156–85.

Kenyon, C. 2001. "A conserved regulatory system for aging." *Cell* 105:165–68.

Kurland, J. A. 1979. "Paternity, mother's brother, and human sociality." In *Evolutionary Biology and Human Social Behavior,* ed. N. A. Chagnon and W. Irons. North Scituate, MA: Duxbury Press, 145–80.

Lahdenperä, M., V. Lummaa, S. Helle, M. Tremblay, and A. F. Russell. 2004. "Fitness benefits of prolonged post-reproductive lifespan in women." *Nature* 428:178–81.

Lee, R. D. 2003. "Rethinking the evolutionary theory of aging: Transfers, not births, shape senescence in social species." *Proceedings of the National Academy of Sciences* 100:9637–42.

Leidy Sievert, L. 2001. "Menopause as a measure of population health: An overview." *American Journal of Human Biology* 13:429–33.

Mace, R. 2000. "Evolutionary ecology of human life history." *Animal Behavior* 599:1–20.

Maruta, T., R. C. Colligan, M. Malinchoc, and K. P. Offord. 2000. "Optimists vs. pessimists: Survival rate among medical patients over a thirty-year period." *Mayo Clinic Proceedings* 75:140–43.

Michikawa, Y., F. Maxxucchelli, N. Bresolin, G. Scarlato, and G. Attardi. 1999. "Aging-dependent large accumulation of point mutations in the human mtDNA control region for replication." *Science* 286:774–80.

Nekhaeva, E., N. D. Bodyak, Y. Kraytsbert, S. B. McGrath, N. J. Van Orsouw, A. Pluzhinikov, J. Y. Wei, and K. Khrapko. 2002. "Clonally expanded mtDNA point mutations are abundant in individual cells of human tissues." *Proceedings of the National Academy of Sciences* 99:5521–26.

Nesse, R. M., and G. C. Williams. 1996. *Why We Get Sick: The New Science of Darwinian Medicine.* New York: Vintage Books.

Nishida, T., H. Takasaki, and Y. Takahata. 1990. "Demography and reproductive profiles." In *The Chimpanzees of the Mahale Mountains: Sexual and Life History Strataegies,* ed. T. Nishida. Tokyo: University of Tokyo Press, 63–97.

Pawloski, L. 1999. "The growth, development, and nutritional status of adolescent girls from the Segou region of Mali (West Africa): A biocultural approach to the analysis of health." Ph.D. diss. Indiana University, Bloomington.

Peccei, J. S. 1995. "The origin and evolution of menopause: The altriciality-lifespan hypothesis." *Ethology and Sociobiology* 16:425–49.

———. 1999. "First estimates of heritability in the age of menopause." *Current Anthropology* 40:553–58.

Pennisi, E. 1999. "Do mitochondrial mutations dim the fire of life?" *Science* 286:664.

Perls, T. T., L. Alpert, and R. C. Fretts. 1997. "Middle-aged mothers live longer." *Nature* 389:133.

Perls, T. T., J. Wilmoth, R. Levenson, M. Drinkwater, M. Cohen, H. Bogan, E. Joyce,

S. Brewster, L. Kunkel, and A. Puca. 2002. "Life-long sustained mortality advantage of siblings of centenarians." *Proceedings of the National Academy of Sciences* 99:8442–47.

Puca, A. A., M. J. Daly, S. J. Brewster, T. C. Matise, J. Barrett, M. Shea-Drinkwater, S. Kang, E. Joyce, J. Nicoli, E. Benson, L. M. Kunkel, and T. Perls. 2001. "A genome-wide scan for linkage to human exceptional longevity identifies a locus on chromosome 4." *Proceedings of the National Academy of Sciences* 98:10505–8.

Rogers, A. R. 1993. "Why menopause?" *Evolutionary Ecology* 7:406–20.

Rowe, J. W., and R. L. Kahn. 1987. "Human aging: Usual and successful." *Science* 237:143–49.

Saito, R. 1966. *Fukenbetsu nenbetsu Kisho Saigai Hyo* (Chronological Tables on Weather and Disasters by Prefectures). Tokyo: Chijinshokan.

Saraste, M. 1999. "Oxidative phosphorylation at the *fin de siècle*." *Science* 283:1488–93.

Sear, R., R. Mace, and I. A. McGregor. 2000. "Maternal grandmothers improve nutritional status and survival of children in rural Gambia." *Proceedings of the Royal Society of London.B* 267:1641–47.

———. 2003. "The effect of kin on female fertility in rural Gambia." *Evolution and Human Behavior* 24:25–42.

Sear, R., F. Steele, I. A. McGregor, and R. Mace. 2002. "The effects of kin on child mortality in rural Gambia." *Demography* 39:43–63.

Shanley, D. P., and T. B. L. Kirkwood. 2001. "Evolution of the human menopause." *BioEssays* 23:282–87.

Sherman, P. W. 1998. "The evolution of menopause." *Nature* 392:759–60.

Simon, A. F., C. Shih, A. Mack, and S. Benzer. 2003. "Steroid control of longevity in *Drosophila melanogaster*." *Science* 299:1407–10.

Skinner, G. W. 1997. "Family systems and demographic processes." In *Anthropological Demography*, ed. D. I. Kertzer and T. Fricke. Chicago: University of Chicago Press, 53–95.

Smith, F. J., A. B. Falsetti, and S. M. Donelly. 1989. "Modern human origins." *Yearbook of Physical Anthropology* 32:35–68.

Snieder, H., A. J. MacGregor, and T. D. Spector. 1998. "Genes control the cessation of a woman's reproductive life: A twin study of hysterectomy and age at menopause." *Journal of Clinical Endorinology and Metabolism* 83:1875–80.

Sorenson Jamison, C., L. L. Cornell, P. L. Jamison, and H. Nakazato. 2002. "Are all grandmothers equal? A review and a preliminary test of the 'grandmother hypothesis' in Tokugawa, Japan." *American Journal of Physical Anthropology* 119:67–76.

Takahashi, Y., M. Kuro-o, and F. Ishikawa. 2000. "Aging mechanisms." *Proceedings of the National Academy of Sciences* 97:12407–8.

Tatar, M. 2003. "Unearthing loci that influence life span." http://sageke.sciencemag.org/cgi/content/full/sageke;2003/9/pe5.

Turke, P. W. 1997. "Hypothesis: Menopause discourages infanticide and encourages continued investment by agnates." *Evolution and Human Behavior* 18:3–14.

Uno, K. S. 1991. "Women and changes in the household division of labor." In *Recreating Japanese Women, 1600–1945*, ed. G. L. Bernstein. Berkeley: University of California Press, 17–41.

Voland, E., and J. Beise. 2002. "Opposite effects of maternal and paternal grandmothers on infant survival in historical Krummhörn." *Behavioral Ecology and Sociobiology* 52:435–43.

Wallace, D. 1999. "Mitochondrial diseases in man and mouse." *Science* 283: 1482–88.

Williams, G. C. 1957. "Pleiotropy, natural selection, and the evolution of senescence." *Evolution* 11:32–39.

Wood, J. W., S. C. Weeks, G. R. Bentley, and K. M. Weiss. 1994. "Human population biology and the evolution of aging." In *Biological Anthropology and Aging: Perspectives on Human Variation over the Life Span*, ed. D. E. Crews and R. M. Garruto. New York: Oxford University Press, 19–75.

Zhang, J., J. Asin-Cayuela, J. Fish, Y. Michikawa, M. Bonafe, F. Oliviera, G. Passarino, G. DeBenedictis, C. Franceschi, and G. Attardi. 2003. "Strikingly higher frequency in centenarians and twins of mtDNA mutations causing remodeling of replication origin in leukocytes." *Proceedings of the National Academy of Sciences* 100: 1116–21.

CHAPTER 6

# Human Age Structures, Paleodemography, and the Grandmother Hypothesis

Kristen Hawkes and Nicholas Blurton Jones

Evolutionary life-history theory and demography provide strong reasons to suppose that long human life spans are not a recent novelty. Here we focus on one robust model of mammalian life history evolution, and a grandmother hypothesis about our own lineage that is based upon it. This hypothesis takes long adult life spans to be an ancient human trait. Claims that few adults survived to old age until the last century are a serious challenge to it. Such claims are generally based on the inference that when life expectancy is less than forty, most adults die before they grow old. We use demographic evidence to show that inference is wrong. Findings in paleo-demography also show that ancient skeletal assemblages do not reflect the age structure of past populations. By contrasting human and chimpanzee age structures, we further underline that point. The comparison with chimpanzees also serves to highlight the likely importance of ancestral grandmothers in human evolution.

## Life History Evolution

Initial work in life-history evolution recognized that the strength of selection on genes with age-specific expression must depend on mortality schedules since juvenile and adult mortality rates have quite different effects on the lifetime reproductive success of the individuals carrying those genes (Fisher 1930; Williams 1957; Hamilton 1966; Gadgil and Bossert 1970; Charnov and Schaffer 1973). Scaling regularities, of interest in their own right, offer especially important clues for students of mammalian life-history evolution as rates of adult mortality, maturation, and fecundity scale with adult body size (Harvey and Clutton-Brock 1985). Consequently, the rate and timing variables correlate with each other, and mammal life histories fall along a fast-slow continuum even when body size is statistically controlled (Harvey, Read, and Promislow 1989).

Eric Charnov (1991, 1993) built a model that reproduces this variation from a few basic trade-offs underlying mammalian life histories. In this most successful theory to explain the empirical patterns (see discussion in Harvey and Purvis 1999; Purvis et al. 2003), stationary populations are assumed

and adult mortality rates determine other life-history variables. When adult mortality rates decline (adult life spans lengthen), the risk of waiting to reproduce goes down, so selection favors longer duration of growth to reach larger adult size. Average adult life span thus determines the optimal age at maturity, which in turn sets the adult size.

Charnov's simple model has the particularly important property that it identifies the (approximately) invariant relationships among species' average life-history traits (Charnov 1993). Values of the traits themselves change across the fast-slow continuum—some mammals mature in months, others take two decades. But the relationship between the age at maturity and average adult life span does not change. The model shows that this results from trade-offs between the costs and benefits of delaying maturity in the face of adult mortality risk.

Charnov (1993) displayed the approximately invariant relationship between these features in primates by plotting average age at maturity and average adult life span across fifteen subfamilies, drawing data from Harvey and Clutton-Brock (1985). Our subfamily fell just as predicted by the mammalian invariant. While unnoted at the time, this showed that our late age at maturity is the expected consequence for a primate with our long adult life spans. Yet for humans, unlike other primates, a substantial component of adulthood is postmenopausal (Pavelka and Fedigan 1991). In wild nonhuman primates, very few of the adult females are past the age of terminal fertility (Hawkes, O'Connell, and Blurton Jones 2003). Not so in humans. Even though fertility declines at similar ages in humans and chimpanzees (Gage 1998; Nishida et al. 2003; Hawkes 2003), we usually live much longer. From the perspective of the life-history model, those longer life spans are the reason for our late maturity. And, as previously expected on other grounds (Williams 1957), the whole adult life span must be reproductive. Moreover, the evolution of that longer (and substantially postmenopausal) life span becomes the key to explaining other aspects of our life histories (Hawkes et al. 1998).

## A Grandmother Hypothesis

The modern Hadza (Blurton Jones et al. 1992) provide clues toward a likely explanation for the evolution of our longevity. Hunting and gathering in the arid tropics of the East African Rift, these modern people display a connection between the foraging patterns of children and their mothers and grandmothers that suggests a scenario for our ancestral past that includes a reproductive role for senior females and a consequent shift in rates of aging (Hawkes 2003). Young Hadza children are energetic foragers (Blurton Jones 1993; Blurton Jones, Hawkes, and O'Connell 1989). Mothers take

advantage of this, choosing to focus on foods the children can handle efficiently when those resources are in season (Hawkes, O'Connell, and Blurton Jones 1995). But the year-round staple in this habitat is deeply buried tubers, which young children are not strong enough to collect effectively. Senior Hadza women, long-experienced gatherers, spend even more time acquiring these foods than do women of childbearing age (Hawkes, O'Connell, and Blurton Jones 1989). With acquisition rates similar to those of younger adults (Hawkes, O'Connell, and Blurton Jones 1989; Blurton Jones and Marlowe 2002), their overall harvest of these resources is greater, making a substantial contribution to the nutritional needs that youngsters cannot fulfill for themselves. Weaned Hadza children usually depend on the foraging effort of their mothers. But when their mothers have a newborn, the weaned juveniles' nutritional welfare depends on the effort of their grandmothers instead (Hawkes, O'Connell, and Blurton Jones 1997).

The economic productivity of these older women and the feeding dependence of weaned children combined with current paleoanthropology suggest the following evolutionary scenario (O'Connell, Hawkes, and Blurton Jones 1999, 2002; Hawkes, O'Connell, and Blurton Jones 2003). Australopithecines are assumed to be ancestral to genus *Homo* (Klein 1999; Wood and Collard 1999). On grounds of body size, brain size, and maturation rates, australopithecines are often characterized as "bipedal apes," estimated to have life histories similar to those of modern chimpanzees (Smith and Tompkins 1995). At weaning, juveniles probably fed themselves. But the increasing aridity and seasonality of late Pliocene east and southern Africa would have constricted the forests and likely reduced the availability of fruits that young juveniles could handle (deMenocal 1995). The same ecological changes would favor plants that cope well with dry seasons by, for example, holding nutrients in underground storage organs. Such resources can give high return rates to those with the strength to extract and process them. Young juveniles cannot do it. To rely on these resources and succeed in these changing environments, mothers would have to provision offspring who are still too small to extract and process the tubers for themselves.

Increased food-sharing would allow mothers and the youngsters accompanying them to remain in habitats they otherwise could not and to colonize new, previously unexploited habitats. But the feeding dependence of those juveniles would delay a mother's next child. Maternal provisioning would create a novel opportunity for older females whose declining fertility made them less likely to have a newborn of their own: feeding their just-weaned grandchildren would allow childbearing-aged daughters to have shorter interbirth intervals without reductions in offspring survivorship.

Assuming these populations initially had aging rates and adult age structures like modern chimpanzees, the ecological change would alter the fitness benefits for slight variation in rates of senescence. The more vigorous elders would raise the fertility of their daughters and nieces more, resulting in more grandchildren endowed with their qualities and lengthening adult life spans (see Hawkes 2003 for further discussion of trade-offs and the evolution of rates of senescence).

The longer average adult life spans would in turn adjust the trade-offs captured in Charnov's mammal model, favoring delayed maturity and growth to larger maternal size. This hypothesis makes distinctive features of human life histories a consequence of the productivity of ancestral grandmothers (Alvarez 2000; Hawkes et al. 1998). The later maturation, increased body size, and rapid spread into previously unoccupied habitats by the first widely successful members of genus *Homo* are consistent with this scenario (O'Connell, Hawkes, and Blurton Jones 1999, 2002; Hawkes, O'Connell, and Blurton Jones 2003; Hawkes 2003).

This grandmother hypothesis claims central importance for the distinctive adult age structure of human populations. The evolutionary scenario proposes that ancestral populations with substantial fractions of elders actually antedate our species. According to it, our life histories evolved and have been maintained by low adult mortalities, implying that old age structures usually characterize human populations. But do they? Serious contrary assertions abound (Washburn 1981; Weiss 1981; Trinkaus 1995; Olshansky, Carnes, and Grahn 1998; Kennedy 2003; Crews and Gerber 2003). High levels of mortality in the past are widely assumed to have sharply limited numbers of surviving elders.

That assumption is fueled by confusion about the information contained in the widely used demographic statistic, life expectancy at birth (e0). Since life expectancy has been steadily increasing in industrialized countries (Oeppen and Vaupel 2002) with ever increasing fractions of seniors, it is easy to mistakenly infer that lower life expectancy in the past means few survived to old age. However, within the range of variation of human age structures, life expectancy—very sensitive to level 1 of fertility—is remarkably insensitive to level 1 of mortality. We use Ansley Coale and Paul Demeny's (1966) *Regional Model Life Tables and Stable Populations* to illustrate this point.

## The Coale and Demeny Model Life Tables

Coale and Demeny used the same stable population theory used in evolutionary life-history theory to model the age distributions implied by 362 observed human life tables. Populations converge on a stable (unchanging)

age distribution when age-specific fertility and mortality rates remain constant for a few generations. That stable age distribution is represented by a mortality schedule that can be characterized by shape (mortality changes with age), by level 1 (life expectancy at birth), and by fertility.

Shape, level, and fertility specify a growth rate, but the dimensions can vary separately. Schedules with similar shapes can differ in level. The overall height of the mortality curve shifts, so the area under it (life expectancy at birth) varies. Schedules can have the same level 1 (the area under the mortality curve) although they have different shapes; and different schedules can share the same level 1 of mortality and fertility, but differ in shape. Coale and Demeny found that their empirical life tables generated four stable population shapes, and they constructed four regional families of models, West, North, East, and South, labeled for the regions of Europe supplying most of life tables associated with each shape. Each regional family of models consists of a series of male and female stable age distributions that vary by mortality level 1 and fertility level 1 while sharing a characteristic shape.

The models do not include variation in the shape of age-specific fertilities, although this variation has been analyzed and characterized by demographers (for example, Coale and Trussell 1974). The neglect is justified by "an empirical property of the age schedules of human fertility.... In all populations where reliable records have been kept, fertility is zero until about age 15, rises smoothly to a single peak, and falls smoothly to zero by age 45–50. The mean age of the fertility schedule is usually between 26 and 33 years" (Coale and Demeny 1983, 27).

Limited variability in the shape of human fertility schedules is represented by the use of the gross reproductive rate (GRR) to characterize fertility level. GRR is the average number of daughters born to a woman who survives the fertile years. Each regional family is a series of stable population models with varying levels of fertility and mortality.

Figure 6.1 builds on Coale and Demeny's (1983) table 13 to show how various parameters of their West female series vary in relationship to each other (Hawkes 2004). Three mortality levels are included here, their level 1 (life expectancy of twenty years), level 9 (life expectancy of forty years), and level 17 (life expectancy of sixty years). Their models assume that the mean age of women giving birth is twenty-nine. The combination of a GRR and a mean maternal age is "sufficient to estimate r [the population growth rate] with a very small margin of error" (1983, 27). The population growth rate is represented as the annual rate of increase per 1000 females. When $r = 0$, the population is non-growing (stable). When $r = 20$, the population is growing at 2 percent per year.

Figure 6.1 reveals the broad pattern of variation in age structures familiar to demographers from stable population models (for example, Coale

1956). Coale and Demeny used their table 13 to draw attention to "the small effect of mortality and the large effect of fertility on the mean age of the population" (1983, 31). Panels A, B, and C show that at the same fertility level 1(GRR), the age structures are similar across varying mortality levels. Consider panel A: when fertility is held constant (each cluster of three bars), the mean age of the population varies less than four years over threefold differences in life expectancy. Conversely, at the same mortality level, mean age decreases by about ten years at each doubling of fertility (compare all the white bars, all the hatched bars, all the black bars).

Panel B shows that the fraction of the population under fifteen years old varies less across different mortality levels with the same fertility (each cluster of three bars), than with differing fertility at the same mortality (compare all the white bars, all the hatched bars, all the black bars). The fraction of adults over forty-five is shown in panel C, similar across mortality levels with the same fertility but decreasing with increases in fertility. Note that, perhaps contrary to initial intuition, at a given fertility (the three bar clusters), populations with higher mortality levels have older mean ages, fewer children, and more women past childbearing age.

Panel D of figure 6.1 shows the population growth rate that results from particular combinations of fertility and mortality. A GRR of 1 (very low fertility) makes populations decline at all mortality levels, but the decline is steeper when overall mortality is high. Conversely, a GRR of 4 (high fertility, an average of four daughters per woman who lived to forty-five) results in a growing population at all mortality levels with growth higher when mortality is lower. Specific population growth rates imply particular combinations of these variables. Where growth rates are highest, the fraction of juveniles is highest and of adults over forty-five is lowest.

This variation in human populations occurs within limits: the fraction of women past their childbearing years drops below 20 percent only when fertility is (unsustainably) high. Population growth reduces the fraction of elders because each succeeding cohort is larger than the last. Noting the ecological unsustainability of continuing growth, Coale (1959) made this point about age structure with special force by pointing out that the fraction of elders would always decrease with increasing population growth *even if no one ever died.*

Following Coale and Demeny's table 13, we used the West series. Drawn from the largest amount of data and the most cosmopolitan group of countries, this category is least tied to European regions. The North, East, and South families show the same patterns. While the shapes differ enough to distinguish for population planning, they are nearly identical on the dimensions highlighted here. The proportion of living seniors found in all models indicates a tendency for women to remain healthy past the end of

**Figure 6.1** Age structure variation in Coale and Demeny's (1983) West series with varying levels of mortality and fertility.

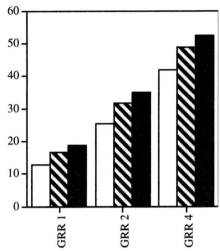

**A.** Variation in mean population age across different life expectancies and fertilities. Fertility on the x-axis. GRR, gross reproductive rate, is the average number of daughters produced by a woman who survives the fertile years. Mean age of the population is on the y-axis. The open bars show West 1 (life expectancy of 20 years), hatched bars West 9 (life expectancy of 40), and black bars West 17 (life expectancy of 60).

**B.** Variation in the percent of the population under 15 years of age with different life expectancies and fertilities. Fertility on the x-axis. GRR, gross reproductive rate, is the average number of daughters produced by a woman who survives the fertile years. Percent of the population under fifteen on the y-axis. The open bars show West 1 (life expectancy of 20 years), hatched bars West 9 (life expectancy of 40), and black bars West 17 (life expectancy of 60).

fertility. This is explicitly recognized in another demographic convention, the "dependency ratio," the number of females assumed to be too young or too old to be productive, relative to the number in the "productive" ages. Those under fifteen and over sixty (sometimes over sixty-five) are considered dependent. Those between the ages of fifteen and fifty-nine (or fifteen and sixty-four) are classified as producers. Each of the Coale and Demeny stable age models specifies a dependency ratio. Just as the use of the birth-woman ratio recognizes that there is limited variation in the shape of human age-specific schedules, this dependency ratio recognizes that women continue to be productive adults well into their grandmothering years.

The Coale and Demeny models illustrate general features of human age-specific mortality and fertility and the effects of changing mortality and fertility levels on age structure. But the sample of life tables they used to construct their models included only those based on good national vital sta-

 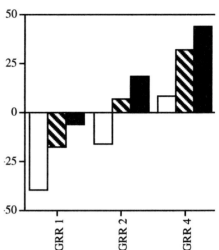

C. Variation in the percent of adults (those over 15) that are over 45 with different life expectancies and fertilities. Fertility on the x-axis. GRR, gross reproductive rate, is the average number of daughters produced by a woman who survives the fertile years. Percent of the adults (those over 15) who are over 45 on the y-axis. The open bars show West 1 (life expectancy of 20 years), hatched bars West 9 (life expectancy of 40), and black bars West 17 (life expectancy of 60).

D. Variation in population growth rate with different life expectancies and fertilities. Fertility on the x-axis. GRR, gross reproductive rate, is the average number of daughters produced by a woman who survives the fertile years. Population growth rate r (annual change per 1000) on the y-axis. The open bars show West 1 (life expectancy of 20 years), hatched bars West 9 (life expectancy of 40), and black bars West 17 (life expectancy of 60).

tistics. So they came largely from European populations. They explicitly recognized an "unresolvable" problem: "[T]here is no strong reason for supposing that the age patterns of mortality exhibited in these four families covers anything like the full range of variability in age patterns in populations under different circumstances.... The question of what is the pattern of mortality in a population of an underdeveloped area is essentially unresolvable, because there exists no way to determine the exact age of an illiterate person who does not know it himself" (1983, 25).

That pessimistic view assumes that mortality schedules can only be constructed from data on large populations collected by demographers' standard census methods, ruling out the appraisal of mortality experience in small nonliterate populations, the setting for most of human history and all of prehistory. "Unresolvable" with demographers' census methods, this is the central inquiry of anthropological demographers.

## Anthropological Demography

Seeking to broaden the range of reference models for ethnographers and paleodemographers, Kenneth Weiss (1973) constructed an alternative set of stable models meant to represent the populations often studied by anthropologists. He used data from fifty populations to build his model life tables. Fourteen data sets came from ethnographic censuses. Thirty-six of them were derived from archaeological assemblages.

Weiss concluded his analysis with the question "why are there no old folks?" (1973, 78). But inspection of Weiss's own data and analysis does not show the finding this question implies. Most of his source cases (Weiss 1973, appendix A) and most of his model populations *do* contain old people. His archaeological cases average more than one-fifth of adults past their mid-forties. In the ethnographic censuses, almost one-third of the adults are past their mid-forties. The difference between the archaeological and ethnographic samples is statistically significant, but neither of the averages justify Weiss's surmise. Old folks are not absent. Weiss concluded that no "evolutionary/adaptive reason for the post-reproductive survival of human beings" is needed because "survival to old age is rare among 'primitive' peoples" (Weiss 1981, 41). But the data he assembled himself do not bear out that claim. We will return to the difference between the ethnographic and archaeological cases below.

Ethnographic demography has been especially influential in highlighting the "old" age structure of human populations even when overall mortality levels are relatively high. Nancy Howell (1979) faced exactly the problem noted by Coale and Demeny when she applied demographic tools to !Kung hunter-gatherers in the Dobe area of western Botswana. Her subjects did not know their ages, so she had to develop methods for estimating them. Through interviews she ranked individuals by age and then used historically known events to anchor points in this array with Gregorian years. To smooth the final age estimates of adults, she chose a stable model from the Coale and Demeny series, West 5. Checks for internal consistency, especially the age differences between mothers and children, showed that she could not be far off in her age assignments.

A central question of Howell's study was whether the age pattern of mortality experience for the !Kung conformed to the Coale and Demeny models.

> The models, after all, have been constructed by summarizing the experience of well-studied populations of agricultural and industrialized societies, people who live under very different conditions than those of hunter-gatherers.... If the !Kung experience fits the model life tables, we can tentatively conclude that the general features of the model life tables express general features of human

biological processes that are sensitive to environmental fluctuations in level 1 but not in age patterns of mortality. (Howell 1979, 79–80)

Several estimation procedures and a series of simulations led her to conclude that, indeed, the observed characteristics of this population did not differ from the age patterns of the models. Elsewhere she explicitly characterized the "uniformitarian assumption" that her analyses supported this way: "the human animal has not basically changed in its direct biological response to the environment in processes of ovulation, spermatogenesis, length of pregnancy, degree of helplessness of the young and rates of maturation and senility over time" (Howell 1976, 25).

The population of hunter-gatherers she analyzed did not suffer age-specific mortality rates that leave no elders. The West 5 model she chose as best representing the !Kung population has life expectancy at birth of thirty years. Yet with this high level 1of mortality, a third of the women (those over fifteen) are over the age of forty-five. This age structure is displayed in figure 6.2, panel A. Howell also constructed another schedule, based on observed !Kung deaths between 1964 and 1973 (both sexes combined). That mortality schedule gives a life expectancy at birth of fifty, and an age structure with 46 percent of the adults past the age of forty-five.

Other anthropological demographers worried that the use of Coale and Demeny's models to estimate ages might obscure differences between the mortality schedules in small populations and those in the (European) regional models. Timothy Gage argued that "the uniformitarian view is overly simplistic and clearly incorrect at some level 1of specificity" (1998, 198–99). He noted that in the European cases used by Coale and Demeny, high mortality "is associated with high-density urban areas in the early 1800s. . . . [M]ortality in low-density populations may not follow this pattern" (1998, 205). As noted above, life tables built from archaeological data have different age structures. The age structures are younger, containing significantly fewer elders. If the Coale and Demeny mortality shapes are restricted to high-density populations, as Gage suggests, the small fraction of living elders estimated from skeletal series might accurately represent human mortality experience in other socioecological contexts. Howell's !Kung demography stands against this, but it is one case, and a case in which the Coale and Demeny models were used in the age estimations.

Three other demographic projects, undertaken with less reliance on the Coale and Demeny series, add to the burden of evidence in favor of Howell's depiction of old age structures in small-scale, low-density, non-European populations. Renee Pennington and Henry Harpending (1993) studied the demography of the Ngamiland Herero, the Bantu pastoralists who moved into the Dobe area occupied by the !Kung mostly after 1950.

**Figure 6.2** Population Age Structures

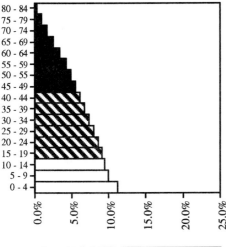

**A.** Female age structure (West 5) chosen by Howell (1979) for Dobe !Kung. X-axis represents the percentage of the female population in each five-year age class. Five-year age classes on the y-axis. Open bars are girls under 15; hatched bars are childbearing-aged women 15–45; black bars are seniors past childbearing age. In this West 5 model selected by Howell (1979) to represent the Dobe !Kung population, life expectancy ($e°$) is 30 years, and 33.5% of the adults are over 45.

**B.** Female age structure from the forest period Ache life table constructed by Hill and Hurtado (1996). X-axis represents the percentage of the female population in each five-year age class. Five-year age classes on the y-axis. Open bars are girls under 15; hatched bars are childbearing-aged women 15–45; black bars are seniors past childbearing age. This model represents the life table constructed by Hill and Hurtado (1996) for the Ache during the forest period. Life expectancy ($e°$) is 37 years, and 39% of the adults are over 45.

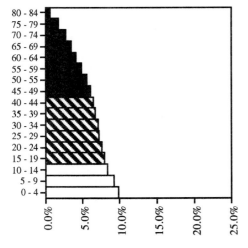

**C.** Female age structure from the Hadza life table constructed by Blurton Jones et al. (2002). X-axis represents the percentage of the female population in each five-year age class. Five-year age classes on the y-axis. Open bars are girls under 15; hatched bars are childbearing-aged women 15–45; black bars are seniors past childbearing age. In this model constructed by Blurton Jones et al. (1992) for the Hadza, life expectancy ($e°$) is 33 years, and 40.4% of the adults are over 45.

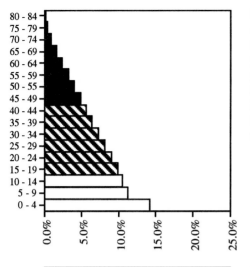

**D.** Female age structure for Coale and Demeny (1983) West Model 1. X-axis represents the percentage of the female population in each five-year age class. Five-year age classes on the y-axis. Open bars are girls under 15; hatched bars are childbearing-aged women 15–45; black bars are seniors past childbearing age. In this West 1 model, life expectancy (e°) is 20 years, and 27.4% of the adults are over 45.

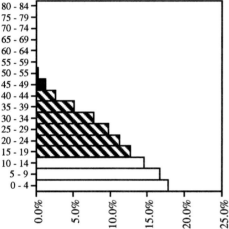

**E.** Female age structure from the Libben life table constructed by Lovejoy et al. (1977). X-axis represents the percentage of the female population in each five-year age class. Five-year age classes on the y-axis. Open bars are girls under 15; hatched bars are childbearing-aged women 15–45; black bars are seniors past childbearing age. In this model, life expectancy (e°) is 20 years, and 2.9% of the adults are over 45.

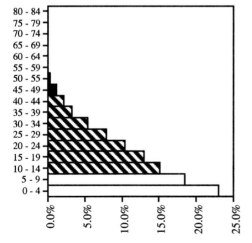

**F.** Age structure for synthetic life table for wild chimpanzees constructed by Hill et al. (2001) using data from five sites. X-axis represents the percentage of the female population in each five-year age class. Five-year age classes on the y-axis. Open bars are juveniles (under 10); hatched bars are childbearing-aged females 10–45; black bars are seniors past childbearing age. In this model, life expectancy (e°) is 15 years, and 2.2% of the adults are over 45.

While Pennington and Harpending disagreed with aspects of Howell's analysis of the Dobe !Kung population, they noted strong similarity between their Herero survival curve and the survival curve Howell had constructed from observed !Kung deaths. Howell had speculated that these observed deaths underestimated actual, long run !Kung mortality, but Pennington and Harpending concluded that, on the contrary, "her estimates of !Kung survivorship are quite reasonable" (1993, 221). In their Herero life table for the period before1966, life expectancy is about 50, and 49.5 percent of the women (those over fifteen) are over forty-five.

Kim Hill and Magdelena Hurtado's (1996) Ache demography describes a hunter-gatherer population with a very different history than the !Kung, occupying a very different habitat. The !Kung (and Herero) live in arid southern Africa; the foraging Ache are Native Americans who live just outside the Amazon Basin in the forests of eastern Paraguay. Hill and Hurtado constructed a population register for the Ache back to the early 1900s. Their survival schedule for forest-living Ache females—without any reliance on the Coale and Demeny models—gives a life expectancy at birth of thirty-seven, and an adult age distribution in which 39 percent of the women (those fifteen years and older) are past their fertility (that is, forty-five and older). This second hunter-gatherer age structure is shown in figure 6.2, panel B.

Additional evidence of old age structure in low-density populations comes from a third hunter-gatherer demography (Blurton Jones et al. 1992; Blurton Jones, Hawkes, and O'Connell 2002), the Hadza discussed above in summarizing the grandmother hypothesis. Like the !Kung, Hadza foragers inhabit the arid African tropics, but they live in northern Tanzania just south of the equator in the East African Rift. From census data collected by James Woodburn in 1966–67, the population was initially analyzed by Tim Dyson (1977), who selected the Coale and Demeny model North 6 to represent it. Blurton Jones and Lars Smith conducted another census in 1985. Using the two censuses and an initial set of age estimates, Blurton Jones corroborated Dyson's analysis (Blurton Jones et al. 1992). Subsequent censuses and reproductive interviews allowed Blurton Jones to further correct the population age ranking, tie births and deaths to datable events, and construct a mortality schedule independent of the Coale and Demeny models (Blurton Jones, Hawkes, and O'Connell 2002). This schedule represents a stable age distribution in which 40.7 percent of the adults (those fifteen and over) are forty-five or older, shown in figure 6.2, panel C.

## The Archaeological Assemblages

Skeletal remains are often said to tell a different story. Weiss (1973) recognized that mortuary assemblages might not reflect the mortality experience

of populations. Still, he used mostly archaeological cases to build his models. As noted above, the adult age structures estimated from those skeletal assemblages are significantly different from the ethnographic life tables. (Recall that, nevertheless, on average more than 20 percent of the adults in the life tables of Weiss's archaeological cases are past the ages of terminal female fertility.)

Subsequent to Weiss's monograph, paleodemographers began to explicitly examine sources of bias in archaeological skeletal samples. Jean-Pierre Bocquet-Appel and Claude Masset showed how much the age structure of reference samples could bias the aging of skeletal material and drew the devastating conclusion that "early mortality of adults, overmortality of women, lack of old people in those populations, whether prehistoric or medieval: all these hackneyed notions were born from the misinterpretation of data. As they are in no way vindicated, we must get rid of them" (1982, 329).

Phillip Walker and colleagues (1988) found dramatic evidence of bias arising from differential preservation of the bones of older individuals in their study of the remains from the California mission cemetery at La Purisma. Mission records showed that 53 percent of the adults buried at the cemetery were over forty-five, but only 7 percent of the recovered adult skeletons were over forty-five. That cemetery is less than 200 years old. The investigators conclude that, other things equal, the magnitude of the age-related bias should be "roughly proportional to the length of time a group of burials has been in the ground" (Walker, Johnson, and Lambert 1988, 188). Implications for Paleolithic samples are severe.

Age estimation techniques have been the center of paleodemographic attention since Boquet-Appel and Masset's "Farewell to Paleodemography" (1982). Age misestimation of skeletal material can be corrected by more sophisticated modeling techniques (Hoppa and Vaupel 2003) and perhaps preservation bias can also be estimated. But, even with these marked improvements in dealing with skeletal series, the age structure of a mortuary assemblage is unlikely to reflect the mortality experience of the population that left it. Deceased members of different ages and sexes are not equally likely to be interred in the same deposits. As Lyle Konigsberg and Susan Frankenberg caution, skeletal assemblages "cannot be considered as random samples of all members of a population who died within a certain period" (1994, 92).

Despite this recognition within paleodemography, a cemetery accumulated between 800 and 1100 AD at the Libben site in northern Ohio (Lovejoy et al. 1977) continues to be cited as empirical evidence that there were few old people in the past (Washburn 1981; Trinkhaus 1995; Austad 1997; Kennedy 2003). C. Owen Lovejoy and colleagues (1977) argued that because the preservation was excellent, the excavation careful, the assemblage

large, and the aging techniques good, the life table they constructed from the Libben skeletons was not subject to the usual archaeological biases. Their life table showed the "typical low infant mortality and high adult mortality of many skeletal series and thus contrasts inversely with most extant 'anthropological populations'. . . This general discrepancy between skeletal and ethnographic censuses is usually attributed to underenumeration of infants and errors of age estimation among adults from skeletal series" (Lovejoy et al. 1977, 291). But they claimed instead that the age profile was a reflection of the actual age structure of a population unexposed to the battery of novel pathogens associated with European arrivals in America.

Howell (1982) elaborated the implications of such a possibility by drawing out the social and economic consequences of the life table proposed for Libben. She compared the age structure for this life table to a Coale and Demeny model with the same level 1 of mortality. The comparison underlined both how little life expectancy says about adult age structure and also how the family relationships and economic interdependencies known for human populations would be absent in the Libben reconstruction.

The female age structure of the West 1 model from Coale and Demeny that has the same life expectancy, $e° = 20$, as the Libben model is shown in figure 6.2, panel D. It is not so different from the three hunter-gatherer populations, panels A, B, and C. The very different age structure of the Libben life table is shown in panel E. Only about half the Libben population is adult (over fifteen) and only 2.9 percent of those are past their childbearing years, that is, there are almost no grandmothers. In contrast, 65 percent of the West 1 population, panel D, is adult (over fifteen), and 27.4 percent of them are past their childbearing years. Howell (1982) pointed out that the dependency ratio of the Libben population implies improbably heavy loads on relatively few young adults. In West 1, there are many adults, and those in their grandmothering years could help younger adults with the children.

## Human vs. Chimpanzee Age Structures and Grandmothers Again

Because chimpanzees are our closest living relatives, many (but not all, cf. Gage 1998; Crews and Gerber 2003) look to similarities and differences between humans and chimps to specify questions about the evolution of human life histories. Our genetic similarities and the paleoanthropological reasons to see chimpanzees as models for australopithecine life histories make these comparisons particularly important (Hawkes 2003).

Figure 6.2, panel F shows the age structure implied by a life table for wild

chimpanzees (Hill et al. 2001). The chimpanzee population is just slightly younger than the Libben model and has a higher mortality level, but the adult age structures are very similar. With their shorter adult life spans, chimpanzees mature earlier than humans. Classifying all those over ten as adults (from the age-specific fertility schedule of Nishida et al. 2003) is parallel to classifying all over fifteen as adults in human populations. That makes 58.5 percent of the chimpanzee population adult (compared to 50.7 percent for Libben). Females past childbearing age are all but absent in both models: less than 3 percent of the adults are past forty-five.

Consistent with aging rates implied by this demographic picture of chimpanzees, observers describe chimpanzees as frail with age by their midthirties (Goodall 1986; Nishida et al. 2003). In humans, strength measures of foraging women show no marked decline through the forties, fifties, and well into the sixties (Blurton Jones and Marlowe 2002; Walker and Hill 2002). Chimpanzees have an age structure similar to the one suggested for Libben. Humans do not. As noted initially, life-history variation across the mammals is correlated with variation in adult age structures. Life-history differences between chimpanzees and humans add to Howell's reasons to surmise that the Libben cemetery assemblage does not represent the mortality experience of the human population that left the remains.

The difference in adult age structure between chimpanzees and humans is associated with a difference in subsistence dependence of juveniles. When chimpanzee infants are weaned, they become nutritionally independent and forage for themselves. By contrast, although human children can be surprisingly eager and successful foragers at very young ages (Blurton Jones, Hawkes, and O'Connell 1989; D. W. Bird and R. B. Bird 2002; R. B. Bird and D. W. Bird 2002), they continue to depend on others to supply substantial fractions of food after their mothers are investing in a subsequent baby. The subsistence dependence of human juveniles increases with reliance on foods that are difficult for youngsters to exploit efficiently enough to completely feed themselves (for example, Hawkes, O'Connell, and Blurton Jones 1995). In the case of the Hadza, the foraging effort of postmenopausal women affects the nutritional welfare of their grandchildren when the mothers of those children are nursing new babies (Hawkes, O'Connell, and Blurton Jones 1997). The grandmother hypothesis links our age structure and our unusual pattern of bearing the next baby before the previous one is independent. Ancestral human mothers could overlap dependents because they had help.

Sarah Hrdy (1999, 2001) has characterized humans as cooperative breeders. She notes that mothers' commitment to their infants may be conditional on social support. Because we overlap dependent offspring, help

can be crucial, and mothers may face large trade-offs between investment in a newborn and other offspring. That need for support (our relatively short interbirth intervals, Hawkes et al. 1998) would only evolve if help was likely. Short-term variation in the availability of help would make it advantageous for mothers to strategically adjust their commitment to a new baby. Uncertain maternal commitment, combined with the importance of allomaternal help, would also have favored features in infants and toddlers that enhanced their likelihood of attracting investors (Hrdy 1999). By this life-history argument, both the range of helpers and the maternal and infant strategies to assess and to extract help depend on the human age structure. If so, our special form of cooperative breeding is a legacy of the importance of ancestral grandmothers.

Only recently have investigators begun to look at grandmothers' help (Hill and Hurtado 1991, 1996; Rogers 1993; Shanley and Kirkwood 2001; Sear, Mace, and McGregor 2000; Voland and Beise 2002; Leonetti et al. this volume; Jamison et al. 2002; Hames and Draper in press; Lahdenperä et al. 2004). There are important difficulties. For example, senior women distributing their help to maximize its marginal effect might supply most to those kin most in need. Then comparisons between the welfare of juveniles with grandmothers and those without would necessarily underestimate the magnitude of grandmother effects (Blurton Jones, Hawkes, and O'Connell this volume). Assessing the fitness benefits (and costs) that flow through characteristic human age structures is challenging.

## Conclusion

Adult age structure and other life-history characteristics are interrelated across the mammals. The most successful evolutionary models currently available to explain that systematic variation make adult life span the determinant of other life-history variables. If theory that applies to primates in general also applies to us, then our late maturity and slow aging imply that old adult age structures have generally been characteristic of humans. Counterarguments that life expectancies of forty or less imply few elders in past populations are in error. Human populations that experience such high mortality levels nevertheless include large fractions of women past childbearing age.

Claims of discrepant evidence from paleodemography depend on unwarranted inferences from mortuary assemblages about the mortality experience of past populations. Other aspects of the fossil and archaeological evidence are consistent with the hypothesis that old age structures are a feature of our lineage that antedate *Homo sapiens* (O'Connell et al. 1999, 2002;

Hawkes, O'Connell, and Blurton Jones 2003). An especially important clue to our evolutionary history is the persistence of a chimpanzee-like age-specific fertility decline to menopause accompanied by much slower aging in other aspects of our physiology (Hawkes 2003).

Ronald Lee (2003) has developed an evolutionary model of aging in which subsistence contributions to kin (transfer effects), not remaining fertility, can favor lower age-specific mortality rates. We construe this as a formal treatment of elements of the verbal grandmother hypothesis, showing how slowed senescence would have been favored in our lineage under socioecological circumstances that prompted the economic productivity of elders. With increased reliance on foods difficult for young juveniles to handle, elder females unencumbered by their own infants could use their productivity to help provision grandchildren, consequently shifting the age structure and the social organizational possibilities of genus *Homo*.

## Summary

A grandmother hypothesis in combination with Charnov's model of mammalian life-history evolution can explain the long potential life spans, short interbirth intervals, late age at maturity, and midlife menopause that distinguish humans from our closest living relatives. We summarize the model and hypothesis that assumes that low adult mortality is a general characteristic of human populations. Then we examine the implications of large variation in human life expectancies over time, something widely seen as evidence against the hypothesis. Shorter expectations of life in the past are misread to imply that few adults survived to old age. We use model life tables and anthropological demography to show this error. Then we turn to paleodemography. Life tables that depict past human age structures unlike any known for living populations have already drawn skepticism from demographers. Models that highlight patterns of life-history variation across species supply additional reasons for doubt. We conclude that claims of younger age structures in the human past are not well warranted. Current evidence is consistent with the hypothesis of an ancient shift to characteristically human age structures when ancestral grandmothers helped to provision younger kin.

## Acknowledgments

We thank the conference organizers for their patient work and Helen Alvarez, Nancy Howell, Sarah Hrdy, Jim O'Connell, Shannen Robson, and Alan Rogers for advice on earlier drafts.

## References

Alvarez, H. P. 2000. "Grandmother hypothesis and primate life histories." *American Journal of Physical Anthropology* 133:435–50.

Austad, S. N. 1997. "Postreproductive survival." In *Between Zeus and the Salmon*, ed. K. W. Wachter and C. E. Finch. Washington, DC: National Academy Press, 161–74.

Bird, D. W., and R. B. Bird. 2002. "Children on the reef: Slow learning or strategic foraging." *Human Nature* 13:269–97.

Bird, R. B., and D. W. Bird. 2002. "Constraints of knowing or constraints of growing? Fishing and collecting by the children of Mer." *Human Nature* 13:239–67.

Blurton Jones, N. G. 1993. "The lives of hunter-gatherer children: Effects on parental behavior and parental reproductive strategies." In *Juvenile Primates*, ed. M. E. Pereira and L. A. Fairbanks. Oxford: Oxford University Press, 309–26.

Blurton Jones, N. G., K. Hawkes, and J. F. O'Connell. 1989. "Studying costs of children in two foraging societies: Implications for schedules of reproduction." In *Comparative Socioecology of Mammals and Man*, ed. V. Standen and R. Foley. London: Blackwell, 365–90.

———. 1997. "Why do Hadza children forage?" In *Uniting Psychology and Biology: Integrative Perspectives on Human Development*, ed. N. Segal, G. E. Weisfeld, and C. C. Weisfeld. Washington, DC: American Psychological Association, 279–313.

———. 2002. "The antiquity of post-reproductive life: Are there modern impacts on hunter-gatherer post-reproductive life spans?" *American Journal of Human Biology* 14:184–205.

Blurton Jones, N. G., and F. W. Marlowe. 2002. "Selection for delayed maturity: Does it take 20 years to learn to hunt and gather?" *Human Nature* 13:199–238.

Blurton Jones, N. G., L. C. Smith, J. F. O'Connell, K. Hawkes, and C. Kamazura. 1992. "Demography of the Hadza, an increasing and high density population of savanna foragers." *American Journal of Physical Anthropology* 89:159–81.

Bocquet-Appel, J.-P. and C. Masset. 1982. "Farewell to paleodemography." *Journal of Human Evolution* 11:321–33.

Charlesworth, B. 1994. *Evolution in Age Structured Populations*, 2nd ed. Cambridge: Cambridge University Press.

Charnov, E. L. 1991. "Evolution of life history variation in female mammals." *Proceedings of the National Academy of Sciences (USA)* 88:1134–37.

———. 1993. *Life History Invariants: Some Explorations of Symmetry in Evolutionary Ecology*. Oxford: Oxford University Press.

Charnov, E. L., and W. M. Schaffer. 1973. "Life history consequences of natural selection: Cole's result revisited." *American Naturalist* 107:791–93.

Coale, A. J. 1956. "The effects of changes in mortality and fertility on age composition." *Millbank Memorial Fund Quarterly* 34:79–114.

———. 1959. "Increases in expectation of life and population growth." Interna-

tional Population Conference, International Union for the Scientific Study of Population, Vienna, 1959, 36–41.

Coale, A. J., and P. Demeny. 1966 [1983]. *Regional Model Life Tables and Stable Populations,* 2nd ed. Princeton: Princeton University Press.

Coale, A. J., and T. J. Trussell. 1974. "Model fertility schedules: Variations in the age structure of childbearing in human populations." *Population Index* 40:185–258.

Cole, L. C. 1954. "The population consequences of life history phenomena." *Quarterly Review of Biology* 29:103–37.

Crews, D. E., and L. M. Gerber. 2003. "Reconstructing life history of hominids and humans." *Collegium Antropologicum* 27:7–22.

deMenocal, P. B. 1995. "Plio-Pleistocene African climate." *Science* 270:53–59.

Dyson, T. 1977. *The Demography of the Hadza in Historical Perspective.* Edinburgh, Scotland: Centre for African Studies, University of Edinburgh.

Fisher, R. A. 1930. *The Genetical Theory of Natural Selection.* Oxford: Oxford University Press.

Gadgil, M., and W. Bossert. 1970. "Life history consequences of natural selection." *American Naturalist* 104:1–24.

Gage, T. B. 1998. "The comparative demography of primates: With some comments on the evolution of life histories." *Annual Review of Anthropology* 27:197–221.

Goodall, J. 1986. *The Chimpanzees of Gombe.* Cambridge: Harvard University Press.

Hames, R., and P. Draper. In press. "Women's work, child care, and helpers at the nest in a hunter-gatherer society." *Human Nature* 15.

Hamilton, W. D. 1966. "The molding of senescence by natural selection." *Journal of Theoretical Biology* 12:12–45.

Harvey, P. H., and T. H. Clutton-Brock. 1985. "Life history variation in primates." *Evolution* 39:559–81.

Harvey, P. H., and A. Purvis. 1999. "Understanding the ecological and evolutionary reasons for life history variation: Mammals as a case study." In *Advanced Ecological Theory: Principles and Applications,* ed. J. McGlade. Oxford: Blackwell Science, 232–48.

Harvey, P. H., A. F. Read, and D. E. L. Promislow. 1989. "Life history variation in placental mammals: Unifying data with theory." *Oxford Surveys in Evolutionary Biology* 6:13–31.

Hawkes, K. 2003. "Grandmothers and the evolution of human longevity." *American Journal of Human Biology* 15:380–400.

———. 2004. "Human longevity: The grandmother effect." *Nature* 428:128–29.

Hawkes, K., J. F. O'Connell, and N. G. Blurton Jones. 1989. "Hardworking Hadza grandmothers." In *Comparative Socioecology of Mammals and Man,* ed. V. Standon and R. Foley. London: Blackwell, 341–66.

———. 1995. "Hadza children's foraging: Juvenile dependency, social arrangements, and mobility among hunter-gatherers." *Current Anthropology* 36:688–700.

———. 1997. "Hadza women's time allocation, offspring provisioning, and the evolution of post-menopausal lifespans." *Current Anthropology* 38:551–78.

———. 2003. "Human life histories: primate tradeoffs, grandmothering socioecology, and the fossil record." In *Primate Life Histories and Socioecology*, ed. P. Kappeler and M. Pereira. Chicago: University of Chicago Press, 204–27.

Hawkes, K., J. F. O'Connell, N. G. Blurton Jones, E. L. Charnov, and H. Alvarez. 1998. "Grandmothering, menopause, and the evolution of human life histories." *Proceedings of the National Academy of Sciences (USA)* 95:1336–39.

Hill, K., and A. M. Hurtado. 1991. "The evolution of premature reproductive senescence and menopause in human females: An evaluation of the 'grandmother' hypothesis." *Human Nature* 2:313–50.

———. 1996. *Ache Life History: The Ecology and Demography of a Foraging People.* Hawthorne, NY: Aldine de Gruyter.

Hill, K., C. Boesch, J. Goodall, A. Pusey, J. Williams, and R. Wrangham. 2001. "Mortality rates among wild chimpanzees." *Journal of Human Evolution* 39:1–14.

Hoppa, R. D., and J. W. Vaupel, eds. 2003. *Paleodemography: Age Distributions from Skeletal Samples.* Cambridge: Cambridge University Press.

Howell, N. 1976. "Toward a uniformitarian theory of human paleo-demography." *Journal of Human Evolution* 5:25–40.

———. 1979. *Demography of the Dobe !Kung.* New York: Academic Press.

———. 1982. "Village composition implied by a paleodemographic life table: The Libben site." *American Journal of Physical Anthropology* 59:263–69.

Hrdy, S. B. 1999. *Mother Nature: A History of Mothers, Infants, and Natural Selection.* New York: Pantheon.

———. 2001. "Mothers and others." *Natural History* 110:50–64.

Jamison, C. S., L. L. Cornell, P. L. Jamison, and H. Nakazato. 2002. "Are all grandmothers equal? A review and a preliminary test of the 'grandmother hypothesis' in Tokugawa, Japan." *American Journal of Physical Anthropology* 119:67–76.

Kennedy, G. E. 2003. "Paleolithic grandmothers? Life history theory and early Homo." *Journal of the Royal Anthropological Institute (n.s.)* 9:549–72.

Klein, R. G. 1999. *The Human Career: Human Biological and Cultural Origins,* 2nd ed. Chicago: University of Chicago Press.

Konigsberg, L. W., and S. R. Frankenberg. 1994. "Paleodemography 'not quite dead.'" *Evolutionary Anthropology* 3:92–105.

Lahdenperä, M., V. Lummaa, S. Helle, M. Tremblay, and A. F. Russell. 2004. "Fitness benefits of prolonged post-reproductive lifespan in women." *Nature* 428:178–81.

Lee, R. D. 2003. "Rethinking the evolutionary theory of aging: Transfers, not births, shape senescence in social species." *Proceedings of the National Academy of Sciences (USA)* 100:9637–42.

Lovejoy, C. O., R. S. Meindl, T. R. Pryzbeck, T. S. Barton, K. G. Heiple, and D. Kotting. 1977. "Paleodemography of the Libben Site, Ottawa County, Ohio." *Science* 198:291–93.

Nishida, T., N. Corp, M. Hamai, T. Hasegawa, M. Hiraiwa-Hasegaawa, K. Hosaka, K. D. Hunt, N. Itoh, K. Kawanaka, A. Matsumoto-Odal, J. C. Mitani, M. Nakamura, K. Norikoshil, T. Sakamaki, L. Turner, S. Uehara, and K. Zamma. 2003.

"Demography, female life history, and reproductive profiles among the chimpanzees of Mahale." *American Journal of Primatology* 59:99–121.

O'Connell, J. F., K. Hawkes, and N. G. Blurton Jones. 1999. "Grandmothering and the evolution of *Homo erectus*." *Journal of Human Evolution* 36:461–85.

———. 2002. "Male strategies and Plio-Pleistocene archaeology." *Journal of Human Evolution* 43:831–72.

Oeppen, J., and J. W. Vaupel. 2002. "Broken limits to life expectancy." *Science* 296:1029–31.

Olshansky, S. J., B. A. Carnes, and D. Grahn. 1998. "Confronting the boundaries of human longevity." *American Scientist* 86:52–61.

Pavelka, M. S. M., and L. M. Fedigan. 1991. "Menopause: A comparative life history perspective." *Yearbook of Physical Anthropology* 34:13–38.

Pennington, R., and H. Harpending. 1993. *The Structure of an African Pastoralist Community: Demography, History, and Ecology of the Ngamiland Herero*. Oxford: Clarendon Press.

Purvis, A., and P. H. Harvey. 1995. "Mammal life-history evolution: A comparative test of Charnov's model." *Journal of Zoology (London)* 237:259–83.

Purvis, A., A. J. Webster, P.-M. Agapow, K. E. Jones, and N. J. B. Isaac. 2003. "Primate life histories and phylogeny." In *Primate Life Histories and Socioecology*, ed. P. M. Kappeler and M. E. Pereira. Chicago: University of Chicago Press, 25–40.

Rogers, A. 1993. "Why menopause?" *Evolutionary Ecology* 7:406–20.

Sear, R., R. Mace, and I. A. McGregor. 2000. "Maternal grandmothers improve the nutritional status of children in rural Gambia." *Proceedings of the Royal Society of London B* 267:1641–47.

Shanley, D. P., and T. B. L. Kirkwood. 2001. "Evolution of the human menopause." *BioEssays* 23:282–87.

Smith, B. H., and R. L. Tompkins. 1995. "Toward a life history of the hominidae." *Annual Review of Anthropology* 24:257–79.

Stearns, S. C. 1992. *The Evolution of Life Histories*. Oxford: Oxford University Press.

Trinkhaus, E. 1995. "Neanderthal mortality patterns." *Journal of Archaeological Science* 22:121–42.

Voland, E., and J. Beise. 2002. "Opposite effects of maternal and paternal grandmothers on infant survival in historical Krummhörn." *Behavioral Ecology and Sociobiology* 52:435–43.

Walker, P. L., J. R. Johnson, and P. M. Lambert. 1988. "Age and sex bias in the preservation of human skeletal remains." *American Journal of Physical Anthropology* 76:183–88.

Walker, R., and K. Hill. 2002. "Modeling growth and senescence in physical performance among the Ache of eastern Paraguay." *American Journal of Human Biology* 15:196–208.

Washburn, S. L. 1981. "Longevity in primates." In *Aging: Biology and Behavior*, ed. J. L. McGaugh and S. B. Kiesler. New York: Academic Press.

Weiss, K. M. 1973. "Demographic models for anthropology." *Society for American Archaeology Memoirs* 27:1–86.

———. 1981. "Evolutionary perspectives on human aging." In *Other Ways of Growing Old,* ed. P. T. Amoss and S. Harrell. Stanford: Stanford University Press.

Williams, G. C. 1957. "Pleiotropy, natural selection, and the evolution of senescence." *Evolution* 11:398–411.

Wood, B. A., and M. Collard. 1999. "The human genus." *Science* 284:65–71.

**PART II**

# BEHAVIOR
*Modern Outcomes of Past Adaptations*

# CHAPTER 7

# Are Humans Cooperative Breeders?
Ruth Mace and Rebecca Sear

The human life history suggests that human females do not raise their children without help. The human interbirth interval of about three years, in natural fertility populations, is out of line with that of other great apes of similar body size. For example, the orangutan has an interbirth interval of about eight years, and chimpanzee four to five (Galdikas and Wood 1990). Only the gibbon (less than 25 percent of the weight of human) has an interbirth interval of three years. The ape mothers rear their offspring without help. If human females are capable of such rapid reproduction (albeit possibly with a higher rate of infant mortality), most anthropologists agree that this is due to the support they receive from other family members. The "traditional view" has been that this help comes from the father—hence the human pair bond is based on mutual interdependence of husband and wife to raise their children. In hunter-gatherer societies, the division of labor is nearly always such that men bring back meat to the band, whereas women gather. However, the importance of the male contribution to the subsistence of the women and children has been questioned (Hawkes 1990). The observation that calories brought back from gathered foods tends to exceed that from hunting, combined with the fact that meat is nearly always shared widely throughout the band rather than strictly within the nuclear family, have lead to the suspicion that women are not as dependent on men to raise their family as once thought (Hawkes, O'Connell et al. 1997). It is possible that older women, grandmothers in particular, fill that gap. If grandmothers were helping to support their daughter's children, then two unusual features of human female life history—menopause and high birthrates—can be explained in one go. Both arise because menopause is an adaptation to enable grandmaternal support, which in turn enables a high human birth rate.

## Who Supports the Family in Hunter-Gatherer Societies?

How might empirical studies help us to distinguish between these two views of the human family? Empirical studies on hunter-gatherer communities are data limited, due to both the very small number of such societies that survive, and the very small number of individuals living in something ap-

proaching a hunter-gatherer lifestyle within those societies. This may have contributed to the fact that a consensus view on the relative importance of fathers as compared to grandmothers has not emerged.

The main line of evidence in this debate came from nutritional studies. Hawkes et al. (1997) point out that in the Hadza of Tanzania, children with older female relatives in their band are better nourished, and their data suggest that the hunting season is not actually a particularly good time of year for children. Studies on foraging strategies in the Ache of Paraguay and in the Hadza highlight the fact that total calories and energy return rates from gathering often equal or even exceed that from hunting (Hill, Kaplan et al. 1987; Blurton Jones, Marlowe et al. 2000; Marlowe 2003). Isotope studies on prehistorical Californians suggest that male and female diets were so different that they appeared to be almost on different trophic levels (Walker and Deniro 1986); the males appeared to have been living almost entirely off marine resources whereas the females must have been eating food almost exclusively terrestrial in origin. This suggests that food sharing between the sexes was minimal. But Hill (1993) and others have argued that the nature of the food brought back by males is superior and very important, leading them to conclude that the contribution of males to family nutrition is very significant, at least in the Ache. And Marlowe (2003) shows that male provisioning occurs at very important times in the Hadza, such as when women's foraging is handicapped because she recently gave birth. Arctic hunters, like the Inuit, are almost entirely dependent on hunted food brought in by men. In the coldest areas, babies and young children could barely survive outside for much of the year, and thus females are dependent on their spouses for almost everything.

A second line of evidence comes from attempts to measure the impact of kin on components of fitness directly; specifically on fertility and mortality. In this sphere, hunter-gatherer studies are even further handicapped by the lack of data. Demographers prefer sample sizes in the thousands rather than the hundreds to estimate age-specific fertility and mortality rates (and estimates that are not adjusted for age are rarely meaningful). To date, really only one study of a hunter-gatherer group—the Ache—have had sufficient demographic data collected to measure kin effects on fitness (Hill and Hurtado 1996). Using life-history data from several hundred Ache children, Hill and Hurtado find that fathers are very important to child survival, probably largely through their roles as protectors from infanticide. There were very few surviving grandmothers in the Ache population at the time of Hill and Hurtado's study, and so, although anecdotal evidence suggested that grandmothers could play an important role, there was little statistical evidence that grandmothers had much impact on the fitness of their descendants.

All these findings raise the possibility that the ecology of the system influences the relative importance of fathers, grandmothers, and potentially other kin such as siblings or older offspring, in the rearing of human children. This should come as no surprise to behavioral ecologists. The variability in hunter-gatherer ecology further highlights the fact that data from just one type of population cannot answer our initial question: are humans cooperative breeders? We will argue here that it is not necessary or sufficient to restrict our studies to hunting and gathering communities, none of which are necessarily cases of special importance in human history. Furthermore, very few hunter-gatherer studies can generate large enough sample sizes to estimate important determinants of rare events like mortality or low-variance measures like fertility. There are a small number of natural fertility and natural mortality populations for which large sets of demographic data are available, some of which are historical populations. These are now being analyzed to enhance our understanding of which kin have an influence on the fitness of their descendants. Most of these populations are of farmers, but still farmers with high workloads, high disease burdens, and high reproductive rates. Whilst most of these populations are/were growing rather than stable, the same can be said of contemporary hunter-gatherers populations, too. We need to use as much data as is available to us to unpack the full story of the evolutionary ecology of human family life.

## Kin Effects on Components of Fitness in a Range of Natural Fertility/Natural Mortality Populations

When measuring the interdependence of family members, it is studies of how the presence or absence of kin are related to the survival of children or the fertility of women that have provided measures most closely related to biological fitness. There are many studies on the contributions of different kin to child care, to nutrition, and to other aspects of development (Hurtado and Hill 1992; Hewlett, Lamb et al. 2000; Ivey 2000) that contribute greatly to our understanding of social networks and child rearing, and can help us interpret findings from demographic data. However, it is not always easy to determine the extent to which such help enhances the fitness of the beneficiary. So in this review we shall concentrate in particular on studies that have examined specific components of fitness.

Table 7.1 lists some of the studies published to date that have investigated how the loss of either a parent or a grandparent has influenced child mortality in a natural fertility/natural mortality population. Rates of child mortality are usually one of the strongest determinants of a woman's lifetime reproductive success (and are clearly the strongest determinant for the child

concerned!). Therefore the results found in these studies are likely to be a good reflection of how family members influence each other's fitness. However, the results of such analyses still have to be interpreted with caution. Correlational studies are helpful but do of course suffer from the problem of attributing causation. Given that kin can share not only genes but frequently much of the same environment, there is a high possibility that confounding variables, not included in the analysis, are of great significance. Thus, if the absence of certain kin is associated with high child mortality, this is not necessarily evidence of their importance as caregivers. Event history analysis with logistic regression, in which the death of a key relative can be entered as a time varying covariate, can go some way towards alleviating this factor; this is because the change in child mortality risk before and after the death of the relevant kin is estimated, while many of the potentially confounding variables will remain constant over time. Many studies are now employing this technique (taking their lead from Hill and Hurtado 1996), when the quality of the demographic data allow, and we have restricted table 7.1 to those studies that have used this approach or something similar. Multilevel event history analysis can be used to estimate family level variance in mortality and attempt to remove it. This allows the use of the maximum amount of data, because several children from the same family can be included in the same statistical analysis. Sear and colleagues (Sear, Mace, and McGregor 2000; Sear et al. 2002) used this technique to show that mothers, maternal grandmothers, and older sisters all had a positive impact on the survival of children under five in rural Gambia, whereas fathers did not have any measurable effect.

Nonetheless, spurious correlations between the mortality of kin could still emerge. For example, if epidemics or other waves of mortality were to hit family members at the same time, they would cause correlated mortality that was actually independent of the effect of parental care. In a study of early Québec, Pavard et al. (2004) use carefully selected data that excluded peaks of mortality and compared the rates of death in families before and after the death of the mother, to estimate the effect of maternal care. They show that the effect of the death of the mother on her children, especially her daughters, is harmful to their survival prospects for over a decade after her death, and throughout the child's teenage years.

Interpreting the absence of an effect is also difficult. It could be lack of data, or it could be simply that a large number of relatives are important, so no single relative emerges as having a significant impact. Thus, a string of nonsignificant results should not necessarily be taken to mean that mothers are capable of rearing children without help. Relationships based on reciprocal altruism (such as with co-wives) may come into play when kin rela-

**Table 7.1** Studies of the effects of parents and grandmothers (gms) on child survival

| Population and study | Effect of mothers | Effect of fathers | Effect of maternal gms | Effect of paternal gms | Other effects and notes |
|---|---|---|---|---|---|
| Ache (Hill and Hurtado 1996) | + | + | n.s. | n.s. | Maternal and paternal gms not distinguished |
| Gambia (Sear, Mace et al. 2000; Sear, Steele et al. 2002) | + | n.s | + | n.s | Teenage sisters + Divorce − |
| Germany (historical) (Voland & Beise 2002) | Not tested | Not tested | + | Mostly − | Paternal gm − in infants, + in older children |
| India (Khasi) (Leonetti et al. in press & this volume) | Not tested | n.s. | + | Not tested | |
| India (Bengali) (Leonetti et al. this volume) | Not tested | Not tested | Not tested | n.s. | |
| Japan (historical) (Jamison et al. 2002) | + | n.s. | + | Mostly − | Paternal grandfathers − (All effects borderline) |
| Spain (historical) (Reher & Gonzalez 2003) | + | n.s. | Not tested | Not tested | Fathers important for nutrition |
| Bangladesh (Bhuiya & Chowdury 1997) | Not tested | Not tested | Not tested | Not tested | Divorce − |
| Québec (historical) (Pavard et al. 2004) | + | Not tested | Not tested | Not tested | |
| (Beise this volume) | + | + | + | Mostly n.s. but see note | Paternal gm + in 1st month of life. Siblings − |

tionships are absent. Different relatives may be substitutable to at least some extent. It is possible that the death of one relative, such as a grandmother, could cause another relative, such as a father, to greatly increase their level of support; Leonetti et al. (in press) give examples of how husbands' workloads are reduced by the presence of maternal grandmothers. In this way, one helper would share some of the burden of the loss of the other kin

helper with the mother. If such facultative helping does occur, then many of the kin effects that we describe that are estimated by the impact of bereavement could be underestimates of the actual contribution of the relative concerned.

## Who Keeps Children Alive?

While taking the appropriate caution, it is nonetheless possible to examine the results in table 7.1 to enhance our understanding of human families. There are clearly differences between groups and/or between studies in which kin are important. Many studies only address one kin relationship, and different sample sizes mean that effects may not be detected in some studies simply because data quantity or quality does not allow it. However, several clear patterns emerge.

All studies that have examined the relationship have found that mothers have an exceedingly important influence on child survival, especially in the first two years of life. This is not surprising, not least due to the requirement of breast-feeding, but some authors have been surprised at the magnitude of the effect when compared to the effect of fathers, especially in societies where fathers generate more of the household income (Reher and Gonzalez-Quinones 2003). What is of particular interest to our study is the fact that the effect usually declines rapidly with the child's age. Older children are disadvantaged by their mother's death, but children as young as two, who are still hopelessly incapable of independent life, often have a very good chance of survival. In our Gambian study, the survival of children who had lost their mothers after their second birthday was not significantly lower than that of children with mothers (Sear et al. 2002). While a significant effect may well have become apparent had there been more data, it nonetheless emphasizes how other kin are capable of playing a key role in child rearing.

The role of fathers is inconsistent. Most studies have not found much effect of fathers on their children's survival. The Ache are an exception in this regard, possibly due to their role in reducing the risk of infanticide (Hill and Hurtado 1996). Where effects are found, authors generally attribute the father's contribution to socioeconomic status as the key intervening variable. It is possible that the care and domestic labor that is generally provided by mothers is even more important to a child's welfare than the additional material resources often provided by fathers. In polygynous societies, men have the option of spending their resources on attracting additional wives. This could account for some of the cross-cultural variation, for example, the absence of a father effect in polygynous Gambians (Sear et al. 2002), but a significant positive effect of fathers in monogamous, historical Québec (Beise, this volume). In some patrilineal societies like the Man-

dinka in the Gambia, it is common practice for women to marry her husband's brother in the event of her husband's death—thus children and property and the women herself remain within the patriline, from which they should be supported. This could explain why divorce appeared to be more damaging to children's survival prospects than father death in the Gambia (Sear et al. 2002).

It is clear that divorce almost always leads to poor outcomes for child survival. But it is not clear how much of this is due to father absence or to stepfather presence or to mother absence (divorcing women may be unwilling or unable to take children with them) or indeed to the stress and violence of the divorce itself (Bhuiya and Chowdhury 1997).

The role of maternal grandmothers is clearly positive. While renewed interest in the grandmother hypothesis for the evolution of menopause, combined with the difficulty of publishing nonsignificant results, may have influenced the published literature on this topic, it nonetheless appears unambiguous that maternal grandmothers are beneficial to the survival of their grandchildren. The magnitude of the maternal grandmother effect is not as large as the effect of mothers (table 7.2); but the data do seem to suggest that their importance to child survival generally equals or exceeds that of fathers.

The role of paternal grandmothers is less clear. In most studies, their impact is not significant or mixed. This may be in part due to their greater age than maternal grandmothers (due to females reproducing earlier than males) and also to their lower level of genetic relatedness to their patrilineal descendants (due to paternity uncertainty). But there are repeated suggestions not just of no effect but of negative effects, nonsignificant in the case of the Gambia (Sear et al. 2002) but more significant in historical Germany (Voland and Beise 2002) and historical Japan (Jamison et al. 2002). The fact that paternal and maternal grandmothers often have opposing effects may also explain why studies that do not distinguish between the two do not find any effect of grandmothers (such as the Ache study, Hill and Hurtado 1996). Jamison et al. (2002) highlight the possibility that paternal grandmothers in Japan are influenced by concerns of lineage, which means that certain children (such as later-born boys who may be unwelcome competitors for favored male heirs) are particularly disadvantaged, whereas other grandchildren may be supported. Such sex-specific and birth-order biases, which are found in a number of wealth-inheriting societies, would confound attempts to label individual kin relationships as always positive or always negative for child survival. Such grandmothers would, nonetheless, be attempting to promote their lineage, albeit at the expense of certain unfortunate grandchildren.

Finally, there are indications in at least one study (Sear et al. 2002) that

sisters old enough to be helpful caregivers (over ten years old) are enhancing the survival prospects of their younger siblings. Correlational evidence from Bolivian Aymara (Crognier et al. 2002) and Moroccon Berbers (Crognier et al. 2001) also suggest older siblings reduce infant mortality, probably in these cases through economic contributions as well as direct care. But it is hard to generalize about sibling effects, as young siblings are usually in competition with each other for food and parental care, and are frequently detrimental to each others' survival (LeGrand and Phillips 1996). So support from offspring helpers at the nest (which is so significant in communally breeding birds) is unlikely to be the underlying cause of the high human birth rate in the way that support from fathers or grandmothers may be. Nonetheless, for a small window in middle age, older daughters who are not yet reproductive may transfer significant assistance to their mother's children lower down the birth order. This window coincides with a time period when grandmothers are more likely to be dead, so older children could be taking their grandmother's place as alloparents.

In table 7.2 we show relative size of the effect of loss of a relative for each category of kin from our Gambian study (Sear et al. 2002). This is one of the few studies that has looked at all these kin relationships and thus allows relative effect sizes to be compared. Clearly one study does not speak for all, but it is notable that so many of the main effects in other studies are similar in outcome.

**Table 7.2** The effect of the death or absence of a relative on childhood mortality (adapted from Sear et al. 2002) measured by logistic regression using event history analysis. Effect sizes are odd ratios compared to that relative being alive/present (so an OR less than 1 means the death of the kin is associated with lower mortality). Effects controlled for include age, sibling mortality, and village.

| Kin relationship | Effect during infancy (under 1 year old) | Effect during toddlerhood (1–2 years old) | Effect in childhood (2–5 years old) |
|---|---|---|---|
| Mother dead | 6.2** | 5.2** | 1.4 |
| Father dead | 1.1 | 0.5 | 0.7 |
| Maternal gm dead | 1.1 | 1.7** | 0.9 |
| Maternal gf dead | 1.1 | 1.3 | 1.0 |
| Paternal gm dead | 0.8 | 0.8 | 0.9 |
| Paternal gf dead | 1.3 | 0.9 | 0.7 |
| No teenage sister | 1.0 | 1.1 | 1.7** |
| No teenage brother | 0.9 | 1.2 | 1.4 |
| Mother reproduces with new husband | | | 1.9** |

NOTE: Effects reaching statistical significance ($p < .05$) are shown with **.

## Which Kin Influence Female Fertility?

Interpreting kin effects on fertility is even more problematic than interpreting effects on mortality. Reproductive success is a combination of fertility (birth rates and reproductive span) and child mortality. Correlates of reproductive success frequently tell us more about infant mortality than they do about birth rates. Furthermore, infant mortality and birth rate are usually highly correlated for the simple reason that the death of an infant speeds the onset of the next pregnancy. Therefore high fertility is a double-edged sword—it may tell you as much about wasted parental investment as it does about reproductive success. Furthermore, fertility is very heavily dependent on age, so any statistical analyses that do not control for age effects run the risk of becoming severely confounded. Fertility also has many components (age at first birth, several birth intervals, age at last birth). So if, for example, effects on birth interval are small, it should be remembered a woman will have many birth intervals so lifetime effects may be cumulative.

In table 7.3 we present studies that have examined kin effects on specific components of fertility, such as birth interval and age at first reproduction, in natural fertility populations. We only include studies that have attempted to control for both age and prior mortality of infant (if relevant) and have used data based on time series when effects can be precisely associated with the absence of a certain relative. We have not included husbands in this table, as clearly the death of a husband is likely to reduce the birth interval in almost any society (albeit only by nine months in the case of the Gambia [Sear, Mace, and McGregor 2003]).

Data are limited, but it is nonetheless striking that the kin who influence fertility tend to be completely different from those influencing child survival. Whereas maternal grandparents and matrilineal kin in general reduce child mortality, they do not appear to have any significant effect on women's rate of giving birth. Although Bereczkei (1998) uses correlational evidence to argue that elder female siblings do enhance mothers' fertility and Crognier et al. (2002) argue that they correlate with later age at last birth, there are as yet no studies using event history analysis that confirm such findings. Several studies using event history analysis seem to suggest adult siblings can even have a negative effect (Hill and Hurtado 1996; Sear, Mace, and McGregor 2003). However patrilineal kin (husband's parents), who tended to have no effect or a negative influence on child survival, tend to be positively associated with female fertility. Studies report patrilineal kin shortening birth intervals and bringing forward age at first birth. Two studies that examine it show father presence correlated with earlier age at first birth in their daughters, which is an effect in the opposite direction of that generally seen in Western society (Ellis et al. 2003). The effect in the natural fertility

**Table 7.3** The effects of parents[a] and siblings on female fertility in natural fertility populations. ($\pm$ and $=$ are with respect to reproductive success, so $\pm$ means shorter birth intervals and earlier age at first birth).

| Population and study | Life-history variable | Effect of mothers | Effect of fathers | Effect of husbands' mothers | Effect of husbands' fathers | Other effects and notes |
|---|---|---|---|---|---|---|
| Ache (Hill and Hurtado 1996) | Birth interval | n.s. | n.s. | n.s. | n.s. | Adult brothers and sisters – |
| Gambia (Sear, Mace et al. 2003) (Waynforth 2002) | Age at first birth | Not tested | + | Not tested | Not tested | |
| | Birth interval | n.s. | n.s. | + | + | Brothers – |
| Allal et al. 2004) | Age at first birth | n.s. | + | n.s. | n.s. | Brothers + |
| Germany (historical) (Voland & Beise 2002) | Birth interval | n.s. | n.s. | n.s. | n.s. | Mothers and mothers-in-law + on parity progression |
| Caribbean (Quinlan 2001) | Age at first birth | Not tested | n.s. | Not tested | Not tested | Co-resident sisters – |
| India (Khasi) (Leonetti et al. this volume) | Birth interval | n.s. | Not tested | Not tested | Not tested | |
| India (Bengali) (Leonetti et al. this volume) | Birth interval | Not tested | Not tested | + | Not tested | Mothers-in-law + via parity progression |

[a] Parents in this table are the same as maternal grandparents in table 7.1 and husbands' mothers and fathers are the same as paternal grandparents in table 7.1

populations could be through nutrition or political influence on marriage and fertility decisions: in the case of the Gambia we suspect the latter, as children with fathers were no better nourished than those without (Sear, Mace, and McGregor 2000). When bride price is an issue, early marriage of daughters might be the source of funds to pay for the marriage of their brothers or remarriage of their fathers, so the extent to which early marriage is beneficial to daughters is not clear. A study of Pakistani families found that fathers and mothers-in-law wanted women to have more children (irrespective of gender) than did the mothers themselves (Kadir et al. 2003). The data we review here suggests that such preferences from the patriline do have an influence on women's fertility. While these kin effects on fertility are small, what is striking is that they are so diametrically opposite to those found for child mortality.

In cases where residence is patrilocal, the husband's parents do have more opportunity to help directly with domestic chores and income generation; but if this were the root of the effect, it is surprising that it does not equally influence child survival. We suspect the explanation lies in the relative importance of female survival to matrilineal and patrilineal kin. In natural fertility populations, women's optimal reproductive rates are likely to be the result of a trade-off between the benefits of high fertility and the costs in terms of both higher child and maternal mortality. Clearly the death of either mother or child would have a strong negative effect on the inclusive fitness of all kin, but the magnitude of the effect nonetheless differs between matrilineal and patrilineal kin. Children are more closely related to matrilineal than equivalent patrilineal kin by $1/p$ where p is the probability of paternity. Thus in all circumstances except that where $p = 1$, grandparents are more closely related to their daughters' children than to their sons' children. Mothers are not related to their children's patrilineal kin at all. Thus the death of either a child or a mother is weighted differently in the currency of inclusive fitness. In the case of the mother's death, while her children do suffer fitness costs, the husband can continue to reproduce through remarriage; to the matriline she is irreplaceable. Costs of reproduction in women are hard to demonstrate in natural populations, due to phenotypic correlations. But life-history theory (Kirkwood and Rose 1991), experiments on animals (Gustafsson and Part 1990), and careful statistical analyses of human life histories (Doblhammer and Oeppen 2003) show us that they are likely to be real. High birth rates are a gamble that hardy mothers may pull off but weaker mothers and their children will suffer from. It is possible that the negative effects of patrilineal grandparents on grandchild survival are a direct consequence of the effect they exert through pressure on women, or on the women's husbands, to achieve higher fertility. It is notable in our Gambia data that, while those women who had the highest birth

rates of all had the highest rates of infant mortality, they did nonetheless have the largest families of surviving children. Whether this was at some cost to their own longevity remains to be seen.

## What Are the Implications for the Grandmother Hypothesis for the Evolution of Menopause?

The mother and grandmother hypotheses have several forms, all basically asserting that menopause is a kin-selected adaptation allowing older mothers to assist with the rearing of either their children or grandchildren (Williams 1957; Hamilton 1966; Peccei 2001). Packer, Tatar, and Collins (1998) argue that a period of reproductive senescence is inevitable for a period at the end of the life span over which offspring are totally dependant on their mothers for survival; but the data reviewed here suggest that period is only a few years in humans—not enough to explain the twenty years of postreproductive survival that is seen even in hunter-gatherer societies. The other models all weigh the costs of maternal mortality risk at later births against the benefits of parental and grandparental care for existing descendants. Most attempts to build quantitative models in which women can compensate for lost fertility in later life through enhancing the fitness of children and grandchildren have failed to find fitness benefits sufficiently large to favor menopause at age fifty (Hill and Hurtado 1991; Rogers 1993). Shanely and Kirkwood (2001) argue that menopause at a slightly older age could be favored if a range of selective forces are combined: in particular, the impact of mothers on their daughters' fertility and grandchild survival both need to be large. When parameterizing this model with data from the Gambia (Shanley et al. in prep.), we find that parental contributions to daughters' fertility are less important, and that maternal and grandmaternal effects on child survival are important. But again, realistic parameter values still suggest a late menopause is adaptive suggesting that some important effect is missing from the model. However, what this approach highlights is an important point about the relative contributions to fitness of grandmothers and mothers. The loss of its mother clearly has a larger impact on a child's survival chances than the loss of its grandmother, especially in early years; but because adult mortality is so low in humans, the chance of a child losing its mother in early childhood is actually very low. The loss of a grandmother may have a smaller effect on child survival, but the chances of losing a grandmother in early childhood are quite high. Therefore the impact of grandmaternal deaths on population levels of infant mortality is greater than that of mothers, and thus the relative fitness benefits of grandmaternal care are actually more significant than those of ma-

ternal care (Shanley et al. in prep.)—grandmothers give children that competitive edge.

That these quantitative analyses suggest marginal, if any, benefits of menopause at fifty has contributed to a belief that grandparental and parental care are a significant selective force on human longevity but not necessarily on the timing of menopause (Hawkes, O'Connell et al. 1998). Some have argued that the human reproductive span is constrained to something similar to that of a chimpanzee, therefore selection for longevity simply "left reproductive span behind" due to life-history invariants (Hawkes et al. 2000). However, explanations that rely on constraints are somewhat unsatisfactory. If age at menopause is resistant to selection, then we need to be specific about what the constraint might be—and it will need to be a good explanation given that life-history traits are generally very plastic across species. The adaptive logic of models such as Shanley and Kirkwood's (2001) still applies even if life span rather than menopause is the derived trait—we would still expect reproductive span to expand with life span unless specific selective forces were favoring early reproductive senescence. The mathematical framework needed to address these problems continues to develop. A full explanation needs to include both the selective forces on dying as well as the selective forces on reproductive senescence and a reason for the two to differ. Mace (1998) modeled optimal human fertility schedules in an environment that includes competition between children for parental resources and predicted optimal family sizes well below the theoretical maximum; thus reproduction right up to the end of life may not be favored in cases where transfers of this kind are important. Lee (2003) develops such ideas, building on the models of Hawkes et al. (1998) and Kaplan and Robson (2002), to formulate a bioeconomic framework that he uses to argue that transfers (be it of care, resources, or status) from older generations to descendants can select for both longer life spans and unusual schedules of fertility in any social species. Whether elaborations of this model using realistic human parameters can explain menopause more fully than existing models awaits further analysis.

## Conclusions

We have presented evidence that human children benefit from an extended family and that kin support can enhance female reproductive success. While nuclear families can survive and reproduce, they are likely to lose out in competition with those families that can draw on a more extensive network of kin. There are several studies on reproductive success that further support this view, but we narrowed our discussions here mainly to those that

could identify a kin effect on a particular component of fitness so that we could identify differing influences within the family. This reveals that different kin help in different ways. Grandmothers are important, but maternal grandmothers seem to concentrate on offspring survival whereas paternal grandmothers are more interested in increasing birth rates. Both theoretical and empirical evidence is building that caring roles in later life are key to long human life spans.

In summary, there is evidence to suggest that human female reproduction is assisted by other members of her family. In particular, studies show that fathers and grandmothers are important in supporting her reproductive success. When we examine the effects of specific kin on specific components of fitness, we can demonstrate that the contributions of matrilineal and patrilineal kin are very different. Fathers' contributions to child survival are mixed, possibly being more significant in monogamous societies. Maternal grandmothers and other matrilineal kin tend to improve child survival but not female fertility, whereas patrilineal grandparents and male kin tend not to help child survival but do enhance the mother's rate of birth. These different strategies could emerge as a response to different relatedness to the mother because the costs of maternal mortality differ between the two lineages: patrilineal kin are less concerned about women paying the high costs of reproduction associated with high fertility.

## References

Allal, N., R. Sear, A. Prentice, and R. Mace. 2004. "An evolutionary model of stature, age at first birth, and reproductive success in Gambian women." *Proceedings of the Royal Society of London.B* 271:465–70.

Bereczkei, T. 1998. "Kinship network, direct childcare, and fertility among Hungarians and Gypsies." *Evolution and Human Behaviour* 19:283–98.

Bhuiya, A., and M. Chowdhury. 1997. "The effect of divorce on child survival in a rural area of Bangladesh." *Population Studies* 51:57–62.

Blurton Jones, N. G., F. Marlowe, et al. 2000. "Paternal investment and hunter-gatherer divorce rates." In *Adaptation and Human Behaviour: An Anthropological Perspective*, ed. L. Cronk, N. Chagnon, and W. Irons. New York: Aldine de Gruyter, 69–89.

Crognier, E., A. Baali, M.-K. Hilali. 2001. "Do 'helpers at the nest' increase their parents reproductive success?" *American Journal of Human Biology* 13:365–73.

Crognier, E., M. Villena, E. Vargas. 2002. "Helping patterns and reproductive success in Aymara communities." *American Journal of Human Biology* 14:372–79.

Doblhammer, G., and J. Oeppen. 2003. "Reproduction and longevity among the British peerage: The effect of frailty and health selection." *Proceedings of the Royal Society of London.B* 270: 1541–47.

Ellis, B. J., J. E. Bates, et al. 2003. "Does father absence place daughters at special risk for early sexual activity and teenage pregnancy?" *Child Development* 74: 801–21.

Galdikas, B. M. F., and J. W. Wood. 1990. "Birth spacing patterns in humans and apes." *American Journal of Physical Anthropology* 83:185–91.

Gustafsson, L., and T. Part. 1990. "Acceleration of senescence in the collared flycatcher *Ficedula albicollis* by reproductive costs." *Nature* 347:279–81.

Hamilton, W. D. 1966. "The moulding of senescence by natural selection." *Journal of Theoretical Biology* 12:12–45.

Hawkes, K. 1990. "Why do men hunt? Benefits for risky choices." In *Risk and Uncertainty in Tribal and Peasant Economies*, ed. E. Cashdan. Boulder, CO: Westview Press, 145–66.

Hawkes, K., J. F. O'Connell, et al. 1997. "Hadza women's time allocation, offspring provisioning, and the evolution of long postmenopausal life spans." *Current Anthropology* 38:551–78.

Hawkes, K., J. F. O'Connell, et al. 1998. "Grandmothering, menopause, and the evolution of human life histories." *Proceedings of the National Academy of Sciences, USA* 95:1336–39.

Hawkes, K., J. F. O'Connell, et al. 2000. "The grandmother hypothesis and human evolution." In *Adaptation and Human Behaviour: An Anthropological Perspective*, ed. L. Cronk, N. Chagnon, and W. Irons. New York: Aldine de Gruyter, 237–59.

Hewlett, B. S., M. E. Lamb, et al. 2000. "Parental investment strategies among Aka foragers, Ngandu farmers, and Euro-American urban-industrialists." In *Adaptation and Human Behaviour: An Anthropological Perspective*, ed. L. Cronk, N. Chagnon, and W. Irons. New York: Aldine de Gruyter, 155–77.

Hill, K. 1993. "Life history theory and evolutionary anthropology." *Evolutionary Anthropology* 2:78–88.

Hill, K., and A. M. Hurtado. 1991. "The evolution of premature reproductive senescence and menopause in human females: An evaluation of the 'grandmother hypothesis.'" *Human Nature* 2:313–50.

———. 1996. *Ache Life History: The Ecology and Demography of a Foraging People*. Hawthorne, NY: Aldine de Gruyter.

Hill, K., H. Kaplan, et al. 1987. "Foraging decisions among Ache hunter-gatherers: New data and implications for optimal foraging models." *Ethology and Sociobiology* 8:1–36.

Hurtado, A. M., and K. R. Hill. 1992. "Paternal effect on offspring survivorship among Ache and Hiwi hunter-gatherers: Implications for modeling pair-bond stability." In *Father-Child Relations: Cultural and Biosocial Contexts*, ed. B. S. Hewlett. New York: Aldine de Gruyter, 31–55.

Ivey, P. K. 2000. "Cooperative reproduction in Ituri forest hunter-gatherers: Who cares for Efe infants." *Current Anthropology* 41:856–66.

Jamison, C. S., L. L. Cornell, P.L. Jamison, and H. Nakazato. 2002. "Are all grandmothers equal? A review and a preliminary test of the 'grandmother hypothesis' in Tokugawa, Japan." *American Journal of Physical Anthropology* 119:67–76.

Kadir, M. M., F. F. Fikree, A. Khan, and F. Sajan. 2003 "Do mothers-in-law matter?

Family dynamics and fertility decision-making in urban squatter settlements of Karachi, Pakistan." *Journal of Biosocial Science* 35:545–58.

Kaplan, H. S., and A. J. Robson. 2002. "The emergence of humans: The coevolution of intelligence and longevity with intergenerational transfers." *Proceedings of the National Academy of Sciences (USA)* 99:10221–26.

Kirkwood, T. B. L., and M. R. Rose. 1991. "Evolution of senescence: Late survival sacrificed for reproduction." *Philosophical Transactions of the Royal Society of London.B* 332:15–24.

Lee, R. D. 2003. "Rethinking the evolutionary theory of aging: Transfers, not births, shape social species." *Proceedings of the National Academy of Sciences (USA)* 16:9637–42.

LeGrand, T. K., and J. F. Phillips. 1996. "The effect of fertility reductions on infant and child mortality: Evidence from Matlab in rural Bangladesh." *Population Studies* 50:51–68.

Leonetti, D. L., D. C. Nath, et al. (in press). "Do women really need marital partners for support of their reproductive success? The case of the matrilineal Khasi of N.E. India." *Research in Economic Anthropology.*

Mace, R. 1998. "The co-evolution of human fertility and wealth inheritance strategies." *Philosophical Transactions of the Royal Society* 353:389–97.

Marlowe, F. W. 2003. "A critical period for provisioning by Hadza men: Implications for pair bonding." *Evolution and Human Behavior* 24:217–29.

Packer, C., M. Tatar, and A. Collins. 1998. "Reproductive cessation in female mammals." *Nature* 392:807–11.

Pavard, S., A. Gagnon, B. Desjardins, and E. Heyer. 2004. "Mother's death and child survival: The case of early Quebec." *Journal of Biosocial Science.*

Peccei, J. S. 2001. "A critique of the grandmother hypotheses: Old and new." *American Journal of Human Biology* 13:434–52.

Quinlan, R. J. 2001. "Effect of household structure on female reproductive strategies in a Caribbean village." *Human Nature: An Interdisciplinary Biosocial Perspective* 12:169–89.

Reher, D. S., and F. Gonzalez-Quinones. 2003. "Do parents really matter? Child health and development in Spain during the demographic transition." *Population Studies: A Journal of Demography* 57:63–75.

Rogers, A. R. 1993. "Why menopause?" *Evolutionary Ecology* 7:406–20.

Sear, R., R. Mace, and I. McGregor. 2000. "Maternal grandmothers improve the nutritional status and survival of children in rural Gambia." *Proceedings of the Royal Society of London.B* 267:461–67.

———. 2003. "The effects of kin on female fertility in rural Gambia." *Evolution and Human Behavior* 24:25–42.

Sear, R., F. Steele, I. McGregor, and R. Mace. 2002. "The effects of kin on child mortality in rural Gambia." *Demography* 39:43–63.

Shanley, D. P., and T. B. L. Kirkwood. 2001. "Evolution of the human menopause." *BioEssays* 23:282–87.

Shanley, D. P., T. B. L. Kirkwood, R. Sear, and R. Mace. In prep. "Evolution of

menopause: Empirical test of the 'grandmother hypothesis' using data from the Gambia."

Voland, E. and J. Beise. 2002. "Opposite effects of maternal and paternal grandmothers on infant survival in historical Krummhorn." *Behavioral Ecology and Sociobiology* 52:435–43.

Walker, P. L., and M. J. Deniro. 1986. "Stable nitrogen and carbon isotope ratios in bone-collagen as indexes of prehistoric dietary dependence on marine and terrestrial resources in southern California." *American Journal of Physical Anthropology* 71:51–61.

Waynforth, D. 2002. "Evolutionary theory and reproductive responses to father absence: Implications of kin selection and the reproductive returns to mating and parenting effort." In *Handbook of Father Involvement: Multidisciplinary Perspectives*, ed. C. S. Tamis-LeMonda and N. Cabera. Mahwah, NJ: Lawrence Erlbaum Associates.

Williams, G. C. 1957. "Pleiotropy, natural selection, and the evolution of senescence." *Evolution* 11:398–411.

# CHAPTER 8

# Hadza Grandmothers as Helpers
## *Residence Data*
Nicholas Blurton Jones, Kristen Hawkes,
and James O'Connell

Our fieldwork on subsistence ecology among the Hadza suggested to us that grandmothers deserved attention, not only in the anthropology and sociology of the modern world, but also in thinking about remoter times and lifeways (Hawkes et al. 1998; Hawkes and Blurton Jones this volume; O'Connell, Hawkes, and Blurton Jones 1999).

If we propose that postovulatory life evolved because of the help that older individuals can give to younger kin, then we must seek more evidence about the effectiveness of grandmothers' help. Hawkes, O'Connell, and Blurton Jones (1997) showed that grandmothers' work predicted early childhood growth, and other "micro-level" studies will be possible, for example, on transfers of food from grandmothers to others. But these will fall short of testing the demographic effect of grandmothers that we must measure if we are to model the plausibility of grandmother help allowing selection to prolong adult vigor and survival. In a small population such as the Hadza, we may not expect to see effects of the small number of recorded deaths of the older generation upon the small number of recorded deaths of the younger generation. Consequently, we may not expect clear results from the approach so effectively used to demonstrate effects of maternal grandmothers by Sear, Mace, and McGregor (2000) and Beise and Voland (2002). A further complication is that while a dead woman cannot help, a live woman may not necessarily be helping all of her daughters or grandchildren all of the time. Hadza are very mobile and camp compositions change incessantly. An older woman may move from place to place, now helping her older daughter, now her younger daughter, her son, or just visiting her adult siblings. But we might expect older women to move opportunistically, giving help where it enhances their fitness, perhaps taking a rest when their help would be ineffective.

In this very mobile population, we may be able to look for effects of presence or absence of living grandmothers. But it is very important to look first at who grandmothers live with. When help is abundant, it may obscure important features of reproductive strategies (Hill and Hurtado 1996). This would be especially true if a helper such as a grandmother directed her help

where it would be most effective. For example, if a young woman gave birth to more children than she could handle, we might expect her to lose a bigger proportion of them than a more prudent woman would lose. But we might not observe a difference in their children's survivorship if help is diverted from the prudent woman and given to the woman in trouble. Then not only would we see a reduced difference between the prudent and the imprudent women, but we would also see a reduced difference between women with helpers and women without helpers. Using our census records, we have taken a preliminary look at whether grandmothers distribute their help in a way that could have this dampening effect. We might expect grandmothers to help those who would be most affected by their help and those who are closely related, giving the biggest return to the older woman's inclusive fitness. Are older women seen where we would expect them to be if selection had acted on their behavior or preferences via their help in raising children?

Around half the calories eaten by hunter-gatherers come from meat acquired by men. Are older men also important helpers of their adult children? We have argued elsewhere that hunting does not enhance the hunter's fitness by provisioning his children but by wider social routes, for instance, as an advertisement of his quality as a mate or neighbor (Hawkes, O'Connell, and Blurton Jones 2001; see also Bliege Bird, Smith, and Bird 2001). Furthermore, older men have more routes by which to enhance their fitness than do postmenopausal women. Men remain fertile to a much greater age and thus can potentially enhance their fitness by seeking new matings with premenopausal women. Among the Hadza, older men continue to be successful hunters, and many marry younger women and raise a second family with them. Thus we would be surprised if older Hadza men behave like helpers toward their adult children. We will present the data on residence of both older men and older women. But first we must introduce the Hadza, describe our methods, and discuss some issues concerning residence patterns.

## The Hadza

The Hadza are best known from James Woodburn's fieldwork beginning in 1959, initially reported at the "Man the Hunter" meeting and published in 1968. His many subsequent publications seem to us always close to the mark. The earliest reports come from Baumann (1894), and especially Obst (1912) and Kohl-Larsen (1958, based on fieldwork in 1930s). Many Hadza today live in ways that appear to differ little from those described by these authors. But surrounding populations have greatly increased and encroached, and Hadzabe have been subjected to a series of failed settlement

attempts imposed upon them by outsiders. Visits by tourists began in 1995. Despite these events, in 1985–86 farm food comprised only 5 percent of the calories in the diet of the people Hawkes and O'Connell stayed with. In 1995, Marlowe worked in a greater variety of locations, including some very near villages of farmers. The proportion of farm food was very similar (Marlowe, personal communication). We know no Hadza who owns a gun, a horse, a donkey, or a motorcycle or car. Hunting is by bow and poisoned arrows and conducted on foot. The only livestock we have seen with Hadza are a few chickens, which seldom live long. One boy had two dogs for several years. All Hadza are now familiar with researchers and believe that Europeans are interested in them because of their ability to live independently in the bush.

We know only one Hadza who has access to piped water; he works for a European-owned fish farm. The great majority of Hadza live in houses that closely resemble those illustrated in Obst (1912) or Woodburn (1970). These are rapidly constructed out of branches and subsequently covered in grass over the next few days. Camps move frequently; even some of those that nowadays await tourists move often.

All thousand or so Hadza, by definition, speak their mother tongue. Although it includes click consonants morphologically close to those of the Khoisan languages (Maddiosen, Sands, and Ladefoged 1992), linguists have been unable to convincingly link Hadzane to any other African language family (Sands 1998). Recent genetic study suggests that Hadza are very distant from Khoisan speakers (Knight et al. 2003). Most Hadza speak the national language KiSwahili and the language of one of their neighbors (which represent Bantu, Cushitic, and Nilotic languages). Some women speak no Swahili. Many children have some Swahili.

Despite their relatively tumultuous recent history, the daily lives of probably more than 90 percent of Hadza comprise the kind of daily routine described by Obst (1912), Woodburn (1968), and Blurton Jones et al. (2000). Between 7 and 9 a.m. people rise and wait for the cold to wear off. Women sharpen and harden their digging sticks (sometimes helped by their children) and prepare to go out to forage. Men leave, individually, for an early morning "walk about" (hunt) and move to "the men's place," on the edge or just outside camp where those in camp spend the day. Small children face the question of whether their mothers will take them or leave them in the care of an older brother; young teenage girls decide whether to go with the women or stay home and play with the toddlers; teenage boys decide whether to go as "guards" for the women or stay home, often to leave later with a few friends. Between 9 and 11 the children in camp usually do some foraging. Between 11 and 1 they might forage more or eat and play. The temperature reaches its daily high by 1 p.m. At about this time, women who

are in the bush digging tubers gather to cook and eat some of the tubers. They then often spread out and continue digging. Between 1 and 3 everyone who is in camp tends to rest in the shade. Between 3 and 5 the women come home, and children rush to get a share of the food they brought. Between 5 and 7 the temperature has fallen to pleasant levels and most people are at home. Women and children go to fetch water. Children play vigorous games, forage some more, and if there are several teenage girls in camp singing and dancing will begin and last until 9:30 or 10 at night. In late dry season, men will organize and prepare themselves for a cold night in a hunting blind at a nearby water hole or game trail. By 7 p.m. all but the men who left for the night are in their houses and around the fire. People eat an evening meal and then visit and chat at each other's houses and fireplaces. On moonless nights a sacred, ceremonial *epeme* dance may be held in which all participate. Quiet, but for coughs, the occasional crying child, once in a while a noisy domestic dispute, closely investigating hyenas, and distant comforting lions, lasts from late evening until next morning.

## Methods of Data Collection

The observations reported here come from a series of censuses, the first conducted in 1985 by Lars Smith and NBJ (Blurton Jones et al. 1992; Blurton Jones, Hawkes, and O'Connell 2002) and subsequent ones by NBJ, helped in 1995 and 1997 by Frank Marlowe and in 1997 by linguist Bonny Sands.

In each census, we were accompanied by a Hadza field assistant, usually Gudo Mahiya. We tried to visit as many Hadza camps as possible, write down the households and the names of all the people in them including children, with a note about their rough age and parents' names. We also weighed and measured as many people as would agree for a small payment. We found camps by asking people in the first camp where there was another, and so on. Depending on time, funding, and conditions, we covered more, or less, ground. The censuses were not complete, and the number of people seen in each varies.

In addition, from 1992 to 2000 we conducted reproductive history interviews with women aged roughly eighteen to fifty. These were the major source of relative age data used to calculate birth dates. Many historical markers were also used. Especially important was a very large earthquake that every adult remembers and that seismologists date to May 1964, and a set of photographs taken by Kohl-Larsen in the 1930s and brought to the Hadza (along with his films) by Annette Wagner while making her films "Hadzabe heisst wir Menschen" and "Tindiga die da laufen . . ." for SWR's Länder-Menschen-Abenteuer series.

Two settlement efforts interrupted the series. In 1990 the Hadza had been encouraged quite aggressively to assemble at Mongo wa Mono. Only when Tanzanian local government officials visited them with the news that they were under no compulsion to stay at the settlement were the Hadza confident enough to disappear back to the bush. But many stayed, and Mono continues to be an atypically large and stable aggregation of people, mostly people who had traditional ties to the Siponga region in which Mono lies. In October 1986 a brief effort was made by a missionary to have Hadzabe settle at Yaeda chini, site of an extensive settlement scheme in the 1960s. About three hundred people stayed in Yaeda for about a month before returning to the bush. This settlement engendered a measles epidemic in which many children died. The Yaeda gathering is omitted from our analyses: camp lists from after the settlement broke up were available for 1986 and are used. In the present study, lists at Mongo was Mono are used, and in some years these were recorded under the separate "sub-villages" that people assembled themselves into. The same was done when a less formal assemblage gathered at "Sanola" in the mid-1990s. The Hadza were under the impression that the Mono and Yaeda settlements were forced upon them by the government, and they had frightening memories of the 1964 roundup mentioned by Woodburn (1968a). The Sanola gathering was much more spontaneous, though centering around missionary activity, and by this time most Hadza had learned that the government does not these days force people to change their way of life. At each settlement, agricultural food was provided and comprised a temporary attraction to many people. Such settlements attract non-Hadza, especially poachers.

## Some Background on Hadza Residence Patterns

Our approach to residence as fitness-enhancing opportunism contrasts with the wide use of categorizations of residence patterns in anthropology. Hadza men say they have to leave home to find a wife because women like to stay in their home region. We might easily be tempted to categorize the Hadza as matrilocal and use this to "explain" our observations. But as shown in figure 8.2, a young woman does not necessarily live with her mother. Woodburn (1968b) reports that both husband and wife value co-residence with their mothers, but while 43 percent of his sample of 28 married men were in camp with their mother, 68 percent of his sample of 34 women whose mothers were alive were in the same camp as their mother. Alvarez (2003) showed that original ethnographers have often described such variability, conflict, and opportunism in residence patterns, particularly if the patterns were observed rather than reported by informants. Sear, Mace, and McGregor (2000) and Beise and Voland (2002) analyzed data from patrilo-

cal populations but found that only maternal grandmothers affected survival of their grandchildren. The categorization as patrilocal has limited predictive value.

Alvarez pointed out that subtleties evident in the original ethnographies were lost in the widely used codings of residence. The literature using these codings generally reports that most hunter-gatherer populations are patrilocal (for example, Ember 1975). Despite this categorization, Ember showed that hunter-gatherer residence patterns were quite varied. Larger economic contributions by women favored bilocality and matrilocality. Warfare was only a significant predictor of patrilocality when combined with the economic contribution of the sexes. Alvarez indicates that bilocality was more numerous in the data than usually claimed. Alvarez and Ember's papers encourage us to expect observed residence to vary within and between populations depending on economic/ecological factors and especially on the extent to which an older man or woman can actually provide significant help.

Mortality is an obvious practical restraint on residence. Not every young adult has a living mother or father. Figure 8.1 shows the number of females at each age who have a living mother. Figure 8.2 shows the probability that an individual of any age was seen in the same camp as his or her mother. Figure 8.3 shows the average number of daughters aged eighteen or more (and thus likely to soon bear grandchildren for the older person) that an older person has. The graph plots the average number of daughters over eighteen observed to mothers alive at particular ages, and the number

**Figure 8.1** Probability that a Hadza female ("daughter") at each age has a living mother.

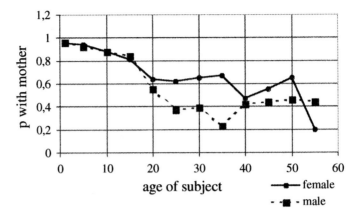

**Figure 8.2** Probability that subject is in camp with his or her mother (if mother is alive) at x age.

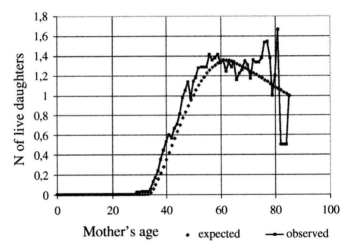

**Figure 8.3** Number of live daughters aged over 18 at mother's age x, observed in censuses and calculated from Hadza age specific fertility and mortality.

expected according to Hadza age-specific fertility and mortality rates. The Hadza population is increasing quite fast (much faster than !Kung [Howell 1979]), so we should not be surprised that the number of live adult daughters substantially exceeds 1.

If an older adult has a living adult son or daughter, where do they live? Eastern Hadza talk of their land as divided into three main regions: Tliika, Siponga, and Mangola, and they occasionally divide off Han!abe, and Munguli. We noted which of these five regions each individual was seen in during each census. Figure 8.4 shows that both men and women are most

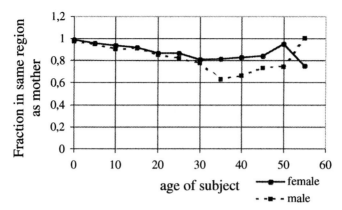

**Figure 8.4** Fraction of observations in which child is in the same region as mother at x age of child. Circles = females. Squares = males.

likely to be seen in the same region as their mother, with very little difference between men and women in this measure. Thus the comment that our informants have made, that men must leave their region to find a wife, can only apply to about 20 to 30 percent of adult men.

## Deriving Some Hypotheses about Where Older People Would Live

We present some hypotheses about with whom we would expect older men and women to live if their help is potentially effective. We only consider cases in which the specified older and younger kin are both alive and recorded in a census. When we say "older woman" or "grandmother," we mean any woman over forty who is alive and whose location was recorded in a census. Our usage is the same for "older man" and "grandfather." When we say "live with" we mean living in the same camp. The older generation does not normally share a house with their adult children. When Hadza move, they may at first simply clear an area under a bush to sleep on and only later take the hour or so needed to construct a house. Camps move, and because people may move individually or as a family, camps change composition quite frequently, at least several times a year, and often every few weeks.

It is important to note that the parents of an adult child often no longer live together. Although some marriages last several decades, divorce is quite frequent. Women do not for long tolerate a bigamous relationship, and so if a man finds a new wife he always leaves his previous wife in the end. This is important for our analysis of residence patterns of older men and women. There is ample opportunity for mother to be with adult child and father to

be elsewhere, or vice versa. In a population with more stable marriages, residence patterns would be more constrained. If grandmother went to live with her daughter, grandfather might have to follow. If grandfather refused to move, grandmother would be unable to live with her daughter. This would be one reason to expect other populations to differ from Hadza residence patterns. Another reason would be the economic contribution of older men and women. If women were able to acquire only small amounts of food, then grandmother's help might best be directed toward babysitting. But then her daughter, although liberated from some child care burdens, will not be able to produce very much more food. Grandmother's contribution, either as babysitter or provider, would be much reduced. In such a circumstance, we would be far less confident of the predictions made below.

Our predictions are derived from the idea that kin selection is a mechanism by which helping can evolve. We do not consider other mechanisms such as reciprocal altruism or costly signaling. Kin selection is believed to underlie parental behavior, and we proceed on the assumption that it is likely to underlie grandparental behavior. Kin selection leads us to expect help to be most often directed to close kin if the benefit to the fitness of the kin, discounted by the degree of genetic relatedness between helper and recipient, exceeds the cost to the fitness of the helper. We expect help to be given most readily to those whose receipt of the help will most enhance the fitness of the helper. This will include giving help to close kin and directing the help where it will have most effect.

Do the older Hadza men and women go where we would expect them to go if they were increasing their fitness by helping their descendants? Three aspects are important in making our predictions:

1. Who will be helped most, who will show the largest increase in fitness as a result of receiving the help? We expect small children to be more affected by help than older children, and we expect help to small children also to allow their mother to divert resources to the next baby and thus enhance her fertility.
2. Who are the closest, and most reliably close kin of the helper? We expect older people to behave in ways that increase their own inclusive fitness and not necessarily in ways that give most help to the most needy. Women can be certain that the babies they bear are their genetic descendents. Men cannot. This concept of "paternity confidence" has been much discussed. In the present instance, while the older man may not be able to be certain that his daughter is his biological descendent, he can be more confident about her children than about his son's children.

3. What are the alternative routes by which the older adults could increase their fitness? We expect older adults to be more helpful if they have few other avenues for increasing their fitness.

Among the Hadza, women are able to acquire and process quite large supplies of food each day, particularly from tubers and Baobab fruit (Hawkes, O'Connell, and Blurton Jones 1997; Blurton Jones, Hawkes, and O'Connell 1997). In a setting where women acquire little, or depend upon men for their economic opportunities, the older women might not be expected to follow our predictions. But the most obvious issue is the physiological difference in fertility of older men and women. Whatever the origins of this difference, it must be expected to affect the fitness payoff to behavior. Older men continue to face a trade-off between pursuit of matings with fertile women and distributing help to their younger kin. But no matter what new husband the postmenopausal women sought out, it would not increase her fertility, although one can imagine ecologies in which marrying the right older man might be an excellent way to enhance the fitness of her younger kin. Among the Hadza, older men are quite often able to marry young women and start new families. This is especially true of older men with reputations for being good hunters. Marrying an older man whose influence could help her young kin is not a widely available option for older Hadza women, however, so we assume that alternatives are available for older men but not for older women. We expect older women to go where their help may be effective. We have a much weaker expectation that men would show the same pattern.

If the behavior of older adults was shaped by its effects on the fitness of their children and grandchildren, we would expect:

1. Grandmothers would more often live in a camp with their daughters than their sons, because their genetic representation in the grandchildren can be more reliably assessed for the daughter's children (improving a daughter-in-law's reproductive success may not increase grandmother's own fitness).
2. Grandmothers would more often stay with daughters who have more small children. Small children are more vulnerable to undernutrition, so we can expect help to be more effective.
3. Grandmothers may even avoid daughters who already have a teenage daughter of their own who can help them. Girls aged ten and over can forage and supervise toddlers quite well, and by fifteen girls acquire and bring home more food than they can eat (Blurton Jones, Hawkes, and O'Connell 1997). If a teenage daughter is an effective helper, then additional help from grandparents may make little difference.

4. There would be no effect of teenage boys. They help a little but also go off on their own a lot, and do much less digging than when they were younger. Teenage boys bring home very little food (Hawkes, O'Connell, and Blurton Jones 1995; Blurton Jones, Hawkes, and O'Connell 1997). Grandparental help may be as important for mothers of teenage boys who also have younger children as it is for any mother.
5. Grandmothers would be expected especially to live in camps with daughters who have a child still suckling (see Hawkes, O'Connell, and Blurton Jones 1997).
6. Older women might be more likely to stay with their son and his wife if his wife had no mother of her own. This young woman, producing probable grandchildren for the older woman, is lacking the help others are expected to get from their mothers. The older woman's help will be especially effective, which may compensate for the less-than-total probability that the grandchildren are her genetic kin.
7. If a woman has a grown daughter who appears to be infertile, we would expect the older woman to live less with her than with her fertile daughters. We assume that help would have zero effect on the fitness of an infertile woman. Her mother would not enhance her own fitness by living with this daughter. Primary sterility is quite low among Hadza: we have records of only seven women who have reached our arbitrary criterion age of twenty-seven without a birth.
8. We have no strong expectation that older men will conform to the predictions we made above for older women. If older men were not pursuing fitness by other means but were behaving as if their help was effective and contributed to their own inclusive fitness, we would expect older men to behave according to the above predictions. But because (1) they have other ways to enhance their fitness, (2) Hadza men's hunting cannot be accounted for by the effect of the food transferred to their offspring (Hawkes, O'Connell, and Blurton Jones 2001), and (3) the rates of divorce do not restrict the older parents to living in the same camp, we do not expect the older men to show the same residence pattern as the older women.

## Results

We examined locations of men and of women over forty with at least one daughter over eighteen recorded in the same census. We scored the number of times they were in the same camp as each other, and the number of times they were in different camps. The preliminary analysis presented in the following tables is perhaps too simple. Some mothers have more than one adult daughter or son; some of the women were seen more often than

**Table 8.1** Results of testing predictions about older women

|  | Mother in camp with | Mother apart from | Chi-square |
|---|---|---|---|
| Daughter over 18 | 339 | 225 | |
| Son over 18 | 243 | 293 | 24.55 $p < .001$ |
| Daughter $> 18$ with under 7s | 199 | 110 | |
| Daughter $> 18$ with no under 7s | 140 | 115 | 5.14 $p < .025$ |
| Daughter $> 18$ suckling C $< 2$ | 154 | 74 | |
| Daughter $> 18$ has no $< 2$ | 185 | 151 | 8.87 $p < .005$ |
| Daughter has teenage daughter | 56 | 52 | |
| Daughter has no teenage daughter | 283 | 173 | 3.86 $p = .05$ |
| Daughter has teenage boy | 59 | 43 | |
| Daughter has no teenage boy | 280 | 182 | 0.18 $p > .70$ |
| Son's wife has no mother alive | 49 | 145 | |
| Son's wife has living mother | 47 | 234 | 5.4 $p < .025$ |
| Daughter $> 18$ is single | 62 | 16 | |
| Daughter $> 18$ is married | 210 | 160 | 14.59 $p < .001$ |
| Daughter $> 18$ with under 7s is single | 24 | 3 | |
| Daughter $> 18$ with under 7s is married | 137 | 91 | 8.7 $p < .005$ |

**Table 8.2** Results of testing predictions about older men

|  | Father in camp with | Father apart from | Chi-square |
|---|---|---|---|
| Daughter over 18 | 188 | 268 | |
| Son over 18 | 134 | 260 | 4.52 $p < .05$ |
| Daughter $> 18$ with under 7s | 101 | 134 | |
| Daughter $> 18$ no under 7s | 88 | 134 | 0.58 $p > .30$ |
| Daughter $> 18$ suckling C $< 2$ | 83 | 97 | |
| Daughter $> 18$ has no $< 2$ | 106 | 171 | 2.78 $p < .10$ |
| Daughter has teenage daughter | 28 | 38 | |
| Daughter has no teenage daughter | 161 | 230 | 0.04 $p > .50$ |
| Daughter has teenage boy | 20 | 44 | |
| Daughter has no teenage boy | 169 | 224 | 3.16 $p > .05$ |
| Son's wife has no mother alive | 20 | 92 | |
| Son's wife has living mother | 23 | 191 | 3.21 $p > .05$ |
| Daughter $> 18$ is single | 42 | 41 | |
| Daughter $> 18$ is married | 113 | 166 | 2.69 $p > .05$ |
| Daughter $> 18$ with under 7s is single | 12 | 11 | |
| Daughter $> 18$ with under 7s is married | 72 | 94 | .805 $p > .30$ |

others in the eight censuses. Tables 8.1 and 2 show results of simple $2 \times 2$ tables testing the first six predictions made above.

The quantitative data on women confirm all of the predictions. As predicted from kin selection theory and the probability that grandchildren are the older woman's genetic kin, older women were more often seen in camp with an adult daughter than with an adult son. Four predictions derived from the idea that smaller children are more affected by help than are older children, and indeed, older women were more often seen in camp with a daughter who had children aged under seven than with a daughter who did not. Older women were seen in camp more often with a daughter who had a child still suckling than with a daughter who was not nursing. Older women were less often with a daughter who had a teenage daughter, potentially an effective helper, than with a daughter who had no teenage daughter. This was not true for teenage sons, as predicted. Our sixth prediction was also confirmed. If a man's wife had no mother of her own to help her, the man's mother was more likely to be in camp with them than if the wife had a living mother. In making this prediction, we assumed that the reduced probability that the grandchildren were really the genetic kin of the grandmother would be more than offset by the effect of her help on their number and survival.

The mothers of five of the seven childless women stayed more with another daughter than with the childless daughter. One of the two exceptions was an older woman living with her childless daughter who was raising the children of her dead sister, her nieces. Thus the older woman was living with her only grandchildren.

The final two comparisons in table 8.1 were engendered by curiosity rather than by reasoned prediction. If a daughter over eighteen was single, even if she had young children, she was more likely to be in camp with her mother than if she was married. These results may mean that a husband's help is useful to Hadza women and that when he is missing (from death or divorce), the wife's mother's help may become more important. But we have already mentioned the conflicting preferences of men and women for living with their own mother. There may also be economic conflicts of interest. Wives may wish to live where they can best obtain food and water. Men may prefer to live where they can best hunt or where the best mixture of successful and unsuccessful rivals are living.

The results on older men produce only one significant association. Men aged over forty who have a daughter aged over eighteen are more likely to live in camp with her than fathers with a son aged over eighteen are likely to live with him. The effect is weaker than for older women but still significant. We mentioned that while there is a less-than-total probability that his children are his genetic descendents, the probability is higher for his

daughter's children than for his son's children. This observation is therefore not totally surprising.

## Discussion

We have reported data about Hadza grandmothers and grandfathers. The seven predictions about grandmothers were supported by the data for older women; only one was significant for the older men. These results generally support the view that grandmothers behave as we would expect if their help makes a difference, they go where their help will most enhance their own inclusive fitness, and as if selection has acted upon them through their effect on their grandchildren's number and survival. Insofar as confirming predictions support the assumptions from which the predictions were derived, then these observations support the view that grandmothers' help does increase their fitness. Alvarez's (2003) proposal that residence patterns are best seen as outcomes of opportunistically strategizing individuals is also strongly supported by these data.

Two results (the older woman is more likely to be in camp with a daughter over eighteen who is single than with a daughter who is married, and with a daughter with children under seven is single than if she is married) may mean that (as Woodburn suggested) there is a conflict of interest between wives and husbands about where to live, or may mean (as most have believed) that husbands are helpers whose missing help it is important to replace. Even if Hadza men can provide help, this seems to have little influence over where they live. We tested the above predictions for men and only one was statistically significant. Furthermore, we have also found that when a mother of young children dies, the children are *less* likely to be seen in camp with their father than if their mother is still alive.

While our results offer indirect support for the grandmother hypothesis, they also confirm that it may be difficult to test whether a grandmother affects the fertility of her daughter and the survival of her grandchildren. She places her help where it is needed, so we will find few data points to make fair comparisons of fertility or mortality in presence and absence of grandmothers. The strategic location of grandmothers illustrates the suggestion made by Hill and Hurtado (1996) that helpers make it more difficult to measure costs and benefits of behavior. If grandmothers go where they are most needed and their help is effective, this will obscure the effects of the "need," and the effects of grandmothers' help will also be obscured because it will have been given more often to those in danger of doing badly. We need to be very careful when we try to test for demographic effects of grandmothers. The above findings were all statistically significant but were fairly weak, so there is plenty of variance to play with although there are many fac-

tors to control for. It may be that in a society where older women are less free to distribute their help where it will be most effective, it would be easier to see effects of grandmother. Among the Hadza, a comparison of daughters with and without their mother's help may tell us partly about their need and partly about their mother's, which may be expected to wash out differences between daughters. But in a sedentary population, mother's help might be allocated by chance not need (or factors unrelated to daughter's need), and we would be better able to see the results of her help. Perhaps this is why Draper and Howell (in press) sees grandmother effects at the later time period studied but not earlier when the !Kung were more mobile.

Our analysis is very preliminary. While we use the data of fifteen years of fieldwork, the analysis of this aspect of the data is only a few months old. We aim for more thorough analyses of the phenomena reported here, perhaps using multilevel modelling statistics. We have many other questions to ask the data. Sometimes children are sent to live with grandmother: can we derive and test some predictions about when grandmother offers this form of help? Who cares for orphans, young children whose mother has died? Some Hadza women tell us they were raised by an aunt after their mother died early. How much do aunts confuse the picture? Is any young woman ever without an older woman who can help her?

## Summary

Our research on the Hadza hunters and gatherers of northern Tanzania has attended to provisioning by postreproductive women and ideas about its possible role in the evolution of the human life history. Here we report some aspects of residence patterns, recorded in a series of censuses spread over fifteen years, and use them to test some hypotheses about grandmothers as helpers and caretakers of children. Our predictions about older Hadza were supported by the data. Older women distribute their help as expected for important caretakers and providers. Older men do not.

### References

Alvarez, H. P. 2003. "Residence groups among hunter-gatherers: a view of the claims and evidence for patrilocal bands." In *Kinship and Behavior in Primates*, ed. B. Chapais and C. M. Berman. Washington, DC: APA.

Baumann, O. 1894. *Durch Massailand zur Nilquelle*. Berlin: Reimer; New York: Johnson Reprint Corp., 1968.

Beise, J., and E. Voland. 2002. "A multilevel event history analysis of the effects of

grandmothers on child mortality in a historical German population (Krummhörn, Ostfriesland, 1720–1874)." *Demographic Research* 7:467–97.
Bliege Bird, R., E. A. Smith, and D. W. Bird. 2001. "The hunting handicap: costly signaling in human foraging strategies." *Behavioral Ecology and Sociobiology* 50: 9–19.
Blurton Jones, N. G., K. Hawkes, and J. F. O'Connell. 1997. "Why do Hadza children forage?" In *Uniting Psychology and Biology: Integrative Perspectives on Human Development*, ed. N. Segal, G. E. Weisfeld, and C. C. Weisfeld. Washington, DC: American Psychological Association.
———. 2002. "Antiquity of postreproductive life: Are there modern impacts on hunter-gatherer postreproductive lifespans?" *American Journal of Human Biology* 14:184–205.
Blurton Jones, N. G., F. W. Marlowe, K. Hawkes, and J. F. O'Connell. 2000. "Paternal investment and hunter-gatherer divorce rates." In *Adaptation and Human Behavior: An Anthropological Perspective*, ed. L. Cronk, W. Irons, and N. Chagnon. New York: Aldine de Gruyter, 65–86.
Blurton Jones, N. G., L. C. Smith, J. F. O'Connell, K. Hawkes, and C. L. Kamuzora. 1992. "Demography of the Hadza, an increasing and high density population of savanna foragers." *American Journal of Physical Anthropology* 89:159–81.
Draper, P., and N. Howell. (in press). "The growth and kinship resources of !Kung children." In *Hunter-Gatherer Children*, ed. B. Hewlett and M. Lamb. New York: Aldine.
Ember, C. R. 1975. "Residential variation among hunter-gatherers." *Behavior Science Research* 10:199–227.
Hawkes, K., J. F. O'Connell, and N. G. Blurton Jones. 1995. "Hadza children's foraging: Juvenile dependency, social arrangements, and mobility among hunter-gatherers." *Current Anthropology* 36:688–700.
———. 1997. "Hadza women's time allocation, offspring provisioning, and the evolution of long postmenopausal life spans." *Current Anthropology* 38:551–57.
———. 2001. "Hadza meat sharing." *Evolution and Human Behavior* 22:113–42.
Hawkes, K., J. F. O'Connell, N. G. Blurton Jones, H. Alvarez, and E. L. Charnov. 1998. "Grandmothering, menopause, and the evolution of human life histories." *Proceedings of the National Academy of Sciences, USA* 95:1336–39.
Hill, K., and A. M. Hurtado. 1996. *Ache Life History: The Ecology and Demography of a Foraging People*. New York: Aldine de Gruyter.
Howell, N. 1979. *Demography of the Dobe Area !Kung*. New York: Academic Press.
Kohl-Larsen, L. 1958. *Wildbeuter in Ost-Afrika: Die Tindiga, ein Jager- und Sammlervolk*. Berlin: Dietrich Reimer.
Knight, A., P. A. Underhill, H. M. Mortensen, B. M. Henn, D. Louis, M. Ruhlen, and J. L. Mountain. 2003. "African Y chromosome and mtDNA divergence provides insight into the history of click languages." *Current Biology* 13:464–73.
Maddioson, I., B. Sands, and P. Ladefoged. 1992. "East African click languages." Paper presented at the Twenty-third Annual Conference on African Linguistics, East Lansing, MI.

Obst, E. 1912. "Von Mkalama ins Land der Wakindiga." *Mitteilungen der Geographischen Gesellschaft in Hamburg* 26:3–45.

O'Connell, J. F., K. Hawkes, and N. G. Blurton Jones. 1999. "Grandmothering and the evolution of *Homo erectus.*" *Journal of Human Evolution* 36:461–85.

Sands, B. 1998. "The linguistic relationship between Hadza and Khoisan." In *Language, Identity, and Conceptualization,* ed. M. Schladt. Koln: Rudiger koppe.

Sear, R., R. Mace, and I. A. McGregor. 2000. "Maternal grandmothers improve nutritional status and survival of children in rural Gambia." *Proceedings of the Royal Society of London.B* 267:1641–47.

Woodburn, J. C. 1968a. "An introduction to Hadza ecology." In *Man the Hunter,* ed. R. B. Lee and I. DeVore. Chicago: Aldine, 49–55.

———. 1968b. "Stability and flexibility in Hadza residential groupings." In *Man the Hunter,* ed. R. B. Lee and I. DeVore. Chicago: Aldine.

———. 1970. *Hunters and Gatherers: The Material Culture of the Nomadic Hadza.* London: British Museum.

# CHAPTER 9

# The Role of Maternal Grandmothers in Trobriand Adoptions

Wulf Schiefenhövel and Andreas Grabolle

A possible avenue for grandmothers to increase their inclusive fitness is to adopt one or more of their grandchildren and thereby become totally responsible for their well-being. Following evolutionary logic, whereby two grandchildren reaching reproductive age represent the same reproductive success as getting one of one's own children to that stage, this would be an effective way of investment, especially in cases when the offspring of one of the grandmother's daughters were in less favorable conditions, for example, insufficient food and other material elements for physical survival as well as less loving care for psychological well-being. Both might be consequences of paternity uncertainty, which would reduce the husband's inclination, and perhaps also that of his wife, the child's biological mother, to invest in her or him the same way they do in others where paternity is more certain. The Trobriand data presented here back this evolutionary scenario.

For the Inuit, Silk has reviewed the anthropological literature and states: "Close kin participate in adoptive transactions more often than distant kin, and most children go [to] their parents' siblings or their parents' parents. Grandparents often adopt children born to their unmarried daughters" (1987a, 324). For Polynesian societies, well-known early on in ethnography for the frequency (up to 31 percent of the children, Silk 1980) and ease with which adoptions were conducted, there is no specific mention of grandparents, or grandmothers in particular, as common or preferred adopters (Rivers 1914; Goodenough 1970; Carroll 1970; Marshall 1976; Brady 1976; Silk 1987b; Betzig 1988; Silk and Boyd 1997; for Trobriand society, Powell [1969] found a 31 percent adoption rate and in Bell-Krannhals' 1990 study, 20 percent of all children were adopted).

Matrilineal Trobriand society represents a very interesting cultural experiment and a test case for evolutionary theory, especially with regard to the role of the maternal grandmother, or *momo*, for alloparenting and adoption, as to give away one's child, very often the firstborn, to momo is the most frequent channel of adoption in this Austronesian people.

## Cultural Overview

Kiriwina, Kaileuna (where our study was carried out), Kitava, Vakuta, and a number of smaller islands are part of the Trobriand group and share culture and, with dialect differences, language. They are situated in the Solomon Sea, north of the eastern tip of Papua New Guinea, and form part of Milne Bay Province with Alotau as capital. Losuia (longitude 151° 05' east and latitude 8° 33' south) on Kiriwina is the location of the government and police station, here are also a small wharf for coastal ships, the Kiriwina Subdistrict Hospital (headed by a health extension officer—no qualified doctors have been there for many decades), the Kiriwina High School, the headquarters of the Protestant Church (that of the smaller Catholic Church is at nearby Gusaweta), the few main shops, and a local market. As of 2000, there were approximately 35,000 Trobriand Islanders; population growth is, as in other areas of Papua New Guinea, very dramatic.

First Austronesian immigrants may have settled on the Trobriand Islands several thousand years ago. It is likely that at this time that the region was already inhabited by a Papuan speaking population, as islands much farther away from mainland New Guinea were settled as early as 23,000 BP by Papuan speakers. There are clear traces of Papuan genes on the Trobriand Islands and on islands in the wider vicinity (Kayser et al. 2000). Only preliminary archaeological surveys have been carried out so far; the earliest dates determined (Excavation Report 1999) range around 1000 BP. A legend of a man-eating giant and a young hero born from a woman who was left behind when the others fled the inhospitable place may represent the clash of the early Papuan population and the Austronesian newcomers.

Bronislaw Malinowski conducted his groundbreaking fieldwork among the Trobriand Islanders, mainly in Omarakana, the village of the paramount chief, between 1915 and 1918 for a total of twenty-three months. Much of what he described in his major works (1922, 1926, 1927, 1929, 1935) is still basically true today; for his neglect of the important roles of women in Trobriand society, see Weiner 1976; for his misjudging frequency and ways of adoption, see Bell-Krannhals 1990; for a criticism of some of his accounts on sexuality, see Schiefenhövel 2004.

Despite acculturation that has set in, particularly on the main island Kiriwina, since around 1900, most Trobriand Islanders still are subsistence farmers (digging stick horticulture), and, depending on the distance of their villages to the sea, collectors of marine food. The women usually gather shellfish and other small animals and plants on or near the reef while the men employ various methods of fishing. Fish and shellfish are the most

important sources of protein; occasionally domesticated pigs are eaten, especially during festival ceremonies. Hunting feral pigs, birds, and a few species of marsupials does not play an important nutritional role.

Relevant for the context of this study is the fact that there is, apart from rare bad harvest years or personal mismanagement of garden work, no shortage of food on Kaileuna Island. This is quite in contrast to Kiriwina, the main island, where overpopulation has led to shortening fallow cycles and thus less yield. Provided that people work reasonably well in the garden, collect a moderate amount of marine resources, and have a normal relationship to helping kin, they don't suffer nutritionally. In this respect Kaileuna is, therefore, probably quite different from other regions of the world and from periods of evolutionarily relevant historic times.

Another spectacular element of Trobriand culture, centering on exchange and reciprocity, is the ceremonial *kula* exchange of two types of valuables, *soulava* necklaces and *mwali* armshells, which are circulated clockwise and counterclockwise in a quasi circle representing various islands in the Solomon Sea (Malinowski 1922; Leach and Leach 1983). To become a successful participant in the *kula* is highly prestigious for a man and requires a well-developed sense of entrepreneurship and social competence. The competitive nature of Trobriand culture becomes obvious in the *kula* for men and in the *kayasa* harvests and the *lisaladabu* exchange carried out by the women.

## Gender Relationships and Social Structure

Descent is matrilinear, as in many other Austronesian societies. That is, a couple's children will inherit the clan of their mother. This is of particular importance with regard to chieftainship; succession of chiefs is usually via sister's sons. Land, on the other hand, is primarily passed on in the patriline. Trobriand society, thus, is matrilineal with respect to genealogical descent but patrilineal for land rights and some other aspects. Residence is virilocal, that is, a newlywed couple will usually live in the village of the husband. For the birth of the first child and often also for that of consecutive children, the women move back to their own mother's household, which not uncommonly means leaving the village of their husbands for some months (in case of the first birth, this includes a long postpartum seclusion) or weeks. Women have, especially compared to other Melanesian societies, a pronounced public role (especially during the *sagali* funeral ceremonies), but they do not make political decisions for the whole community, which is the exclusive function of male chiefs. Trobriand matrilineality, therefore, has not led to matrifocality or matriarchy.

Women and men are expected to take gender-specific roles typical for this traditional society with regard to the division of labor and the concept that both sexes are basically and necessarily different and, at the same time, in a psychosocial and cosmological sense, complementary to each other. Both adult men (except very few who say that they are not interested in women) and women plan to be married and to have children; most of the women of reproductive age are married. To be an unwed mother is socially acceptable, however: 21 percent of all mothers had at least one child while they were not married. Trobriand society was exclusively heterosexual, but male homosexuality and pedophilia have been introduced through white expatriates.

Quite many marriages are without children, most likely due to gonorrhea and other sexually transmitted diseases such as lymphogranuloma venereum and chlamydiasis. Some younger men have come to Schiefenhövel to be treated for gonorrhea, but they chivalrously resisted naming their sexual partners, so only very few women were given penicillin injections and generally only a small proportion of the gonorrhea-infected subpopulation was sufficiently treated. The first white administrator of the Trobriand Islands, R. L. Bellamy, who was also a medical doctor, established a hospital at Losuia with the outspoken aim to combat sexual diseases (Bell-Krannhals 1990, 34), a move that, according to government records, was successful. It remains unclear how this was possible in pre-sulphonamide and pre-antibiotic times; possibly antimony and mercury compounds were used. It is, thus, very likely that STDs have been a problem for Trobriand people since the early contacts with sailors, whalers, and traders, especially the ones who were in the then and now lucrative bêche-de-mer business: sea cucumbers shipped as aphrodisiac to Chinese ports. The STD problem is particularly important in the context of this paper because infertility is partly responsible for the high rate of adoption.

Adult women's and men's roles do not change very much during the span of their lives, except in very old age, when some of them become helpless and frail yet seem to remain in remarkably good mental health. There are a number of persons well over eighty in the village of Tauwema (for age estimates, see below). Women beyond menopause (which they seem to reach without complaint—at least none that I heard from several thousand patients) are seen to have slightly more male characteristics in the way they look and behave than younger women, but there is no marked change in their behavior or lifestyle. Some elderly ladies have quite an elegant, dignified flair around them and many postreproductive women are esteemed for their role as providers of food, producers of mats and other useful things as well as conductors of ceremonies. Men can exercise their roles as village

leader *(tokarevaga)* or fully fledged chief *(guyau)* until they die; here lies one of the differences with the big men system of the Papuan societies where these functions are tied to vitality and performance—an archaic form of meritocracy vis-à-vis Trobriand aristocracy.

## Parental and Other Caretaker Roles

A quantitative study on infant caretaking (Schiefenhövel 1991; Schiefenhövel and Schiefenhövel 1996) demonstrated that the biological mother is by far the most important person in the life of babies until they are weaned. (Weaning typically takes place when the child is around two years old with a wide individual variation; weaning age and the period of postpartum sex taboo has gone down markedly in recent times to as little as one year, resulting in more children being born.) There is a high degree of physical body contact during the day (around 60 percent) and to an even greater extent during the night, when babies sleep beside their mothers. Measuring body movements via actimeters revealed that mothers synchronize their nocturnal and, to a lesser degree, their diurnal activities closely with that of their infants. That is, the baby's unrest, cries, or other signals are answered almost immediately with very competent intuitive parenting (Siegmund, Tittel, and Schiefenhövel 1995). The average duration of infant cries is about 30 seconds; taking the child into body contact or breastfeeding successfully soothes the infants. Infants spend around 20 percent of their daytime hours at the breast, not only drinking but also suckling for psychological comfort. There is no special weaning food. To become separated physically as well as psychosocially from their mother causes, therefore, the first trauma in the lives of infants; some of the weanlings cry more often than they did before weaning and feel generally quite miserable. Weaning is the time when grandmothers play a very important role as effective allomothers—at a period when the baby's stress level is otherwise high. We have seen quite many recently weaned infants developing upper respiratory tract infections and other diseases (regarding the role of grandmothers as medically knowledgeable curers, see the discussion section below).

All grandparents, irrespective whether matriline or patriline and whether grandfather or grandmother, are termed *tabula* in Kilivila, the language of the Trobriand Islanders (we follow the orthography laid down in Senft 1986), and it is interesting that this is also the word for grandchildren. In this case, therefore, a relationship across two generations is expressed by this single two-directional term. For other relationships, for example, that between parents and their children, monodirectional terms apply (for example, *inala* mother, and *latula*, child).

## Demography

Since the begin of our interdisciplinary field project on Kaileuna Island in 1982, demographic data are included in this analysis were mainly collected by Ingrid Nina Bell-Krannhals (1990), Renate Krell, Karin and Klaus Grossmann (Grossmann et al. 2003), Gerhard Medicus (1996), and Wulf Schiefenhövel. Entering the field data into the genealogical "Reunion" software program and carrying out statistical work was the task of Christian Berger (and Schiefenhövel 1994) and Andreas Grabolle (2000). Interviews with informants were carried out in Kilivila or English; a number of informants speak basic English, and to collect or check demographic data does not require a large vocabulary, so the work done in English can be considered reliable, especially as genealogical and demographic data were frequently cross-checked. For a number of children and adolescents, the date of birth was known because someone in the family/clan had noted it down on a piece of paper (some persons can read and write) and kept it, usually in the family Bible. These data were, as we were able to verify, very reliable. In the last decade, some mothers had health cards with the date of birth issued by the hospital in Losuia; mistakes on those cards were small, as we could judge from those cases where birth happened while we were in the village. In other cases, ages were estimated according to dentition in younger people. Since the amount of time between children's births is usually well-established, birth intervals (usually around three years for biological children) was another important method of arriving at matched age estimates. Older people gave us their approximate age at the time when World War II was raging in the Pacific, including the Trobriand Islands (1943–45). During the war, the Americans built a very large landing field near Losuia, currently the islands' only airport. We produced a demographic file for each person that contains all relevant information, including adoption data. In total, 729 persons were included in this study.

## Adoptions

In the studied sample, there were 111 cases of adoption and 8 cases of stepparenthood. The ratio of adopted children was 27 percent, and 95 percent of the adopted children were born after 1964 (Grabolle and Schiefenhövel 2001). The sex ratio of adopted children was balanced: in 57 cases the adopted child was a girl, in 54 cases a boy. Six children were adopted twice, that is, the first adoption agreement was, for some reason or other, dissolved, so the child left one household and joined another one. Usually, children were adopted when they were still infants, in most cases just after weaning when they were around two years old (weaning age has declined in

the last decade as discussed above), but in some cases adoption took place when a child/adolescent was much older. Mean age at adoption was 5.9 years, and the oldest child at adoption was 20 years old. We have included children/adolescents of up to 16 years old as possible adoptees because this is more or less the age until which they are dependent on their families for subsistence support.

The motive for a person to take care of an older adoptee is often to have a help with the daily chores and to have someone who will take care of her/him in older age, and, especially and interestingly, "to have somebody to bury me," when the adopting person does not have relatives who can be expected to perform the traditional funeral rites (*sagali*). These motives are also described in ethnographic accounts by Silk (1987a, 327) for the Inuit.

The reproductive period, measured as age at birth of a child of the youngest (fifteen) and oldest (forty-five) mother in our sample is thirty years; for this analysis 245 births to 72 mothers were included. The average age for first birth was 21.3 (standard deviation 3.8); the oldest primipara was thirty-three years old. In the postmenopausal age group between forty-eight and fifty-six years old, women had an average of 5.2 living children; the figure for men was 5.6.

One of the hypotheses we tested was that children would be given away for adoption more frequently when an unusually large number of members in a family had to be fed; this turned out not to be the case (n = 37, p = .4009, z = −0.251, Wilcoxon test for matched samples, one-sided). The food situation on Kaileuna is actually quite good in most years, due to the facts that the island still has enough fertile soil and that the coral sea with its rich array of foods is so close.

In families where one parent died or left (for example, due to divorce) significantly more children were given away for adoption (21 of 109, p = .0304, Fisher's test). There were twenty-four mothers (21 percent) who were unmarried at the time of birth of at least one of their children. Surprisingly, those children were not significantly more often given away than the ones born in an existing marriage (n = 114, p = .8208, Fisher's test): 47 percent of mothers with "legitimate" children gave one of them away for adoption, whereas 50 percent of the unwed mothers did so.

Childlessness as a motive to adopt one or more children is very common. Trobrianders often say that having children is a very important part of their lives. It is, therefore, not surprising that being without children is a prime reason to adopt a child. There are a number of such marriages in Tauwema where this was observed. One of our main associates and his wife had adopted three children because they did not have offspring of their own. Some years ago, the couple divorced and the husband had, much to his joy, a biological child with his new wife. Another couple, neighbors in the vil-

lage, also did not have any children of their own and had, at last census, adopted five children, one from the elder sister of the wife, the others from other relatives. We tested the general hypothesis that adoptions should take place more often when fewer biological children were in the family. This turned out to be the case (n = 105, p = .0388, z = −2,1, Kendall's rank correlation). Childlessness or having, by Trobriand standards, too few children can, therefore, lead to adopting a child.

Another important issue is whether women who give away a child for adoption are increasing their reproductive success by thus shortening the interval to their next birth. Some Kaileuna women said that they weaned babies whom they planned to be adopted a bit faster than the others. We found a trend towards reduced birth intervals in women who gave away children for adoption ($n_1$ = 33, $n_2$ = 31, p = .0524, z = −1.6, Mann-Whitney-U test, one-sided). The difference between the intergenetic intervals of children given away for adoption to their next sibling and children who stayed with their biological mother and their sibling was not significant either ($n_1$ = 55, $n_2$ = 136, p = .4529, z = −0,1, Mann-Whitney-U test, one-sided).

In stark contrast to adoption strategies of couples in western countries who often get babies from unknown families and even from other, usually poor countries, Trobriand adoption follows a clear kin pathway: 81 percent of adopters were related at least on the r = 0.125 level with the child. With an increasing degree of relatedness, the likelihood that an adoption would occur increased; this result was a bit below statistical significance (n = 111, p = .0648, z = 1.8, Kendall's rank correlation). Only 10 percent of the adopted children were not (according to our data; the actual figure may be even a bit smaller as we might have missed some more distant kinship ties) related to the adopting parents. Relatives of the matriline were much more often adopters (78 percent of all cases) than those of the patriline (22 percent); this result was statistically highly significant (n = 65, p < .0005, z = 6.7, binomial test, one-sided).

Two results are particularly interesting: (1) the high rate of *firstborn children* given away for adoption (42 percent of all adoptions) and (2) the very high preference of the maternal grandmother to adopt firstborn children (58 percent of all adoptions by momo, see table 9.1). Women in our sample had 5.2 children on average. Momo, therefore, has this number to chose from, but she clearly prefers the firstborns. If one assumes the less favorable case that 30 percent (instead of an estimation of 20 percent) of all children are firstborns, then momo choosing firstborns is highly significant (chi-square [df1] = 9.08, p < .01); similarly, the general preference of firstborns versus later-borns as adoptees is significant (chi-square [df1] = 8.18, p < .01), but the ratio of firstborns versus later-borns in the other adopters group is not (chi-square [df1] = 1.5, n. s.).

**Table 9.1** Preference of maternal grandmothers to adopt the firstborn child of their daughters

|  | Momo | Other adopters |  |
|---|---|---|---|
| Firstborn children | 19 | 31 |  |
| Later-born children | 14 | 55 |  |
| Total | 33 | 86 | 119 |

NOTE: Chi-square = 4.537, p < .05; see text

Generally very high is the percentage of maternal grandparents as adopters (sixty cases) vis-à-vis paternal grandparents (five cases); this difference is, therefore, highly significant (p = .0005, z = 6.7, binomial test, one-sided). Our informants named momo as adopter in thirty-three cases and mofa in twenty-seven cases. It is likely that in quite a number of these adoptions, both grandparents were still alive and that, therefore, both would be seen as the new parents of the adopted child. There is an obvious growing patrilineal tendency in Trobriand society; father's names are generally chosen as family/second names, which are needed for modern administrative purposes, despite the matrilineal descent rule that regulates clan membership. Also, men, rather than women, are much more often mentioned, for example, in the demography interviews, as head of the family. It is therefore very likely that mofa was mentioned as adopter even though his wife (momo) was alive and involved in the decision process leading to adoption. She would definitely be more involved in the actual taking care of the grandchild than her husband. We did not test the family situations at the time of adoption, so it remains uncertain whether the high rate of mofa as "official" adopters is due to a male bias when it comes to naming family heads or whether men are also such frequent adopters when they no longer have a wife. In all likelihood, the ratio of momo as the main provider of care for the adopted child is underrepresented in the 33:27 adoption ratio. A fascinating aspect of this data set is that our informants told us in one of the last field stays about a particular cultural rule among Trobriand Islanders that clearly specifies that young mothers should give their firstborn child to be adopted and raised by their own mothers. The analysis of the demographic data carried out for this paper reveals that this is exactly what people are still doing today.

Trobrianders handle adoptions in a psychologically competent way. As in other Pacific societies (Silk 1980, 815), children are separated from their biological parents immediately after weaning—the earliest possible point in time. Good mutual attachment is thereby more likely to be achieved than when adoptions take place later in the child's life. The adoptees are always

fully aware of their biological parents, and the process of including an infant into the new household is gradual and takes the child's reactions very much into account. Should she or he refuse various gentle attempts to become a member of the new family, the adoption is halted or even reversed. In by far the majority of cases, the process works very well. As one informant told Nina Bell-Krannhals, *"bivagi latugu iga bitoveka inala tamala bipeki,"* (the child will then become my child, and when he grows a bit older he won't have a desire any more to live with his mother and father.) The children are given new names that gradually replace their former ones (Bell-Krannhals 1990), so that also in this respect the adoptee acquires a new identity without shedding the old one completely.

## Discussion

In this volume, possible roles of postreproductive grandmothers in increasing the fitness of their offspring are discussed. In evolutionarily relevant times, it was probably very important for a young mother to have a person to whom she could turn in times of crisis, particularly when one of her children was seriously sick. We saw this very clearly in a case of the birth of premature twins of a young Trobriand mother; the infants would not have survived without the self-sacrificing twenty-four-hour care provided by momo and mofa. The cumulative experience of older women regarding disease and ways to cure is still a very valuable asset in many traditional and even modern cultures. It might have been exactly these critical periods in the lives of the grandchildren that made the postmenopausal grandmother an evolutionary success story, as a child's chances to survive a life-threatening disease would greatly benefit from her knowledge and dedication. One of us (Schiefenhövel) has repeatedly witnessed grandmothers in Melanesian societies taking complete charge in situations where serious illness befell one of her grandchildren; the diagnostic intuition and the ability to judge competently the state of the sick child were impressive. To our knowledge, there is no analysis yet on this function of grandmothers as curers in traditional societies, a survival-securing function that may be as important for their grandchildren as providing food, especially as the question of whether Paleolithic grandfathers were more important food suppliers than grandmothers is still debated (see the introduction of this volume).

Another historically and cross-culturally possibly quite common way to ensure the well-being of grandchildren is to adopt them. This study shows that Trobriand culture uses this option frequently. It is not surprising that in a matrilineal society adoptions in the matriline are by far the predominant mode. But the fact that momo is so often the adopter of her daughter's

children is noteworthy and gives weight to the arguments for an evolutionary role of postreproductive grandmothers discussed in this volume.

In Trobriand society, children who were born while their mother was not married do not seem to be perceived as a problem. In any case, they are not more often given away for adoption than others (cp. the opposite in Inuit society, Silk 1987a). From our observations in the villages, it seems that often these unmarried women are supported by their own kinfolk well enough to make up for the economic input of a husband and his family. Yet there are also cases where unwed mothers have a harder time making ends meet than married ones.

We have not seen on the Trobriand Islands lactating grandmothers feeding a grandchild, yet this phenomenon of being able to breastfeed without prior pregnancy is well known (Silk 1990, 33). One case was documented in another region of Papua New Guinea by Schiefenhövel.

To give one's firstborn child away for adoption is a scenario quite foreign to our custom, which attaches special significance to the firstborn not only with regard to inheritance rules but also, and particularly, in the realm of psychosocial reactions and values. For the socioecological world of the Trobrianders, on the other hand, their custom could represent a sensible adaptive choice: as young, unmarried people have the freedom to have love affairs (which require a lot of circumspect courtship, go-betweens, and so forth), it is possible that some firstborn children may not have been fathered by the man who is the legal husband at the time of their birth. The fact that so many firstborn children are given away for adoption and the interesting cultural rule that they should preferably be adopted by momo may well reflect this situation and compensate for a possible lack of investment by the woman's husband and/or perhaps also the woman herself.

For the argument put forward here, it is not necessary that individual husbands know or suspect that the first child born in their marriages may not be their own offspring (in stark contrast to Malinowski's [1929] statement, Trobrianders know and most likely have always known that intercourse is a necessary element in causing pregnancy, cp. Schiefenhövel 2004). It is probably sufficient that this kind of scenario (a young woman having more than one partner before marriage) happens more or less regularly; this may have prompted Trobriand culture to develop the specific rule that momo should routinely adopt the firstborn child of her daughter and thereby counteract a possible tendency of his or her parents to underinvest. A similar scenario, namely that of women having to handle a trade-off problem between their mate value versus investment in illegitimate children, has been described by Voland and Stephan (2000). If this strategy to

avoid underinvestment were an important one in prehistoric and contemporary societies, the other possible fitness-increasing benefits of grandmothers might prove less important, for example, their effect on shortening birth intervals of their daughters. In our study, this effect was slight when women's interbirth intervals were measured and even less strong when the intergenetic intervals between the given-away children and the ones born after them are taken into account.

The second offspring in a Trobriand marriage (in contrast to societies were virginity is stressed) is more likely to be the husband's own child, as the mild premarital promiscuity is much reduced in married couples. Momo is, therefore, the ideal candidate to raise the firstborn child in a culture that does not stress premarital virginity, provided momo does not have to take care of one of her own children at that time. But that is not likely because she would be just around the age of menopause when her first grandchild is born (first births occurred at an average of 21.3 years, last recorded birth at 45), and she would still be vital and an ideal surrogate mother. This form of adoption flow from daughter to mother may also represent a symbolic gesture: making one's own child one's sibling establishes a new biological-cultural relationship and gives life back to one's mother in return for being given life by her. This interpretation was suggested by Peter Neumann (personal communication) and has not been verified by our Trobriand informants themselves.

One might argue that a reason for a grandmother to adopt the firstborn child of her daughter (or daughter-in-law in this argument) could be that, as in the animal kingdom, young mothers have more problems giving birth and taking care of their firstborn infant compared to later-born ones. Yet this does not explain the Trobriand setting, as mothers there manage (with lots of competent and unobtrusive help from allomothers, including especially momo, but also famo, husband, siblings, and so forth) the most difficult period of breastfeeding and other care in the first one-and-a-half to two years on their own; it is after this critical time period that mothers give the healthy infant away for adoption. Avoiding negative effects of paternity uncertainty seems, therefore, a better explanation for the specific Trobriand custom of adopting firstborns. This view is also backed by the fact that adoption occurred significantly more often when one parent died or left, for example, after divorce: an intact nuclear family with a father able and willing to invest into his own children is obviously seen by Trobrianders as providing the best chances for offspring survival.

Other cultures, especially those that have, in contrast to Trobriand society, developed concepts like multiple paternity (see Hrdy this volume), represent a different environment, triggering different biopsychic and social responses. The Trobriand momo raising the firstborn (and possibly other

children) of her daughter provides a strong argument for the "cooperative breeder" hypothesis (Hrdy 1999).

The high rate of Trobriand infants adopted by momo (29.7 percent of all adoptions) represents a special and interesting case for the reconstruction of evolutionary models that can help to explain the appearance of long-lived postreproductive females some time in the process of hominization. Our data show, on the other hand, that grandfathers also fit the scenario of an adaptive long human life span with investment into their grandchildren via the role of institutionalized alloparent, as mofa was almost as often named adopter of his daughter's children (24.3 percent of all adoptions) as momo (although see above for possible overrepresentation of the grandfather due to a new patrilineal trend in Trobriand society).

The paternal grandparents had a strikingly less important role as adopters and thereby institutionalized alloparents (famo: 3.6 percent, fafa: 0.9 percent). In the Trobriand sample, by far the majority of these grandparental as well as other adoptions are taking place in the matriline. This marked asymmetry could be a general human pattern, shaped by varying degrees of uncertainty of fatherhood (for married couples in the Trobriand population, we estimate this to be low, a few percent perhaps). Or it could be typical only of a matrilinear society: comparable data are not yet available from patrilineal societies to discussion the question. Notwithstanding this necessary cross-check, it seems to us that the preference adopting maternal mothers have for the firstborn children of their daughters suggests that paternity uncertainty played an important role as evolutionary motor.

The net gain of alloparenting is often difficult to assess. Whether "helping at the nest" behavior is adaptive or not is therefore by no means always clear. For adoption (a special case of helper behavior) there is, according to Thierry and Anderson (1986), a remarkable gap in primate societies between actual data and the role adoption has in sociobiological theorizing. Hypotheses to explain which factors may have led to developing and sustaining adoption behaviors are as numerous as they are equivocal. Yet the Trobriand example fits well an evolutionary scenario in which grandmothers became, as their life spans went up, increasingly more important for the survival of their grandchildren and who were, possibly, in many cases culturally institutionalized allomothers and "cooperative breeders" as they adopted the children of their daughters, thereby becoming totally responsible for their well-being and placement in society. This strategy probably worked especially well in societies that did not stress premarital virginity and thus had a certain amount of uncertainty as to the fatherhood of a man's firstborn children. Those are the ones Trobriand maternal grandmothers, following an old custom, take care of—an example of *secundam naturam*: a cultural norm following evolutionary biology.

## Summary

Trobriand Islanders, as other ethnic groups in Oceania, are known to freely adopt children. In this study, demographic and genealogical data were collected over a time span of almost two decades in the village of Tauwema on Kaileuna Island, Trobriand Islands, Papua New Guinea, and the ratio of adopted versus non-adopted children was 27 percent. In contrast to adoption in Western societies, children are given away to be raised by close relatives: in the matrilineal culture of the Trobrianders mostly in the matriline. One reason for adoption is infertile marriages, a problem most likely created by the introduction of venereal diseases after early contact with whalers, bêche-de-mer collectors, and traders more than one hundred years ago.

A striking feature of Trobriand adoption is that the maternal grandparents, especially the maternal grandmother (momo), so frequently raise offspring of their daughters. This is most often the case with firstborn children (58 percent of all adoptions by momo). We argue here that the mild form of premarital promiscuity typical for Trobriand society creates a higher amount of paternity uncertainty for the firstborn child in a marriage than for the later-born ones, as marital fidelity is highly valued, albeit not always achieved. This may lead to a tendency to underinvest in the firstborns. This is counteracted by a specific Trobriand custom (still followed to large degree today) that stipulates that firstborn children should be given to momo for adoption. This strategy to avoid underinvestment in firstborns would be, we think, typical for societies that don't stress premarital virginity. At the same time, this cultural rule gives maternal grandmothers (in line with Hrdy's cooperative breeder hypothesis) a very important role as institutionalized permanent allomothers, who thereby contribute decisively to their daughters' and their own fitness. We suggest that our Trobriand data represent an evolved adaptive pattern that can explain, perhaps better than effects on shortening birth intervals in their daughters, the evolution of the long-lived postmenopausal grandmother.

## Acknowledgments

We thank Ingrid Nina Bell-Krannhals and also Renate Krell, Karin and Klaus Grossmann, and Gerhard Medicus for collecting demographic and genealogical data. Thanks are also extended to Eckart Voland and Athanasios Chasiotis for many valuable comments. We are especially grateful to those Tauwema women and men who have spent countless hours carefully and patiently explaining the intricacies of Kaileuna family ties; they are the

ones who have provided the basic data for this paper and deserve our sincere thanks: *amatokisi sena kweveaka!*

## References

Bell-Krannhals, I. 1990. *Haben um zu geben: Eigentum und Besitz auf den Trobriand-Inseln, Papua Neuguinea.* Basel, Swtizerland: Wepf and Co.

Berger, C., and W. Schiefenhövel. 1994. "Adoption in Tauwema, Trobriand Inseln, Papua Neuguinea." Poster paper, first International Congress, Gesellschaft für Anthropologie, Universität Potsdam.

Betzig, L. L. 1988. "Adoption by rank on Ifaluk." *American Anthropologist* 90: 111–19.

Brady, I., ed. 1976. *Transactions in Kinship: Adoption and Fosterage in Oceania.* ASAO Monograph no. 4. Honolulu: University of Hawaii Press.

Carroll, V., ed. 1970. *Adoption in Eastern Oceania.* ASAO Monograph no. 1. Honolulu: University of Hawaii Press

Excavation Report. 1999. *The Archaeology of the Trobriand Islands, Milne Bay Province, Papua New Guinea.* Visby, Sweden: Gotland University College.

Goodenough, R. 1970. "Adoption on Romonum, Truk." In *Adoption in Eastern Oceania,* ed. V. Carroll. ASAO Monograph no. 1, Honolulu: University of Hawaii Press, 314–40.

Grabolle, A. 2000. "Zwischen Evolutionsbiologie und Kulturanthropologie: Adoptionspraxis auf den Trobriandinseln." Diploma thesis. Humboldt University, Berlin.

Grabolle, A., and W. Schiefenhövel. 2001. "Adoptionsentscheidungen in Trobriand-Familien." In *Homo: Unsere Herkunft und Zukunft,* ed. M. Schultz, K. Atzwanger, G. Bräuer, K. Christiansen, J. Forster, H. Greil, W. Henke, U. Jaeger, C. Niemitz, C. Scheffler, W. Schiefenhövel, I. Schöder, and I. Wiechmann. Proceedings, 4. Kongress der Gesellschaft für Anthropologie (GfA), Potsdam, September 25–28, 2000. Göttingen: Cuvillier Verlag, 155–58.

Grossmann, Karin, Klaus Grossmann, A. Keppler, M. Liegel, and W. Schiefenhövel. 2003. "Der förderliche Einfluß psychischer Sicherheit auf das spielerische Explorieren kleiner Trobriand Kinder." In *Spiel und Kreativität in der frühen Kindheit,* ed. M. Papousek and A. von Gontard. Stuttgart: Klett-Cotta, 112–37.

Hrdy, S. B. 1999. *Mother Nature: A History of Mothers, Infants, and Natural Selection.* New York: Pantheon.

Kayser, M., S. Brauer, G. Weiss, P. A. Underhill, L. Roewer, W. Schiefenhövel, and M. Stoneking. 2000. "Melanesian origin of Polynesian Y chromosomes." *Current Biology* 10, no. 20: 1237–46.

Leach, J. W., and E. Leach, eds. 1983. *The Kula: New Perspectives on Massim Exchange.* Cambridge: Cambridge University Press.

Malinowski, B. 1922. *Argonauts of the Western Pacific: An Account of Native Enterprise and Adventure in the Archipelagoes of Melanesian New Guinea.* New York: E. P. Dutton.

———. 1926. *Crime and Custom in Savage Society*. New York: International Library of Psychology, Philosophy, and Scientific Method.
———. 1927. *Sex and Repression in Savage Society*. New York: Meridian Books.
———. 1929. *The Sexual Life of Savages in Northwestern Melanesia*. London: Routledge and Kegan Paul.
———. 1935. *Coral Gardens and Their Magic: A Study of the Methods of Tilling the Soil and of Agricultural Rites in the Trobriand Islands*. 2 vols. New York: American Book Co.
Marshall, M. 1976. "Solidarity or sterility?" In *Transactions in Kinship: Adoption and Fosterage in Oceania*, ed. I. Brady. ASAO Monograph no. 4. Honolulu: University of Hawaii Press, 28–50.
Medicus, G. 1996. "Brutpflegehilfe, kindliche Geschwisterbetreuung und Puppenspiel, eine humanethologische Feldstudie." In *Ethnomedizinische Perspektiven zur frühen Kindheit*, ed. C. E. Gottschalk-Batschkus and J. Schuler. Berlin: Verlag für Wissenschaft und Bildung, 235–40.
Powell, H. A. 1969. "Genealogy, residence, and kinship in Kiriwina." *Man* 4: 177–202.
Rivers, W. H. R. 1914. *The History of Melanesian Society*. Cambridge: Cambridge University Press.
Schiefenhövel, S., and W. Schiefenhövel. 1996. "Am evolutionären Modell: Stillen und frühe Kindheit bei den Trobriandern." In *Ethnomedizinische Perspektiven zur Frühen Kindheit*, ed. C. Gottschalk-Batschkus and J. Schuler. Berlin: Verlag für Wissenschaft und Bildung, 263–82.
Schiefenhövel, W. 1991. "Ethnomedizinische und verhaltensbiologische Beiträge zur pädiatrischen Versorgung." *Curare* 14:195–204.
———. 2004. "Trobriands." In *Encyclopedia of Sex and Gender: Men and Women in the World's Cultures*, 2 vols., ed. C. R. Ember and M. Ember. New York: Kluwer Academic/Plenum, 912–21.
Schiefenhövel, W., and I. Bell-Krannhals. 1986. "Wer teilt, hat Teil an der Macht: Systeme der Yams-Vergabe auf den Trobriand-Inseln, Papua Neuguinea." *Mitteilungen der Anthropologischen Gesellschaft in Wien (MAGW)* 116:19–39.
Senft, G. 1986. *Kilivila: The Language of the Trobriand Islanders*. Berlin: Mouton de Gruyter.
Siegmund, R., M. Tittel, and W. Schiefenhövel. 1995. "Untersuchungen zur Eltern-Kind-Interaktion im Aktivitäts- und Ruheverhalten an Bewohnern der Trobriand-Inseln (Papua Neuguinea)." *Wiener Medizinische Wochenschrift* 17/18: 464–67.
Silk, J. B. 1980. "Adoption and Kinship in Oceania." *American Anthropologist* 82: 799–820.
———. 1987a. "Adoption among the Inuit." *Ethos* 15:320–30.
———. 1987b. "Adoption and fosterage in human societies: Adaptations or enigmas?" *Cultural Anthropology* 2:39–49.
———. 1990. "Human Adoption in Evolutionary Perspective." *Human Nature* 1: 25–52.

Silk, J. B., and R. Boyd. 1997. *How Humans Evolved.* New York: W. W. Norton.
Thierry, B., and J. R. Anderson. 1986. "Adoption in anthropoid primates." *International Journal of Primatology* 7:191–216.
Voland, E., and P. Stephan. 2000. "The hate that love generated: Sexually selected neglect of one's own offspring in humans." In *Infanticide by Males and Its Implications,* ed. C. P. Van Schaik and C. H. Janson. Cambridge: Cambridge University Press, 447–65.
Weiner, A. B. 1976. *Women of Value, Men of Renown: New Perspectives in Trobriand Exchange.* Austin: University of Texas Press.

## CHAPTER 10

# Kinship Organization and the Impact of Grandmothers on Reproductive Success among the Matrilineal Khasi and Patrilineal Bengali of Northeast India

Donna L. Leonetti, Dilip C. Nath,
Natabar S. Hemam, and Dawn B. Neill

The role of grandmothers in the reproductive success of their offspring is thought to have made a critical contribution to the success of our species and to the evolution of longer lives in humans, often including many post-menopausal years. Being a critical helper in the reproduction of the younger generation during these years could have been the selective force in prolonging life (Hawkes, O'Connell, and Blurton Jones 1998). With the development of human societies along differing family organizational and economic pathways, this supporting role may have been constrained by social and economic aspects of its ecological context. Beise and Voland (2002) have called for research on groups with differing family systems after finding positive effects of the maternal grandmother and negative effects of the paternal grandmother on child survival in historical data from Germany. They suggest that grandmothers may have pursued differing strategies according to the type of relationship of the grandmother to the mother, given the local socioeconomic system. As Hames and Draper (in press) have pointed out, the helping response is dependent upon ecological context. Opportunities must be right for the helping response to occur and to be effective and are also likely to structure the strategy grandmothers follow.

This paper examines the grandmother role in two ethnic groups in northeast India: a patrilineal society of Bengalis in southern Assam, where the paternal grandmother plays the predominant role, and a matrilineal society of Khasis in eastern Meghalaya, where the maternal grandmother is the predominant helper. In these two groups where women have very different kinship, social, and economic positions, we explore dimensions of contemporary expressions and strategies of grandmotherhood with respect to effects on measures of reproductive success in their offspring's generation.

In the system of patriliny studied here, males control resources and are gatekeepers of access to resources for females. In this way, female depen-

dency is intensified. With patrilocality, male investment versus paternity-certainty issues are resolved by a high level of control over women's movements and, accordingly, sexual access to her. The husband and his mother have no genetic interest in the wife, who can be replaced by another should she fail to reproduce successfully. In the system of matriliny studied here, females have control of and direct access to resources and have choice regarding sexual access. Males variably attach themselves to women's households and their land, offering their labor contributions that may be seen as mating effort. The woman's mother has a sure genetic relationship to her daughter and her daughter's children.

Although both live at a low socioeconomic level and are monogamous, these groups differ dramatically in their cultural, kinship, and economic systems. The Bengali restrict female mobility and activities, with women being confined to their own homes and their immediate neighborhood. They do not go to the market nor work in the fields although they apply themselves to tasks such as winnowing and kitchen gardening. Marriages are arranged, and the woman joins her husband's household to be supervised by her mother-in-law, providing paternity and grandmaternity certainty. Women may not remarry, so this further increases their dependence for reproductive success on their husband's family. Dowries and bride prices rarely figure in these arranged marriages since the group is so poor. Men control all property and dominate selling and buying in the markets. In addition, a Hindu religious ideology sanctifies male dominance and female submission and chastity.

In contrast, Khasi women own property and run the markets. They also work the fields, run businesses, and work for wages although many are housewives. Marriages are based on "love" attachments, and courtship is particularly active at festivals. When a woman marries, the husband usually but not always joins her household. In any case, he is expected to provide labor and income. She often continues to reside with her mother until one or two children are born and then is expected to move into her own household in the same village, often in close proximity to her mother. She may marry serially more than once. The youngest daughter is expected to stay with her mother and inherit the house and spiritual headship of the lineage. Although Christianity has become common among the Khasi, ancient traditions of ancestor worship have honored both female and male matrilineal clan founders with megalithic monuments.

Among both Bengali and Khasi, demand for children is high, although contraceptive use has begun in both populations: 19 percent among the Bengali and 18 percent among the Khasi have any history of use. In both populations, women's work is labor intensive and their nutritional status can be poor. Therefore, a reproductive-age woman's energetic capacity to pro-

duce and raise children may be marginal and dependent on her culturally constrained access to help and resources.

Both groups occupy low positions in the Indian social hierarchy: most of the Bengali belong to the scheduled caste and the Khasi are a scheduled tribe ("scheduled" is an Indian government designation for the lowest status groups). Resources available to both groups are generally very low. Total income in our study samples from all sources is somewhat higher on average for Bengali households at (mean ±SD) $979 ±1,071 than for Khasi at $726 ±495 per year. The median income for Bengali households, however, is lower at $556 compared to $622 per year for Khasi households.

Among the Bengali, the mother-in-law/daughter-in-law relationship is central, and among the Khasi, it is the mother/daughter relationship. These situations obviously entail differing genetic interests by the grandmother in the woman she helps. Among the Bengali, a mother-in-law is expected to be more exploitative of her daughter-in-law since the daughter-in-law's welfare may be secondary to the mother-in-law's interest in having grandchildren. Conversely, among the Khasi, a mother is expected to be more solicitous of her daughter's welfare, given that the daughter is the preserver of her own genes and her conduit to genetic continuity and success.

Given these differences in social organization and ecology, grandmother effects on fertility and survivorship and growth of children are contrasted between the groups. Available household resources and the mother's and grandmother's physical condition are also considered in multivariate analyses. Specific work contributions by grandmothers and mothers are a focus of the research to see if they have independent effects on child growth.

## Methods

The samples are community based. Bengali and Khasi villages were selected for study based on road access to groupings of villages. All women who had borne at least one child were asked for an interview after obtaining permission from village headmen. Women of reproductive age (age fifty years or less) were targeted, and 617 Bengali (497 with no history of contraception) and 664 Khasi (543 with no history of contraception) women participated in the study. Only those with no history of contraception are included in the fertility analysis. The data for children of all of the women are used in the analyses of child mortality of those born between 1980 and 2000 (2,069 Bengali children and 2,545 Khasi) and child growth of those less than seven years of age (816 Bengali and 1,039 Khasi).

One issue is the comparability of the two samples with regard to sample selection bias with reference to marital status of the women. Since Bengali

women usually do not remarry after their husbands die, widows may have been overlooked in the recruitment process. Custom requires that women in these situations, considered very inauspicious, stay in the background. Widowhood, however, would be fairly rare for women in their prime childbearing years. Were widows included, their effect would tend to lower Bengali fertility and nutritional status of the women and their children, and possibly increase offspring mortality, further separating the two ethnic groups in the directions shown in our analysis. Thus our findings can be considered conservative from the perspective of this issue.

Questionnaires were designed to elicit comparable data between the two ethnic communities but also were tailored to their differing kinship systems. Topics covered were household composition and socioeconomic characteristics, reproductive histories of the women, and child mortality. The data from household records and reproductive histories were checked for internal consistency.

The grandmother targeted in the Bengali sample was the woman's mother-in-law and in the Khasi sample the woman's own mother. The grandmother's living status at the time of each birth was recorded as well as her current living and residential status. Her current general health (good, average, poor) and work-activity capability (high, medium, low, disabled) were recorded. Women with grandmothers in poor condition (that is, eighty years of age or older, in poor health, or disabled) comprised 13 percent of the Bengali women, 22.5 percent of these due to old age. Among the Khasi, the association of grandmothers with youngest daughters with respect to shared residence suggests the possibility of older grandmothers with reduced capacities being less helpful to these daughters. However, only 3 percent of Khasi women had grandmothers in poor condition (4.4 percent of youngest daughters and 2.1 percent of older daughters, not significant [ns]), 75 percent due to old age. Thus the Bengali women appear to carry a greater burden of grandmothers with compromised vigor at younger ages.

The percentages of women with a living grandmother for their children at the time of their first births were 69 percent for Bengali and 89 percent for Khasi women. For those with a currently living grandmother, the percentages were 50 percent for Bengali and 76 percent for the Khasi. Currently residing in a household where the grandmother was present were 32 percent of Bengali women and 22 percent of Khasi women. Thus the Bengali were more likely to have deceased grandmothers but also more likely to have grandmothers living in the same household than the Khasi. This was partly a function of the age of marriage of Bengali sons, who are older than Khasi daughters at the time of marriage. The Bengali grand-

mothers (median age sixty-two) were therefore relatively older than the Khasi grandmothers (median age sixty) or more likely to be deceased.

Bengali grandmothers are expected always to live with one of their sons. Sons commonly divide the household soon after a second son marries, so very few households (less than 5 percent of our sample) have more than one reproductive-age woman in them. In these cases, only data from one of the women picked at random was used in the analysis. The Khasi also expect, although this practice is not always followed, that all but the youngest sister will move out of their mother's home. Some youngest daughters also establish separate homes and some older daughters stay or return to live with the grandmother. This movement of daughters leads to the low percentage of women with co-resident grandmothers.

To observe their effects on children's growth, we measured the work effort of mothers and grandmothers. We used a questionnaire (designed after Paffenbarger, Wang, and Hyde 1978) that listed thirty-eight activities normally accomplished in northeast Indian households and placed them in three categories: subsistence production, domestic, and child care work efforts. The list was compiled by one of the authors who is a native of the region (Nath) and confirmed through interviews with local cultural consultants. The mother and grandmother were asked which activities they pursued and how often, and if this activity was seasonal or done throughout the year.

Each activity is weighted with its relative kilocalorie cost (Paffenbarger, Wang, and Hyde 1978). Strenuous activities are weighted at 10.0 (that is, aerobic movement, heavy lifting—examples are plowing, digging). Moderate activities are weighted at 7.5 (that is, standing, active but not strenuous—examples are meal preparation, sweeping). Light activities are weighted at 5.0 (that is, sitting with some movement—examples are feeding, watching children) and very light activities at 2.5 (that is, lying down with some movement—an example is lying with a sleeping child). The frequency (daily, 365; weekly, 52; monthly, 12; less often, 3) is multiplied by the weight and seasonal performance (multiplied by 0.25 per season). The resulting figure is labeled kcal units per year. This approach can provide rough, but most importantly also relative, estimates of activities for large numbers of subjects. These estimates are found to be correlated with women's age, self-reported general level of activity (heavy, moderate, light), and number of children in the household under five years of age (Leonetti 2002). The measures of work effort are rough, and the weighting of the activities is not independently validated but assigned from published data. The weights may be too high given the results of field studies such as that by Dufour (1984). The intent, however, is not to measure energy use exactly but to provide a relative indicator of activity level and most importantly to

specify the types of activities in which different persons engaged. A full published report based on Leonetti (2002) is in preparation.

Heights of mothers were measured with a steel anthropometer. All mothers and children less than seven years of age were weighed on digital scales. BMI (body mass index) is a measure of adiposity and was calculated for the mothers as weight/height$^2$ (kg/m$^2$). Weights for children were converted to weight for age and sex z-scores based on National Center for Health Statistics (NCHS) standards using their program EpiInfo6. The scores provide a measure for each child that is relative to the NCHS reference value for children of the same age and sex. A negative measure indicates the child is below the standard and a positive one above the standard. This conversion allows direct comparison of all children in the sample, removing variance due to gender and current age (WHO 1995). In the present text, the terms "weight" or "growth" wherever used refer to these scores.

## Analysis

Outcome variables of interest in relationship to grandmother effects are the number of live-born children, the number of surviving children, the number of infant and child deaths per woman, the risk of dying for individual children born between 1980 and 2000, and growth (weight) of children under seven years of age. Cox proportional hazards models were used to analyze risk of dying and multiple regression analysis for numbers of live-born children, numbers of surviving children, infant and child deaths per woman, and child weight. Analyses were controlled where appropriate for sex and birth order of child, year of birth, mother's age (to adjust fertility measures and also because children of younger mothers may be more likely to have living grandmothers), mother's condition (height, weight, and BMI), grandmother's condition, and socioeconomic characteristics of the household. In analyses where data on more than one child from a particular mother were used, robust estimates of the standard errors were used to adjust for this lack of independence among subjects. The general linear model provides adjusted means, standard errors, and confidence intervals (CI). Unadjusted means are presented with standard deviations.

## Results

### Mother's Condition and Marital Status

The Bengali women range from ages 17 to 50 years with a mean of 30.6 ±6.1 (median 30) for the total sample and the same for the non-contracepting subset. The Khasi are ages 16–50 years with a mean of 31.6 ±7.6 (median 31) for the total sample and the same for the non-contracepting subset. The dif-

ference in mean ages between the groups is small but significant (p < .03). Khasi women are significantly larger than Bengali women. Khasi women are over 3 cm taller, almost 7 kg heavier, and have 2.3 kg/m² higher body mass index (height: 150.4 ±0.2 vs. 147.2 ±0.3 cm, p < .001; weight: 47.8 ±0.2 vs. 41.0 ±0.2 kg, p < .001; BMI = 21.2 ±0.1 vs. 18.9 ±0.1, p < .001). All comparisons of size measures remain equally significant when adjusted for mother's age.

Bengali women are expected to marry only once, and all women in our sample were married. Khasi women may remarry after divorce or widowhood, a factor that may prolong their childbearing years. However, divorce or widowhood without remarriage can curtail their childbearing years. Of the Khasi women, 181 (27.3 percent) had moved beyond their first husbands and 51.9 percent of these have remarried, but 18.8 percent of all Khasi women were currently with no husband. Thus, Khasi women may have gaps in their reproductive histories between marriages, while others may have already borne their last child at a relatively young age if they never remarry.

## Fertility

For those who didn't use contraceptives, Bengali women had 1 to 11 live births, with a mean of 3.7 ±0.1, adjusted for mother's age. The Khasi women had 1 to 15 live births with an adjusted mean of 4.1 ±0.1, which is significantly higher than the mean for the Bengali (F = 12.5, p < .001). Age at first birth was significantly older for Bengali women compared to Khasi women (21.5 ±0.2 vs. 20.2 ±0.2 years, adjusted for age of woman). Fewer Bengali women have families of six children or more compared to Khasi women (17.7 percent vs. 27.4 percent, chi-square 14.1, p = .001). Of the Khasi women, 12.4 percent reported themselves to be currently pregnant compared to 5.8 percent of the Bengali women (chi-square = 13.2, p < .001).

In multivariate analysis of Bengali fertility (see table 10.1), a living grandmother at the birth of the first child is independently associated with a higher number of surviving children, although not with total live births. It thus appears that losing fewer children provides higher reproductive success for Bengali women with a living grandmother compared to Bengali women with no grandmother, given the same number of births. A scatter plot (figure 10.1) of surviving children by total number of children, with the grandmother's living status at first birth indicated by lowess regression lines, shows that she is an important factor in keeping children alive in large families. This is further documented below in the effect of grandmothers in reducing mean number of child deaths when family size is large.

**Table 10.1** Grandmother's status at time of mother's first birth and grandmother's current status in relation to fertility measures, adjusted for mother's age and her age at first birth, for Bengali women and Khasi women, ages 16–50 years with no history of contraception

|  | Total live births | | | Surviving children | | |
| --- | --- | --- | --- | --- | --- | --- |
|  | β | SE | p | β | SE | p |
| Bengali women (n = 497) | | | | | | |
| Grandmother alive at first birth (1 = yes, 0 = no)[a] | 0.105 | 0.107 | .326 | 0.217 | 0.100 | .030 |
| Grandmother currently alive (1 = yes, 0 = no)[b] | 0.024 | 0.102 | .812 | 0.118 | 0.095 | .214 |
| Khasi women (n = 543) | | | | | | |
| Grandmother alive at first birth (1 = yes, 0 = no)[c] | −0.107 | 0.197 | .587 | 0.257 | 0.214 | .231 |
| Grandmother currently alive (1 = yes, 0 = no)[d] | | | | | | |
| Living in household | −0.117 | 0.022 | .595 | 0.085 | 0.204 | .676 |
| Living elsewhere | 0.330 | 0.188 | .080 | 0.406 | 0.174 | .020 |

[a] Data also adjusted for mother's height (ns), land held (ns).
[b] Data adjusted as above in [a] plus for poor condition of grandmother (ns). Grandmother residing with the woman makes no difference.
[c] Data also adjusted for mother's height (ns); land held (positive, p < .001), presence of a husband (positive, p < .001).
[d] Data adjusted as above in [c] plus for poor condition of grandmother (ns) and woman being youngest daughter (for total births, positive, p = .04; for surviving children, ns).

For the Bengali mother, a grandmother effect is also evident in measures of cumulative fertility in those women who have reached ages 30 and 35 years. For women with a living grandmother at their first birth versus those with a deceased grandmother, the data indicate that the pace of fertility was faster for those with living grandmothers (at age 30, Gm alive = 3.8 ±1.8 children, n = 182, vs. Gm deceased = 3.3 ±1.8, n = 77, p = .039; and at age 35, Gm alive = 5.1 ±1.8, n = 92, vs. Gm deceased = 4.4 ±2.0, n = 46, p = .029). For Khasi women there are no significant differences in cumulative fertility at these ages by grandmother's living status at the first birth.

In multivariate analysis of Khasi fertility (table 10.1), having a living grandmother at the time of the first birth has no association with total numbers of live births or surviving children. However, having a currently living grandmother who is not co-resident is positively associated with total births (p = .08) and number of surviving children (p = .02). Thus we see evidence of grandmother's ability to increase fertility somewhat but again more importantly to reduce mortality among her grandchildren.

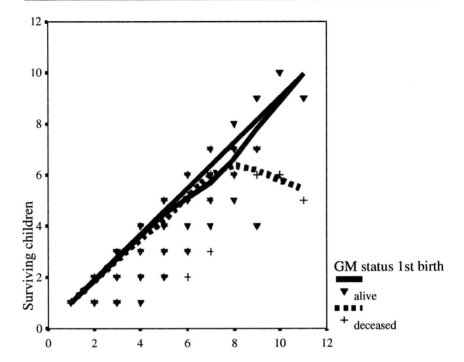

**Figure 10.1** Number of surviving children by total live born children, showing lowess regression lines for grandmother alive or deceased at first birth, for Bengali women ages 17–50 years (n = 497).

## Infant and Child Deaths per Woman

Among Bengali women, the numbers of deceased children per woman ranged from 0 to 6, and 20.4 percent of mothers had lost one or more children under the age of five years. Among the Khasi, with a range of 0 to 7 child deaths, only 12.2 percent of mothers had lost one or more children. Mean number of infants (age < 1 year) dying per woman, adjusted for total number of live-born children, is similar between the two groups: 0.14 ±0.02 (CI 0.11, 0.18) for Bengali and 0.14 ±0.02 (CI 0.11, 0.18) for Khasi. For children (ages 1–5 years) dying per woman, however, the Bengali show a significantly higher mean number of deaths per woman: 0.18 ±0.02 (CI 0.14, 0.22) vs. 0.06 ±0.01 (CI 0.04, 0.08) among the Khasi.

The Bengali grandmother whether alive or deceased at the birth of the first child had no significant effect on mean number of infant deaths per woman (Gm alive = 0.15 ±0.02 vs. Gm deceased = 0.12 ±0.03; ns). The Khasi grandmother, however, significantly reduces mean infant deaths per woman (Gm alive = 0.12 ±0.02 vs. Gm deceased = 0.31 ±0.06; F = 9.7,

p = .002). For child deaths at ages 1–5 years, a Bengali grandmother alive at the birth of the first child is associated at borderline significance with lower child mortality (Gm alive = 0.16 ±0.03 vs. Gm deceased = 0.24 ±0.04; F = 3.1, p = .08). For the Khasi, we see no grandmother effect (Gm alive = 0.06 ±0.01 vs. Gm deceased = 0.05 ±0.04; ns).

In both groups where the grandmother appears to make a difference, the effect of reducing deaths is greater when family size is large. The interaction terms for grandmother alive times family size are significant (table 10.2). For large families (6 or more children), mean number of infant deaths for Khasi women with no grandmother alive at their first birth is strikingly higher than for Bengali women (figure 10.2a), although the Khasi women with a grandmother show the lowest mortality at this family size. The mean number of child deaths for all Bengali women climbs steadily from small (1–2 children) to midsize (3–5 children) to large families, but the mean number of deaths rises faster for those with no grandmother living at

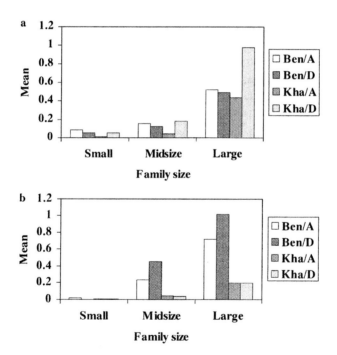

**Figure 10.2a, b** Adjusted means (±SE) per woman of (a) number of deceased children aged < 1 year, and (b) number of deceased children aged 1 to 5 years, by family size and grandmother's (Gm) status at the time of the woman's first birth for Bengali (n = 617) and Khasi (n = 664) women. Means are adjusted for mother's age, age at first birth, and contraceptive use. Differences in means by grandmother's status are significant for Khasi in the top figure and significant for Bengali in the bottom figure. See table 10.3 for companion regression analysis and p values.

the time of the first birth (figure 10.2b). The number of child deaths per woman is also significantly associated with mother's age and her age at first birth among Bengali women, indicating that a tighter interbirth interval may be responsible for many deaths (table 10.2). For the Khasi women, these factors are not significant and no such pattern of influence of fast-paced births is seen. Instead, the high mean number of infant deaths to women with large families and a deceased grandmother at the time of the first birth (n = 17) appears to be attributable to deaths among low-birth-order children in these families. These children have a survival rate of 0.72 compared to over 0.90 for all other categories of family sizes and birth orders (not shown).

Cox proportional hazards analysis of survival of individual children to age 10 reveals that Khasi children with a deceased grandmother at the time of their birth have a 74.3 percent greater chance of dying than those children with a living grandmother. This effect is independent of year of the birth, birth order, twin status, death of previous child, mother's height, and age of mother at the birth, all of which also have significant effects on mor-

**Table 10.2** Grandmother status at time of mother's first birth in relation to infant (<1 year of age) and child (ages 1–5 years) deaths per woman adjusted for family size, mother's age, and her age at first birth[a]

| Deaths <1 year of age | Bengali (n = 617) | | | Khasi (n = 664) | | |
|---|---|---|---|---|---|---|
| | $\beta$ | SE | p | $\beta$ | SE | p |
| Total family size (1–15) | 0.094 | 0.016 | .000 | 0.161 | 0.021 | .000 |
| Grandmother alive at first birth (1 = yes, 0 = no) | 0.026 | 0.036 | .471 | 0.181 | 0.108 | .095 |
| Interaction GM × family size | — | — | — | −0.087 | 0.021 | .000 |
| Mother's age | −0.011 | 0.005 | .035 | −0.005 | 0.004 | .147 |
| Mother's age at first birth | 0.000 | 0.006 | .994 | −0.003 | 0.007 | .666 |

| Deaths ages 1–5 years | Bengali (n = 617) | | | Khasi (n = 664) | | |
|---|---|---|---|---|---|---|
| | $\beta$ | SE | p | $\beta$ | SE | p |
| Total family size (1–15) | 0.243 | 0.025 | .000 | 0.044 | 0.007 | .000 |
| Grandmother alive at first birth (1 = yes, 0 = no) | 0.204 | 0.085 | .017 | 0.003 | 0.035 | .933 |
| Interaction GM × family size | −0.086 | 0.022 | .000 | — | — | — |
| Mother's age | −0.023 | 0.006 | .000 | −0.002 | 0.002 | .273 |
| Mother's age at first birth | 0.028 | 0.008 | .000 | −0.001 | 0.004 | .752 |

[a]Controlled for history of contraceptive use.

tality (table 10.3). Sex of the child and which husband (first, second, third) fathered the child have no significant relationship to a child's risk of dying. The significance of the grandmother effect stems from her influence on infant death, as no effect is seen on survival after one year of age (additional analysis not shown). Figure 10.3 shows that the effect of having the grandmother alive at their birth is greatest for low-birth-order Khasi children and decreases for higher-birth-order children. Khasi children of higher birth orders (6+) with living grandmothers have lower rates of survival that are comparable to those children without grandmothers.

Unlike the Khasi, the Bengali grandmother's living status at the time of a child's birth has no significant effect on the survival from birth to ten years of age (table 10.3). However, if the analysis is confined to risk of dying after one year of age, Bengali children with a deceased grandmother have a risk of dying before ten years of age that is increased significantly by 42.7 percent compared to children with living grandmothers ($p = .035$, analysis not shown)

**Table 10.3** Multivariate Cox proportional hazards analysis of survival to age 10 years of 2,069 Bengali children (240 deaths) and 2,545 Khasi children (138 deaths), born from 1980–2000[a]

|  | Hazard ratio | Robust SE | p | 95 percent CI |
|---|---|---|---|---|
| *Bengali* |  |  |  |  |
| Grandmother deceased | 1.173 | 0.176 | .288 | 0.874–1.574 |
| Year of birth | 0.960 | 0.014 | .004 | 0.934–0.987 |
| Birth order | 1.135 | 0.059 | .015 | 1.025–1.257 |
| Twin birth | 2.740 | 1.243 | .026 | 1.126–6.669 |
| Previous child dead | 1.861 | 0.473 | .015 | 1.130–3.064 |
| Mother's height | 0.980 | 0.014 | .142 | 0.954–1.007 |
| Mother's age at birth | 0.942 | 0.019 | .004 | 0.904–0.981 |
| *Khasi* |  |  |  |  |
| Grandmother deceased | 1.743 | 0.384 | .012 | 1.132–2.684 |
| Year of birth | 0.942 | 0.017 | .001 | 0.909–0.977 |
| Birth order | 1.239 | 0.072 | .000 | 1.106–1.388 |
| Twin birth | 4.875 | 1.705 | .000 | 2.457–9.675 |
| Previous child dead | 2.875 | 0.649 | .000 | 1.848–4.474 |
| Mother's height | 0.967 | 0.019 | .094 | 0.931–1.006 |
| Mother's age at birth | 0.950 | 0.025 | .048 | 0.903–0.999 |

[a] Sex is not a significant variable for either ethnic group and, for Khasi, the husband (first, second+) who fathered the child is not significant. Binary variables coded as yes = 1, no = 0. Birth order ranged from 1 to 15; year of birth ranged from 1980 to 2000. Previous child dead includes only those who died prior to one year of age. Mother's height measured in cm.

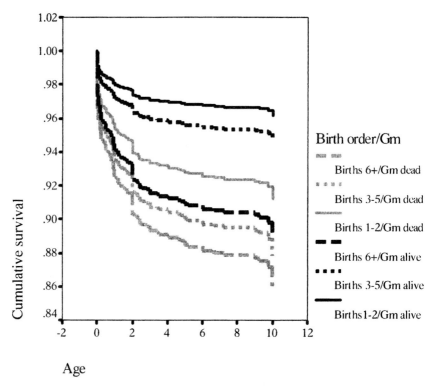

**Figure 10.3** Cumulative survival to 10 years of age for Khasi children born 1980–2000 (n = 2,545) by birth order and grandmother status (alive/deceased) at time of their birth. The risk (Exp$\beta$) of dying for each group relative to births 1–2/Gm alive (n = 994) is 1.39 (ns); for births 3–5/Gm alive (n = 876); for births 6+/Gm alive (n = 364) is 3.00 (p = .000); for births 1–2/Gm dead (n = 136) is 2.34 (p = .019); for births 3–5/Gm dead (n = 217) is 3.28 (p = .000); for births 6+/Gm dead (n = 174) is 3.81 (p = .000).

## *Child Growth*

Khasi children are significantly heavier than Bengali children, with respective mean weight-for-age z-scores of −1.60 ±0.04 vs. −2.40 ±0.04, p < .001, age adjusted. In both groups, the weight-for-age z-scores decline with child age (p < .001); children lose ground relative to the international standards and age adjustment is necessary. Both groups of children fall considerably below the NCHS standards on average, but the figures indicate Bengali children are generally malnourished, being more than two standard deviations below the standards. Among both Bengali and Khasi children, differences between boys and girls are not significant, although girls are on average slightly heavier than boys relative to the NCHS standards in both groups.

In the multivariate analysis of weight-for-age z-scores, in addition to data on mother's condition and socioeconomic resources, we use the data on

work activities of the grandmothers and mothers to estimate their effect on child growth. A brief look at these data shows that Bengali grandmothers do less domestic work than Khasi grandmothers (medians of 173 vs. 2,513 kcal units/yr), while Bengali mothers do more domestic work than Khasi mothers (medians of 16,483 vs. 9,810 kcal units/yr). Bengali grandmothers do more child care than Khasi grandmothers (medians of 6,777 vs. 2,085 kcal units/yr) and Bengali mothers do more child care than Khasi mothers (medians of 13,686 vs. 8,863 kcal units/yr). For productive subsistence work, the comparisons are less clear. The 5 to 95 percent range for Bengali women of both generations is 0 to 8,426 kcal units/yr (medians of 1,952 for mothers and 912 for grandmothers). The range for the Khasi mothers is much wider at 0 to 22,389 kcal units/yr with, however, a low median of 215, as many Khasi women are housewives and others are highly active in economic pursuits. In particular, Khasi women in cultivation show a median of 5,207 kcal units/yr. The range for Khasi grandmothers is 0 to 6,302 kcal units/yr (median of 106).

For Bengali children under seven years of age (n = 816), the presence of the grandmother in the household is positively related to the weight-for-age z-scores of the children in multivariate analysis. Accompanying this finding is the strongly significant negative relationship of mother's domestic work efforts to child weight. These results are independent of other significant factors including those pertaining to mother's condition and socioeconomic resources. Sex and birth order of the child are not significant. For Bengali children where grandmother is present in the household (n = 271), her child care efforts are positively related to child weight, with the same variables in the model as above, if significant (table 10.4).

For Khasi children under seven years of age (n = 1,039), in multivariate analysis (table 10.4), the presence of the grandmother living in the household is positive, but this is only if the mother is the youngest daughter of the grandmother. If the mother is an older daughter living with the grandmother, the effect is negative. However, a living grandmother has a positive effect on children of older daughters when she is not co-resident with them. Khasi mothers' productive work is significantly associated with child weight and her child care efforts are positive but not quite significant. These results are independent of other significant variables pertaining to mother's condition and socioeconomic resources. Birth order of the child has a negative effect, and in this particular model males have significantly lower weight than females. Presence of a husband to the mother has no effect on child growth.

For Khasi children where grandmother is present in the household (n = 212), her domestic work efforts relate positively and independently to child weight, as do the mother's child care efforts.

**Table 10.4** Grandmother's living status and residence, her work activities, and mother's work activities in relation to weight-for-age z-scores for Bengali and Khasi children less than 7 years of age, adjusted for child age

|  | Total sample | | | Grandmother in household | | |
|---|---|---|---|---|---|---|
|  | β | Robust SE | p | β | Robust SE | p |
| Bengali (total, n = 816; grandmother in household, n = 271)[a] | | | | | | |
| Grandmother alive (ref: deceased) | | | | | | |
|   In household | 0.262 | 0.111 | .019 | — | — | — |
|   Not in household | 0.139 | 0.142 | .326 | — | — | — |
| Grandmother's childcare (kcl) | — | — | — | 0.056 | 0.027 | .040 |
| Mother's domestic work (kcl) | −0.071 | 0.025 | .005 | — | — | — |
| Khasi (total n = 1,039; grandmother in household, n = 212)[b] | | | | | | |
| Mother is youngest daughter | −0.117 | 0.148 | .429 | 0.392 | 0.173 | .025 |
| Grandmother alive (ref: deceased) | | | | | | |
|   Living with youngest daughter | 0.620 | 0.195 | .002 | | | |
|   Living with older daughter | −0.581 | 0.242 | .017 | | | |
| Grandmother living | | | | | | |
|   Not with older daughter | 0.449 | 0.193 | .021 | | | |
| Grandmother's domestic work (kcl) | — | — | — | 0.088 | 0.024 | .000 |
| Mother's childcare work (kcl) | 0.017 | 0.010 | .073 | 0.062 | 0.018 | .001 |
| Mother's productive work (kcl) | 0.028 | 0.006 | .000 | — | — | — |

NOTE: kcl = 1000 kilocalorie units/yr

[a] Also adjusted for mother's height (+), her pregnancy status (−), household subsistence cultivation (+), household wage income (+), household size (−), business/professional status of father (+), sex (ns) and birth order of child (ns). Note direction of significant variables in parentheses.

[b] Also adjusted for mother's height (+) and BMI (+), her pregnancy status (−), household subsistence cultivation (+), household wage income (ns), household size (ns), business/professional status of the mother (+), presence of mother's husband (ns), male sex (−) and birth order of child (−). Note direction of significant variables in parentheses.

## Discussion

The effects of maternal and paternal grandmothers have been found to vary in other studies. Positive effects of maternal grandmothers on infant and child survival (Sear, Mace, and McGregor 2000; Sear et al. 2002) and nutritional status (Sear, Mace, and McGregor 2000), as well as positive effects of paternal grandmothers and grandfathers on fertility (Sear, Mace, and McGregor 2003), have been found in the Gambia. In modern Germany, Euler and Weitzel (1996) found the maternal grandmother to be the most caring of all of the grandparents. Pashos (2000) found greater paternal grandparental solicitude in a Greek sample where patrilateral bias is an important part of the culture. Beise and Voland (2002), in constrast, found a negative

effect of paternal grandmothers on child survival in historical data from Germany.

Here we have attempted to directly compare paternal and maternal grandmother effects between a patrilineal Bengali group and a matrilineal Khasi group. Basically we must consider how grandmother strategies might vary within differing sociocultural kinship systems and genetic contexts. The general roles of women with regard to access and control of resources vary fundamentally between the two groups studied and, therefore, constrain the types of responses grandmothers can make and how beneficial these responses might be. Paternity/grandmaternity certainty is an issue, as is the genetic relationship of the grandmother (mother or mother-in-law) to the reproducing woman. Both issues are likely to structure grandmother strategies.

The timing of potential investment is also altered by these systems as the Bengali mother-in-law must work with a daughter-in-law whose reproductive capacity has already been determined by her earlier growth over which this paternal grandmother has had no control (Lindstrom 1999). Given the poor economic status of the Bengali community, dowries or bride prices are generally not paid and cannot be used to bargain for a fatter daughter-in-law with more reproductive promise, as in the case of the Kipsigis (Borgerhoff Mulder 1988). The Bengali grandmother thus has little previous investment to protect in her daughter-in-law. Khasi grandmothers, in contrast, have investment opportunities in their daughters from the time of conception and can enhance reproductive capacities from that time on, especially if they live together or nearby. They in turn can receive good reproductive payoff with absolute grandmaternity certainty. Matriliny has been argued to be a system of daughter-biased investment, which makes sense where paternity certainty is less (Holden, Sear, and Mace 2003), as indicated in this case by the Khasi marital system wherein women exercise choice in selecting partners. Cooperative breeding systems among females described by Hrdy (1999) could also be reinforced by such long-term investment. Both systems probably perpetuate differential patterns of investment in women and children via this lifetime perspective.

The fact that Khasi women are larger in height, weight, and general adiposity (BMI) than Bengali women is unlikely to be due to genetic factors, as the populations both have roots in the general area although they have different historical backgrounds and languages. More likely, many of the Bengali women have suffered from stunted growth and malnourishment in childhood and undernourishment that continues into the present. This explanation is likely, given the current poor condition of Bengali children relative to Khasi children with respect to weight and the lower BMIs of the Bengali women compared to the Khasi women. The Bengali patrilineal sys-

tem thus appears to produce women who are shorter and thinner than those of the Khasi matrilineal system, even though the socioeconomic status of the two groups is apparently similar. This heritage of deprivation is also probably related to the higher mortality rate of Bengali children ages one to five years, as they start life from a poorly nourished base in their mothers and may be more vulnerable to the environmental stresses of this age period. These may include poor weaning conditions aggravated by energy drain on the mother from her domestic work activities and a quickly succeeding pregnancy, as the Bengali pace of fertility is related to child mortality. However, Bengali women's physical condition is not likely to be the result of gender discrimination in childhood. Gender-biased investment can also accompany a kinship system with males commonly being favored in patrilineal societies (Das Gupta 1987). Although when wealth is highly limited as in the Bengali case, biased investment in males may not prove beneficial as it would be difficult to improve male quality sufficiently to create a male reproductive advantage (Trivers and Willard 1973). The better condition of the Khasi women may also be related to their greater fertility. Early development is seen as preparatory to later reproductive success (Lindstrom 1999; Lummaa 2003) and intergenerational effects are also now well recognized (Lummaa and Clutton-Brock 2002).

The specific effects of the grandmothers in each group suggest different strategies given these biocultural constraints. For the Bengali grandmother, hastening the fertility of her daughter-in-law appears to be a goal. The data on Bengali cumulative fertility at ages thirty and thirty-five years show a faster pace of child production with a living compared to deceased grandmother, although grandmothers are not associated with higher numbers of total births. Those with a living grandmother do have more surviving children. Thus the Bengali grandmother appears to be speeding up the pace of fertility and creating a safety net of child care to buffer the stress on children of close birth intervals.

Strassmann and Gillespie note that the strong linear relationship between numbers of children born and lifetime reproductive success seen in hunter and gatherer (!Kung and Ache) demographic data is surprising and suggest humans do not maximize fitness. They state, "life history theory predicts diminishing return to fitness from higher fertility, which would produce . . . a downturn in fitness at high fertility" (Strassmann and Gillespie 2002, 553). It is relevant to discussion of the evolutionary roles of grandmothers that the Bengali data do show such a downturn but only in the absence of a grandmother. Her reproductive fitness role of protecting grandchildren from mortality via child care and promotion of child weight gain (first noted by Hawkes et al. 1997) while mothers are reproducing at a fast

pace can be seen in these data and may help explain why humans may not suffer the expected diminishing returns with high levels of fertility.

Bengali mothers reveal greater reproductive stress in a higher mean number of deceased children ages one to five years compared to Khasi mothers. The Bengali grandmother, if alive, however, is associated with lower numbers of child deaths per woman, particularly in large families. The numbers still greatly exceed those among the Khasi, however, even where the Bengali grandmother is present. The reproductive stress experienced by Bengali women is further evident in the association of number of deceased children with mother's age and mother's age at first birth, which together indicate smaller intervals between births. These variables are not significant in the Khasi data indicating a greater maternal capacity to bear children who survive better or a less intensive reproductive pace that spares children. Our future analyses of birth spacing will be directed at this issue.

Beise and Voland (2002) suggest their finding of a negative effect of the paternal grandmother on child survival was the result of commonly acknowledged tension between daughter-in-law and mother-in-law, perhaps due to domestic restrictions on daughters-in-law imposed by their mothers-in-law in the interest of paternity/grandmaternity certainty. Among the Bengali, daughters-in-law are greatly restricted in their movements, suggestive of a concern about paternity/grandmaternity certainty. We have also found that mothers carry heavy domestic duties that sap their capacities to nurture their children as seen in the negative relationship of mother's work to child's weight. Compared with Khasi mothers, Bengali mothers carry a far heavier domestic workload. Bengali grandmothers' child care efforts do have a positive relationship to children's weight, however, indicating that the grandmothers are compensating to some degree for mother's work overload. Family system values among the Bengali exhort grandmothers to care for grandchildren, and their activity profiles indicate this type of effort is high compared to the child care effort put forth by Khasi grandmothers. Thus the Bengali grandmother, in comparison, spends her efforts directly on her grandchildren while the mother is burdened by domestic chores to the detriment of her child.

Interestingly, Khasi grandmothers are associated with lower infant mortality, a grandmother effect that at this age has not been previously found. The fact that many daughters reside with their mothers after marriage until a child or two are born may be one important avenue for this effect. Her living presence appears to reduce infant mortality by at least half. The effect is seen for children at all positions in the birth order but is greatest for low birth orders, particularly in large families. Thus young inexperienced women with no grandmother guidance and support suffered the highest

risk of low-birth-order infant deaths. Since neonatal (under one month) mortality, which usually makes up most of the mortality in the first year, is affected by mother's condition even early in her own life (for example, her own birth weight, Emanuel et al. 1992; Hackman et al. 1983), the Khasi grandmother may be functioning to support her pregnant daughter as an extension of her lifetime of investment. She thus increases infant viability, a well-known critical sign of population health. Khasi grandmothers also appear to devote much more energy to domestic work activities, which would be a sign of support for the daughter, than do the Bengali grandmothers who focus on direct child care while the mothers do the domestic chores.

Among the Khasi, the grandmother's effect on child growth is positive when she is living with her youngest daughter. It is also positive for children of older daughters when she is not living with them, although she is probably close by. It is negative, however, where she is living with any of her older daughters. This finding suggests that failure of the kinship/family system to work as expected may result in poor conditions for the child. It is likely in these cases that the older daughter has failed to find good work opportunities or to attract adequate husband contributions for support of her children. Rather than this situation being the fault of the grandmother, she is probably a fall-back position for a mother and children who are already suffering resource deprivation.

## Summary

We have found that paternal grandmothers in a patrilineal society under a situation of high paternity certainty do appear to boost the pace of daughter-in-law fertility, lower child mortality in larger families, and increase weight of grandchildren compared to situations where a grandmother is not present. These results show how a family system that restricts female mobility and creates high levels of surveillance by the mother-in-law can compensate for the inherent male problem of paternity certainty. The negative side of this situation is that women are highly dependent and may suffer along with their children because of lack of direct access and control of resources. They and their children remain undernourished and their fertility is lower than among a culture with similar economic resources but matrilineal structure. The Bengali grandmother strategy thus appears to be targeted at what can be garnered and salvaged from this poor base as she devotes herself to child care. The Khasi system in contrast creates a more solid foundation for reproduction via better child nutritional status leading to bigger, better-reproducing daughters who do well especially with lifelong grandmother support directed to them as well as to their children who survive better as a result.

## Acknowledgments

This study was supported by the INDO-US Programme on Contraceptive and Reproductive Health Research sponsored by the Indian Ministry of Science and Technology and the U.S. National Institute for Child Health and Development, Family Health International, and the Center for Studies in Demography and Ecology at the University of Washington. The cooperation of the Bengali and Khasi participants is gratefully appreciated. We also wish to thank Patricia Draper, Sarah Hrdy, and David Nolin for helpful comments.

## References

Beise, J., and E. Voland. 2002. "A multilevel event history analysis of the effects of grandmothers on child mortality in a historical German population (Krummhörn, Ostfriesland, 1720–1874)." *Demographic Research* 7 (article 13): 467–97.

Borgerhoff Mulder, M. 1988. "Kipsigis bride wealth payments." In *Human Reproductive Behavior: A Darwinian Perspective*, ed. L. Betzig, M. Borgerhoff Mulder, and P. Turke. Cambridge: Cambridge University Press, 65–82.

Das Gupta, M. 1987. "Selective discrimination against female children in rural Punjab, India." *Population and Development Review* 13:77–100.

Dufour, D. L. 1984. "The time and energy expenditure of indigenous women horticulturalists in the northwest Amazon." *American Journal of Physical Anthropology* 65:37–46.

Emanuel, I., H. Filakti, E. Alberman, and S. J. Evans. 1992. "Intergenerational studies of human birth weight from the 1958 birth cohort: Evidence for multigenerational effect." *British Journal of Obstetrics and Gynaecology* 99:67–74.

Euler, H. A., and B. Weitzel. 1996. "Discriminative grandparental solicitude as reproductive strategy." *Human Nature* 7:39–59.

Hackman, E., I. Emanuel, G. van Belle, and J. Daling. 1983. "Maternal birth weight and subsequent pregnancy outcome." *Journal of the American Medical Association* 250:2016–19.

Hames, R., and P. Draper. In press. "Women's work, child care, and helpers at the next in a hunter-gatherer society." *Human Nature*.

Hawkes, K., J. F. O'Connell, and N. G. Blurton Jones. 1997. "Hadza women's time allocation, offspring provisioning, and the evolution of long postmenopausal life spans." *Current Anthropology* 38:551–77.

Hawkes, K., J. F. O'Connell, N. G. Blurton Jones, H. Alvarez, and E. L. Charnov. 1998. "Grandmothering, menopause, and the evolution of human life histories." *Proceedings of the National Academy of Science* 95:1336–39.

Holden, C. J., R. Sear, and R. Mace. 2003. "Matriliny as daughter-biased investment." *Evolution and Human Behavior* 24:99–112.

Hrdy, S. B. 1999. *Mother Nature: Maternal Instincts and How They Shape the Human Species*. New York: Ballantine Books.

Kaplan, H., J. B. Lancaster, W. T. Tucker, and K. G. Anderson. 2002. "Evolutionary approach to below replacement fertility." *American Journal of Human Biology* 14:233–56.

Leonetti, D. L. 2002. "The interplay of kinship organization and grandmother's impact on reproductive success in N. E. India." Paper presented at the conference on "Grandmotherhood—On the psychological, social and reproductive relevance of the second half of life." Delmenhorst, Germany: Hanse Institute for Advanced Study.

Lindstrom, J. 1999. "Early development and fitness in birds and mammals." *Trends in Ecology and Evolution* 14:333–73.

Lummaa, V. 2003. "Early developmental conditions and reproductive success in humans: downstream effects of prenatal famine, birthweight, and timing of birth." *American Journal of Human Biology* 15:370–79.

Lummaa, V., and T. Clutton-Brock. 2002. "Early development, survival, and reproduction in humans." *Trends in Ecology and Evolution* 17:141–47.

Paffenbarger, R. S., A. L. Wang, and R. T. Hyde. 1978. "Physical activity as an index of heart attack risk in college alumni." *American Journal of Epidemiology* 108:161–75.

Pashos, A. 2000. "Does paternal uncertainty explain discriminative grandparental solicitude?" *Evolution and Human Behavior* 21: 97–109.

Sear, R., R. Mace, and I. A. McGregor. 2000. "Maternal grandmothers improve nutritional status and survival of children in rural Gambia." *Proceedings of the Royal Society of London.B* 267:461–67.

———. 2003. "The effects of kin on female fertility in rural Gambia." *Evolution and Human Behavior* 24:25–42.

Sear, R., F. Steele, I. A. McGregor, and R. Mace. 2002. "The effects of kin on child mortality in rural Gambia." *Demography* 39:43–63.

Strassmann, B. I., and B. Gillespie. 2002. "Life-history theory, fertility, and reproductive success in humans." *Proceedings of the Royal Society of London.B* 269:553–62.

Trivers, R., and D. E. Willard. 1973. "Natural selection of parental ability to vary the sex ratio of offspring." *Science* 179:90–92.

World Health Organization. 1995. "Physical status: The use and interpretation of anthromopetry." WHO Technical Report Series 854. Geneva: World Health Organization.

CHAPTER 11

# The *Helping* and the *Helpful* Grandmother
## The Role of Maternal and Paternal Grandmothers in Child Mortality in the Seventeenth- and Eighteenth-Century Population of French Settlers in Québec, Canada

Jan Beise

The helping grandmother plays an important role in explaining human life history, in particular the evolution of human longevity (see, for example, Hawkes 2003). The interest of evolutionary biologists in grandmothers originates in William's seminal paper of 1957 on the evolution of senescence. He aimed at finding an evolutionary explanation for the existence of the sudden decline in reproductive function, followed by a postreproductive life span in human females—a trait that according to evolutionary theory should not exist since "sterility is the selective equivalent of death" (Williams 1957, 407). In an explanation for this apparent contradiction, he pointed out that in a species that has a considerable dependency of offspring on the care of parents, any postreproductive period does not begin with senile sterility but at the earliest when the last child is self-sufficient. This is because "any individual, of whatever age, who is caring for dependent offspring is acting in a way that promotes the survival of his own genes" (Williams 1957, 407). Although Williams was thinking in particular of mothers caring for their children, his statement is valid for any genetic relationships and generational overlap.

In William's scenario, the prolonged need for the care of children started an evolutionary development in which the termination of female fertility shifted to younger ages. Since late pregnancies are increasingly risky for the mother (Loudon 1992) and since her death would leave the existing children without maternal care, the inclusive fitness of the mother could be increased by giving up reproduction at an earlier stage than physiologically possible and instead invest the resources saved thereby in her living children. Looking at it this way, female menopause would be an adaptation in its own right.

This "stopping early hypothesis" has been increasingly disputed in recent years on empirical and analytical grounds (see, for instance, Packer, Tatar, and Collins 1998; Peccei 2001). The main argument is that it is difficult for

women to compensate for forgone direct reproduction by the indirect benefits of help and support (see Grainger and Beise 2004 for a dynamic model approach to this problem). Instead, it is argued that it is not menopause but an extended postmenopausal longevity identifying parental care and intergenerational transfer as the driving evolutionary force that is the adaptive trait (Kaplan 1997; Carey and Judge 2001). Irrespective of which hypothesis one prefers, critical to both is the existence of substantial contributions of postmenopausal women to their kin and thereby to their inclusive fitness.

Looking at the hunting and foraging Hadzabe in northern Tanzania, Hawkes and colleagues were the first to show that grandmothers were helpful supporters by providing food for their adult daughters' families (Hawkes, O'Connell, and Blurton Jones 1989, 1997). Hill and Hurtado (1991, 1996) studied the Ache of eastern Paraguay and found a positive relationship between the survival of grandmothers and that of their grandchildren, but this effect was statistically insignificant. Only in very recent years has it been shown that grandmothers had a measurable effect on important fitness components. Sear and colleagues (2000, 2002) analyzed the effect of grandparents on nutritional status (height and weight) in a farming population of Gambia and on the survival of their grandchildren. They found that while maternal grandmothers improved both nutritional status and survival significantly, the paternal grandmothers and both grandfathers had almost no effect.

Beise and Voland (2002; Voland and Beise 2002) studied a historical agrarian population of northern Germany (Krummhörn, eighteenth and nineteenth centuries) and found here, too, that the presence of maternal grandmothers decreased the grandchildren's mortality significantly. Jamison and colleagues (2002) found the same effect for a historic village population in central Japan (seventeenth to nineteenth centuries). Again, in both populations this positive effect was solely limited to the maternal grandmother and did not occur with any of the other grandparents.

And, finally, Lahdenperä and colleagues (2004) presented a study of a historic Finnish population in which a number of fitness correlates are positively associated with the presence of a grandmother. Furthermore, the longer the women's postreproductive life span was, the more grandchildren she had. This last relationship was found both for the Finnish population and a nineteenth- and twentieth-century Canadian population.

In this study, we will further explore the ecological and cultural validity of these findings by analyzing the French Canadian population of the seventeenth and eighteenth centuries in Québec, Canada. The population differs substantially from all previous tested ones. It consists of the first French emigrants to Québec, who established a permanent European settlement in

the beginning of the seventeenth century, and their descendents. The population experienced a high growth rate of 2.5 to 3 percent, which only in the beginning of this period was due to immigration (Charbonneau et al. 2000). As early as 1673, population growth was fueled mainly by the reproduction in the local population and immigration became an increasingly marginal contribution (Desjardins 1997). The population was highly fertile: the average family had between seven and eight children. Mortality was lower in the first years of settlement, then increased over time, but still remained below the level found in France during the same period. This pattern reflects a favorable environment, selection of healthy immigrants, and low population density (Charbonneau et al. 2000).

In this study, we analyzed child mortality from birth to age five in relation to the survival of their grandmothers and other kin. We applied event-history models that allow us to find out at which age of the child grandmothers had the biggest impact on its survival. In order to obtain deeper insight into the potential mechanisms of this support, we analyzed the grandmaternal effect in relation to the mother's age.

## Population and Data

The data came from the population register created by the Programme de Recherche en Démographique Historique (PRDH) at the University of Montreal. The PRDH data are based on some 690,000 baptisms, marriages, and burials registered in Québec parishes (St. Lawrence Valley) from the first settlers in 1621 to 1799. The final data set was compiled using the family reconstitution technique (Fleury and Henry 1976; see Voland 2000 for a summary on its use in evolutionary anthropology). The Québec data set is unique since it covers a complete population over the whole territory, thus largely freeing the analysis of the usual problem of out-migration.

Although the first Europeans settled permanently in Québec in 1608, the actual populating process did not start until two decades later. Between 1632 and 1650, the population grew from around 60 inhabitants to over 1,000 and finally reached a size of around 55,000 about 100 years later. By the year 1750, approximately 10,000 immigrants had settled in the colony. After the end of the great immigration 1663–1673, the population growth was mainly "home made." Whereas in 1663 around 60 percent of the inhabitants were immigrants, in 1700 this was true for less than 20 percent (Charbonneau et al. 2000).

This analysis is limited to children born between 1680 and 1750. This has the advantage of excluding pre-1680 high immigration rates and of limiting the analysis to the more stable period of the expanding colony. The cutoff year 1750 marks the beginning of increasing political turmoil between the

French and English colonies, which had an impact on the quality of the data (Desjardins 1997; Charbonneau et al. 2000).

Only children were included in the data sample that were born to a married couple whose exact wedding date was known. The exact date of birth had to be known: cases with a calculated date of birth (using age declaration) were excluded. If no date of birth was given, the date of baptism was used instead (according to Charbonneau [1985], the majority of children were baptized within few days after birth).

Additional data selection resulted from the necessity to construct family histories over three generations. For many children, no grandmothers could be identified or information about their deaths was missing. Only those children were included in the data sample for whom information about both grandmothers was available. These selections resulted in the primary data sample that was then used to calculate child mortality rates and survival. A final selection concerns missing covariate values used in the parametric model. In the secondary sample, only those children were included that had valid values for all covariates.

The existence of missing death entries needs some careful consideration since they can cause bias in the analysis. Missing values are a common problem in nearly all family reconstitution data. In our secondary sample, around 34 percent of the children had no recorded date of death. Death entries may be missing due to underregistration, the loss of registers, out-migration (not relevant here), or due to survival beyond the end of the observation period (which means that the death of the individual is not recorded in the evaluated registers). However, for the majority of these cases, a marriage entry was registered, confirming a survival beyond childhood (75 percent of all cases with missing death entry). We considered the remaining cases without death entry as having survived for two reasons. First, there is a strong bias towards younger cohorts, and this suggests that death after the end of the observation (1765, fifteen years after the end of the period of analysis) is the major reason for the missing entries. Second, where underregistration led to missing death entries, it is more likely that the children survived age five (over three-quarters survived age one and around two-thirds lived until age fifteen [Nault, Desjardins, and Légaré 1990]). Although this method underestimates the true level of mortality, the error is smaller than ignoring those cases, which would overestimate mortality. Furthermore, although the absolute level of mortality is biased, this is not necessarily true for the relative effects of our main covariates, the survivorship of the grandmothers. In fact, our estimated infant mortality rates (in total and differentiated for different periods) are very close to what Nault, Desjardins, and Légaré (1990) found. They analyzed the same population using more sophisticated control methods in order to account for

underregistration and loss of registers. Finally, we estimated the same models presented later in this study using a very rigid data selection criteria (considering only children with known dates of death, which grossly overestimates infant mortality) and found almost identical patterns of the estimated parameters (those results are not shown here).

## Methods

### The Model

We used event-history models to analyze the probability of children's death over time. These models have the advantage of accounting for the time dependency of the process itself and of the covariates, and they can cope easily with censored data. Transition rate models can be represented mathematically by:

$$\ln \mu_i(t) = y(t) + \sum_k \beta_k x_{ik} + \sum_l \lambda_l z_{il}(t) \qquad (1)$$

where $\ln \mu_i(t)$ is the log hazard of the event occurrence at time $t$ for the $i$th child, $y(t)$ captures the baseline hazard, $x_k$ is the $k$th time constant covariate and $z_l$ is the $l$th time varying covariate with $\beta$ and $\lambda$ as the respective regression parameters.

In order to control for confounding effects, some of the following analyses are based on parametric event-history models. A piecewise constant exponential model was chosen because it has some features that are useful for our case. First, no strong assumptions about the time dependency of the process need to be made since the model allows splitting the time axis into several time intervals for which the transition rates are estimated separately (the only assumption is that the rates are constant within each interval). Second, since it is known from previous studies that grandmaternal help is not evenly distributed over large age intervals (Beise and Voland 2002a; Sear et al. 2002), it is important to be able to pinpoint potential effects on specific age intervals. This can be done by choosing meaningful age intervals (following to theoretical and/or empirical considerations) and allowing the parameters of the covariates to change freely between these intervals ("period-specific effects"—see, for example, Blossfeld and Rohwer [1995, 110–19] for a detailed description of such models). This means that we do not need to assume proportionality of the hazards concerning the covariates.

We used the following age classes for the parametric modeling: 0 months (from birth to 30.4 days), 1–5, 6–11, 12–23, 24–35, and 36–59 months. We separated the first month because neonatal mortality is caused by different factors than mortality at higher ages. The former is mainly caused by endogenous factors such as congenital malformations and prenatal life cir-

cumstances in contrast to post-neonatal mortality, which is dominated by exogenous reasons such as infections and so forth (McNamara 1982). Note that in this study we included stillbirths since stillbirths and neonatal deaths are outcomes of the same causal processes (Hart 1998; note further that the stillbirth rate in this sample—based only on the number of children for whom we had the birth record—is rather low, 1.9 percent, which may be an indication of stillbirth underregistration). All surviving children were censored at the end of their fifth year (60.0 months).

All event-history models were estimated using the free software Transition Data Analysis version 6.3b (Rohwer and Pötter 1999).

## The Covariates

The effect of grandmothers is the main focus of this study. Since we have no information on the quality and quantity of support that a grandmother gave to the mother or the child, we used her survival as a proxy. In addition to the grandmother, we included in the model the survival status of the mother, the father, and both grandfathers in order to control for any other kin effect. All variables are entered as time-varying covariates.

Furthermore, the following time-constant covariates were included, all of which are known to have an impact on infant and child mortality: sex of the child, age of mother at the birth of the child, birth cohort, and number of living siblings at time of childbirth. The covariates are categorized to allow for nonlinear dependencies.

In order to decrease the number of parameters that need to be estimated, constraints were added to the time-constant variables so that the parameters of each variable are equal across the model's time periods (which means that for these variables the assumption of proportional hazards is reintroduced).

Table 11.1 gives a short statistical description of the sample used in the parametric model.

## Results

Figure 11.1 shows the death rate and the associated survival function resulting from the life table for the 49,206 children who formed the primary data sample (this sample is substantially larger than the sample used in the parametric model below since it is based on all children in the data set irrespective of information on grandparents). Mortality was high in the very first month, with a rate of over 0.11 in the neonatal period. Between the age of three and approximately nine months, mortality declined exponentially but still remained at a high level. From age nine months to the end of censoring age (five years) the mortality rate continued to decline exponentially

**Table 11.1** Description of the sample and explanatory variables considered in the parametric event-history model (both sexes)

| Baseline | Number of children at risk[a] | Number of deaths |
|---|---|---|
| Total | 26,449 | 7,992 |
| Age classes [months] | | |
| 0 | 26,449 | 2,670 |
| 1–5 | 23,779 | 2,116 |
| 6–11 | 21,663 | 856 |
| 12–23 | 20,807 | 888 |
| 24–35 | 19,919 | 400 |
| 36–59 | 19,519 | 441 |

| Time varying covariates | Number of episodes with children at risk[b] | Number of deaths |
|---|---|---|
| Total | 41,296 | 7,992 |
| Mother | | |
| Dead | 1,788 | 247 |
| Alive | 39,508 | 8,521 |
| Father | | |
| Dead | 1,472 | 145 |
| Alive | 39,824 | 8,623 |
| Maternal grandmother | | |
| Dead | 16,152 | 3,389 |
| Alive | 25,144 | 5,379 |
| Paternal grandmother | | |
| Dead | 20,534 | 4,254 |
| Alive | 20,762 | 4,514 |
| Maternal grandfather | | |
| Dead | 23,238 | 4,786 |
| Alive | 18,058 | 3,982 |
| Paternal grandfather | | |
| Dead | 27,870 | 5,882 |
| Alive | 13,426 | 2,886 |

(*continued*)

**Table 11.1** (*continued*)

|  | Time constant covariates | Number of children at risk | Number of deaths |
|---|---|---|---|
|  | Total | 29,431 | 7,992 |
|  | **Sex** | | |
|  | Male | 15,087 | 4,207 |
|  | Female | 14,344 | 3,785 |
|  | **Age of mother** | | |
|  | 15–25 | 7,561 | 1,822 |
|  | 25–30 | 7,775 | 1,938 |
|  | 30–35 | 6,959 | 1,926 |
|  | 35–50 | 7,136 | 2,306 |
|  | **Birth cohort** | | |
|  | 1680–1710 | 3,479 | 698 |
|  | 1710–30 | 9,617 | 2,360 |
|  | 1730–50 | 16,335 | 4,934 |
|  | **Number of living siblings** | | |
|  | none | 4,610 | 1,261 |
|  | 1–2 | 8,683 | 2,181 |
|  | 3–5 | 9,948 | 2,716 |
|  | 6+ | 6,190 | 1,834 |

[a] At the beginning of each age class.
[b] For the time varying covariates, not the number of *cases* are given but the number of *episodes*, since the death of a kin divides (if the death occurred after the child was born) the child's time at risk in one episode in which the kin concerned is still alive and one episode in which the kin is dead.

but now at a lower rate. The mortality trajectory resulted in a proportion of children dying in the first month of over 10 percent. After one year, over one-fifth of all children born had died and only 73 percent survived to age five.

Figure 11.2 displays the survivor functions (Kaplan-Meier estimators) for children over the first five years of age according to the survival constellation of maternal and paternal grandmothers at the time of the child's birth. When both grandmothers were alive, around 76 percent of all children survived to age five; when none of the grandmothers were alive, only 71 percent reached this age. Almost right in between these two extremes are the survival outcomes for those children who had either only a living maternal or paternal grandmother at the time of their birth (75 percent survival after five years). Although their outcome after five years is almost identical, it can be noted that in the very early ages the paternal grandmother seems to have had a greater impact on the child's survival. From approximately age

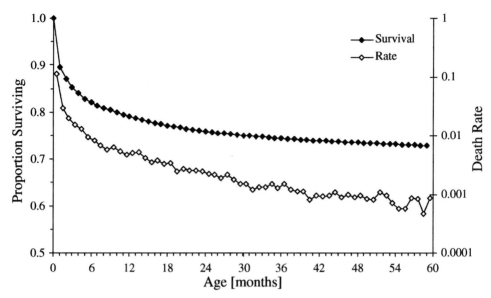

**Figure 11.1** Death rate and associated survival function by age over the first five years of life.

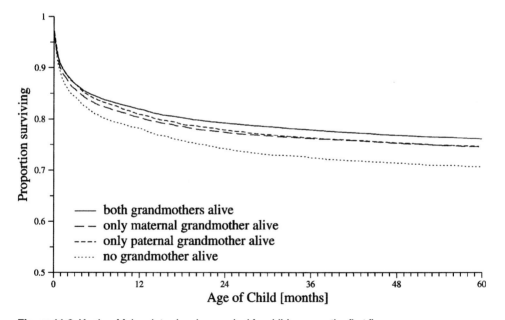

**Figure 11.2** Kaplan-Meier plots showing survival for children over the first five years according to the different combinations of survival of maternal and paternal grandmother.

twelve months onwards, the gap between the two grandmothers narrows and finally closes at around twenty-nine months.

Although these survivor plots are very illustrative, it is dangerous to translate observable differences directly into causal relationships: nonparametric techniques do not allow controlling for potential influential background variables. In this case, the most important variable is maternal age at birth. As seen in figure 11.3, maternal age at birth had an important effect on child survival. Younger mothers offered their children higher survival chances than old mothers did: while over three quarters of the children of mothers aged twenty-five to thirty years survived until age five, only two thirds of those whose mother was above thirty-five years of age did so (note that the children of the youngest maternal age group showed even slightly higher mortality, a result of the in-general J-shaped relationship between infant death rates and maternal age [for example, McNamara 1982]). Naturally, maternal age is also highly correlated with the survival status of the grandparents: the older the mother, the older the grandparents, and therefore the more likely it is that they are not alive when the child is born. Furthermore, due to the age gap between wife and husband, every child is more likely to have a maternal grandmother that is alive rather than a paternal one. Translated into the child's situation, this means that a child with a paternal grandmother that is alive is born on average to a younger mother

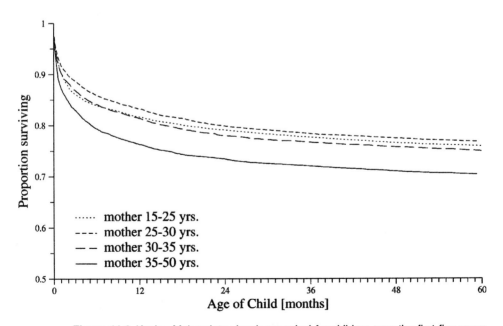

**Figure 11.3** Kaplan-Meier plots showing survival for children over the first five years according to the age of mother when giving birth.

than one with a maternal grandmother alive—and the children of younger mothers experienced a higher survival regardless of the status of their grandmothers.

In order to control for these hidden confounding effects, the following analyses are based on parametric event-history models. Table 11.2 shows the results of the applied piecewise constant model with period specific effects.

The death of the mother had a very strong influence on the child's mortality as could be expected. Its risk to die increased by a factor between two and three or more in almost all age intervals. The death of the father increased the mortality risk for the child, but this effect was much less pronounced. Only at ages six months to two years did these effects exceed the 5 percent significance level.

Children without a living maternal grandmother had a significantly increased mortality risk in the second and third year of life; it rose by around one third and one fourth to one fifth, respectively. This effect is very pronounced and contrasts sharply with the complete lack of maternal grandmothers' influence in the surrounding age classes. Interestingly, this temporal pattern fits nicely with breastfeeding behavior in Québec. Henripin (1954) estimated for its early-nineteenth-century population approximately fourteen months of breastfeeding on average and Landry (cited in Charbonneau et al. 2000, n. 5) estimated a duration of fourteen to fifteen months. Thus, it seems that maternal grandmothers were most valuable during weaning and the transition to a milk substitute. Grandmaternal experience and knowledge may have played an important role here—but also directly taking care of the child while the mother increased gradually her work participation for the household economy.

The paternal grandmother shows a very moderate effect only—and it is limited furthermore to the very first month after birth. At this age, children without a paternal grandmother suffered from a 12 percent higher mortality compared to children with a living one. Effects at all other ages were insignificant. Although this effect seems to be quite moderate—in particular compared to the effects of the maternal grandmother, which is three times greater—it has to be taken into account that mortality in the first month was very high. This means that although a paternal grandmother that is alive saved only every ninth child that would have died otherwise, these lives amount to a considerable number because the underlying mortality at this point in the life span was very high (see figure 11.1). A living maternal grandmother, by contrast, could save even every third child during the second year and every fourth to fifth child during the third year. However, since mortality was comparatively low at these ages, these effects were not translated into very large numbers of saved lives. When the underlying mortality rate is figured into the calculations, it can be shown that a paternal

**Table 11.2** Parameter estimates (for the baseline) and relative risks (antilog of parameters estimations, for the covariates) from the piecewise constant model with period specific effects

| Baseline | All children Estimate | Male children Estimate | Female children Estimate |
|---|---|---|---|
| Age of child (months) | | | |
| 0 | −2.59 | −2.51 | −2.74 |
| 1–5 | −4.27 | −4.26 | −4.38 |
| 6–11 | −5.29 | −5.21 | −5.46 |
| 12–23 | −6.07 | −6.03 | −6.20 |
| 24–35 | −6.80 | −6.77 | −6.90 |
| 36–59 | −7.43 | −7.31 | −7.68 |

| Covariate | Relative risk | Relative risk | Relative risk |
|---|---|---|---|
| Mother | | | |
| 0 | 2.88** | 3.00** | 2.80** |
| 1–5 | 3.83** | 4.55** | 3.19** |
| 6–11 | 2.94** | 3.07** | 2.91** |
| 12–23 | 2.16** | 2.18** | 2.16** |
| 24–35 | 1.83** | 1.90* | 1.75+ |
| 36–59 | 1.95** | 1.81* | 2.09** |
| Father | | | |
| 0 | 1.28 | 1.22 | 1.35 |
| 1–5 | 1.40 | 0.84 | 2.00** |
| 6–11 | 1.66* | 2.28** | 0.91 |
| 12–23 | 1.93** | 2.45** | 1.50 |
| 24–35 | 1.12 | 0.98 | 1.20 |
| 36–59 | 1.35 | 1.22 | 1.46 |
| Maternal grandmother | | | |
| 0 | 1.07 | 1.06 | 1.07 |
| 1–5 | 1.04 | 1.02 | 1.06 |
| 6–11 | 1.06 | 1.14 | 0.98 |
| 12–23 | 1.30** | 1.33** | 1.28** |
| 24–35 | 1.22* | 1.12 | 1.31* |
| 36–59 | 0.92 | 1.09 | 0.79+ |
| Paternal grandmother | | | |
| 0 | 1.12** | 1.13* | 1.11+ |
| 1–5 | 1.03 | 0.99 | 1.08 |
| 6–11 | 0.96 | 0.95 | 0.97 |

**Table 11.2** (*continued*)

| Covariate | Relative risk | Relative risk | Relative risk |
|---|---|---|---|
| 12–23 | 1.03 | 0.94 | 1.12 |
| 24–35 | 1.04 | 0.94 | 1.15 |
| 36–59 | 0.95 | 0.98 | 0.91 |
| Maternal grandfather | | | |
| 0 | 1.01 | 1.06 | 0.95 |
| 1–5 | 1.00 | 1.03 | 0.97 |
| 6–11 | 0.94 | 0.88 | 1.01 |
| 12–23 | 1.01 | 1.03 | 0.99 |
| 24–35 | 1.02 | 1.01 | 1.02 |
| 36–59 | 1.33** | 1.29+ | 1.37* |
| Paternal grandfather | | | |
| 0 | 1.05 | 1.04 | 1.07 |
| 1–5 | 1.03 | 1.08 | 0.99 |
| 6–11 | 1.09 | 1.14 | 1.03 |
| 12–23 | 1.10 | 1.05 | 1.17 |
| 24–35 | 1.11 | 1.14 | 1.07 |
| 36–59 | 1.12 | 0.85 | 1.51* |
| Sex | | | |
| Male | 1 | — | — |
| Female | 0.92** | — | — |
| Age of mother (years) | | | |
| 15–25 | 1 | 1 | 1.00 |
| 25–30 | 1.04 | 1.05 | 1.03 |
| 30–35 | 1.16** | 1.17** | 1.15* |
| 35–50 | 1.37** | 1.31** | 1.45** |
| Birth cohort | | | |
| 1680–1710 | 1 | 1 | 1.00 |
| 1710–30 | 1.18** | 1.14* | 1.22** |
| 1730–50 | 1.49** | 1.44** | 1.54** |
| Number of living siblings | | | |
| none | 1 | 1.00 | 1.00 |
| 1–2 | 0.84** | 0.83** | 0.85** |
| 3–5 | 0.81** | 0.79** | 0.84** |
| 6+ | 0.78** | 0.75** | 0.80** |

NOTE: **p < .01, *p < .05, +p < .1

grandmother that was alive saved almost as many lives in the first month of the child's life than a maternal grandmother one and two years later. Nevertheless, the great difference between the two grandmothers is their method of assistance: The maternal grandmothers seem to have saved children's lives by directly helping with child care while the effect of the paternal grandmother was mediated via the mother's condition during pregnancy (referring to the endogenous nature of mortality during the first month).

Both grandfathers have almost no effect on the child's survival chances. The only exception is the maternal grandfather who has a significant effect on the child's mortality just in the very last age interval, that is, from three to five years. Here, the risk to die increased by 33 percent when the maternal grandfather was not alive.

All other control variables show the expected effects on children's mortality (note that constraints are added to the parameters of these covariates, resulting in the same estimate for all ages): Girls had a lower mortality than boys, child mortality was higher at higher maternal ages, and children who occupied a low position in the birth order showed increased mortality compared to children at the higher positions. Later cohorts suffered from higher mortality compared to the earlier ones. Prima facie, this is a surprising finding, but it is a distinctive feature of the Québec population. It is related to a healthy migrant effect and to the generally favorable environmental conditions as mentioned above.

Since it is known that at least parental investment in children may depend on the children's sex (for example, Sieff 1990; Beise and Voland 2002b) we ran the same model separately for both sexes. The second and third columns in table 11.2 show the corresponding results.

For both sexes, the death of the mother is a dramatic event in terms of mortality. But it seems that the early death of the mother affected sons more than daughters. Up to age three, boys suffered a higher risk of dying than girls when the mother died. Only in the last age group is this relation reversed. The higher responsiveness at early ages of boys to the loss of their mother may be a consequence of the general higher biological frailty of boys compared to girls at young ages, which is also reflected in the generally higher general infant mortality of boys.

The loss of the father had a mixed effect on the mortality of sons and daughters although it seems that the sons were influenced more strongly. When the father was dead, daughters suffered from a twofold risk of dying between age one to five months and sons suffered from up to almost two and a half times higher a risk in the second half of the first year and the following second year of life. These effects are difficult to interpret, not least because it is unclear what the mechanism could look like. A direct benefi-

cial effect of a living father on the children at these ages (when most children were still breastfed) is unlikely; rather there may be a harmful effect by the death of the father on the household economy or the mother's mental health due to the loss of her husband. But in those circumstances, a sex difference is not expected.

The effect of the maternal grandmother is quite stable for children of both sexes, although there seems to be as slight preference for daughters. In the second and third year of life, girls without a living maternal grandmother suffered from a mortality risk that is around 30 percent higher, while this was true for boys only in the second year. In the third year, boys' risk is still increased by 12 percent, but this effect does not differ statistically from a zero effect.

We observed only very slight sex differentiating effects concerning the paternal grandmother. Although the effect for boys and girls differ in the level of significance, the absolute values are very similar (a risk to die when the paternal grandmother was not alive that increased by 13 percent and 11 percent for boys and girls respectively). This is not surprising: If we assume that the effects can be traced back to the maternal condition during her pregnancy, then there is no place for an intentional preference of one sex since the sex of the developing child is unknown. The remaining difference between boys and girls, if it is real, could be related to boys' higher frailty at the time around birth or a potentially higher receptivity for an improvement of their fetal environment.

Grandfathers had only small effects on boys and girls. A missing maternal grandfather increased the mortality of boys by almost 30 percent and that of girls by 37 percent in the last age group (four to five years). The paternal grandfather had a similar effect on the same age group, but only concerning girls. Their risk to die was rising by 51 percent when the grandfather was not alive. The effects on the last age group are difficult to interpret, but note again that although the effect values seem to be high, they are much less influential compared to the grandmaternal effects because mortality is very low at these ages.

As already mentioned, grandmothers seem to be especially important in the context of weaning (see Beise and Voland 2002a; Sear et al. 2002). But the question remains about the quality of this help. Was help especially important to young and inexperienced mothers? Or was grandmaternal help something given additionally to improve the child's condition—not necessarily intended for compensating insufficiency by the mother. In answer to this question, we introduced an interaction between the survival status of the grandmother and the age of the mother in the model presented in table 11.2. This was done by creating four dummy variables, which coded for four maternal age categories, and a maternal grandmother that passed away

(in order to get a contrasting age group of very young mothers, the first age group was reduced to mothers from age fifteen to twenty-two). The mortality risks of the children were compared to the average mortality risk for children when their maternal grandmother was alive (irrespective of the mother's age). The dummy variables entered the full model, substituting the grandmother variable but in addition to the variables coding for the mother's age. This was done in order to catch the true interaction effect and not to confound this relationship by the strong maternal age effect. Furthermore, it was done only for the maternal grandmother since she was the only one who showed a substantial influence on the child's well-being.

Figure 11.4 depicts that part of the model's results that concerns the maternal grandmother. It shows the risk of death for children when the maternal grandmother was dead, depending on the age of the mother at the time of birth and relative to the risk of children whose grandmother was alive. As can be seen, the effect of grandmothers on the survival of their grandchildren did indeed show an age-graded effect: the older the mother, the less important the grandmaternal effect, it seems. But still, even for older and therefore presumably experienced mothers in their early thirties,

**Figure 11.4** Grandmaternal effect and its relationship to mother's age when giving birth. Shown is the outcome of a piecewise constant model with period-specific effects as relative risks: These are the risks for a child of a mother of a specific age to die if a maternal grandmother was dead at childbirth compared to the average risk for a child when she was alive (Note: ** $p < .01$, * $p < .05$, + $p < .1$).

the presence of the maternal grandmother increased the survival chances substantially, especially during the second year of the children's life. Grandmothers seemed to be most important to the youngest mothers, though. At age three, their children faced even a double risk of dying when the grandmother was not present (although the observed pattern speaks in favor of a delayed grandmaternal effect compared to older mothers: perhaps young mothers weaned slightly later than the older mothers). And in the very first month of life, the children's risk was 35 percent higher when the maternal grandmother was dead. Since infant mortality in the first four weeks is mainly due to endogenous causes reflecting among others maternal health (McNamara 1982), this effect can be interpreted as support that the mother's mother gave to her daughter during pregnancy.

## Discussion

Grandmaternal or grandparental support was postulated based on theoretical considerations. Up until very recently, almost no hard empirical tests on grandmaternal help were available. Psychological or sociological studies found special relationships between grandparents and grandchildren, which are in accordance with expectations based on evolutionary theory (for example, Euler and Weitzel 1996). Anthropological studies provided evidence for support that grandmothers give to their adult children and grandchildren (Hawkes, O'Connell, and Blurton Jones 1997; Hewner 2001).

Only in the last few years have studies emerged that focused on the immediate genetic fitness benefits of grandparents on their grandchildren. Most of these studies took the survival of the grandchildren as (the ultimate) outcome (Jamison et al. 2002; Sear et al. 2002; Beise and Voland 2002; Voland and Beise 2002; Lahdenperä et al. 2004), but they also considered their nutritional status (Sear, Mace, and McGregor 2000) or the fertility of the parent generation (Sear et al. 2002; Voland and Beise 2002; Lahdenperä et al. 2004). Very interestingly, these studies show a remarkable resemblance to the basic pattern: grandmothers have a significant survival benefit on children. This applies, however, mainly to the maternal grandmother. The paternal grandmother had no impact on the child's life after the very first month (only Lahdenperä et al. [2004] found no differences for the Finnish grandmothers). Furthermore, both grandfathers did not come close to the level of support that the maternal grandmother gave.

Irrespective of why only maternal grandmothers are supportive, the contrasting pattern among the grandparents is a lucky result from an analytic point of view: It gives support to the argument that the observed relationships are driven by causality and are not just phenotypic associations based on shared genetic, behavioral, or environmental background (Lee [1997]

warns of such flawed conclusions). Phenotypic associations would have led to similar patterns for all four grandparents.

A further parallel finding concerns the timing of this beneficial effect in the populations of Gambia, the Krummhörn, and Québec. Although the age at which the survival effect is most pronounced differs between the three populations who offer such information, it is possible to establish a connection between these ages and the weaning event. In Gambia, weaning occurs mostly in the second year, the only age at which a significant grandmaternal effect was found (Sear et al. 2002); in the Krummhörn population, the average age at weaning is estimated to be around ten months[1] and the grandmaternal effect is most pronounced at ages six to eleven months (Voland and Beise 2002); in the Quebéc population, the children were breastfed on average for fourteen to fifteen months with the age categories that are most sensitive towards grandmaternal presence being the second and third year.

Thus, the observed pattern of differential grandparental support (with influence on the survival) seems to be a robust finding. We find very similar patterns across time, space, and socioecological conditions. Furthermore, the discriminative grandpaternal effect was also found in psychological studies. Most of these studies noted a pattern of caregiving or emotional closeness among the grandparents, with the maternal grandmother being the most caring grandparent (some studies find even a ranked pattern for all four grandparent types; see van Ranst, Verschueren, and Marcoen 1995; Euler and Weitzel 1996).

But the question remains why it is the maternal grandmother who helps most? A good candidate reason is the notorious paternity uncertainty. As with most mammals, men can never be entirely sure about their genetic relatedness while mothers are. This imbalance has also an impact on the relatives of both parents. The mother of the mother can be sure about her relatedness with her daughter's children while the father's mother is sure about the relatedness with her son but not about his children. Both grandmothers have therefore different motivations to invest in their grandchildren. It may be argued that in a society that is characterized by a moderate uncertainty concerning paternity it still may be beneficial for a paternal grandmother to invest in a grandchild rather than not to invest at all because the chances that she is genetically related to the child (and thus that the investment is not wasted) are not negligible. Let's remember, though, that many of these women have adult sons *and* daughters, so they are both a maternal and a paternal grandmother. Their support resources—may they be in terms of time or energy—are limited and may be only partially dividable, if at all (especially if the daughter's family and the son's family live a considerable distance apart). Thus, if a grandmother has to decide

whether to invest in her daughter's children or her son's, she "should" decide for her daughter's children even if the difference in terms of probability of relatedness is only small.

Nevertheless, it seems that there is an additional level of grandmaternal behavior than solely the support a paternal grandmother is willing—or in this case—not willing to give to their grandchildren: that is her behavior towards her daughter-in-law. Voland and Beise (2002, this volume) argue that in the Krummhörn population a tense relationship between mother- and daughter-in-law is responsible for the observed increased risk of a stillborn fetus or newborn death in the very first month if the mother-in-law was alive. The argument is based on the three following factors: the causal relationship between the early death of the child (stillbirth or death in the first month) and maternal health during pregnancy (see Hart 1998), the conflicting life-course interests of the (genetically unrelated) mother- and daughter-in-law, and the specific socioecological context of the Krummhörn.

Our results for the Québec population show that the mother-in-law has an effect on the child's risk to die in the first month (in fact, it is the only effect found concerning her), but—contrary to the situation in the Krummhörn—the effect here is positive, that is, an alive mother-in-law decreased the risk of dying. Does this mean that there were no in-law conflicts in Québec? Not necessarily, but at least potential conflicts could not have been so stressful for the mother that it harmed her condition during pregnancy. Rather it seems that a mother-in-law influenced the mother's environment during her pregnancy in a beneficial way. The reason for the opposing effects lies very likely in the differing socioecological conditions of the two populations.

The Krummhörn population was in a demographic sense an almost stationary population characterized by high population density, very low growth rates, and low fertility. The agrarian economy was very competitive and common land was virtually nonexistent (see Voland [1995] for a more detailed description of the socioecological situation of the Krummhörn population). There were plenty of opportunities—and needs—for women to contribute to the family economy. In total, the situation favored the exploitation of the daughter-in-law's labor for the sake of the patrilineal household economy (see Voland and Beise [this volume] for a more detailed description of the exploitation scenario).

The Québec case is very different. The colonization of the region took place just a few generations before the start of the period under analysis, the population was still growing at high rates, fertility was high, and new land was readily available. But above all else, women have been for a long time a rare and therefore valuable "resource" in the Québec population due to the

male bias in immigration (leading, among other factors, to very low marriage ages for women and high rates of remarriage after widowhood [Charbonneau et al. 2000]). Therefore, women in Québec were less replaceable than their counterparts in the Krummhörn population and should have been less exploited (Voland and Beise this volume). This may have led mothers-in-law to help their son's family with domestic and subsistence work during times when the daughter-in-law was pregnant and thereby relieve her workload. The Québec population was comparatively mobile due to the easy and cheap availability of land. Nevertheless, there may have existed sufficient opportunities for such help because parents tried to establish their offspring close by—which was in particular true for sons (Bouchard and Pourbaix 1987; Bouchard 1991).

In conclusion, although in Québec both grandmothers saved in the end almost the same numbers of lives, their motivations and the pathway of their help was very different. The maternal grandmother was a true helping grandmother, who supports her daughter and her grandchildren in times of increased needs—in terms of the mother's age (when the mother was young and still comparatively inexperienced) and in terms of the child's developmental stage (when it got weaned). The paternal grandmother, on the other hand, is less willing to support her grandchildren and is interested in her daughter-in-law only as much as it fits her reproductive strategies. Since reproductive women were precious in Québec, the paternal grandmother supported her daughter-in-law during the hazardous time of pregnancy and only in this sense was she helpful in the survival of her grandchildren.

## Summary

This study analyzed the effect of grandparents and in particular grandmothers on children's mortality in the population of historic Québec (1680–1750). The population consisted of French immigrants who started to settle in Québec in 1621 and their descendents. The results show that the only helping grandparent is the maternal grandmother. With her being alive, the risk of death decreased for grandchildren by around 20 to 30 percent at the ages one and two years. The time pattern of the effect makes it very likely that this influence is connected with the process of weaning. It seems that children of younger women benefited most from the grandmother's help; even so the maternal grandmother continued to be important also for children of older mothers. Neither paternal grandmother nor both grandfathers came close to reaching the survival-increasing effect in post-neonatal ages to the extent that the maternal grandmother showed. The differential pattern of grandparental support and the temporal aspect

of it is astonishingly similar to what was found in comparable studies despite the fact that all these populations differ largely with regard to geographical, historical, and sociocultural conditions. But contrary to these studies, which could not find any effects by the paternal grandmother, this study found a beneficial effect of these grandmothers on survival in the neonatal period (first month). We argue that this effect is not due to direct grandmaternal support for the child but rather reflects her efforts in improving the mother's environment during pregnancy, which influences the fetus viability by mediation through the mother's body. The reason for this variability in the paternal grandmother's behavior may lie in the specific socioecological conditions of Québec in which women and therefore mothers were a rare "resource." Under these special conditions, the usually tense relationship between mother- and daughter-in-law probably eased, and the mother-in-law turned out to be even helpful for the child's survival by improving the mother's health condition during pregnancy.

## Acknowledgments

Thank you to Bertrand Désjardins of the Programme de Recherche en Démographie Historique of the University of Montréal for providing the data on the St. Lawrence Valley. Thanks also to Bertrand Désjardins and the editors of this volume for thoughtful comments on an earlier version of this paper, and to Susann Backer for language editing.

## Note

1. This value is based on my calculations following Gehrmann (2000, 717f), who regards the difference of the interbirth intervals following a surviving child and following a child who died in the first month as a good estimation for the age at weaning in historical populations (only the first two intervals and not the last one should be considered).

## References

Beise, J., and E. Voland. 2002a. "A multilevel event history analysis of the effects of grandmothers on child mortality in a historical German population (Krummhörn, Ostfriesland, 1720–1874)." *Demographic Research* 7:469–97.
———. 2002b. "Differential infant mortality viewed from an evolutionary biological perspective." *Journal of Family History* 7:515–26.
Biesele, M., and N. Howell. 1981. "'The old people give your life': Aging among !Kung hunter-gatherers." In *Other Ways of Growing Old*, ed. P. Amoss and S. Harrell. Palo Alto, CA: Stanford University Press, 77–98.

Blossfeld, H.-P., and G. Rohwer. 1995. *Techniques of Event History Modeling: New Approaches to Causal Analysis.* Mahwah, NJ: Lawrence Erlbaum.

Bouchard, G. 1991. "Mobile populations, stable communities: social and demographic processes in the rural parishes of the Saguenay, 1842–1911." *Continuity and Change* 12:225–42.

Bouchard, G., and I. de Pourbaix. 1987. "Individual and family life courses in the Saguenay region, Québec, 1842–1911." *Journal of Family History* 12:225–42.

Carey, J. R., and D. S. Judge. 2001. "Life span extension in humans is self-reinforcing: a general theory of longevity." *Population and Development Review* 27:411–36.

Charbonneau, H. 1985. "Colonisation, climat, et âge au baptême des Canadiens au XVIIe siècle." *Revue d'Histoire de l'Amérique Française* 38:341–56.

Charbonneau, H., B. Desjardins, J. Légaré, and H. Denis. 2000. "The population of the St. Lawrence Valley, 1608–1760." In *A Population History of North America,* ed. R. H. Haines and R. H. Steckel. Cambridge: Cambridge University Press, 99–142.

Desjardins, B. 1997. "Family formation and infant mortality in New France." In *Infant and Child Mortality in the Past,* ed. A. Bideau, B. Desjardins, and H. Pérez Brignoli. Oxford: Clarendon, 174–87.

Euler, H. A., and B. Weitzel. 1996. "Discriminative grandparental solicitude as reproductive strategy." *Human Nature* 7:39–59.

Fleury, M., and L. Henry. 1976. *Nouveau Manuel de Dépouillement et l'Exploitation de l'état Civil Ancien,* 2nd ed. Paris: L'Institut National d'Ètudes Démographiques.

Gehrmann, R. 2000. "Methoden der historischen Bevölkerungsforschung: historische Demographie und Bevölkerungsgeschichte." In *Handbuch der Demographie,* vol. 2, *Anwendungen,* ed. U. Mueller, B. Nauck, and A. Dieckmann. Berlin: Springer, 709–28.

Grainger, S., and J. Beise. 2004. "Menopause and post-generative longevity: Testing the 'stopping-early' and 'grandmother' hypotheses." MPIDR Working Paper WP-2004-XYZ.

Hart, N. 1998. "Beyond infant mortality: Gender and stillbirth in reproductive mortality before the twentieth century." *Population Studies* 52:215–29.

Hawkes, K. 2003. "Grandmothers and the evolution of human longevity." *American Journal of Human Biology* 15:380–400.

Hawkes, K., J. O'Connell, and N. Blurton Jones. 1989. "Hardworking Hadza grandmothers." In *Comparative Scoioecology: The Behavioral Ecology of Humans and Other Mammals,* ed. V. Standen and R. A. Foley. Oxford: Blackwell, 341–66.

———. 1997. "Hadza women's time allocation, offspring provisioning, and the evolution of long postmenopausal life spans." *Current Anthropology* 38:551–77.

Henripin, J. 1954. "La fécondité des ménages canadiens au début du XVIIIe siècle." *Population* 9:61–84.

Hewner, S. J. 2001. "Postmenopausal function in context: Biocultural observations on Amish, neighboring non-Amish, and Ifugao household health." *American Journal of Human Biology* 13:521–30.

Hill, K., and A. M. Hurtado. 1991. "The evolution of premature reproductive senescence and menopause in human females: an evaluation of the 'grandmother hypothesis.'" *Human Nature* 2:313–50.

———. 1996. *Ache Life History: The Ecology and Demography of a Foraging People*. New York: Aldine de Gruyter.

Jamison, C.S., L. L. Cornell, P. L. Jamison, and H. Nakazato. 2002. "Are all grandmothers equal? A review and a preliminary test of the grandmother hypothesis in Tokugawa, Japan." *American Journal of Physical Anthropology* 119:67–76.

Kaplan, H. 1997. "The evolution of the human life course." In *Between Zeus and the Salmon: The Biodemography of Longevity*, ed. K. W. Wachter and C. E. Finch. Washington, DC: National Academy Press: 175–211.

Lahdenperä, M., V. Lummaa, S. Helle, M. Tremblay, and A. F. Russell. 2004. "Fitness benefits of prolonged post-reproductive life span in women." *Nature* 28: 178–81.

Lee, R. D. 1997. "Intergenerational relations and the elderly." In *Between Zeus and the Salmon: The Biodemography of Longevity*, ed. K. W. Wachter and C. E. Finch. Washington, DC: National Academy Press: 212–33.

Loudon, I. 1992. *Death in Childbirth: An International Study of Maternal Care and Maternal Mortality 1800–1950*. Oxford: Clarendon.

McNamara, R. 1982. "Infant and child mortality." In *International Encyclopedia of Population*, ed. J. A. Ross. New York: Free Press, 339–43.

Nault, F., B. Desjardins, and J. Légaré. 1990. "Effects of reproductive behaviour on infant mortality in French-Canadians during the seventeenth and eighteenth century." *Population Studies* 44:273–85.

Packer, C., M. Tatar, and A. Collins. 1998: "Reproductive cessation in female mammals." *Nature* 392:807–11.

Peccei, J. S. 2001. "A critique of the grandmother hypotheses: old and new." *American Journal of Human Biology* 13: 434–52.

Rohwer, G., and U. Pötter. 1999. "TDA User's Manual." Ruhr-Universität Bochum. http://www.stat.ruhr-uni-bochum.de/tda.html.

Sear, R., R. Mace, and I. A. McGregor. 2000. "Maternal grandmothers improve the nutritional status and survival of children in rural Gambia." *Proceedings of the Royal Society of London.B* 267:461–67.

———. 2003. "The effects of kin on female fertility in rural Gambia." *Evolution and Human Behavior* 24:25–42.

Sear, R., F. Steele, I. A. McGregor, and R. Mace. 2002. "The effects of kin on child mortality in rural Gambia." *Demography* 39:43–63.

Sieff, D. F. 1990. "Explaining biased sex ratios in human population: A critique of recent studies." *Current Anthropology* 31:25–48.

Van Ranst, N., K. Verschueren, and A. Marcoen. 1995. "The meaning of grandparents as viewed by adolescent grandchildren: An empirical study in Belgium." *International Journal of Aging and Human Development* 41:311–24.

Voland, E. 1995. "Reproductive decisions viewed from an evolutionary informed historical demography." In *Human Reproductive Decisions: Biological and Social Perspectives*, R. I. M. Dunbar. London: Macmillan. 137–59.

———. 2000. "Contributions of family reconstitution studies to evolutionary reproductive ecology." *Evolutionary Anthropology* 9:134–46.

Voland, E., and J. Beise. 2002. "Opposite effects of maternal and paternal grandmothers on infant survival in historical Krummhörn." *Behavioral Ecology and Sociobiology* 52:435–43.

Williams, G. C. 1957. "Pleiotropy, natural selection, and the evolution of senescence." *Evolution* 11:398–411.

## CHAPTER 12

# "The Husband's Mother Is the Devil in House"

## Data on the Impact of the Mother-in-Law on Stillbirth Mortality in Historical Krummhörn (1750–1874) and Some Thoughts on the Evolution of Postgenerative Female Life

Eckart Voland and Jan Beise

---

Twee Wiefen over een Deel, is een to vööl.
(Two women in one house is one too many.)

—C. J. Hibben

There is growing evidence that grandmothers are helpful towards their adult daughters in different ways depending on the opportunities that the local socioecology offers (cf. various chapters in this volume). Thinking of the helping grandmother thus usually means thinking of the maternal one. With respect to the paternal grandmother, things are a bit more complicated. All relevant studies so far report that the impact of the paternal grandmother on familial reproduction is either less pronounced than the support provided by the maternal grandmother, or is not detectable or even negative (Beise this volume; Beise and Voland 2002; Bereczkei and Dunbar 1997; Ragsdale 2004; Sear, Mace, and McGregor 2000, 2003; Sear et al. 2002; Sorenson Jamison et al. 2002; Voland and Beise 2002; but see Leonetti this volume). In this article, we aim to trace this finding on the not-so-helpful grandmother and try to put it into an evolutionary framework.

## Intrafamilial Conflicts of Interests

The difference between maternal and paternal grandmothers with regard to their support of the reproduction of their adult offspring has to be thought of as an adaptive difference that, in our opinion, is based on evolved intrafamilial conflicts of interests. Whereas the reproductive interests of postmenopausal mothers and their adult daughters overlap for the most part (and only conflict if a mother has to divide her support among several adult daughters), the reproductive interests of mothers and the mates of their adult sons are different and only run parallel to each other

under certain circumstances. Darwinian theory predicts that mothers are shaped by natural selection to promote the reproductive interests of their adult sons, while the mates of these sons can be expected to pursue their own reproductive interests. Consequently, within a family, both sexual and dynastic conflicts of interest are bundled. Therefore, the interest of mothers-in-law in their daughters-in-law only stretches as far as the latter contribute to the former's dynastic interest. In contrast to mothers, mothers-in-law have no ultimate reason for assuming a perspective regarding the lifelong well-being of their daughters-in-law. Their ultimate interest is limited to the stage of life in which the daughter-in-law is married to (or mating with) their son. In demographic regimes with significant pre-senile mortality, marriages last for a relatively short time on average. Second marriages or periods of widowhood are correspondingly probable. Thus, the reproductive interests of mothers-in-law in their daughters-in-law are limited to a much narrower period of time than that of the latters' own mothers. Considerate treatment has, therefore, a much lower chance of becoming a mother-in-law's behavioral trait than a mother's trait. In brief: There is ample room for severe intrafamilial behavioral conflicts, as folk wisdom is well aware.

Psychological and anthropological studies show that this in-law conflict manifests itself under the most varied ethnohistorical conditions (for example, in Israel, Linn and Breslerman 1996; in the Bolivian highlands, Van Vleet 2002; in rural Taiwan, Gallin 1994; in central Sudan, Kenyon 1994). The obviously transcultural dissemination of this potential for conflict (Adler, Denmark, and Ahmed 1989) supports the assumption that this could be a species-specific genetic conflict of *Homo sapiens,* for the resolution of which mothers-in-law and daughters-in-law have developed adaptive psychological mechanisms and behavioral strategies. What is interesting is that there are signs that the relationship between mothers- and daughters-in-law is characterized by latent bilateral mistrust even if the living conditions do not provide any grounds for an open conflict. Even under the conditions of the modern age (Apter 1999), daughters-in-law not infrequently report emotional tension when visiting their mothers-in-law, even if the areas of life do not overlap geographically, economically, or socially. The odds are in favor of an evolved background for this conflict, which can appear even if the adaptive logic of its evolution has long disappeared.

## In-law Conflicts Generate Costs: The Krummhörn Case

In an earlier study, we were able to show by a family reconstitution study of the population of the Krummhörn region (Ostfriesland, Germany) of the eighteenth and nineteenth centuries that the existence of the paternal

grandmother significantly increased neonatal mortality, that is, the risk of dying in the first month of life. This effect was very drastic if the mother of the infant's mother (that is, the maternal grandmother) was no longer alive and the young woman was exposed to the influence of her husband's mother without the protection of her own mother. And this effect was even greater if the mother-in-law's family and the woman's own family lived in the same parish, that is, if the families were close to each other geographically. Under these circumstances, the risk of a newborn's dying within the first month after birth rose to 2.48 times that of the situation in which the paternal grandmother no longer lived at the time of the child's birth (Voland and Beise 2002). We have interpreted this increased mortality as being primarily caused endogenously. One reason could have been an escalation of the in-law conflict, which was so stressful that it led to prenatal damage and reduced viability of the children. It is well known that lack of social support to pregnant women reduces fetal growth and birth weight and therefore infant survival (Feldman et al. 2000). This interpretation has been given new nourishment through additional analyses of differential stillbirth mortality, which we report here.

The basis for this study is the reconstitution of the families of the Krummhörn population during the eighteenth and nineteenth centuries. The entries in the church registers of this coastal region in northwest Germany, when taken together with information provided by tax lists and a few other historical sources, form the basis for the reconstitution of lineage histories that overlapped individuals, families, and residences (cf. Voland 2000 on the methods and applications of family reconstitution studies in evolutionary anthropology, and Voland 1995 on the specifications of the socioecological features of the Krummhörn population and a few earlier main results of this study). Stillbirths are notoriously underregistered in the parish records, which makes an estimate of their incidence very difficult (Hart 1998). This applies in particular to the pietistic population of the Krummhörn, in which stillbirths were traditionally considered to be hardly worth mentioning. In the early days of record keeping by Krummhörn pastors, stillbirths were only registered in a very sketchy way. However, statistics show that such underregistration noticeably decreased as of the 1750s. The documented stillbirth rate then increases approximately 3 percent, which lies within the expected range in view of historical comparative data. Therefore, we begin our analysis with the birth cohort of 1750 but still have to take into account underregistration in the first few years after that. However, this possible sample bias is neutral in view of the hypothesis being tested and can probably be neglected in the analysis.

From the database of the reconstituted Krummhörn families, we have extracted 6,206 legitimate births from all social groups during the period from

**Table 12.1** Risk of stillbirth (Krummhörn, Ostfriesland, 1750–1874). Logistic regression with the type of birth (live birth = 0, still birth = 1) as a dependent variable

| Variable | B | SE | Wald | df | Sig. | Exp(B) |
|---|---|---|---|---|---|---|
| Maternal grandmother | | | | | | |
| Dead | | | | | | 1.000 |
| Alive | −0.025 | 0.141 | 0.033 | 1 | 0.857 | 0.975 |
| Paternal grandmother | | | | | | |
| Dead | | | | | | 1.000 |
| Alive | 0.299 | 0.141 | 4.492 | 1 | 0.034 | 1.349 |
| Age of mother | | | 24.359 | 3 | 0 | |
| <25 | −0.284 | 0.294 | 0.931 | 1 | 0.335 | 0.753 |
| 25–30 | | | | | | 1.000 |
| 30–35 | 0.193 | 0.204 | 0.895 | 1 | 0.344 | 1.213 |
| 35+ | 0.727 | 0.187 | 15.091 | 1 | 0 | 2.069 |
| Birth cohort | | | 6.746 | 3 | 0.08 | |
| 1750–1800 | −0.6 | 0.239 | 6.311 | 1 | 0.012 | 0.549 |
| 1800–25 | −0.048 | 0.192 | 0.064 | 1 | 0.801 | 0.953 |
| 1825–50 | −0.06 | 0.168 | 0.127 | 1 | 0.722 | 0.942 |
| 1850–74 | | | | | | 1.000 |
| Constant | −3.627 | 0.222 | 267.92 | 1 | 0 | 0.027 |
| n = 6206 | | | | | | |

1750 to 1874. Of these, 202 (3.3 percent) were stillbirths. The type of birth (live birth or stillbirth) was subjected to a logistic regression as an independent variable. After statistically controlling for the age of the mother and cohort effects, it becomes evident that whether the paternal grandmother was still alive at time of birth had a significant influence on stillbirth incidence (table 12.1). Whereas the existence of the mother's mother did not have any impact on the risk of a stillbirth, the existence of the mother-in-law elevated the stillbirth incidence by 34.9 percent (p = .034) in comparison with when the mother-in-law was no longer alive. As expected, the existence of either grandfather did not have any impact on stillbirth incidence, so we have removed this variable from the models.

The impact of mothers-in-law on stillbirth incidence is not evenly distributed across the duration of the marriage (figure 12.1). After controlling for cohort effects and the age of the mother at marriage, the overall rate of stillbirths shows a J shape across the duration of the marriage. At the beginning of a marriage and again after many years of marriage, stillbirth rates increase to an above-average level. This very likely reflects the well-known age distribution of stillbirth incidence (Knodel 1988; Reid 2001). Interestingly,

the relative risk of having a mother-in-law has a similar course—independent from mother's age, which is controlled. It is elevated in all phases of a marriage, but it is particularly high at the beginning of a marriage and once more after many years of marriage: in the beginning, the risk of having a stillbirth is increased for women having a mother-in-law around by 62 percent compared to women without a mother-in-law and after twelve or more years of marriage it is increased for these women by 53 percent. The high value at the beginning of a marriage seems easy to understand. The social constellation after marriage is new and correspondingly stressful for young women. The elevated level after many years of marriage deserves more interest, however. This observation indicates that mothers-in-law did not reduce their pressure or that the daughters-in-law did not develop habituated or suitable coping strategies over time. On the contrary, the stress-induced effects appear to accumulate with the length of the marriage. This observation implies that long-term effects of the conflict are to be expected, which could possibly even adversely affect life expectancy (cf. Skinner 1997).

Psychological studies do not show a "habituation effect," either. For example, in an Israeli study, 49 percent of the mothers-in-law interviewed said

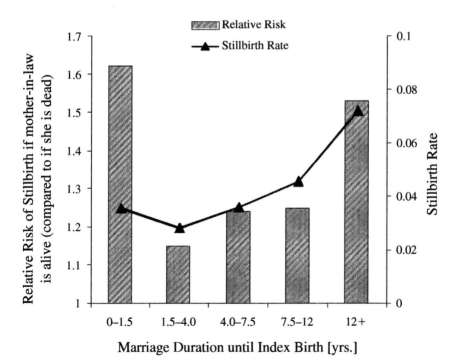

**Figure 12.1** The relative risk of a living mother-in-law on stillbirth mortality depending on the duration of the marriage (Krummhörn 1750–1874). The birth cohort effects and the age of the mother at marriage were statistically controlled.

the opinion that their relationship with their daughters-in-law had improved over the years, while 51 percent believed that they had noticed a worsening of the relationship. On the part of the daughters-in-law, 45 percent saw an improvement and 55 percent did not see any change or saw a worsening (Linn and Breslerman 1996).

Interestingly, the geographical proximity between the mother-in-law and the daughter-in-law models the relative risk of stillbirth mortality. Church register entries permit us to determine the center of life for every reconstituted family (see Beise 2001 for the method). This variable (place of residence) provides an indication of in which parish the family members primarily resided and spent their lives. If the place of residence of the mother-in-law and the daughter-in-law was identical, the relative risk of stillbirth in the case of a living mother-in-law increased by 45 percent ($p = .033$) (table 12.2). If the places of residence were different, how-

**Table 12.2** Risk of stillbirth in cases where mother-in-law and daughter-in-law have same place of residence (other factors same as table 12.1)

| Variable | B | SE | Wald | Df | Sig. | Exp(B) |
|---|---|---|---|---|---|---|
| Maternal grandmother | | | | | | |
| Dead | | | | | | 1.000 |
| Alive | −0.025 | 0.171 | 0.021 | 1 | 0.884 | 0.975 |
| Paternal grandmother | | | | | | |
| Dead | | | | | | 1.000 |
| Alive | 0.371 | 0.174 | 4.569 | 1 | 0.033 | 1.450 |
| Age of mother | | | 14.925 | 3 | 0.002 | |
| <25 | −0.144 | 0.344 | 0.175 | 1 | 0.676 | 0.866 |
| 25–30 | | | | | | 1.000 |
| 30–35 | 0.116 | 0.25 | 0.216 | 1 | 0.642 | 1.123 |
| 35+ | 0.700 | 0.226 | 9.595 | 1 | 0.002 | 2.014 |
| Birth cohort | | | 12.422 | 3 | 0.006 | |
| 1750–1800 | −1.092 | 0.332 | 10.833 | 1 | 0.001 | 0.336 |
| 1800–25 | 0.029 | 0.224 | 0.017 | 1 | 0.897 | 1.029 |
| 1825–50 | −0.211 | 0.206 | 1.052 | 1 | 0.305 | 0.810 |
| 1850–74 | | | | | | 1.000 |
| Residence with maternal grandmother | | | | | | |
| Not identical | | | | | | 1.000 |
| Identical | 0.143 | 0.184 | 0.598 | 1 | 0.439 | 1.153 |
| Constant | −3.599 | 0.272 | 175.389 | 1 | 0 | 0.027 |
| n = 4100 | | | | | | |

**Table 12.3** Risk of stillbirth in cases where mother-in-law and daughter-in-law have different places of residence (other factors same as table 12.1)

| Variable | B | SE | Wald | Df | Sig. | Exp(B) |
|---|---|---|---|---|---|---|
| Maternal grandmother | | | | | | |
| Dead | | | | | | 1.000 |
| Alive | −0.087 | 0.267 | 0.106 | 1 | 0.745 | 0.917 |
| Paternal grandmother | | | | | | |
| Dead | | | | | | 1.000 |
| Alive | 0.158 | 0.268 | 0.346 | 1 | 0.556 | 1.171 |
| Age of mother | | | 9.365 | 3 | 0.025 | |
| <25 | −0.748 | 0.651 | 1.318 | 1 | 0.251 | 0.473 |
| 25–30 | | | | | | 1.000 |
| 30–35 | 0.388 | 0.377 | 1.059 | 1 | 0.303 | 1.474 |
| 35+ | 0.809 | 0.362 | 4.978 | 1 | 0.026 | 2.245 |
| Birth cohort | | | 5.508 | 3 | 0.138 | |
| 1750–1800 | 0.478 | 0.41 | 1.36 | 1 | 0.244 | 1.613 |
| 1800–25 | −0.15 | 0.437 | 0.117 | 1 | 0.732 | 0.861 |
| 1825–50 | 0.601 | 0.34 | 3.119 | 1 | 0.077 | 1.824 |
| 1850–74 | | | | | | 1.000 |
| Residence with maternal grandmother | | | | | | |
| Not identical | | | | | | 1.000 |
| Identical | −0.039 | 0.261 | 0.022 | 1 | 0.882 | 0.962 |
| Constant | −3.942 | 0.471 | 70.159 | 1 | 0 | 0.019 |
| n = 1747 | | | | | | |

ever, the effect disappears below the threshold of statistical significance (table 12.3). In the models depicted in both table 12.2 and 12.3, the impact of geographical proximity to the natal family, that is, to the family of the maternal grandmother, has been statistically controlled.

Unfortunately, the data do not permit any further differentiation of the impact of geographical proximity on the intensity of the in-law conflict. Presumably the conflicts became more severe when the families not only lived in the same parish but in the same house or even in the same household. A contemporary proverb says, "Twee Wiefen over een Deel, is een to vööl" (Hibben 1919, 49). The gist of this proverb is that two women in the same household will not get along. Another proverb, which has provided the title of this paper, makes clear that this is a reference to the in-law conflict, namely: "Mann's Moo'r is de Düvel over de Floo'er" ("The husband's mother is the devil in the house" [Hibben 1919, 46]). The fact that the re-

lationship between mother-in-law and daughter-in-law was not unproblematic but filled with tension appears to have been widespread folk wisdom in the Krummhörn and in Ostfriesland in general.

As far as the grandchildren are concerned, the costs of the paternal grandmother are limited to stillbirth and neonatal mortality. Post-neonatal mortality is not affected (Voland and Beise 2002). The correlates and causes for stillbirth and neonatal mortality thought to be very similar (Reid 2001), so it is hardly surprising that the mother-in-law effect is found in both forms of mortality. However, why no positive effect of the paternal grandmother becomes visible once the grandchildren have survived the risks of stillbirth and neonatal mortality (Voland and Beise 2002) still needs to be explained.

## What Is This About, Then?

There are at least three different fields of behavioral conflict in which the genetic interests of mothers clash with the interests of their sons' mates. They revolve around strategies for the sexual monopolization of women, around strategies to increase the mating success of the sons, and around strategies to increase economic exploitation.

First, as indicated by Pashos (2000) for patrilocal populations in rural Greece, by Leonetti et al. (this volume) for patrilocal Bengali, and by Nosaka and Chasiotis (this volume) for traditionally patrilocal Turkish immigrants to Germany, the authority of the mother-in-law could have contributed in the Krummhörn to increasing paternity certainty. It is conceivable that "harassing" mothers-in-law in premodern Krummhörn exerted pressure on their daughters-in-law in the interest of their sons, and thus ultimately in their own interests, in order to compel marital faithfulness and virtue, that is, they helped their sons with mate guarding. A majority of the Krummhörn population was Calvinistic, and if religious history (Hollweg 1978) and folkloric literature (Ohling 1963) is to be believed, they were also strict believers. We do not have any indications whatsoever that sexual liberty would have lowered the probability of paternity to any significant degree. Only towards the end of the nineteenth century are the morals likely to have loosened up here and elsewhere in Europe during the course of a generally emerging sexual liberalization. There were surely occasional episodes of marital infidelity previous to this time—like everywhere in the world, even under the strictest of sexual moral codes—but it appears most unlikely in view of Krummhörn cultural history that the lethal impact of mothers-in-law affected mainly children who were conceived in extramarital relationships. Instead, the mate-guarding tendencies of the mother-in-law very likely had a more prophylactic effect.

We would have to postulate a naturally selected distrust, that is, a kind of

sensor, that recognizes risks and reacts promptly. Nesse (2001) uses the metaphor of a smoke detector in order to illustrate the evolution of defensive mechanisms against fitness risks. A sensor like a smoke detector can make two types of mistakes. It can react too quickly and too frequently with a false alarm, or it can be adjusted so that it is not sensitive enough and therefore not detect a real risk. Which error is more serious with regard to the consequences? In the case of the smoke detector, the answer is clear: Frequent false alarms are annoying, but ultimately do not have any consequences. An undetected fire, on the other hand, can be fatal, which is why smoke detectors should be adjusted to be hypersensitive (and they are). Perhaps the situation regarding a mother-in-law's distrust is similar. Raising false alarms too quickly strains family relations, and can also, as the Krummhörn data teach us, generate costs. On the other hand, indifference to the sexual behavior of daughters-in-law and their family loyalty is also expensive because some of the grandchildren would not be one's own.

It cannot be ruled out that the Krummhörn mothers-in-law could have become the victims of their own morality. The extremely strict sexual morality of the eighteenth and the nineteenth centuries that was molded by Calvinism tried to prevent unclear paternities, and with quite a bit of success, too. The evolutionarily built-in "daughter-in-law monitoring sensor" had to react more and more sensitively in accordance with the predominant morals of the time, which could have led to the result that, in some cases, this "continuous alarm" made the women ill. Seen from this perspective, "evil mothers-in-law" are exaggerated executors of that adaptive distrust that is peculiar to their evolutionary role. The efficacy of the strategy eventually reaches a limit, however, since habituation to continuous hostility can be expected like habituation to continuous false alarms.

The high strain to which the daughters-in-law were subjected by their mothers-in-law at the beginning of a marriage (figure 12.1) indicates that the Krummhörn in-law conflict may serve to increase paternity certainty since there might be some concern about the young wife's loyalty, especially at the beginning of a marriage. Mothers-in-law could be particularly motivated to exercise discipline during this phase in order to set things straight from the very beginning. With the increasing duration of the marriage and security regarding the marital relationship, the pressure should diminish. The fact that this did not happen persistently, however, allows the surmise to be made that the in-law conflicts in the Krummhörn population only partially corresponded to the logic of mate-guarding scenarios.

Secondly, mothers-in-law could try to increase the mating success of their sons whereas the daughters-in-law would have an interest to continue reproductive cooperation with their husbands. The hostility of mothers-in-law would be directed at weakening the emotional bond between their sons

and their daughters-in-law and at finally pushing them out of the family or to a less important position in order to create additional mating opportunities for their sons. Of course, the success of such a strategy would be subject to specific demographic and sociobiological conditions that are not present in the Krummhörn situation. The predominance of monogamy alone, which did not allow for divorce and did not tolerate extramarital affairs, made strategies of mating enhancement more difficult here than in many other societies.

The third type of conflict centers around the contribution the daughter-in-law is expected to make to the economy of the family. A mother-in-law would, provided her intrafamilial power position is strong enough, tend to pressure her daughter-in-law to do more work than her own daughter in order to divert the proceeds of work from nonkin women to her own lineage. Concretely, this could have meant that the mother-in-law unduly compelled the daughters-in-law to do work in the house, garden, or business. It is well known that the workload of pregnant women has an impact on stillbirth and neonatal mortality (for example, Dupâquier 1994; Reid 2001). Generally, in historical and traditional societies, the stillbirth rate is considered to be an indicator of maternal condition (Hart 1998). Being kind to daughters-in-law during their pregnancy or after they gave birth may not ultimately have paid. Even if the economic exploitation of daughters-in-law occasionally cost unborn or just-born grandchildren, the strategy could have been worth it in the long run under certain socioeconomic conditions because deceased grandchildren were able to be replaced quickly, as a rule. Even a deceased daughter-in-law was not irreplaceable. We are dealing with a system of exploitation here in which the toil of daughters-in-law was demanded just as matter-of-factly as their fertility was.

Historical family sociologists have repeatedly developed the theme that in the agrarian societies of Western Europe, the relations among family members are solely characterized by the concept of possession (for example, Sabean 1990). Emotional distance in farmer families is deemed to be a truism in historical family research. There is no doubt that in a pragmatic and emotionally icy family context, in which the economic balances are valued more than the emotional ones, in-law conflicts can easily thrive.

And regional research into epics also provides indications that particularly the "exploitation" motive promotes in-law conflicts. The "ballad of the evil mother-in-law" is a folk song in many parts of Europe with numerous regional variations (Stein 1979). Seemann writes as follows:

> There are numerous European folk songs describing how havoc is wreaked for the family due to the hatred that the mother-in-law fuels against the daughter-in-law who has come into her life. According to such songs, she attempts to poi-

son her son's bride with the welcoming drink; or she sows lethal seeds of discord between husband and wife through malicious slander; she slowly torments her daughter-in-law to death with her tyrannical personality; or she contributes to this death by failing to provide assistance in need. She also attempts to achieve her criminal goal through the use of magic: She prevents birth, so that the eight-year-old twins finally have to be cut out of her daughter-in-law's body, or she transforms the young woman into a tree and orders her son to cut the tree down. (quoted in Stein 1979, 7–8: our translation)

This reflects poetic interpretations with a highly metaphorical charge. The detailed analysis of this song material shows, however, that the topos of the "evil mother-in-law" frequently deals with everyday motives that are plausible in terms of evolutionary psychology. The motive of exploitation in particular is repeatedly varied. For example, the son has to leave the house and asks his mother to take care of his young wife. She does the opposite, however: she forces her to do heavy work or perform menial services, or gives her bad food and bad clothing (Stein 1979, 8). In another variant, the young woman changes into a bird after ordered to do heavy fieldwork by her mother-in-law and flies to her relatives to tell them all her woes. The mother-in-law's influence on reproductive failure is also dealt with in an epic fashion. The mother-in-law does not help with the birth; on the contrary, she places a monster into the cradle instead of the child, or she attempts to inhibit the birth through magic (Stein 1979, 9, 10).

## Trade-offs

In all of the three variants of the in-law conflict discussed, the dominant mother-in-law runs the risk of generating too high a cost and thus reducing her own fitness. Thus the mother-in-law is faced with a typical trade-off problem. Other things being equal, the pressure on her daughter-in-law by the mother-in-law should be all the stronger when the costs are lower for her. Costs are low, for example, when the mating system does not provide for divorce, or if divorce is out of the question for the daughter-in-law for other reasons, for example, because she lacks the support of her natal family. The more autonomously the daughter-in-law is able to make biographical decisions, the riskier and thus more costly the escalation of dominance claims by the mother-in-law becomes.

Secondly, the costs of the conflict for the mother-in-law are relatively low if the reproductive losses (stillbirths, infants who die young) can quickly be compensated for. The infant-mortality cost is reduced further the younger, and thus the more fecund, the daughters-in-law are. In fact, a "replacement strategy," that is, the attempt to replace deceased offspring, is well known in

the Krummhörn population (Straka-Geiersbach and Voland 1988). If, however, the marriage market is skewed toward males, as is often the case in founding populations, individual females become more valuable as a reproductive resource and mothers-in-law harassment becomes a risky strategy (Beise this volume).

According to the logic of the mate-guarding scenario, furthermore, the dominance of the mother-in-law should increase to the same degree as her help and support is valuable. This consideration is, to a certain degree, an extension of the sociobiological model on the correlation between the prevailing degree of paternity uncertainty and paternal investment (Hartung 1985). The higher the paternal investment is, on average, the more sustainedly fathers are able to impact the fate of their children. In brief, the more patriarchal and the more resource-stratified a society is, the more the men are going to act in a sexually monopolizing way. This correlation can easily be transferred to grandmotherly investment: The more grandmothers can do for their adult children and grandchildren, the more certain they want to be that their grandchildren really are their grandchildren. Accordingly, we can expect an additive effect: The more grandmothers develop an interest in supporting not only their adult daughters but also the families of their adult sons, that is, the more patrifocal a society is and the more truly helpful grandmothers can be, the more pronounced the in-law conflicts will be.

According to the logic of the exploitation scenario, the behavioral dominance of mothers-in-law should increase to the degree that young women can productively contribute to the household economy. For this to happen, opportunities and economic incentives must exist. This was doubtlessly the case in the Krummhörn (as probably in all preindustrial rural societies in Europe). Both in the farmer and nonfarmer segments of society, there were many opportunities for women to profitably contribute to the family economy. The more extended the opportunities were, the more developed the familial expectations were to actually use these economic possibilities. Demands increased, the fewer other family members there were who were available to harvest the economic opportunities.

Without being able to achieve final certainty on this issue, the exploitation scenario appears to us to be the one that best reflects the Krummhörn circumstances. The sociological prerequisites for a mating-enhancement scenario are lacking. The mate-guarding scenario could have existed "in the background" in the mentality and in the basic convictions of the population, but the exploitation scenario was primarily the one that determined behavior and induced stress at this time in the Krummhörn population, with its Calvinistic appreciation for work, production, and property.

## Two Evolutionary Routes to Female Longevity?

How do the foregoing considerations affect the issue of the evolution of postmenopausal longevity? If the hypothesis that the in-law conflict has to be interpreted as a genetic conflict is correct and the behavioral strategies of mothers-in-law and daughters-in-law are strategic adaptations to this conflict, then the following question arises. Are we dealing with a consequence or even a cause of the evolution of female longevity? In order to be able to answer this question with any plausibility, the cost-benefit ratio of the in-law conflict in the milieu of its evolution would have to be reconstructed. This is not possible, of course. Due to the notorious hypercomplexity of social strategies, even exhaustive modern data do not permit empirically secure statements on the reproductive consequences of the in-law conflict to be made.

A nonadaptive interpretation of the in-law conflict could take approximately the following argumentation structure. People have the adaptive motive of socially dominating others, especially nonkin. Due to an extended life span for whatever reasons and to patrilocal lifestyles, the spheres of life in which mothers and the mates of their adult sons find themselves overlap. Consequently, intrafamilial conflicts arise due to the adaptive dominance motive that has evolved in other social contexts. This conflict has costs for all of the parties involved and is therefore dysfunctional. However, as a by-product of an adaptive social striving for dominance, it is very difficult to suppress.

Even if this dysfunctional interpretation cannot be ruled out, a functional interpretation appears to us to be more likely. In line with Darwinian theory, costly behavioral strategies may persist where they also provide benefits that compensate for the costs on average. Therefore, it is not ruled out a priori, that it paid off on average for historical mothers-in-law to manipulate their daughters-in-law, both socially and reproductively. The more the older women were able to exert influence in their own interest on the production and reproduction behavior of their daughters-in-law, the greater the genetic reward for growing older. The "genes for longevity" were able to assert themselves evolutionarily to the degree that the postmenopausal life span was associated with positive fitness gains for adult sons and daughters, because Lee (2003) is right when he states, "Transfers, not births, shape senescence in social species." However, transfers can come in two shapes, namely help and manipulation.

Whereas help characterizes the mother-daughter relationship and is the basis for Hawkes' version of the grandmother hypothesis (cf. Hawkes this volume), social manipulation is added to the mother-son relationship.

Not that help does not play a role here, but it is not the only avenue for postgenerative women to maximize their reproductive fitness. By increasing the reproductive success of her son, possibly even at the expense of her daughter-in-law, the exploitative manipulation by the mother-in-law has the potential to transport "genes for longevity." The historical and quantitative relationship between the two strategies of assistance and manipulation depends on the predominant forms of families. The help strategy is an adaptation to the matrilocal lifestyle, in which older women and their adult daughters share a common living space. Matrilocality can be perfectly understood to be the evolutionary result of the help strategy (Holden, Sear, and Mace 2003). In patrilocal societies, there is less possibility of daughter-biased help because older women are more likely to live with their daughters-in-law than their own daughters due to female exogamy. The help strategy cannot lastingly manifest itself here. Instead, social manipulation becomes the predominant strategy of fitness maximization during senescence.

Whether matrilocality or patrilocality predominantly shaped social life during the environment of human evolutionary adaptation is a question of heavy dispute. While new insights from anthropology at present swing the pendulum back to the assumption of matrilocality as the more likely arena of human social evolution, it nevertheless is not improbable that patrilocal lifestyles also played a phylogenetically significant role. Most contemporary hunter-gatherer societies (in remarkable continuity with chimpanzees and bonobos) favor male philopatry and female dispersal. Kayser et al. (2003) have shown the same contrasting pattern for Papuan populations in Melanesia: The diversity of Y-chromosomes is narrow, while that of mitochondrial DNA is not, that is, historically, a limited number of genetically related men have been the fathers whereas the mothers came into those clan-exogamous, virilocal groups from outside (but see Hage and Marck 2003). In such social systems, however, it is unlikely, but not impossible, that many elderly women are living in the same house or settlement as their adult daughters or other of their kin. From all of this, it follows that the evolution of the grandmother cannot be conceived of without the evolution of the mother-in-law, therefore two social strategies, namely "help" and "social manipulation," could have favored the evolution of female postgenerative life.

## Summary

We have argued that the psychology of the mother-in-law and daughter-in-law conflict traces back to a genetic conflict of interests. This conflict generates reproductive costs for the daughters-in-law. We demonstrated this with statistics on differential incidence of stillbirth in the Krummhörn population (Ostfriesland, Germany, 1750–1874). Whether mothers-in-law also

incur costs remains unclear. The costs of the conflict are particularly high at the beginning of a marriage but increase once again after many years of marriage.

We discussed three scenarios that could have led to the evolution of the in-law conflict. In the mate-guarding scenario, the mother-in-law wants to achieve the best possible increase in her son's paternal certainty, thus increasing the likelihood of her genetic relationship with her grandchildren. In the mating-enhancement scenario, mothers-in-law break up emotional bonds between their sons and the latters' mates in order to facilitate additional extramarital mating opportunities for their sons. In the exploitation scenario, mothers-in-law strive to transfer economic earnings from the work done by daughters-in-law to their own family's economy. The Krummhörn in-law conflicts most likely corresponded to the logic of the exploitation scenario. We hypothesize that the social and reproductive manipulation of daughters-in-law by their mothers-in-law could be another evolutionary route to female longevity. Whereas the "help strategy" in matrilocal situations has had an impact on the evolution of the grandmother, in patrilocal societies, longevity was increased by the strategy of reproductive manipulation.

## Acknowledgments

We would like to thank Harald Euler, Peter Stephan, and an anonymous reviewer for helpful suggestions. This research was undertaken with financial support from the Deutsche Forschungsgemeinschaft (grant #Vo 310/10-1).

## References

Adler, L. L., F. L. Denmark, and R. A. Ahmed. 1989. "Attitudes toward mother-in-law and stepmother: A cross-cultural study." *Psychological Reports* 5:11–94.

Apter, T. 1999. "Mothers-in-law and daughters-in-law: Friendship at an impasse." Paper presented at the British Psychological Society Conference, London, Dec. 19.http://www.motherinlawstories.com/terri_apter_research_paper.htm.

Beise, J. 2001. "Verhaltensökologie menschlichen Abwanderungsverhaltens: am Beispiel der historischen Bevölkerung der Krummhörn (Ostfriesland, 18. und 19. Jahrhundert)." Ph.D. diss., University of Giessen. http://bibd.uni-giessen.de/ghtm/2001/uni/d010060.htm.

Beise, J., and E. Voland. 2002. "A multilevel event history analysis of the effects of grandmothers on child mortality in a historical German population (Krummhörn, Ostfriesland, 1720–1874)." *Demographic Research* 7:469–97 (article 13).

Bereczkei, T., and R. I. M. Dunbar. 1997. "Female-biased reproductive strategies in a Hungarian Gypsy population." *Proceedings of the Royal Society of London.B* 264: 17–22.

Dupâquier, J. 1994. "Pour une histoire de la prématurité." *Annales de Démographie Historique* 1994:187–202.

Feldman, P. J., C. Dunkel-Schetter, C. A. Sandman, and P. D. Wadhwa. 2000. "Maternal support predicts birth weight and fetal growth in human pregnancy." *Psychosomatic Medicine* 62:715–25.

Gallin, R. S. 1994. "The intersection of class and age: Mother-in-law/daughter-in-law relations in rural Taiwan." *Journal of Cross-Cultural Gerontology* 9:127–40.

Hage, P., and J. Marck. 2003. "Matrilineality and the Melanesian origin of Polynesian Y chromosomes." *Current Anthropology* 44 (suppl.): S121–S127.

Hart, N. 1998. "Beyond infant mortality: Gender and stillbirth in reproductive mortality before the twentieth century." *Population Studies* 52:215–29.

Hartung, J. 1985. "Matrilineal inheritance: New theory and analysis." *Behavioural and Brain Sciences* 8:661–88.

Hibben, C. J. 1919. *Ostfriesland Wie Es Denkt und Spricht.* Aurich, Germany: Dunckmann.

Holden, C. J., R. Sear, and R. Mace. 2003. "Matriliny as daughter-biased investment." *Evolution and Human Behavior* 24:99–112.

Hollweg, W. 1978. *Die Geschichte des Älteren Pietismus in den Reformierten Gemeinden Ostfrieslands von Ihren Anfängen bis zur Großen Erweckungsbewegung (um 1650– 1750).* Aurich: Ostfriesische Landschaft.

Kayser, M., S. Brauer, G. Weiss, W. Schiefenhövel, P. Underhill, S. Peidong, P. Oefner, M. Tommaseo-Ponzetta, and M. Stoneking. 2003. "Reduced Y-chromosome, but not mitochondrial DNA, diversity in human populations from west New Guinea." *American Journal of Human Genetics* 72:281–302.

Kenyon, S. M. 1994. "Gender and alliance in central Sudan." *Journal of Cross-Cultural Gerontology* 9:141–55.

Knodel, J. E. 1988. *Demographic Behaviour in the Past: A Study of Fourteen German Village Populations in the Eighteenth and Nineteenth Centuries.* Cambridge: Cambridge University Press.

Lee, R. D. 2003. "Rethinking the evolutionary theory of aging: Transfers, not births, shape senescence in social species." *Proceedings of the National Academy of Sciences* 100:9637–42.

Linn, R., and S. Breslerman. 1996. "Women in conflict: On the moral knowledge of daughters-in-law and mothers-in-law." *Journal of Moral Education* 25: 291–307.

Nesse, R. M. 2001. "The smoke detector principle: Natural selection and the regulation of defensive responses." *Annals of the New York Academy of Science* 935: 75–85.

Ohling, G. D. 1963. "Kulturgeschichte des Krummhörn." In *Die Acht und Ihre Sieben Siele*, ed. J. Ohling. Pewsum, Germany: 1. Entwässerungsverband Emden, 17–288.

Pashos, A. 2000. "Does paternal uncertainty explain discriminative grandparental solicitude? A cross-cultural study in Greece and Germany." *Evolution and Human Behavior* 21:97–109.

Ragsdale, G. 2004. "Grandmothering in Cambridgeshire, 1770–1861." *Human Nature* 15:301–17.

Reid, A. 2001. "Neonatal mortality and stillbirths in early twentieth century, Derbyshire, England." *Population Studies* 55:213–32.

Sabean, D. W. 1990. *Property, Production, and Family in Neckarhausen, 1700–1870.* Cambridge: Cambridge University Press.

Sear, R., R. Mace, and I. A. McGregor. 2000. "Maternal grandmothers improve nutritional status and survival of children in rural Gambia." *Proceedings of the Royal Society London.B* 267:1641–47.

———. 2003. "The effects of kin on female fertility in rural Gambia." *Evolution and Human Behavior* 24:25–42.

Sear, R., F. Steele, I. A. McGregor, and R. Mace. 2002. "The effects of kin on child mortality in rural Gambia." *Demography* 39: 43–63.

Skinner, G. W. 1997. "Family systems and demographic processes." In *Anthropological Demography: Toward a New Synthesis*, ed. D. I. Kertzer and T. Fricke. Chicago: University of Chicago Press, 53–95.

Sorenson Jamison, C., L. L. Cornell, P. L. Jamison, and H. Nakazato. 2002. "Are all grandmothers equal? A review and a preliminary test of the 'grandmother hypothesis' in Tokugawa, Japan." *American Journal of Physical Anthropology* 119:67–76.

Stein, H. 1979. *Zur Herkunft und Altersbestimmung einer Novellenballade: Die Schwiegermutter beseitigt die ihr anvertraute Schwiegertochter.* Helsinki: Academia scientiarum Fennica [FF Communications 95,1 (No. 224)].

Straka-Geiersbach, S., and E. Voland. 1988. "Zum Einfluß der Säuglingssterblichkeit auf die eheliche Fruchtbarkeit am Beispiel der Krummhörn, 18. und 19. Jahrhundert." *Homo* 39:171–85.

Van Vleet, K. E. 2002. "The intimacies of power: Rethinking violence and affinity in the Bolivian Andes." *American Ethnologist* 29:567–601.

Voland, E. 1995. "Reproductive decisions viewed from an evolutionarily informed historical demography." In *Human Reproductive Decisions: Biological and Social Perspectives*, ed. R. I. M. Dunbar. Houndsmills: MacMillan; New York: St. Martin's, 137–59.

———. 2000. "Contributions of family reconstitution studies to evolutionary reproductive ecology." *Evolutionary Anthropology* 9:134–46.

Voland, E., and J. Beise. 2002. "Opposite effects of maternal and paternal grandmothers on infant survival in historical Krummhörn." *Behavioral Ecology and Sociobiology* 52:435–43.

## CHAPTER 13

# Exploring the Variation in Intergenerational Relationships among Germans and Turkish Immigrants

*An Evolutionary Perspective of Behavior in a Modern Social Setting*

Akiko Nosaka and Athanasios Chasiotis

The grandmother hypothesis is part of a broader discussion about allomothering and the unique characteristics surrounding the evolutionary history of human beings. According to this perspective, compared to other primates, humans feed their offspring long after they are weaned and human females have extremely lengthy postmenopausal life spans (Hawkes et al. 2000). Also, mothers often must raise multiple children in different stages of dependency (Draper 1999) because children are born altricial and continue to receive care even when they have younger siblings (Lancaster 1997). Evolutionary theory suggests that the behaviors shaping the human female production of multiple offspring with relatively short birth intervals could not have evolved unless mothers were getting significant consistent assistance. Moreover, a general increase in longevity would not have evolved unless such postmenopausal individuals were somehow contributing to their own inclusive fitness. Consequently, aging females with declining to nonexistent reproductive capabilities are considered to provide assistance that will lead to an increase in their inclusive fitness (Williams 1957; Lancaster and Lancaster 1983).

The grandmother hypothesis, therefore, predicts that postreproductive women will contribute significantly to enhancing the fertility of their adult children and the survival of their grandchildren (Hamilton 1966; Williams 1957). In addition, the hypothesis suggests that such intergenerational familial help is strongest in mother-daughter dyads. While women may invest in sons, they are expected to invest more in daughters with offspring because grandchild paternity is comparably uncertain (Hawkes et al. 2000). This expectation implies the importance of co-residence or close living arrangements between mothers and adult daughters (Hawkes et al. 2000). When related females live geographically close, it is most beneficial because interactions are easier and thereby promote the convenient provisioning of assistance.

## Study Background

The obvious place to test the grandmother hypothesis is in foraging societies with traditional sociodemographic environments where fertility control is minimal, people reside with their kin, and there is little to no western medicine affecting a higher level of child survivorship. In such societies, having enough to eat is often the most critical variable to survival, so women may help their adult children, especially daughters, by providing food to ensure the survival of their grandchildren. Those women may also play an important role in caring for their grandchildren particularly when parents are away foraging.

Previous research has examined how grandmothers invest in younger family members and how such investments affect the well being of the recipients. In the 1980s, a series of studies on the traditional Hadza hunting and gathering culture in Tanzania examined the importance of grandmothers and identified the beneficial effects that older women have on the nutritional status of children (Blurton Jones, Hawkes, and O'Connell 1996; Hawkes, O'Connell, and Blurton Jones 1989, 1997). In contrast, a study of the hunting and gathering Ache of Paraguay found that the presence of grandmothers did not significantly affect the survival of their young grandchildren (Hill and Hurtado 1996).

Some research efforts on more traditional farming societies have also focused on evaluating the difference between the familial contributions of maternal versus paternal grandmothers. In the natural-fertility/mortality social setting of rural Gambia, Sear, Mace, and McGregor (2000) reported that maternal grandmothers positively affected the nutritional status and survival of their grandchildren. A study by Beise and Voland (2002) on European data from the Krummhörn (a rural area in northern Germany, 1720–1874) showed some similar patterns for a two-class society. Using data from church register entries, they examined the presence and effect of grandmothers on the survival rate of grandchildren during their first five years. They identified a weak positive correlation between grandchild survivorship and the presence of maternal grandmothers. There appeared to be a negative correlation, however, between grandchild survivorship and the presence of the paternal grandmother. Beise and Voland concluded that these results supported the grandmother hypothesis by showing that maternal grandmothers contributed to the well-being of their grandchildren and that the lack of such contributions by paternal grandmothers may be related to paternity uncertainty.

In comparison, testing the validity of the grandmother hypothesis in contemporary modernized societies presents a greater challenge because the characteristics associated with such settings make it difficult to test the hy-

pothesis as originally conceived. First, because food procurement in modernized societies does not require actual foraging behavior and is relatively effortless, such assistance is neither in great demand nor critical to survival. Second, advanced knowledge and technology have considerably reduced human mortality rates so childhood death is unlikely to occur even during the period of greatest risk when children are less than five years old. Consequently, the survival of offspring is unlikely to be dramatically affected by the degree of kin assistance. Third, people can consciously control their fertility, using modern, effective contraceptives. There may be little need for grandmother help when people can have fewer children and control the length of time separating each birth. Fourth, economic opportunities and political conditions often separate family members geographically. As a result, people may rely less on kin-based support. The demand for child care assistance provided by the grandmother may not be as critical because it can be acquired from private and public institutions. Therefore, the nature of grandmother assistance in modernized societies undoubtedly differs from that associated with hunting and gathering societies.

Despite such conditions, it should be possible to examine how the predictions of the grandmother hypothesis can be used to explain the familial relationships of middle- and old-aged women in modern settings, especially their relationships with those family members who might benefit most from their assistance. Among considerable research that has examined grandparenthood in modern societies, some studies have evaluated the emotional ties grandparents have with their grandchildren and the differences between the family relationships of maternal and paternal grandparents (for example, Dubas 2001; Eisenberg 1988; Euler and Weitzel 1996; Fischer 1983; Kennedy 1990; Matthews and Sprey 1985; Rossi and Rossi 1990; Russell and Wells 1987). Overall, researchers agree that maternal grandparents are likely to have closer ties to their grandchildren than their paternal counterparts. A study by Pashos (2000), however, showed that grandchildren in rural Greece have stronger relationships with their paternal grandparents. This may reflect the influence of a strong patrilineal-patrilocal culture that continues to be prevalent in rural Greece today. In other words, it suggests that social organization may have a strong effect on the quality of intergenerational interactions according to gender.

Studies of parent–adult child interactions have also suggested that child gender is an important influencing factor (for example, Burton 1990; Eisenberg 1988; Hartshorne and Manaster 1982; Hoffman 1988; Smith 1988). A study in the United States by Silverstein and Bengtson (1997) indicated that compared to mother-son relationships, mother-daughter relationships were likely to be close with respect to emotional ties, geographic proximity, communicative frequency, and the provision and recep-

tion of instrumental assistance. Mother-daughter relationships were especially strong when daughters had dependent children in their households. A United States–based study by Cooney and Uhlenberg (1992) examined how the support adult children received from their parents changed as those children approached middle age. They evaluated how gender and reproductive status of adult children related to the reception of assistance. The results indicated that adult children with offspring were more likely to receive gifts and services from their parents than those without, and that male children were significantly less likely to receive advice, service, and child care assistance.

This study looks at the intergenerational family interactions of middle- and old-aged women in contemporary German society. It examines their behavioral and emotional relationships with their adult children and how these relationships vary according to child gender, reproductive status (for example, whether they have young offspring), and ethnic background. Specifically, our intent is to see if the data are consistent with any of the behavioral tendencies predicted by the "grandmother hypothesis" (Hamilton 1966; Williams 1957).

Our study adds to these previous efforts by using an evolutionary perspective to examine the behavioral and emotional relationships that German national and Turkish immigrant women have with their adult children. These ethnic groups differ culturally and socioeconomically in some important respects. In terms of social structure, Germans practice bilateral kinship and neolocal postmarital residence, whereas Turks are traditionally patrilineal-patrilocal. On the one hand, Turkish women generally establish intimate relationships with their daughters while rearing them to adulthood (Magnarella 1974; Olson 1982). Moreover, daughters may remain close to their natal families even after marrying because community endogamy is the norm (Olson 1982). On the other hand, a traditional married couple is more likely to have close ties to the husband's parents because of patrilineal-patrilocal family values (Fisek 1982; Timur 1972).

The degree of kin reliance is also different for both ethnic groups. Germans have been integrated into modern state institutions for a long time, so we expect them to be relatively independent of kin support networks. In comparison, we expect Turks to be more dependent on their families because immigrants often must rely on strong relationships with their kin members to survive in an unfamiliar social environment. Also, recent Turkish immigrants came from a society with relatively few state institutions set up to assist the family. Studies suggest that Turks have a more interdependent psychological orientation that places a keen emphasis on the well-being of the group to which they belong (Agarwal and Misra 1986; Kagitcibasi 1996; Sinha 1985).

Furthermore, Turkish culture has an Islamic religious orientation that is associated with more rigid prescribed codes of behavior. Therefore, German and Turkish cultures differ in terms of social customs and the degree of social control over an individual's behavior. Finally, although Turkish immigrants have made significant strides elevating their overall standard of living since they began immigrating to Germany in 1960s (for the history of Turkish immigration to Germany, see Doomernik 1995; Koray 1999; Muenz and Ulrich 1997; Uygur 1992), their overall socioeconomic status is still lower than that of German nationals (Seifert 1998).

German and Turkish interethnic variation produces different normative patterns of family interaction. This study looks at how the familial strategies of German and Turkish women and their adult children vary, and how such variation can be interpreted along ethnic lines. We place specific emphasis on whether the predictions of the grandmother hypothesis are apparent in contemporary German society.

## Hypotheses

This study was concerned with two hypotheses formulated according to the grandmother hypothesis.

1. Women are likely to have closer relationships to daughters than to sons.
2. Women are likely to have closer relationships to children who have young offspring than they are to those who do not.

These hypotheses were expected to hold true for both Germans and Turks. The important question was whether the quality of these evolutionary predictions varied according to cultural orientation.

## Methods

### Data Collection and Study Subjects

Data was collected with questionnaire interviews in native language from women who were forty years old or older and had at least one child. The sample consisted of 106 German nationals and 82 Turkish immigrants living in Germany. Study subjects were recruited through individual/private networks and public advertisements. They were asked to provide sociodemographic information about themselves and their family members and information about their relationships with their children. The majority of study subjects were interviewed in their private residences; some of them were interviewed in public settings such as schools or parks. The average age of the German women was 59.50 (SD = 12.05; from 41 to 88); the average

age for Turkish women was 51.34 (SD = 6.09; from 41 to 70). The average number of children for the study subjects was 2.52 (SD = 1.17; from 1 to 6) for Germans, and 3.70 (SD = 1.35; from 2 to 7) for Turks. At the time the interviews were conducted, sixty-seven German and sixty Turkish women had at least one grandchild.

We restricted this study to the evaluation of women's relationships to their adult children who were twenty years old or older. Furthermore, we only looked at adult children who were not living with their mothers because of a strong association between two variables used in this study. One important dependent variable was the geographical distance between residences of women and their adult children; one independent variable was the reproductive status of those adult children (see the "Construction of Variables" section below). Among the adult children living with their mothers, 85 percent (96 out of 113) were childless, and a Fisher's exact test showed a strong statistical correlation ($p < .001$) between the living arrangements of adult children (living with their mothers or not) and their reproductive status (childless or not). The analyses focused, therefore, on adult children who were not living with their mothers.

Consequently, the number of women considered in this particular study was reduced to eighty-two Germans and seventy-one Turks. The average ages of the women in these groups were 61.96 (SD = 11.47; from 42 to 88) and 52.20 (SD = 5.96; from 41 to 70), respectively. The German study subjects had a total of 176 adult children whose average age was 35.85 (SD = 9.13; from 20 to 64); the Turkish study subjects had a total of 169 adult children whose average age was 30.08 (SD = 5.67; from 20 to 45). The German adult children had an average of 1.00 child (SD = 1.07; from 0 to 4), whereas the Turkish adult children had an average of 1.33 children (SD = 1.05; from 0 to 6).

## Construction of Variables

This study is based on two dependent variables, three independent variables, and two control variables (see table 13.1).

### DEPENDENT VARIABLES

Six characteristics were used to represent the familial relationships women have with their adult children. These characteristics include distance, frequency of verbal interaction, frequency of face-to-face interaction, provisioning, motivation, and value. Distance is a measure of how far a woman's residence is from the residence of each of her adult children. Study subjects were asked, "How far does each of your children live from your current residence?" Responses were placed in three categories; those within 5 km were rated 3, those between 5.1 and 50 km were rated 2, and those further than

**Table 13.1** Variables

|  | Frequency | Percent | Valid percent |
|---|---|---|---|
| Behavioral relationship | | | |
| 3 | 27 | 7.8 | 8.0 |
| 4 | 90 | 26.1 | 26.6 |
| 5 | 49 | 14.2 | 14.5 |
| 6 | 45 | 13.0 | 13.3 |
| 7 | 56 | 16.2 | 16.6 |
| 8 | 26 | 7.5 | 7.7 |
| 9 | 45 | 13.0 | 13.3 |
| Missing cases | 7 | 2.0 | |
| (Mean = 5.8; Std. Dev. = 1.89) | | | |
| Emotional relationship | | | |
| 3 | 8 | 2.3 | 2.5 |
| 4 | 10 | 2.9 | 3.1 |
| 5 | 8 | 2.3 | 2.5 |
| 6 | 40 | 11.6 | 12.5 |
| 7 | 36 | 10.4 | 11.3 |
| 8 | 36 | 10.4 | 11.3 |
| 9 | 181 | 52.5 | 56.7 |
| Missing cases | 26 | 7.5 | |
| (Mean = 7.88; Std. Dev. = 1.59) | | | |
| Child gender | | | |
| Male | 179 | 51.9 | 51.9 |
| Female | 166 | 48.1 | 48.1 |
| Child reproductive status | | | |
| At least one young child | 176 | 51.0 | 51.0 |
| No young child | 169 | 49.0 | 49.0 |
| Ethnicity | | | |
| German | 176 | 51.0 | 51.0 |
| Turkish | 169 | 49.0 | 49.0 |
| Child education [years] | | | |
| 1 [0–9] | 105 | 30.4 | 31.1 |
| 2 [10–12] | 115 | 33.3 | 34.0 |
| 3 [13 or more] | 118 | 34.2 | 34.9 |
| Missing cases | 7 | 2.0 | |
| (Mean = 2.04; Std. Dev. = .81) | | | |
| Monthly income [Euro] | | | |
| 1 [≤1200] | 84 | 24.3 | 32.6 |
| 2 [>1200 – ≤2000] | 99 | 28.7 | 38.4 |
| 3 [>2000] | 75 | 21.7 | 29.1 |
| Missing cases | 87 | 25.2 | |
| (Mean = 1.97; Std. Dev. = .77) | | | |

50 km were rated 1. A 5-km threshold was used because it represents a reasonable walking distance separating a study subject from her adult child. Similarly, a threshold of 50 km was used because it represents a distance that is generally within one hour by car or train.

The frequencies of verbal and face-to-face interactions are measures of how often a woman interacts with each of her adult children. Study subjects were asked, "How often do you usually talk to your child?" and "How often do you usually see your child?" The same procedure was used to categorize the responses to both the verbal and face-to-face interactions. Subjects who said that they interacted with their children every day were rated 3, those who interacted at least once a week were rated 2, and those who said they interacted less than once a week were rated 1.

Provisioning is the amount of emotional and mental support a woman thinks she provides her child(ren). Motivation represents how willing and eager she is to provide emotional support to her child(ren). Value is the level of significance she thinks her child(ren) attach to the emotional support she provides. These measures were derived by asking women to rate statements on a 7-point scale (1 meaning "not at all," to 7 meaning "very much"). We recoded the responses for each of the three variables such that ratings of 1 to 3 were coded 1, those of 4 to 6 were coded 2, and those of 7 were coded 3.

These six items were subjected to a factor analysis that resulted in the extraction of two components using principal component analysis with an eigenvalue of 1. Behavioral relationships (BR) were represented by one component consisting of distance, frequency of verbal interaction, and frequency of face-to-face interaction. Emotional relationships (ER) were represented by another component consisting of provisioning, motivation, and value. We found the Alpha-Cronbach interitem correlation for the three measures of BR (.80) and ER (.82) to be high. Consequently, the sum of distance and verbal and face-to-face interactions was used as a measure of the dependent BR variable. Similarly, the sum of provisioning, motivation, and value was used as a measure of the dependent ER variable.

## INDEPENDENT AND CONTROL VARIABLES

There are three dichotomous independent variables: ethnicity, gender of adult child, and the reproductive status of adult child. Ethnicity was coded as German or Turkish; gender was coded as male or female. Reproductive status was coded as active if an adult child had at least one child less than twelve years of age. In addition, two variables relating to socioeconomic status were incorporated as controls. One is the adult child's educational level, and the other is the study subject's level of household income.

# Results

The statistical analyses were conducted with univariate analysis of variance using SPSS computer software. The BR analysis revealed the following patterns (see table 13.2).

**Table 13.2** Descriptive statistics and results of behavioral relationship

| Gender | Reproductive status | Ethnicity | Mean | Std. dev. | N |
|---|---|---|---|---|---|
| Male | No young child | German | 5.0455 | 1.47781 | 44 |
| | | Turkish | 5.8261 | 1.66930 | 23 |
| | | Total | 5.3134 | 1.57835 | 67 |
| | At least one | German | 5.5000 | 1.62161 | 28 |
| | | Turkish | 6.4750 | 2.16010 | 40 |
| | | Total | 6.0735 | 2.00236 | 68 |
| | Total | German | 5.2222 | 1.54028 | 72 |
| | | Turkish | 6.2381 | 2.00575 | 63 |
| | | Total | 5.6963 | 1.83772 | 135 |
| Female | No young child | German | 5.0968 | 1.73887 | 31 |
| | | Turkish | 6.2353 | 1.98524 | 17 |
| | | Total | 5.5000 | 1.89063 | 48 |
| | At least one | German | 6.4000 | 1.70783 | 25 |
| | | Turkish | 6.0556 | 2.20317 | 36 |
| | | Total | 6.1967 | 2.00682 | 61 |
| | Total | German | 5.6786 | 1.83012 | 56 |
| | | Turkish | 6.1132 | 2.11824 | 53 |
| | | Total | 5.8899 | 1.97831 | 109 |
| Total | No young child | German | 5.0667 | 1.57971 | 75 |
| | | Turkish | 6.0000 | 1.79743 | 40 |
| | | Total | 5.3913 | 1.71011 | 115 |
| | At least one | German | 5.9245 | 1.70800 | 53 |
| | | Turkish | 6.2763 | 2.17623 | 76 |
| | | Total | 6.1318 | 1.99758 | 129 |
| | Total | German | 5.4219 | 1.68181 | 128 |
| | | Turkish | 6.1810 | 2.04981 | 116 |
| | | Total | 5.7828 | 1.90028 | 244 |

| | Type III sum of squares | Df | F | Sig. |
|---|---|---|---|---|
| Gender | 3.233 | 1 | .947 | .331 |
| Reproductive status | 15.180 | 1 | 4.446 | .036** |
| Ethnicity | 12.106 | 1 | 3.546 | .061* |
| Gender × Reproductive status | 0.001633 | 1 | .000 | .983 |
| Gender × Ethnicity | 3.115 | 1 | .913 | .340 |

**Table 13.2** (*continued*)

|  | Type III sum of squares | Df | F | Sig. |
|---|---|---|---|---|
| Reproductive status × Ethnicity | 6.073 | 1 | 1.779 | .184 |
| Gender × Reproductive status × Ethnicity | 9.494 | 1 | 2.781 | .097* |
| Education | .290 | 1 | .085 | .771 |
| Income | 2.180 | 1 | .639 | .425 |

NOTE: **p < .05, *p < .1

- Turkish women have closer behavioral relationships with their adult children than German women.
- Women have closer behavioral relationships with adult children who have young offspring.
- Behavioral relationships are strongest between Turkish women and sons with young offspring; they are weakest between German women and sons without young offspring.

The ER analysis revealed the following patterns (see table 13.3).

- Turkish women have closer emotional relationships with adult children than German women.
- Overall, women are emotionally closer to daughters than sons.

**Table 13.3** Descriptive statistics and results of emotional relationship

| Gender | Reproductive status | Ethnicity | Mean | Std. dev. | N |
|---|---|---|---|---|---|
| Male | No young child | German | 7.5122 | 1.45124 | 41 |
|  |  | Turkish | 7.7727 | 1.95014 | 22 |
|  |  | Total | 7.6032 | 1.63174 | 63 |
|  | At least one | German | 7.6923 | 1.69161 | 26 |
|  |  | Turkish | 7.7692 | 2.13322 | 39 |
|  |  | Total | 7.7385 | 1.95478 | 65 |
|  | Total | German | 7.5821 | 1.53888 | 67 |
|  |  | Turkish | 7.7705 | 2.05259 | 61 |
|  |  | Total | 7.6719 | 1.79724 | 128 |
| Female | No young child | German | 7.8889 | 1.36814 | 27 |
|  |  | Turkish | 8.4118 | 1.17574 | 17 |
|  |  | Total | 8.0909 | 1.30862 | 44 |
|  | At least one | German | 7.8182 | 1.78982 | 22 |
|  |  | Turkish | 8.6389 | .89929 | 36 |

(*continued*)

**Table 13.3** (continued)

| Gender | Reproductive status | Ethnicity | Mean | Std. dev. | N |
|---|---|---|---|---|---|
| | | Total | 8.3276 | 1.35579 | 58 |
| | Total | German | 7.8571 | 1.55456 | 49 |
| | | Turkish | 8.5660 | .99052 | 53 |
| | | Total | 8.2255 | 1.33429 | 102 |
| Total | No young child | German | 7.6618 | 1.42064 | 68 |
| | | Turkish | 8.0513 | 1.66936 | 39 |
| | | Total | 7.8037 | 1.51993 | 107 |
| | At least one | German | 7.7500 | 1.71972 | 48 |
| | | Turkish | 8.1867 | 1.70606 | 75 |
| | | Total | 8.0163 | 1.71772 | 123 |
| | Total | German | 7.6983 | 1.54481 | 116 |
| | | Turkish | 8.1404 | 1.68742 | 114 |
| | | Total | 7.9174 | 1.62866 | 230 |

| | Type III sum of squares | Df | F | Sig. |
|---|---|---|---|---|
| Gender | 10.984 | 1 | 4.447 | .036** |
| Reproductive status | 1.939 | 1 | .785 | .377 |
| Ethnicity | 23.845 | 1 | 9.653 | .002*** |
| Gender × Reproductive status | 0.0154 | 1 | .004 | .948 |
| Gender × Ethnicity | 3.822 | 1 | 1.548 | .215 |
| Reproductive status × Ethnicity | .299 | 1 | .121 | .728 |
| Gender × Reproductive status × Ethnicity | .712 | 1 | .288 | .592 |
| Education | 7.169 | 1 | 2.902 | .090* |
| Income | 18.944 | 1 | 7.669 | .006*** |

NOTE: *p < .1, **p < .05, ***p < .01

## Discussion and Interpretation

The study hypotheses predicted that (1) women would have closer relationships with adult daughters than adult sons, and (2) women would have closer relationships with adult children who have young offspring. Although the BR results suggest that while women tend to be behaviorally closer to children with young offspring, they are not significantly closer to daughters than sons. Furthermore, although the level of significance is low, Turkish women appear to have the strongest relationships to sons with young offspring. These findings do not appear to support our first hypoth-

esis but they do support the second. A more detailed analysis of each ethnic group, however, does reveal significant tendencies towards daughter-biased interactions.

In the study sample, about 50 percent of Turkish adult children (80 out of 169) lived within a distance of 10 km from their mothers. A Fisher's exact test shows that among Turkish children with young offspring, sons are significantly more likely than daughters to live within 10 km of their mothers ($p = .004$); gender is not a significant factor for those children without young offspring. These results may indicate that although both sons and daughters tend to live with or close to parents when they are young, sons are more likely to maintain a geographic closeness to their natal family after marrying and having children. In comparison, daughters tend to move away because they must go close to their husband's parents/family. Gender is not a significant predictor, therefore, of whether a child without offspring will live close to its mother, but it is a significant predictor for a child who has young offspring.

This pattern of geographic closeness/remoteness characterizing Turkish women and their sons/daughters may relate to their traditional patrilocal postmarital residential pattern. On one hand, Turkish immigrants have been influenced by German cultural norms. Turkish children who are married, therefore, may no longer live with their parents or parents-in-law in the same household. On the other hand, they are still likely to follow their traditional residential rules, and male children are expected more than female children to maintain a close proximity to their natal family. Consequently Turkish women are more likely to have adult sons with young offspring living close by.

It should be noted, however, that not all Turkish daughters lived far from their mothers; some of them continued to live close to their mothers even after marrying and having children. We found it prudent, therefore, to investigate the variation in a woman's interactions with sons and daughters who both live close by. Accordingly, we examined the Turkish women with adult children of both genders living within 10 km and formulated a dependent variable by summing the verbal and face-to-face interaction variables. The results of a univariate analysis of variance interestingly showed a tendency with borderline significance indicating that women interacted (verbally and face-to-face) more frequently with their daughters than their sons. This interactive tendency was not dependent on a child's reproductive status (see table 13.4).

This statistical analysis was also conducted for German study subjects with adult children of both genders living within a distance of 10 km. The same tendency, albeit at a higher level of significance, showed that German

**Table 13.4** Descriptive statistics and results of interactional relationship for Turkish case

| Gender | Reproductive status | Mean | Std. dev. | N |
|---|---|---|---|---|
| Male | No young child | 4.2500 | 1.38873 | 8 |
| | At least one | 4.8571 | 1.11270 | 28 |
| | Total | 4.7222 | 1.18590 | 36 |
| Female | No young child | 5.3333 | 1.03280 | 6 |
| | At least one | 5.2500 | .77460 | 16 |
| | Total | 5.2727 | .82703 | 22 |
| Total | No young child | 4.7143 | 1.32599 | 14 |
| | At least one | 5.0000 | 1.01156 | 44 |
| | Total | 4.9310 | 1.09002 | 58 |

| | Type III sum of squares | Df | F | Sig. |
|---|---|---|---|---|
| Gender | 4.530 | 1 | 3.885 | .054* |
| Reproductive status | .904 | 1 | .775 | .383 |
| Gender × Reproductive status | .978 | 1 | .839 | .364 |
| Education | .338 | 1 | .290 | .593 |
| Income | .179 | 1 | .154 | .696 |

NOTE: *p < .1

women are likely to interact most frequently with their daughters (see table 13.5). Thus, both Turkish and German women had a propensity to interact more closely with their daughters than their sons when they both lived relatively close by. It should be pointed out that the reproductive status is no longer a significant factor once the distance is controlled. This suggests that women are likely to have closer behavioral relationships to their children with young offspring than to those without young offspring, but when children of both genders live close by, regardless of reproductive status, women tend to invest more daughters than they do sons.

The ER results also reflect this interethnic tendency of a greater level of emotional closeness to daughters with or without children. This overall daughter bias might signify behavior consistent with inclusive fitness and paternity uncertainty. The evolutionary perspective predicts that women will tend to invest more in their daughters; such behavior maximizes inclusive fitness because the maternity of a daughter's children is more certain than the paternity of a son's children (Hawkes et al. 2000). Consequently, our study reflects a pattern consistent with the behavioral predictions of the grandmother hypothesis.

While the relationships of women to their adult children are influenced by the gender and reproductive status of their children, such relationships also vary according to ethnicity. The BR and ER results showed that Turkish

**Table 13.5.** Descriptive statistics and results of interactional relationship for German case

| Gender | Reproductive status | Mean | Std. dev. | N |
|---|---|---|---|---|
| Male | No young child | 3.6250 | 1.14746 | 16 |
| | At least one | 3.9231 | 1.25576 | 13 |
| | Total | 3.7586 | 1.18488 | 29 |
| Female | No young child | 4.0909 | 1.04447 | 11 |
| | At least one | 4.5714 | 1.34246 | 14 |
| | Total | 4.3600 | 1.22066 | 25 |
| Total | No young child | 3.8148 | 1.11068 | 27 |
| | At least one | 4.2593 | 1.31829 | 27 |
| | Total | 4.0370 | 1.22802 | 54 |

| | Type III sum of squares | Df | F | Sig. |
|---|---|---|---|---|
| Gender | 5.648 | 1 | 4.111 | .048** |
| Reproductive status | .735 | 1 | .535 | .468 |
| Gender × Reproductive status | 0.0256 | 1 | .016 | .899 |
| Education | 3.363 | 1 | 2.448 | .124 |
| Income | 2.818 | 1 | 2.051 | .159 |

NOTE: **$p < .05$

women had stronger relationships to their adult children than did German women. When the distance separating them was controlled, however, the results indicated that, while women in both ethnic groups had more frequent interactions with their daughters than sons, this tendency was more significant for the Germans. In addition, the BR results showed a borderline significance reflecting that German women had the weakest behavioral relationships to sons without children. These results imply that compared to German women, Turkish women are closer to sons, and have more equally close relationships with both sons and daughters.

One reason for this ethnic variation may relate to differing levels of perception in paternity certainty. Although paternity is inherently less certain than maternity, the degree to which it is culturally perceived can differ in relation to the presence of institutions that determine or emphasize social control over a women's behavior. This ethnic variation may also relate to different strategies that women use to increase their inclusive fitness. The ability of a woman to maximize inclusive fitness can be largely constrained by gender-specific roles and statuses that are culturally determined. In some cases, norms defining the proper behavior of men and women might promote tendencies of parental investment in one gender because that investment yields a greater overall inclusive fitness to the family (Dickemann 1981).

Comparing German nationals and Turkish immigrants in Germany indicates that the latter have institutions that support a strong sense of patriarchy and social control over female behavior. Many characteristics of Turkish culture today have origins during the Ottoman Empire when people became sedentary food producers and adopted Islamic culture (Dengler 1978). In the 1920s, Turkey became a republic and underwent changes including the introduction of secularization, Western laws, liberal capitalism, industrialization, and equal rights for men and women (Cosar 1978). Nevertheless, even by the 1960s and 1970s when many Turks started immigrating to Germany, Turkish culture in Turkey continued to maintain many of its traditional patriarchal and Islamic cultural characteristics. Patrilineal kin members remained important sources of wealth, power, and security even though some people also relied on bilateral kinship support (Aswad 1978). Although there was variation between regions and people of different socioeconomic classes, women were not only more likely than men to have limited access to economic resources, political power, and public positions, but they were still expected to be the exclusive caretakers of children and domestic activities (Aswad 1978; Cosar 1978; Good 1978). Moreover, female children were socialized according to the concepts of discretion, chastity, and obedience in order to become good wives and mothers rather than independent, public figures (Cosar 1978, 126).

Today, Turkish people including those who have immigrated to Germany have been influenced by Western cultural ideals. Many of their traditional values and norms, however, remain largely intact. Similar to German couples, young Turkish couples are likely to establish their own households independent of their parents or parents-in-law. But, in line with traditional norms, sons rather than daughters are still most likely to live close to their parents. Also, kinship and community-based networks are considered to be valuable sources of informal support in addition to providing a strong measure of social control over the behavior of community members (Tan and Waldhoff 1996; White 1997). Moreover, Islam continues to be an important feature in the lives of many Turkish immigrants, and Islamic religious groups are active and influential organizations in their communities (Karakasoglu 1996; Kursat-Ahlers 1996). Islamic traditions represent an important factor upholding the traditional Turkish patriarchal family structure.

It can be argued that these cultural characteristics help to maintain a strong sense of certainty about the paternity of children. It has been suggested that patrilocality is an institutional structure that acts to reinforce the level of child paternity certainty (Pashos 2000). Women in patrilocal societies tend to lose a significant measure of social support from biological relatives when they marry, and they become surrounded by in-laws who watch them carefully to ensure that they behave properly. One result of strict in-

law vigilance over the behavior of a young wife is a greater level of confidence in the paternity of her children. Also, one feature associated with Islamic ideals is the confinement of women to the domestic sphere and their restriction from public exposure. Dickemann argues that this institutionalized feature represents a social evolutionary development that limits the mobility and visibility of women to increase the familial level of confidence in the paternity of their children (1981, 428). A young woman who behaves properly may enhance her chances to attract a successful husband who will provide a secure household environment for the family (Dickemann 1981; Smuts 1995).

Patrilocality and female confinement also encourage a reliance of women on male family members for security. When men enjoy close-knit ties with their male relatives because of patrilocality and a monopoly over the public sphere where formal political and economic activities take place, women must depend entirely on them for economic support especially if there is no system of social security. This condition not only further encourages a woman to behave properly according to normative demands, but it may also promote a biased investment in her son(s) to eventually enhance her inclusive fitness. In patrilocal societies where daughters marry out, the family loses their labor contributions when they are relatively young. Especially when female economic contributions to the family are limited to domestic labor, daughters may be perceived as an economic burden (Dickemann 1981; Lancaster 1997; Schlegel 1991). In contrast, sons are expected to stay and support the family. Consequently, a mother may differentially invest in sons to ensure the prosperity and perpetuity of the family to the maximum benefit of all its members.

On the one hand, the traditional culture of Turkish people in Germany has changed. Many Turks no longer live in patrilineal extended households, and women are not strictly confined to the domestic sphere. In addition, they have access to public security and modern services. On the other hand, some traditional Turkish norms and values still persist. Compared to their German counterparts, therefore, Turkish women are involved in family interactions that still promote a relatively high level of paternity certainty, and their reliance on men for security and well-being is stronger. This is partially reflected in the relationship patterns of women and adult children in both ethnic groups. Turkish women generally have stronger relationships with their adult children, whereas those of German women are relatively weak, especially their relationships with their sons.

It is possible that the ethnic variation we have detected will diminish in the next generation. Some evidence suggests that strategies of parental investment are more influenced by one's past experiences, especially those of childhood (Voland et al. 1997). Many of the adult Turkish children in our

study grew up in Germany constantly exposed to German culture. Even though Turkish norms differ from those in German society, the process of acculturation may eventually diminish those differences.

## Conclusion

This study examined middle- and old-aged women's relationships with their adult children from the perspective of the grandmother hypothesis. It looked specifically at how their behavioral and emotional relationships with their children varied according to gender, reproduction, and ethnicity. We found that women were behaviorally closest to their children with young offspring, and that overall Turkish women have closer behavioral relationships with their children than German women. Although the Turkish results reflected a borderline significance, women in each ethnic group also have face-to-face and verbal interactions more frequently with their daughters than sons if the distance separating them from their children is controlled. Also, both groups of women appear to be emotionally closest to their daughters, and Turkish women are more likely to have closer relationships to children of either gender. Our objective was to see how consistent these findings are with the behavioral tendencies predicted by the grandmother hypothesis. We wanted to see if the variation exhibited by both ethnic groups might relate to the affects that social organization has on strategies for enhancing inclusive fitness and perceptions of paternity certainty.

Based on the grandmother hypothesis as it was originally conceived, women should be closest to their daughters, especially those with young offspring. In addition, because females usually expend greater parental effort than males, investment in daughters with children is expected to be the most efficient strategy for maximizing one's inclusive fitness (Euler and Weitzel 1996). Our results, however, are not entirely consistent with these predictions. Although there is a cross-cultural tendency for interactions to be daughter biased, *this is not dependent on whether daughters have children.* In other words, women may be closest to their daughters in their capacity as mothers but not necessarily as grandmothers.

This behavior is consistent with a recent evolutionary theory that suggests the prolonged postreproductive life spans of human females are related to mothering rather than grandmothering. This theory submits that the reproductive senescence of human females must have evolved "to ensure prolonged investment in offspring who were already born" (Peccei 2001, 447). Nevertheless, this theory does not explain why our data indicate that mothering behavior is daughter biased but grandmothering occurs regardless of child gender.

A central concept of the grandmother hypothesis (and the mothering hypothesis) regards the inclusive fitness of women who are no longer reproductively active (Peccei 2001). Because humans are extremely adaptive (Smuts 1995), the strategies they use to maximize their fitness vary according to their sociocultural environment. Therefore, it is not surprising that some of our results were inconsistent with the grandmother hypothesis because it was originally formulated for foraging societies. Even though they live in the same physical environment, we maintain that the ethnic variation exhibited by our data is related to the different social institutions characterizing German and Turkish cultures. While measuring an individual's inclusive fitness is extremely difficult because strategies for maximizing it vary widely, this is precisely why the concept is useful for exploring the cross-cultural basis of behavioral differences. Our study is consistent with this view because it highlights the variation characterizing the intergenerational relationships of women in two distinct ethnic groups despite the fact that they live in the same contemporary setting.

## References

Agarwal, R., and G. Misra. 1986. "A factor analytical study of achievement goals and means: An Indian view." *International Journal of Psychology* 21:717–31.

Aswad, B. C. 1978. "Women, class, and power: Examples from the Hatay, Turkey." In *Women in the Muslim World*, ed. L. Beck and N. Keddie. Cambridge, MA: Harvard University Press, 473–81.

Beise, J., and E. Voland. 2002. "A multilevel event history analysis of the effects of grandmothers on child mortality in a historical German population." *Demographic Research* 7:469–97 (article 13).

Blurton Jones, N. G., K. Hawkes, and J. F. O'Connell. 1996. "The global process and local ecology: How should we explain differences between the Hadza and the !Kung?" In *Cultural Diversity among Twentieth-Century Foragers: An African Perspective*, ed. S. Kent. Cambridge: Cambridge University Press, 159–87.

Burton, L. 1990. "Teenage childbearing as an alternative life-course strategy in multigeneration black families." *Human Nature* 1:123–43.

Cooney, T. M., and P. Uhlenberg. 1992. "Support from parents over the life course: The adult child's perspective." *Social Forces* 71:63–84.

Cosar, F. M. 1978. "Women in Turkish society." In *Women in the Muslim World*, ed. L. Beck and N. Keddie. Cambridge, MA: Harvard University Press, 124–40.

Dengler, I. C. 1978. "Turkish women in the Ottoman Empire: The Classical Age." In *Women in the Muslim World*, ed. L. Beck and N. Keddie. Cambridge, MA: Harvard University Press, 229–44.

Dickemann, M. 1981. "Paternal confidence and dowry competition: A biocultural analysis of purdah." In *Natural Selection and Social Behavior: Recent Research and New Theory*, ed. R. D. Alexander and D. W. Tinkle. New York: Chiron Press, 439–75.

Doomernik, J. 1995. "The institutionalization of Turkish Islam in Germany and the Netherlands: A comparison." *Ethnic and Racial Studies* 18:46–63.

Draper, P. 1999. "Room to maneuver: !Kung women cope with men." In *To Have and to Hit: Cultural Perspectives on Wife Beating*, ed. D. A. Counts, J. K. Brown, and J. C. Campbell. Urbana: University of Illinois Press, 53–72.

Dubas, J. S. 2001. "How gender moderates the grandparent-grandchild relationship: A comparison of kin-keeper and kin-selector theories." *Journal of Family Issues* 22:478–92.

Eisenberg, A. R. 1988. "Grandchildren's perspectives on relationships with grandparents: The influence of gender across generations." *Sex Roles* 19:205–17.

Euler, H. A., and B. Weitzel. 1996. "Discriminative grandparental solicitude as reproductive strategy." *Human Nature* 7:39–59.

Fischer, L. R. 1983. "Transition to grandmotherhood." *International Journal of Aging and Human Development* 16:67–78.

Fisek, G. O. 1982. "Psychopathology and the Turkish family: A family systems theory analysis." In *Sex Roles, Family, and Community in Turkey*, ed. C. Kagitcibasi. Bloomington: Indiana University Press, 73–99.

Good, M. D. 1978. "A comparative perspective on women in provincial Iran and Turkey." In *Women in the Muslim World*, ed. L. Beck and N. Keddie. Cambridge, MA: Harvard University Press, 482–500.

Hamilton, W. D. 1966. "The moulding of senescence by natural selection." *Journal of Theoretical Biology* 12:12–45.

Harriland, W. A. 2000. *Anthropology*. Fort Worth, TX: Hartcourt College Publishers.

Hartshorne, T. S., and G. L. Manaster. 1982. "The relationship with grandparents: Contact, importance, role conceptions." *International Journal of Aging and Human Development* 15:233–45.

Hawkes, K., J. F. O'Connell, and N. G. Blurton Jones. 1989. "Hardworking Hadza grandmothers." In *Comparative Socioecology of Mammals and Man*, ed. V. Standen and R. Foley. London: Blackwell, 341–66.

———. 1997. "Hadza women's time allocation, offspring production, and the evolution of long postmenopausal life spans." *Current Anthropology* 38:551–77.

Hawkes, K., J. F. O'Connell, N. G. Blurton Jones, H. Alvarez, and E. L. Charnov. 2000. "The grandmother hypothesis and human evolution." In *Adaptation and Human Behavior: An Anthropological Perspective*, ed. L. Cronk, N. Chagnon, and W. Irons. New York: Aldine de Gruyer, 237–58.

Hill, K., and A. M. Hurtado. 1996. *Ache Life History: The Ecology and Demography of a Foraging People*. New York: Aldine de Gruyter.

Hoffman, E. 1988. "Young adults' relations with their grandparents: An exploratory study." *International Journal of Aging and Human Development* 10:299–310.

Kagitcibasi, C. 1996. *Family and Human Development across Cultures: A View from the Other Side*. Mahwah, NJ: Lawrence Erlbaum.

Karakasoglu, Y. 1996 "Turkish cultural orientations in Germany and the role of Islam." In *Turkish Culture in German Society Today*, ed. D. Horrocks and E. Kolinsky. Providence, RI: Berghahn Books, 157–79.

Kennedy, G. E. 1990. "College students' expectations of grandparent and grandchild role behavior." *Gerontologist* 30:43–48.

Koray, S. 1999. "Study on migrations: The case of Turkey." Commissioned by the Economic and Social Committee of the European Communities, Zft-aktuell Nr. 73, Essen.

Kursat-Ahlers, E. 1996. "The Turkish minority in German society." In *Turkish Culture in German Society Today*, ed. D. Horrocks and E. Kolinsky. Providence, RI: Berghahn Books, 113–35.

Lancaster, J. B. 1997. "The evolutionary history of human parental investment in relation to population growth and social stratification." In *Feminism and Evolutionary Biology*, ed. P. D. Gowaty. New York: International Thomson Publishing, 466–88.

Lancaster, J. B., and C. S. Lancaster. 1983. "Parental investment: The hominid adaptation." In *How Humans Adapt: A Biocultural Odyssey*, ed. D. Ortner. Washington, DC: Smithsonian Institution Press, 33–66.

Magnarella, P. J. 1974. *Tradition and Change in a Turkish Town*. New York: Schenkman Publishing.

Matthews, S. H., and J. Sprey. 1985. "Adolescents' relationships with grandparents: An empirical contribution to conceptual clarification." *Journal of Gerontology* 40:621–26.

Muenz, R., and R. Ulrich. 1997. "Changing patterns of immigration to Germany, 1945–1995." In *Migration Past, Migration Future: Germany and the United States*, ed. K. J. Bade and M. Weiner. Providence, RI: Berghahn Books, 65–119.

Olson, E. A. 1982. "Duofocal family structure and an alternative model of husband-wife relationships." In *Sex Roles, Family, and Community in Turkey*, ed. C. Kagitcibasi. Bloomington: Indiana University Press, 33–72.

Pashos, A. 2000. "Does paternal uncertainty explain discriminative grandparental solicitude? A cross-cultural study in Greece and Germany." *Evolution and Human Behavior* 21:97–109.

Peccei, J. S. 2001. "A critique of the grandmother hypotheses: Old and new." *American Journal of Human Biology* 13:434–52.

Rossi, A. S., and P. H. Rossi. 1990. *Of Human Bonding: Parent-Child Relations across the Life Course*. New York: Aldine.

Russell, R. J. H., and P. A. Wells. 1987. "Estimating paternity confidence." *Ethnology and Sociobiology* 8:215–20.

Schlegel, A. 1991. "Status, property, and the value of virginity." *American Ethnologist* 18:917–34.

Sear, R., R. Mace, and I. A. McGregor. 2000. "Maternal grandmothers improve nutritional status and survival of children in rural Gambia." *Proceedings of the Royal Society of London* 267:1641–47.

Seifert, W. 1998. "Social and economic integration of foreigners in Germany." In *Path to Inclusion: The Integration of Migrants in the United States and Germany*, vol. 5, ed. P. H. Schuck and R. Münz. Providence, RI: Berghahn Books, 83–113.

Silverstein, M., and V. L. Bengtson. 1997. "Intergenerational solidarity and the

structure of adult child–parent relationships in American families." *American Journal of Sociology* 103:429–60.

Sinha, J. B. P. 1985. "Collectivism, social energy, and development in India." In *From a Different Perspective: Studies of Behavior across Cultures*, ed. I. R. Lagunes and Y. H. Poortinga. Lisse: Swets and Zeitlinger, 120–35.

Smith, M. S. 1988. "Research in developmental socio-biology: Parenting and family behavior." In *Sociobiological Perspectives on Human Development*, ed. K. B. MacDonald. New York: Springer, 271–92.

Smuts, B. 1995. "The evolutionary origins of patriarchy." *Human Nature* 6:1–32.

Tan, D., and H. Waldhoff. 1996. "Turkish everyday culture in Germany and its prospects." In *Turkish Culture in German Society Today*, ed. D. Horrocks and E. Kolinsky. Providence, RI: Berghahn Books, 138–56.

Timur, S. 1972. *Türkiyede Aile Yapisi* (The Structure of the Family in Turkey). Yayinlari, Turkey: Hacettepe University.

Voland, E., R. I. M. Dunbar, C. Engel, and P. Stephan. 1997. "Population increase and sex-biased parental investment: Evidence from eighteenth and nineteenth century Germany." *Current Anthropology* 38:129–35.

Uygur, E. 1992. "Foreign aid as a means to reduce emigration: The case of Turkey." International Labour Office, WEP working paper, Geneva.

White, J. B. 1997. "Turks in the new Germany." *American Anthropologist* 99:754–69.

Williams, G. C. 1957. "Pleiotropy, natural selection, and the evolution of senescence." *Evolution* 11:398–411.

## CHAPTER 14

# Variability of Grandmothers' Roles

Axel Schölmerich, Birgit Leyendecker, Banu Citlak,
Amy Miller, and Robin Harwood

Probably for the first time in the history of our species, average parents live to see their own children reach fifty and their grandchildren twenty-five years of age. Grandparents, and grandmothers in particular, are interested in their grandchildren and exert multiple influences upon them. Several contemporary theories explain the evolution of human longevity or the existence of menopause through inclusive fitness effects of provisioning grandchildren. In this chapter, we attempt to review existing psychological research on the influence of grandmothers on children and grandchildren, and we illustrate some of the points with material from an ongoing study on cultural change in child-rearing beliefs and practices among migrant families: Turkish immigrants in Germany and Puerto Rican in the United States. In this study, there are six groups of mothers, Anglo (A), Puerto Rican first-generation immigrant (PR1), Puerto Rican second-generation immigrant (PR2), German (G), Turkish first-generation immigrant (T1), and Turkish second-generation immigrant (T2). The migrant populations with a more sociocentric cultural background provide a contrast for the role of family members in the social network of mothers compared to more individualistic populations in the host countries. By putting grandmothers in a wider perspective as members among other people of social networks, we draw attention to the multiple roles grandmothers can play and the many forms of adaptation to specific life circumstances enhancing or diminishing their influence and importance.

## The Human Life Cycle

The human life cycle is traditionally segmented into phases reflecting age and reproductive capacity (Bühler 1959). Childhood and early adolescence are prereproductive, young and middle adulthood are reproductive phases, and late adulthood and old age are postreproductive. Based on available data of small-scale hunter-gatherers, a species-specific normative age at birth of first child is between nineteen and twenty years for females (Kaplan et al. 2000), which implies the transition to grandmother at age forty, with normative data ranging between thirty-seven and forty-two years, still about a decade before menopause. Given the altriciality of human infants and

children, life expectancy should include at least a postreproductive phase sufficiently long for the last child born to reach maturity (Packer, Tatar, and Collins 1998). Hrdy suggested calling this the "reasonable mother hypothesis" (Hrdy 2000).

Baltes, Lindenberger, and Staudinger (2000) had postulated the "life-span artifact hypothesis" in line with early theorizing by Williams (1957). This hypothesis is more subtly isolated against criticism by stating that "there are not many ways in which genetic optimization is possible in old age" (Lindenberger 2002). Since mutations occurring late in life will not influence the presence of their particular genes in the population, evolution has no way to optimize these changes; therefore, old age is characterized by increases in deficits and losses of function, with very limited gains and diminishing reserve capacities. Why reproductive function ceases particularly early is not a focal point of this theory.

Kaplan and his coworkers believe that there is direct evolutionary pressure on longevity (Hill and Hurtado 1991; Kaplan et al. 2000), based on actual data and simulation of caloric production across life. Central elements in their theory are the exceptionally long (as compared to other species) life span, an extended juvenile (and relatively unproductive) period, postreproductive care by females, and male provisioning of females. The "grandmother hypothesis" (Hawkes, O'Connell, and Blurton Jones 1997) suggests that grandmotherhood may be an effective way to influence the reproductive success of the second generation, typically illustrated with hard-working postreproductive females who provision their daughters and grandchildren. This provisioning may be especially effective under conditions of high infant mortality or around weaning time. Most recently, Peccei (2001) has pointed to difficulties with the grandmother hypothesis, among them the problem that it does not explain menopause but presupposes it, and that the effectiveness of selection through inclusive fitness may have been limited by the proportion of individuals who reached that age.

## Psychological Research on Grandmothers

### Grandmothers' Contributions to Raising Children under Conditions of Risk

The theme of the ability of grandmothers to buffer existing risk factors for child survival and well-being is reflected in the bulk of psychological research, which focuses on impoverished inner-urban, African American families with high rates of teenage pregnancies and drug abuse (Apfel and Seitz 1991; Black and Nitz 1996; Brody, Flor, and Neubaum 1998; Burton 1993; Dorsey et al. 1999; George and Dickerson 1995; Minkler and Roe 1993; Murry et al. 2001; Owens and Brome 1997; Perrin 1992; Sugar 1993;

Voight, Hans, and Bernstein 1996; Wilson et al. 1995). In the United States, one study found about 270,000 children in the sole custody of their grandmothers (Brown et al. 2000), Joslin and Brouard (1995) found that 8 percent of children in an impoverished sample were cared for by their grandmothers exclusively, and a fairly large random survey sample in Ohio found 10 percent received most care from their grandmothers (Landry Meyer 1999). Among incarcerated females, 53 percent of their children are under care of their grandmothers (Ruiz 2002). Under risk circumstances, grandmothers provide the best nonmaternal care (Baydar and Brooks Gunn 1991; Chase Lansdale, Brooks Gunn, and Zamsky 1994), and grandmothers are effective at alleviating risk factors associated with single motherhood, as are some other adults (Kellam, Ensminger, and Turner 1977, 1978). However, some data indicate that grandfathers are more influential on the well-being of the children of teenagers than grandmothers (Oyserman, Radin, and Benn 1993; Oyserman, Radin, and Saltz 1994).

There are also negative consequences of grandmothers' involvement: for example, grandmother co-residence and support exerted a negative influence on the educational achievement of teenage mothers (Way and Leadbeater 1999). From the perspective of the grandchildren, care arrangements involving grandmothers are not necessarily experienced positively. One mother in our sample described such feelings when she was separated from her parents and sent back to Turkey to live with the grandmother there: "Both of my parents were working. That's why I was sent back to my grandmother for 1 1/2 years" (T2 #209). Grandparents may buffer risk factors around parental divorce, but there is also potential for conflict in face of a failed marriage (Peterson 1999). In a study of Navajo teenage mothers, the variability in support provided by maternal grandmothers was emphasized (Dalla and Gamble 1999). Acculturation processes may play a moderating role on acceptance of grandmaternal support by Latino teenage mothers (Contreras et al. 1999). Different effects on the development of adaptive behavior in two-year-olds born to teenage mothers were reported in one study comparing black and white grandmothers assisting with child care. There was an increase of negative outcomes associated with increased care by grandmothers in the white sample, and this was not found in the black sample (Unger and Cooley 1992).

Mixed findings are reported on effects of grandmothers on psychological development. In a study comparing infants born prematurely with those of normal gestational age, available grandmother support was associated with more securely attached children for both samples (Poehlmann 1996), however, adolescent mothers who had neither mother nor partner received better mother-infant interaction scores (Spieker and Bensley 1994). The graded similarity in terms of providing security in a strange situation be-

tween mothers and grandmothers was also found to reflect the responsibilities the grandmother had in the everyday lives of their grandchildren (Tomlin and Passman 1989), which points to the importance of experiential factors in the ontogenesis of such relationships. In a rare experimental study, infants' behavior toward mother and grandmother was compared to behavior towards a stranger, and results indicate that infants used both mothers and grandmothers as a source of security, with mothers being preferred when both were available in the situation (Myers, Jarvis, and Creasey 1987). A direct comparison of interaction between adolescent mothers and grandmothers results in less active and successful (measured as eliciting infant attention) grandmothers, leading to the conclusion that adolescent mothers are better caregivers than is commonly assumed (Rowland 1996).

Contrary to expectations, nonemergency use of emergency rooms by inner-city African Americans was documented to be more frequent for children living in proximity of their grandmothers (Ellen, Ott, and Schwarz 1995). Available social support does not appear to reduce the reliance on other social services.

## *Contributions in Absence of Risk*

The role of grandmothers in child development in the absence of specific risk factors has not received comparable attention. Contemporary risk populations may provide a skewed picture since they are characterized by social circumstances including few helpers and lack of fathers, who were the primary source of support for the mothers in a nonrisk sample, followed by grandmothers (Levitt, Weber, and Clark 1986). In a Greek study, 68 percent of respondents indicated that grandmothers provided some form of participation in child care (Houndoumadi 1996). Grandmothers who are the sole caregivers do provide the most care, closely followed by those who co-reside with their husband, and grandmothers who co-reside with a mother/father family provide the least care (Pearson et al. 1997). Changing relationships over time were observed in a three-country comparison involving young mothers and their grandparents in Korea, Hong Kong, and the United States. Only the Korean respondents indicated that they received more social support from the grandparental generation, typically paternal grandmothers, than from their husbands (Hyun et al. 2002). The roles grandmothers can play especially under conditions of migration and social change may be enhanced as compared to stationary living conditions (Olmedo 1997). Developmental trends as well as gender differences were apparent in an exploratory study in India, with infant girls receiving more grandmaternal care than boys, who are cared for by their mothers, and a shift with increasing age of the child towards more extended family care for both boys and girls (Sharma 1997). In our own study, we asked mothers about signifi-

cant members of the social networks of their children and their own. The average proportion of relatives (including grandmothers) in social networks is 43 percent for G, 52 percent for T1, and 60 percent for T2. When mothers were interviewed about the importance of relatives and friends in social networks, the importance of relatives was higher for all three groups. However, in the German sample the difference was notably smaller (importance of relatives = 17.3 points on an arbitrary scale, of friends = 14.0) than among the first-generation Turkish mothers (relatives = 18.5, friends = 10.4). This finding points to the importance of relatives, but it also alerts us to the fact that there is a remarkable number of nonrelated members in the social networks of young mothers, something that tends to get overlooked when participants are only asked about their relationships with their grandmothers.

## Actual Contact between Grandmothers and Grandchildren

For our German sample, roughly one third of the participants indicated that their children had weekly contact, another third monthly contact, and another third less than monthly contact between grandmothers and grandchildren. In the Turkish sample of first-generation immigrants, only 10 percent had weekly contact with their grandmothers, who by definition live in Germany without appropriate legal status. In the second-generation Turkish families, grandmothers do live within reach, but only about 25 percent report weekly contact between grandmother and grandchildren. Less than 20 percent report monthly contact and about 55 percent report that contact is limited to less than once a month. The actual contact was surprisingly low, even among those whose grandmothers were easily accessible.

## Instrumental Help and Emotional Closeness

Grandmothers' involvement in caregiving was mentioned by eighteen out of twenty-six German mothers. However, only two out of twenty-six grandmothers in the first-generation Turkish sample and eleven out of twenty-four mothers from the second-generation Turkish sample indicated that grandmothers were participating in active caregiving of children. While grandmothers for the Turkish samples were less accessible and less oriented towards practical help, their proximity in the social network system across all three samples is very similar. The vast majority of respondents in each group indicated that the closeness to the grandmother from the perspective of her daughter is high. Members of all three groups report receiving emotional support with roughly similar proportions in the samples (for example, two-thirds indicate that they receive some type of emotional support

and one-third indicate they do not). Regarding instrumental support, even more German mothers indicate that they receive support—for example, in caretaking or assistance in any type of household activity—while this is very rare for the first-generation Turks and mentioned by less than half of the participants of the second-generation Turkish sample. The similarity across groups is greater in terms of financial support where only a minority of the respondents report receiving financial support from their mothers. Looking at the relationship between mothers and their mothers-in-law, it appears that the differences are stronger for both Turkish samples than for the German one. While relationships are markedly less close for all three samples, the proportions of mothers reporting emotional, instrumental, and financial support by their mothers-in-law are very small among those Turkish samples.

Emotional closeness among our U.S. samples was analyzed using analysis of variance, and Anglo mothers reported the highest scores on closeness, significantly different from the scores of Puerto Rican mothers from the second generation. This unexpected finding may be related to the cultural norm of respect for the elders among the Puerto Ricans, while emotional relationships are the basis of including such members of the family in the social network. The dimension of individualism versus sociocentrism may play a role in how people perceive and use social networks accessible to them. Members of individualistic cultures typically maintain larger social networks containing more individuals, while members of sociocentric cultures maintain more intense relationships with a limited number of people.

Under nonrisk circumstances, the amount of instrumental support appears to have positive effects on the relationship between grandmother and grandchild (Gattai and Musatti 1999). Again, such mutual assessment of emotional closeness is subject to cultural variations (Giarrusso et al. 2001) leading to suggestions of considering such factors in social policy (Gibson 2002). The role of grandmothers seems to depend on the social and cultural context.

## Grandmothers' Self-concept

Another body of literature addresses grandmothers' own feelings in the role of a caregiver (Bowers and Myers 1999), leading to the suggestion of possible difficulties arising from multiple responsibilities (Burton 1996; Kelley et al. 2000; Kolomer 2000), lack of social support (Roithmayr 2002), and to suggestions of the need for professional support (Dennison and Ingledew 1999; Kelley et al. 2001; Kivett 1993; Landry Meyer 1999; See, Bowles, and Darlington 1998; Wakschlag and Hans 2000; Winston 1999) for this popu-

lation. The transformation to grandmother is experienced as ambiguous not only by those who become grandmothers prematurely, but also by women who are overwhelmed by the responsibilities of full-time caregiving and lack of resources (Robinson 1989; Robinson, Kropf, and Myers 2000).

Some differences were reported in predicting stress, mental health, and role satisfaction for grandmothers who were informal or custodial care providers (Pruchno and McKenney 2000). Most frequently, grandmothers who are the sole care providers for their grandchildren worry about their own chances of living long enough to raise the child; however, this anxiety may be maximized by the loss of their own children leading to the custodial arrangement (Forlenza 1998).

In the self-definition of grandmothers, most emphasized the emotional-symbolic features rather than instrumental support for the relationship (Fischer 1983). For their own satisfaction with life, closeness to the grandchildren appears to be one relevant dimension, as one very small qualitative study has found (Glass and Jolly 1997). Especially the ability to connect to both following generations appears to enhance general satisfaction (Goodman and Silverstein 2001). Providing instrumental support as measured by the time spent with a grandchild appears to help in establishing a more positive mutual relationship (Heeder 1998). However, being the primary caregiver is associated with a self-reported health risk, and supplementary caregivers seem to be at higher risk for depression (Musil and Ahmad 2002). In one rare study on feelings about grandmotherhood among middle-class African American women, respondents indicated that their grandchildren were of great importance to them, and those who became grandmothers later in life and had more contact with them valued them most highly (Timberlake and Chipungu 1992). One interesting observation was that women who as grandmothers had caregiving responsibility for grandchildren experienced less satisfaction with this role when they had small children themselves (Voran and Phillips 1993).

## Role of Grandmothers as Viewed by Their Children and Grandchildren

Based on a global rating of grandparental solicitude, Euler and Weitzel (1996) showed that there is a rank order of the four potential grandparents following the theory of differentiated reproductive investments with maternal grandmothers ranking first, followed by maternal grandfathers, paternal grandmothers, and paternal grandfathers, with the difference between maternal and paternal grandmothers reaching statistical significance (Euler and Weitzel 1999). This is in agreement with the observation that grand-

mothers spend more time with their daughters' than with their sons' children (Smith 1991) while it contradicts the observation of only marginal differences between grandfathers and grandmothers from the same source.

Intergenerational ties between adults and their parents are subject to ethnic and cultural variation. African American adolescents report strongest ties to maternal grandmothers, significantly more so than white or Hispanic young adults. This difference held across different socioeconomic strata while other social network variables were sensitive to SES (Hirsch, Mickus, and Boerger 2002). Maternal grandparents and grandmothers in particular come out as the emotionally closest relationships of the female respondents in one sample (Hoffman 1980), and the author stresses the surprising variability in closeness and interaction frequency among the respondents, with no demographic factors to account for it. Relationships between young teenagers and their grandmothers were studied to investigate the influence of more frequent or less frequent contact on quality of the relationship (Sticker and Holdmann 1988). Kennedy (1990) showed that the expectations on how a grandparent should behave with respect to the grandchildren varied systematically with ethnic background and socioeconomic variables; however, such relationships were generally described in positive and respectful terms. Considering the changes in relationships to grandparents, young adults frequently mentioned deaths or other losses in the family system leading to improvements in the grandmother-granddaughter relationship, with geographical distance and engaging in shared activities also being influential, while increases in geographical distance and negative experiences with the grandmother led to decreases in emotional closeness (Holladay et al. 1998; Muransky 2001). Emotional closeness was also dependent on kinship position, with maternal grandmothers having the closest relationships (Mills, Wakeman, and Fea 2001). Positive relationships between the child's parents and the grandmother also seem to be predictive of increased emotional closeness (Muransky 2001). Maternal grandmothers and their daughters are reported to be more similar in their views of childrearing issues than paternal grandmothers and their daughters-in-law, with a marked degree of disagreement about the common past among them (Myers and Williams Petersen 1991).

Mothers in our sample also voiced negative aspects of relationships with the grandmothers of their children. Particularly first-generation mothers often felt oppressed by a traditional mother-in-law, and others said that they enjoy the freedom they have without the control of their own mother or their mother-in-law in this country. At the same time, the need for a close relationship remains entirely intact: "If I don't see my parents for a week or two I start missing them. I want to see them. That's how I was raised, so I would miss them. They have attached me to themselves. I constantly think

about them because this is how I was raised. I want my child to be like this as well. I also behave this way towards my husband's parents because this is the way I was raised because I respect them. I have my own parents but still I feel respect for these people because they are the parents of my husband. I always give them a call and I visit them" (T1 #130). Likewise, missing family members is frequent: "I came here when I was really young, umm, my father died, so I missed all those years I could've been with my dad. My mother, my grandmother, my family because the only one that was here was my aunt" (PR1 #531). "I give them a call each month and we maintain good contact. We write to each other and send each other pictures once in a while. I miss them a lot" (PR2 #542). Many mothers talk about their relationship with their own mother and their mother-in-law with mixed feelings. They still emphasize the importance of a close and lifelong relationship with their own child and with the child's future family.

Some mothers commented on the special role of grandmothers in their own lives. For example, grandmothers appear to emphasize the cultural heritage: "my grandmother, my, you know, that's where I got my Spanish from, that's where I got the food from, that's where I got everything else that's Puerto Rican from" (PR2 #526). Another mother told us: "Well I believe that after my grandparents, my parents, and my great grandparents were all raised and born in Puerto Rico, well they gave me a complete upbringing of Puerto Rican culture" (PR1 #563).

## Summary and Outlook

The studies reviewed have brought some important insights about the psychological role of grandmothers. First, grandmothers seem to be especially beneficial under conditions of risk. Second, there is typically a positive emotional connection between grandmothers and their children and grandchildren, with some systematic variation in terms of contact frequency, sociodemographic, and cultural variables. Stunning is the variability of roles grandmothers play in the family context, thus assuming a uniform positive influence on offspring well-being is not supported by the existing literature.

Maternal grandmothers are more likely to see their grandchildren on a regular basis than paternal grandmothers. The example of first-generation migrant families shows, however, that contextual conditions may easily override such preferences, leading to increased contact with the paternal grandmother. German grandmothers were most likely and grandmothers of the Turkish first-generation sample were least likely to be involved in caregiving on a regular basis. Grandmothers are more important to their daughters than to their daughters-in-law. This difference was small for the German sample but more pronounced for both Turkish samples. Grand-

mothers do provide more emotional, instrumental, and financial support to their daughters than to their daughters-in-law. Across the board, all three samples describe the support relationships as more or less balanced. The discrepancy between the mothers' evaluation of close family ties in concordance with the cultural model and the actual contact between children and their grandmothers is striking. The cultural value of close family ties seem not to be diminished by the discrepant experiences these mothers report from their own childhoods nor by the limited availability and the sometimes problematic relationship between mothers and their mothers-in-law. This is another good example of the psychological difference between norms that represent broader cultural constructs and behavior that is organized according to the individual situation and actual needs and possibilities. The cultural norms and values put much emphasis on the importance of respectful relationships towards the older generation. However, in practical behavior the difference between the relationships towards one's own mother and mother-in-law seem to be organized by a different set of rules. Interestingly, Turkish mothers saw the German families as not really connected. However, the German families had close relationships with the elder generation and reported less problematic relationships between daughter and mother-in-law. Future research should include a broader perspective on families including grandparents to assess both their potential contribution to a successful adaptation of migrants and the additional difficulties they may impose on the family.

Both the review of psychological research on the role of grandmothers in the lives of their offspring as well as the illustrative examples from our own studies highlight the flexibility in social networks in humans. Cultural norms and values assigning elders a place in society differ widely, and historical processes contribute to continuous change as well. Even clear cultural norms and values are mediated according to practical considerations, as becomes apparent under conditions like migration, which introduces artificial separations into the family system. Grandmothers can be of tremendous influence and importance. Characterizing human reproduction as "cooperative breeding" implies some overlap of functions of central figures. Maybe it is under conditions of adversity or high risk that the unique role of grandmothers becomes most visible. Grandmotherhood may start quite early in life: even our small sample included one grandmother of only thirty-six years of age. The "gap" in the life cycle between caring for one's own offspring and the transition to grandparenthood observed in modern western societies may be atypical for our species; under more natural conditions one would find at least some overlap between providing for one's own children and assuming the helpful role of a grandmother for the next generation.

Obviously, contemporary psychological research has only limited relevance for the question of evolutionary mechanisms in the development of human longevity. With this caveat in mind, we see close emotional relationships between young mothers and their relatives, including grandmothers, as a universal human characteristic compatible with the grandmother hypothesis. However, the marked variability supports the idea that grandmothers are special, but not unique, figures in the game of life. Others may play similar roles, and more general empathic abilities among humans, relatives and nonrelatives alike, may have been essential mechanisms evolved to support cooperative breeding, which offers additional pathways to contribute to the well-being of the young.

## References

Apfel, N. H., and V. Seitz. 1991. "Four models of adolescent mother-grandmother relationships in black inner-city families." *Family Relations: Interdisciplinary Journal of Applied Family Studies* 40:421–29.

Baltes, P. B., U. Lindenberger, and U. Staudinger. 2000. "Life-span theory in developmental psychology." In *Handbook of Child Psychology*, vol. 1, *Theoretical Models of Human Development*, ed. R. Lerner. New York: Wiley. 1029–44.

Baydar, N., and J. Brooks Gunn. 1991. "Effects of maternal employment and childcare arrangements on preschoolers' cognitive and behavioral outcomes: Evidence from the Children of the National Longitudinal Survey of Youth." *Developmental Psychology* 27:932–45.

Black, M. M., and K. Nitz. 1996. "Grandmother co-residence, parenting, and child development among low income, urban teen mothers." *Journal of Adolescent Health* 18:218–26.

Bowers, B. F., and B. J. Myers. 1999. "Grandmothers providing care for grandchildren: Consequences of various levels of caregiving." *Family Relations: Interdisciplinary Journal of Applied Family Studies* 48:303–11.

Brody, G. H., D. L. Flor, and E. Neubaum. 1998. "Coparenting processes and child competence among rural African-American families." In *Families, Risk, and Competence*, ed. M. Lewis and C. Feiring. Mahwah, NJ: Lawrence Erlbaum, 227–43.

Brown, E. J., L. Sweet Jemmott, F. H. Outlaw, G. Wilson, M. Howard, and S. Curtis. 2000. "African American grandmothers' perceptions of caregiver concerns associated with rearing adolescent grandchildren." *Archives of Psychiatric Nursing* 14:73–80.

Bühler, C. 1959. *Der menschliche Lebenslauf als psychologisches Problem*, 2nd ed. Göttingen: Verlag für Psychologie.

Burton, L. M. 1993. "Teenage childbearing as an alternative life-course strategy in multigeneration black families." In *Life Span Development: A Diversity Reader*, ed. R. A. Pierce and M. A. Black. Dubuque, IA: Kendall/Hunt Publishing, 163–76.

———. 1996. "Age norms, the timing of family role transitions, and intergenera-

tional caregiving among aging African American women." *Gerontologist* 36: 199–208.
Chase Lansdale, P. L., J. Brooks Gunn, and E. S. Zamsky. 1994. "Young African-American multigenerational families in poverty: Quality of mothering and grandmothering." *Child Development* 65:373–93.
Contreras, J. M., I. R. Lopez, E. T. Rivera Mosquera, L. Raymond Smith, and K. Rothstein. 1999. "Social support and adjustment among Puerto Rican adolescent mothers: The moderating effect of acculturation." *Journal of Family Psychology* 13:228–43.
Dalla, R. L., and W. C. Gamble. 1999. "Weaving a tapestry of relational assistance: A qualitative investigation of interpersonal support among reservation-residing Navajo teenage mothers." *Personal Relationships* 6:251–67.
Dennison, C., and H. Ingledew. 1999. "Groupwork with the mothers of teenage mothers." *Groupwork* 11:5–20.
Dorsey, S., M. W. Chance, R. Forehand, E. Morse, and P. Morse. 1999. "Children whose mothers are HIV infected: Who resides in the home and is there a relationship to child psychosocial adjustment?" *Journal of Family Psychology* 13:103–17.
Ellen, J. M., M. A. Ott, and D. F. Schwarz. 1995. "The relationship between grandmothers' involvement in child care and emergency department utilization." *Pediatric Emergency Care* 11:223–25.
Euler, H. A., and B. Weitzel. 1996. "Discriminative grandparental solicitude as reproductive strategy." *Human Nature* 7:39–59.
———. 1999. "Grandparental caregiving and intergenerational relations reflect reproductive strategies." In *The Darwinian Heritage and Sociobiology: Human Evolution, Behavior, and Intelligence*, ed. J. M. G. Dennen and D. Smillie. Westport, CT: Praeger Publishers, 243–52.
Fischer, L. R. 1983. "Transition to grandmotherhood." *International Journal of Aging and Human Development* 16:7–78.
Forlenza, S. G. 1998. "A qualitative study of a culturally diverse group of grandmothers parenting their grandchildren with implications regarding family processes." Ph.D. diss., Seton Hall University.
Gattai, F. B., and T. Musatti. 1999. "Grandmothers' involvement in grandchildren's care: Attitudes, feelings, and emotions." *Family Relations: Interdisciplinary Journal of Applied Family Studies* 48:35–42.
George, S. M., and B. J. Dickerson. 1995. "The role of the grandmother in poor single-mother families and households." In *African American Single Mothers: Understanding Their Lives and Families*, vol. 10, ed. B. J. Dickerson, *Sage Series on Race and Ethnic Relations*. Thousand Oaks, CA: Sage Publications, 146–63.
Giarrusso, R., D. Feng, M. Silverstein, and V. L. Bengtson. 2001. "Grandparent-adult grandchild affection and consensus: Cross-generational and cross-ethnic comparisons." *Journal of Family Issues* 22:456–77.
Gibson, P. A. 2002. "Caregiving role affects family relationships of African American grandmothers as new mothers again: A phenomenological perspective." *Journal of Marital and Family Therapy* 28:341–53.

Glass, J. C., Jr., and G. R. Jolly. 1997. "Satisfaction in later life among women sixty or over." *Educational Gerontology* 23:297–314.

Goodman, C. C., and M. Silverstein. 2001. "Grandmothers who parent their grandchildren: An exploratory study of close relations across three generations." *Journal of Family Issues* 22:557–78.

Hawkes, K., J. F. O'Connell, and N. G. Blurton Jones. 1997. "Hazda women's time allocation, offspring provisioning, and the evolution of long postmenopausal life spans." *Current Anthropology* 38:551–77.

Heeder, S. D. 1998. *Black Grandmothers' Strengths and Needs: A Three Generational Assessment.* Ph.D. diss., Arizona State University.

Hill, K., and A. M. Hurtado. 1991. "The evolution of premature reproductive senescence and menopause in human females: An evaluation of the grandmother hypothesis." *Human Nature* 2:313–50.

Hirsch, B. J., M. Mickus, and R. Boerger. 2002. "Ties to influential adults among black and white adolescents: Culture, social class, and family networks." *American Journal of Community Psychology* 30:289–303.

Hoffman, E. 1980. "Young adults' relations with their grandparents: An exploratory study." *International Journal of Aging and Human Development* 10:299–310.

Holladay, S., R. Lackovich, M. Lee, M. Coleman, D. Harding, and D. Denton. 1998. "(Re)constructing relationships with grandparents: A turning point analysis of granddaughters' relational development with maternal grandmothers." *International Journal of Aging and Human Development* 46: 287–303.

Houndoumadi, A. 1996. "Maternal separation anxiety and attitudes about maternal grandmother participation in child care." *Early Development and Parenting* 5:93–100.

Hrdy, S. B. 2000. *Mutter Natur: Die weibliche Seite der Evolution.* Berlin: Berlin-Verlag.

Hyun, O. K., W. Lee, A. J. Yoo, B. H. Cho, K. H. Yoo, B. C. Miller, J. D. Schvaneveldt, and S. Lau. 2002. "Social support for two generations of new mothers in selected populations in Korea, Hong Kong, and the United States." *Journal of Comparative Family Studies* 33:515–27.

Joslin, D., and A. Brouard. 1995. "The prevalence of grandmothers as primary caregivers in a poor pediatric population." *Journal of Community Health: The Publication for Health Promotion and Disease Prevention* 20:383–401.

Kaplan, H., K. Hill, J. Lancaster, and A. M. Hurtado. 2000. "A theory of human life history evolution: Diet, intelligence, and longevity." *Evolutionary Anthropology* 89:156–84.

Kellam, S. G., M. E. Ensminger, and R. J. Turner. 1977. "Family structure and the mental health of children: Concurrent and longitudinal community-wide studies." *Archives of General Psychiatry* 34:1012–22.

———. 1978. "Family structure and the mental health of children." *Annual Progress in Child Psychiatry and Child Development* 264–91.

Kelley, S. J., D. Whitley, T. A. Sipe, and B. C. Yorker. 2000. "Psychological distress in grandmother kinship care providers: The role of resources, social support, and physical health." *Child Abuse and Neglect* 24:311–21.

Kelley, S. J., B. C. Yorker, D. M. Whitley, and T. A. Sipe. 2001. "A multimodal inter-

vention for grandparents raising grandchildren: Results of exploratory study." *Child Welfare* 80:27–50.

Kennedy, G. E. 1990. "College students' expectations of grandparent and grandchild role behaviors." *Gerontologist* 30:43–48.

Kivett, V. R. 1993. "Racial comparisons of the grandmother role: Implications for strengthening the family support system of older black women." *Family Relations: Interdisciplinary Journal of Applied Family Studies* 42:165–72.

Kolomer, S. R. 2000. "Kinship foster care and its impact on grandmother caregivers." *Journal of Gerontological Social Work* 33:85–102.

Landry Meyer, L. 1999. "Research into action: Recommended intervention strategies for grandparent caregivers." *Family Relations: Interdisciplinary Journal of Applied Family Studies* 48:381–89.

Levitt, M. J., R. A. Weber, and M. C. Clark. 1986. "Social network relationships as sources of maternal support and well-being." *Developmental Psychology* 22:310–16.

Lindenberger, U. 2002. "Erwachsenenalter und Alter." In *Entwicklungspsychologie*, 5th ed., ed. R. Oerter and L. Montada. Weinheim: Beltz, 350–91.

Mills, T. L., M. A. Wakeman, and C. B. Fea. 2001. "Adult grandchildren's perceptions of emotional closeness and consensus with their maternal and paternal grandparents." *Journal of Family Issues* 22: 427–55.

Minkler, M., and K. M. Roe. 1993. *Grandmothers as Caregivers: Raising Children of the Crack Cocaine Epidemic.* Thousand Oaks, CA: Sage Publications.

Muransky, J. M. 2001. "Predictors of relationship quality between children and their maternal grandmothers." Ph.D. diss., Ohio State University, Columbus.

Murry, V. M., M. S. Bynum, G. H. Brody, A. Willert, and D. Stephens. 2001. "African American single mothers and children in context: A review of studies on risk and resilience." *Clinical Child and Family Psychology Review* 4:133–55.

Musil, C. M., and M. Ahmad. 2002. "Health of grandmothers: A comparison by caregiver status." *Journal of Aging and Health* 14:96–121.

Myers, B. J., P. A. Jarvis, and G. L. Creasey. 1987. "Infants' behavior with their mothers and grandmothers." *Infant Behavior and Development* 10:245–59.

Myers, B. J., and M. G. Williams Petersen. 1991. "Beliefs and memories about childrearing across generations: Mothers and grandmothers of one-year-old infants." *Early Child Development and Care* 67:111–28.

Olmedo, I. M. 1997. "Voices of our past: Using oral history to explore funds of knowledge within a Puerto Rican family." *Anthropology and Education Quarterly* 28:550–73.

Owens, M. D., and D. R. Brome. 1997. "A preliminary examination of family environment and social support among African American nongrandmothers, grandmothers, and grandmothers-to-be." *Journal of Black Psychology* 23:74–89.

Oyserman, D., N. Radin, and R. Benn. 1993. "Dynamics in a three-generational family: Teens, grandparents, and babies." *Developmental Psychology* 29:564–72.

Oyserman, D. N. Radin, and E. Saltz. 1994. "Predictors of nurturant parenting in teen mothers living in three generational families." *Child Psychiatry and Human Development* 24:215–30.

Packer, C., M. Tatar, and A. Collins. 1998. "Reproductive cessation in female mammals." *Nature* 392:807–11.

Pearson, J. L., A. G. Hunter, J. M. Cook, N. S. Ialongo, and S. G. Kellam. 1997. "Grandmother involvement in child caregiving in an urban community." *Gerontologist* 37:650–57.

Peccei, J. C. 2001. "A critique of the grandmother hypotheses: Old and new." *American Journal of Human Biology* 13:434–25.

Perrin, A. S. 1992. "Grandmothers as caregivers to their grandchildren born with positive toxicological screenings for illicit drugs: Degree of burden and their coping processes." Ph.D. diss., University of San Francisco.

Peterson, D. J. 1999. "The experience of living in a three-generation household after an adult daughter's divorce." Ph.D. diss., University of Arizona.

Poehlmann, J. A. 1996. "Infant risk status and infant-mother attachment: Moderator and mediator functions of grandmother support and maternal affect." Ph.D. diss., Syracuse University.

Pruchno, R., and D. McKenney. 2000. "Living with grandchildren: The effects of custodial and coresident households on the mental health of grandmothers." *Journal of Mental Health and Aging* 6:269–89.

Robinson, L. H. 1989. "Grandparenting: Intergenerational love and hate." *Journal of the American Academy of Psychoanalysis* 17:483–91.

Robinson, M. M., N. P. Kropf, and L. L. Myers. 2000. "Grandparents raising grandchildren in rural communities." *Journal of Mental Health and Aging* 6:353–65.

Roithmayr, S. 2002. "Emotional distress of grandmothers raising grandchildren." Ph.D. diss., New York University.

Rowland, S. B. 1996. "Effects of adolescent mother-infant and grandmother-infant interaction on infant attention: A normative study of an African-American sample." Ph.D. diss., Georgia State University.

Ruiz, D. S. 2002. "The increase in incarcerations among women and its impact on the grandmother caregiver: Some racial considerations." *Journal of Sociology and Social Welfare* 29:179–97.

See, L. A., D. Bowles, and M. Darlington. 1998. "Young African American grandmothers: A missed developmental stage." In *Human Behavior in the Social Environment from an African American Perspective*, ed. L. A. See. Binghamton, NY: Haworth Press, 281–303.

Sharma, D. 1997. "Child care, family, and culture: Lessons from India." Ph.D. diss., Harvard University.

Smith, M. S. 1991. "An evolutionary perspective on grandparent-grandchild relationships." In *The Psychology of Grandparenthood: An International Perspective*, ed. P. K. Smith. International Library of Psychology. New York: Routledge/Taylor and Francis Books, 157–76.

Spieker, S. J., and L. Bensley. 1994. "Roles of living arrangements and grandmother social support in adolescent mothering and infant attachment." *Developmental Psychology* 30:102–11.

Sticker, E. J., and K. Holdmann. 1988. "Die Beziehung zwischen 13- bis 14-jährigen

Mädchen und ihren Grossmüttern" (Relations between 13- to 14-year-old girls and their grandmothers). *Psychologie in Erziehung und Unterricht* 35:27–33.

Sugar, M. 1993. "Adolescent motherhood and development." In *Female Adolescent Development*, ed. M. Sugar, 2nd ed. New York: Taylor and Francis Group, 213–30.

Timberlake, E. M., and S. S. Chipungu. 1992. "Grandmotherhood: Contemporary meaning among African American middle-class grandmothers." *Social Work* 37:216–22.

Tomlin, A. M., and R. H. Passman. 1989. "Grandmothers' responsibility in raising two-year-olds facilitates their grandchildren's adaptive behavior: A preliminary intrafamilial investigation of mothers' and maternal grandmothers' effects." *Psychology and Aging* 4:119–21.

Unger, D. G., and M. Cooley. 1992. "Partner and grandmother contact in black and white teen parent families." *Journal of Adolescent Health* 13:546–52.

Voight, J. D., S. L. Hans, and V. J. Bernstein. 1996. "Support networks of adolescent mothers: Effects of parenting experience and behavior." *Infant Mental Health Journal* 17:58–73.

Voran, M., and D. Phillips. 1993. "Correlates of grandmother childcare support to adolescent mothers: Implications for development in two generations of women." *Children and Youth Services Review* 15:321–34.

Wakschlag, L. S., and S. L. Hans. 2000. "Early parenthood in context: Implications for development and intervention." In *Handbook of Infant Mental Health*, ed. C. H. J. Zeanah, 2nd ed. New York: Guilford, 129–44.

Way, N., and B. J. Leadbeater. 1999. "Pathways toward educational achievement among African American and Puerto Rican adolescent mothers: Reexamining the role of social support from families." *Development and Psychopathology* 11:349–64.

Williams, G. C. 1957. "Pleitropy, natural selection, and the evolution of senescence." *Evolution* 11:398–411.

Wilson, M. N., C. Greene Bates, L. McKim, F. Simmons, T. Askew, J. Curry El, and I. D. Hinton. 1995. "African American family life: The dynamics of interactions, relationships, and roles." In *African American Family Life: Its Structural and Ecological Aspects*, ed. M. N. Wilson. San Francisco: Jossey-Bass, 5–21.

Winston, C. A. 1999. "Self-help for grandmothers parenting again." *Journal of Social Distress and the Homeless* 8:157–65.

**PART III**

# SYNTHESIS
*The Evolutionary Significance of Grandmothers*

# CHAPTER 15

# Cooperative Breeders with an Ace in the Hole
Sarah Blaffer Hrdy

## Rethinking the Role of Postmenopausal Women

As a woman beyond a certain age as well as a scientist, I was doubly pleased to attend this first international conference on the evolutionary significance of grandmothers. Truth to tell, anthropologists have not always been interested in this subject. Consider the legendary ethnographer C. W. M. Hart who first studied the Tiwi when they still lived as hunters and gatherers. The new Fieldwork Edition of his 1928 classic *Tiwi of Northern Australia* tells how Hart came to be accepted into the Tiwi's intricately networked matrilineal society.

"I was in camp," wrote Hart, "where there was an old woman who had been making herself a terrible nuisance." "(She was) physically quite revolting . . . (and) kept hanging around me, asking for tobacco, whining, wheedling, sniveling, until I finally got thoroughly fed-up with her. As I had by now learned the Tiwi equivalents of 'Go to hell' . . . I rather enjoyed being rude to her . . . (Then) one day the old hag used a new approach. 'Oh my son,' she said, 'please give me tobacco.' Unthinkingly I replied, 'Oh my mother, go jump in the ocean.' Immediately a howl of delight arose from everybody within earshot and they all gathered around me . . . calling me by a kinship term" (1979, 124).

Hart's elation soon turned to disappointment when he was left behind in camp with the old women while the others went off to forage: "During the day," he wrote, "only the babies and one or maybe two old wives to look after them would be left in the camp [while] the rest [of the group] would be scattered through the bush, the women and children gathering wild fruits, vegetables and nuts, the men hunting. . . . Encamped with such a household, what was I supposed to do all day? The hunters did not want me. I made too much noise and frightened the game . . . The women did not want me since their gathering habits were all business and in any case unmarried men were supposed to stay away . . ." (apparently it did not occur to Hart that these women may not have wanted him tagging along because some anticipated visits from lovers). In any event, Hart was left behind in camp with the old women and "such a role had little appeal" (127). After, all what

could be more pointless? Unless, of course (as now seems likely), the behavior of these same old women was critical for the survival of the offspring left in their charge. But today's Tiwi no longer live as foragers, and at the time when they still did, researchers like Hart did not consider the behavior of old women worth studying. Hence, we may never know.

Hart's bias was typical of the time. Anthropologists and evolutionists alike—most of them males—assumed that the function of women was to bear and rear children. Postreproductive women seemed irrelevant. In the last quarter century, however, researchers have become far more interested in women's roles, and evolutionary theory has expanded to include the interests and strategies of both sexes at all ages, from infancy to old age. In particular, evolutionists working in the wake of Hamilton's revolutionary ideas about inclusive fitness (1964) have started to examine the effects individuals have not only on their own reproductive success but on the reproductive success of close kin. For evolutionary anthropologists, these changes in research focus are taking place concurrently with other social and theoretical transformations that inspire new interest in selection pressures on females. Contrast Hart's repulsion with the intense interest displayed by Kristen Hawkes and coworkers when they first noticed how hard old women worked among Hadza foragers in East Africa (1989, 1997), or with the discovery by Rebecca Sear and her colleagues (2000) that the presence of a maternal grandmother can double the survival chances of a Mandinka child. Such transformations have brought with them not only new research questions about old women but major paradigm shifts in the way that we conceptualize the earliest human families.

## Rethinking the Origins of the Human Family

Many primates have costly young, but none are so costly to rear as human immatures. In other apes, gestation lasts eight or more months, followed after birth by two to four years or longer of lactation. But once weaned, juvenile apes are nutritionally independent. This is not the case for humans (Lancaster and Lancaster 1983). From comparative data across traditional foraging societies, Kaplan (1994) estimates that it takes some 13 million calories to rear human offspring from birth to independence. Consumption of resources typically exceeds the amount that youngsters produce themselves, so youngsters must depend on nutritional subsidies from someone for eighteen or more years. Human mothers produce a new baby long before its older sibling is independent. So this is the problem: How could natural selection have favored any female who produced offspring so far beyond her means to rear? Mother apes in the line leading to early hominids must have had help caring for and provisioning their young. But help from whom?

Since Darwin, the conventional solution to this riddle has been the presumption of a contract between a mother and her mate. In exchange for sexual access and rearing his children, a hunter would provision both mother and her offspring during prolonged periods of dependency (for example, Lovejoy 1981). Decades of criticism notwithstanding (Hrdy and Bennett 1981; Cann and Wilson 1982; Hawkes in press), the Victorian stereotype of father-as-provisioner still weighs heavily on reconstructions of the past. "The latest studies of ancient human family structure," write Lawrence and Nohria "report that monogamous pair-bonding and nuclear families were dominant throughout human history in hunter-gatherer societies" (2002, 182). Yet even such "man the hunter" scenarios have begun to acknowledge active female roles in at least one domain, choosing mates, although the provisioning role of fathers remains paramount: "The most straightforward explanation of the trend toward monogamy," the authors suggest, "is that smart female hominids went to work on chimpanzee hominid-like males and—step by step, mate-selection by mate-selection—shaped them up into loving husbands and fathers with true family values" (2002, 182). Echoing long-standing patriarchal presumptions about husbands guaranteed paternity by sexually "coy," chaste and monandrous mates, the authors assume that women actively chose the husband most able to support them. No mention is made of female subsistence contributions or of help from any quarter besides this "loving husband."

## Help from Fathers: Important but Unreliable

Popular assumptions about Victorian "family values" were projected back to the Pleistocene. The conventional solution to the dilemma of how mothers could have produced children so far beyond their means to rear was that wives chose husbands who would support them. Unquestionably, men do provide important support—protein as well as protection. As the proportion of men's contribution to diet goes up across foraging societies, so does female reproductive success (Marlowe 2001). But as Kristen Hawkes has stressed (1991), among hunter-gatherers, meat tends to be shared among the group at large. Furthermore, decisions made by a hunter often have more to do with maintaining a man's prestige (and with it his future mating opportunities) than with maximizing protein available for his family (see also Kaplan, Hill, and Hurtado 1984). According to Hawkes' "show-off hypothesis," big-game hunting is better understood as "mating effort" than "parenting effort." Key assumptions of the "provisioning father" hypothesis are further undermined by comparative evidence. Paternal behavior in men is very variable, and they only sometimes behave as though their top priority was remaining near to and caring for young. Phenotypically, men do not

resemble titi monkeys, California mice, or other species with obligate (which in zoological parlance means *always found*) paternal care.

There are abundant examples of men devoted to their families. But worldwide, many appear more interested in status or seeking new mates than in investing in the immature offspring or wives that they already have. Scanning the large number of female-headed households around the world, paternal care among humans must be considered as a facultative, highly labile trait. There is a vast literature on "fatherless" households. Consider data from one of the world's most rigorously censused human populations, the contemporary United States. Even though this population experiences unusually low mortality rates at all ages, so that the fathers of most children are still alive, 40 percent of children are not living in the same family (defined here as household) as their genetic father (Cohen 2003, 1175). On what grounds can we expect Pleistocene fathers, arguably more mobile and at higher risk of early death, to stick around?

Indisputably, fathers have the potential to contribute greatly, and many do. In many foraging societies, the father's death means survival chances for his offspring are so diminished that a mother may opt to kill her fatherless child because it is so unlikely to survive (Hill and Hurtado 1996). But the father's impact on survival is variable in the human case, depending not just on whether immatures need protection but on who else is available to bring food, for genetic fathers are not necessarily the only men, nor men the only sex, providing food (Hill and Kaplan 1988; Blurton Jones et al. 2000; Beckerman and Valentine 2002). When a father died in the horticultural Gambian population studied by Sear et al. (2002), there was no significant effect on the growth and survival chances of his children unless their mother remarried. This more nearly resembles a misfortune from encountering a stepfather (which primate-wide tends to be bad news) rather than a liability of father absence.

Nevertheless, a strict division of labor between provisioning fathers and nurturing mothers was taken for granted. Departures from "true family values" were treated as outliers, even though customs like wife-sharing are found in approximately one third of human cultures (Broude 1994, 334; see also Beckerman and Valentine 2002). In some foraging societies, children whose mothers had relationships with several men, and hence more than one "possible father," actually survived better simply because if one "father" came up short-handed, the other provided (Beckerman et al. 1998; Hill and Hurtado 1996). Yet cultures with several "fathers" or extensive male caretaking (for example, Hewlett 1992) were regarded as unusual, rather than as representative of a naturally occurring human potential.

Thinking back to a time when foraging peoples lived hand to mouth, and rates of child mortality were high, children whose mother relied exclusively

on her husband were at greater risk of starvation than were children who had alternative sources of support. Given that natural selection does not ordinarily shape maternal reproductive physiologies and psychologies so as to fail to leave surviving descendants, we return to the question of how could there ever have been selection on any ape female to produce young so far beyond her means to rear? At present there are two alternative possibilities: paternal care or allomaternal assistance within a cooperatively breeding family system. Based on comparative evidence across species, ethnographic evidence from surviving hunting and gathering people, and specific psychological, emotional, and life-history traits of humans, I believe the latter is more likely.

## The Cooperative Breeding Hypothesis

Across arthropod, avian, and mammalian taxa, breeding systems where *alloparents* (individuals other than the genetic parents, Wilson 1975) help to care for and provision young have evolved many different times. Because it is often difficult to know for sure which male is actually the genetic father, it can be more accurate to refer to "allomothers," male or female group members other than the mother. For cooperative breeding to evolve, group members must remain in the group to be susceptible to offspring or maternal solicitations. I will argue here that early hominids, perhaps beginning with *Homo erectus,* evolved as cooperative breeders among whom mothers relied on allomothers to help care for and provision young—the only extant apes to do so. Buffered by allomaternal assistance, mothers less burdened by their young bred faster and produced more offspring that survived, allowing them to persist, and even expand into a wide range of new habitats as other large animals that bred cooperatively did (lions, canids, elephants, eusocial insects).

Cooperative breeding takes various forms. Some cooperative breeders are rigidly hierarchical with dominant mothers penalizing subordinates for breeding. For example, among wolves, wild dogs, marmosets, and meerkats, subordinate females suppress ovulation since if they were to conceive, the alpha female might kill any offspring they produced thereby making alloparental assistance more available for her own young (Solomon and French 1997; Digby 2000). In extreme cases known as *eusociality,* domination leads to the evolution of "sterile" castes (for example, bees, naked mole rats). But in other cooperative breeders such as elephants or communally living house mice, females support one another's reproductive endeavors. Co-mothers even take turns guarding or suckling one another's offspring. Although suppressed ovulation and other forms of coercion are commonly cited along with kin benefits to helpers, in fact there are many reasons why benefits

from helping could outweigh costs, especially if the allomother's own reproductive options are so poor that they lose little by helping. Plus helping behaviors may be facultative. If helping is too costly, allomothers may decline. Major benefits include enhanced survival or eventual reproductive chances from remaining in a group (benefits of *philopatry*) as well as benefits from practice caretaking.[1]

Whatever the reasons, allomothers forego reproduction themselves and help others. Mothers in cooperatively breeding species rely on assistance from phenotypically flexible group members who switch between reproductive and nonreproductive roles. Groupings tend to be flexible and unstable, so mothers (and their young) are selected to be flexible and opportunistic in soliciting assistance. Even within the same species, cooperative breeders may exhibit variable relations between the sexes, ranging from temporarily mateless mothers to monogamously, polygynously, or polyandrously mated pairs with helpers, depending on local ecologies and social history and on which partner currently has the most leverage. As it happens, human families fit this profile well. Over the course of her life, the same mother may find herself eliciting help from within a monogamous, polygynous, informally polyandrous relationships or during a period when she is "a single mother" (for example, Marshall 1976; Shostak 1981; Emlen 1995; Hrdy 1999; Beckerman and Valentine 2002).

In a nomadic foraging society like the !Kung or Ache, a just-married man typically comes to live with his young wife's family until after the birth of one or more offspring, providing material and social support for new mothers at this vulnerable transition.[2] After the first birth(s), the couple might move back to live with his family, or go to live with some other group that offered better resources (including allomaternal assistance). Across primates, remaining among her own kin typically improves a female's social autonomy, and translated into a human context, a sufficiently autonomous woman has greater flexibility as to whether to opportunistically take lovers (Hrdy 1999). Despite common evolutionary typecasting of women as monandrous/men as polygynous, and in spite of the common assumption that early residence patterns were inevitably patrilocal, the actual situation would have been far more flexible (Alvarez 2004).

Like all primates (Dunbar 1998; Silk, Alberts, and Altmann 2003), humans descend from intensely social creatures innately predisposed to protect immatures in their group. Although full-fledged cooperative breeding with food sharing is rare, the order Primates is studded with traits that preadapt primates to shared care, for example, gregariousness, susceptibility to signals from immatures, protection of the group against outside threats. Tests of human decision making indicate that human primates are cogni-

tively and emotionally predisposed to cooperate (Fehr and Fischbacher 2003). To a greater degree than any other ape, humans develop into unusually cooperative, "hyper-social" primates (Tomasello 1999; Hrdy 2004), with brains that register pleasure when we help others (Rilling 2002).

## A Deep History of Sociality and Shared Care

The transition from an ape ancestor with exclusive maternal care to a cooperative breeder is not as daunting as at first appears. For safety reasons, great ape mothers like chimps are unusually possessive of their infants, and these frugivores tend to forage on their own. But this does not mean that other chimps are not interested in their young. Although rebuffed by the mother, other chimps are eager to get their hands on her baby, and should a mother die, an older sibling may adopt the orphan and attempt (albeit often unsuccessfully) to rear it. Remarkably few primates (except perhaps mothers burdened by their own infants) are unresponsive to signals of need from infants, and under the right circumstances, males respond as well (Hrdy 1999). More importantly, the bipedal apes that gave rise to *Homo erectus* and eventually *Homo sapiens* were more omnivorous than chimps, lived more gregariously, and engaged in much more food sharing (with novel opportunities for shared care of offspring). This is why the other extant great apes make poor models for *Homo erectus* mothers whose bipedality, greater tool use, larger body size, and changed diet (a greater reliance on animal protein, underground tubers, and hard-to-open nuts) propelled them into different—and almost certainly more gregarious—socioecological niches.

Shared care of offspring has evolved many times in prosimian, New World, and Old World monkey species. In this respect, taxonomically more closely related great apes are less like early hominids than more distantly related infant sharing and cooperatively breeding animals are. Across primates, there exists a continuum of caretaking that ranges from exclusive mother care (for example, in chimps or gorillas) to shared care without any provisioning (as in vervets, langurs, and most other colobine monkeys), to full-fledged cooperative breeding among marmosets and tamarins.

Members of the family Callithrichidae (marmosets and tamarins) are the only nonhuman primates with suppressed ovulation, and the only ones where alloparents provide allomaternal provisioning as well as care. Offspring are relatively large and costly, typically twins. By the second week of life, adult males (usually former sexual partners of the mother) carry infants most of the time, returning them to the mother to suckle. The more males in the group, the higher the mother's reproductive success. Helping is costly to males who spend less time foraging and fail to gain weight until after their

charges are weaned. By a few weeks of age, long before infants are weaned, mother's milk will be supplemented by insects provided by prereproductives and other alloparents (see Snowdon 1996 for review).

Across primates, wherever solicitous caretakers (typically kin) are available, and the environment is safe enough, monkey mothers may take advantage of assistance (Paul this volume). Temporarily freed from the burden of caring for their infants, mothers with allomaternal assistance forage more efficiently and their young grow faster, so mothers can wean sooner, conceive again sooner, without compromising infant survival. Thus shared care allows primate mothers to breed at shorter intervals (Mitani and Watts 1997; Ross and MacLarnon 2000).

## Cross-taxa Correlates of Cooperative Breeding

Shared care enhances offspring survival, and thereby alters the landscape on which natural selection acts with profound implications for how infants monitor their social world and engage caretakers, for infant attractiveness, for alloparental susceptibilities to their charms, and for maternal predispositions to cultivate allomaternal support as well as for the life histories of all concerned. Because allomothers provision young, periods of nutritional dependency are significantly longer than in noncooperative breeders, and if food is scarce or hard for young to access, those periods tend to be longer still. As in humans, allomothers continue to provide food for young even after they are "fledged from the nest" (or weaned). In birds, cooperative breeding is correlated with a longer period of post-fledging dependence (Langen 2000) as well as with higher adult survivorship (Arnold and Owens 1999), in part because assisted mothers are less likely to die (Rowley and Russell 1990).

Prolonged periods of nutritional dependency evolved independently in various cooperatively breeding birds and mammals where alloparents provision young. Among cooperatively breeding magpie jays in Costa Rica, young leave the nest (fledge) at about three weeks of age. Fledglings then start to produce loud begging calls from conspicuous perches, eliciting food from nonbreeding allomothers who may provide as much food as parents do. Young are subsidized by this post-fledging provisioning while they learn to hunt insects and gather berries (Langen 1996). As in humans, many young jays are physically capable of reproducing (and do so as early as eleven months) *before* they have acquired adult foraging proficiencies (around sixteen months). However, their chances of success would be poor, and few young jays have, or take, opportunities to breed, and help instead. Among wild dogs, group members provide older pups regurgitated meat, and some alloparents even spontaneously lactate to suckle the alpha female's pups.

Once pups are weaned from both milk and the regurgitated "baby food," other group members allow pups to feed first at kills, buffering youngsters from starvation while they acquire hunting skills (Creel and Creel 2002).

Longer childhoods mean more opportunities to learn specialized foraging behaviors, and in the case of a cooperatively breeding ape, prolonged periods of subsidized dependency would have meant novel opportunities for selection to favor further brain growth in creatures that were already clever, tool using and culture bearing (see Bock 2002; cf. Langen 1996 for birds). However, this does not mean that longer childhoods evolved *because* they were necessary to develop big brains, or because it was useful to have more time to learn special skills. Rather, long "childhoods" could be a corollary of cooperative provisioning that happened to reduce pressures on young to grow up fast or starve by allowing Darwinian selection to favor larger, slower growing ape-quality brains without incurring the otherwise prohibitive costs (energetic costs as well as the increased risk of dying before breeding). That is, cooperative breeding would have allowed a new range of behaviors to be expressed phenotypically so selection favoring slightly smarter, slightly bigger brained apes could take place (West Eberhard 2003). Furthermore, if childhoods were already long, big brains evolved at a discount (Hrdy 1999, 287). At some point, big brains, human-caliber learning capacities, and long childhoods coevolved, but I am proposing that the prolonged period of nutritional dependence permitted by cooperative breeding came first, setting the stage for selection to favor traits like big brains.

Traits that increase the availability of allomothers or that make allomothers more useful may be favored though either natural selection or its subsidiary, kin selection. These include life-history traits such as delayed dispersal, extended life spans, and suppressed ovulation or nonmaternal lactation (as in wild dogs) as well as cognitive and emotional traits that make individuals at different life stages more aware of infant needs and susceptible to responding to them. Other traits that increase the ratio of allomothers to offspring occur by chance. For example, the prevalence in a population of sexually transmitted diseases, and with them high levels of infertility, increases the availability of alloparents simply by increasing the ratio of nonparents to needy immatures (Hewlett 1991). Similarly, longer life spans leading to slow population turnover may increase pressure for youngsters to help rather than to breed themselves (Arnold and Owens 1999). Over generations, even chance effects can alter the landscape on which selection acts. Provided the social and physical environments are safe enough that mothers can afford to leave infants in the care of others (Hames and Draper in press) and provided there are willing allomothers, we would expect selection for infantile attributes that exaggerate their appeal (Hrdy 1976, 1999) as well as developmental sequences that tend to engage caretakers at

opportune times for increased survival (Hrdy 2004). This means that in taxa with deep histories of shared caretaking, allomothers primed to respond to such signals may respond to infants whether they are related or not—as is the case with cooperatively breeding birds and most primates, including humans.

## Allomothers Are Not Only Helpful, They Improve Maternal Reproductive Success

Ethnographers have long been aware of "childminding" (LeVine et al. 1996; Weisner and Gallimore 1977), often by prereproductive females. LeVine et al. (1996) reported that girls between age five and adolescence spend almost as much time within five feet of infants as mothers do among Gusii horticulturalists in Kenya. (This predominance of juvenile females among caretakers is also found in infant-sharing primates, like langurs, where prereproductive group members seek out and carry infants more often than others do and keep them longer [Hrdy 1999; Paul this volume].) Such help frees mothers to forage while also providing useful practice for the young babysitters. But do these helpers impact maternal reproductive success?

It was 1988 when sociobiologist Paul Turke decided to find out if allomothers affected reproductive success among the matrilineal, matrilocal islanders of Ifaluk atoll in the Pacific. Women who bore a helper-daughter first had higher reproductive success than women whose first two children were sons. Shortly after, Flinn similarly reported that older sisters also enhanced reproductive success among Trinidadian villagers, although birth order did not matter. A comparison of nine mothers living in households in a Trinidadian village with nonreproductives on hand to help—usually daughters—had significantly higher reproductive success than the twenty-nine mothers without (Flinn 1989). Among foraging peoples as well, babysitting by older girls (approximately age fourteen) reduced the mother's workload so much that her activity budget (including time devoted to obtaining and preparing food for her family) resembled that of a woman without dependent children (Peacock 1985). Thus, help from older children (especially daughters) offsets heavy child-rearing responsibilities (Blurton Jones 1993; Henry, Morelli, and Tronick 2005), so mothers give birth to more children (Kramer 2002). In some environments, prereproductive caretakers provide charges with supplementary food, berries, and small game (Bird and Bliege Bird in press)

Social workers and medical personnel in industrial societies emphasize how much emotional and material support children derive from extended,

multigenerational families. If maternal competence is compromised (by immaturity, inexperience, father absence, or resource scarcity, for example [Stack 1974; Wilson 1986]), alloparents are even more critical. Even under modern conditions, babies born to unmarried, low-income U.S. teenagers had improved cognitive development at age four if a grandmother was present (Furstenberg 1976). Similarly, if older siblings were on hand, infants were more likely to develop a sophisticated "theory of mind" by age three and later on exhibit greater social skills (Ruffman et al. 1998). For children at risk, grandmothers have a positive effect at almost all ages (Werner 1984).

A vast historical and sociological literature attests to the emotional, sociocognitive, and physiological as well as material benefits for children who grow up in extended families with older siblings, grandmothers, or other kin or as-if kin to help nurture them. However, the evolutionary implications of such correlations were overlooked. It was not until researchers began to study the effects of allomaternal assistance in societies with high rates of child mortality that the fitness consequences of allomaternal assistance became apparent. Just in the last few years, we have learned that the presence of an older female kinswoman (often but not necessarily the mother's mother) can be correlated with increased growth rates or significantly increased probabilities of child survival. Such correlations were found among the East African Hadza foragers studied by Hawkes, O'Connell, and Blurton Jones (2001, this volume) and among eighteenth-century German peasants studied by Beise and Voland (2002, this volume). Among South Asian swidden agriculturalists, mothers with grandmothers on hand had shorter intervals until the birth of their next infant (Leonetti 2002, this volume), while among children of West African horticulturalists, the presence of a maternal grandmother was correlated with both faster growth rates and improved survival so that mortality rates dropped from 40 to 20 percent (Sear, Mace, and McGregor 2000). Sustained over generations, such allomaternal effects have enormous evolutionary implications.

Across primates, matrilineal kin can significantly affect offspring survival and hence maternal reproductive success, and mothers act as if they know it, remaining near kin when feasible (Hrdy 1999, chap. 2 ff.). Comparative studies suggested that this primate-wide rule applies to nomadic hunting and gathering societies, both those where meat brought in by men was an important part of the diet and especially among those societies where gathered food by women is important (Witkowski and Divale 1996, 674). A painstaking and important reanalysis of ethnographies of hunting and gathering peoples undertaken by Helen Alvarez (2004) reveals that patrilocal residence patterns characterize fewer than 25 percent of hunter-gatherers (far less than previously assumed) with matrilocal and bilocal residence be-

ing the preferred living arrangement. This suggests that hunter-gatherer mothers took advantage of the option to align themselves according to which group offered them the best access not only to food and water, but to allomaternal assistance. This level of female autonomy meant that grandmothers as well could also distribute themselves in line with the needs of kin. For pre-Neolithic nomads, mothers apparently had more options to avoid potentially oppressive in-laws than in cultures where patriarchal residence patterns and other customs constrained female choices (cf. Mace and Sear this volume; Voland and Beise this volume; Jamison et al. 2002).

Therefore, even though the best single predictor of infant survival is maternal commitment, her level of commitment would be influenced by her perception of who else is around and willing to help rear her offspring. Even when the mother is the main caretaker (as she usually is in the first months right after birth) allomaternal support matters. Based on the ethnographic and historical records, poor, unwed mothers with supportive matrilineal extended families were less likely to abandon their babies (reviewed in Hrdy 1999). In modern postindustrial societies as well, even with the father present, adolescent mothers are more sensitive to their infants' needs and have infants who become more securely attached if a supportive grandmother is also on hand (Spieker and Bensley 1994).

## Grandmothers as a Special Class of Allomother

Most human immatures would benefit from more allomaternal attention. But survival effects on fitness vary with just what immatures of different ages need most (be they newborns, teething babies, toddlers, or juveniles), and with what different (and variably committed) allomothers have to offer. For most newborns, mothers loom so large as to make allomothers irrelevant in the first months except for pre- and postpartum support to the mother herself, and for the mother's assessment of how much assistance she and her child can expect in the future. Human mothers probably were the primary caretakers right after birth (for important exceptions, see Henry, Morelli, and Tronick 2005 and literature cited therein) so that the practical role of allomothers right after birth would have been helping to offset the mother's reduced foraging efficiency (Hurtado et al. 1985). Within months, though, infants begin to smile, babble, and engage a wider circle of caretakers, just about the time they can benefit from allomaternal caretaking and provisioning with soft or premasticated foods. The inclusion of allomothers in the context in which infants develop has important implications for the way we conceptualize certain traits such as theory of mind and the ability to read the intentions of other from an early age (Hrdy 2004).

With a nursing mother nearby, even caretakers little bigger than their charges can take care of an infant whose mother now is freed for productive activities. Typically, it is prereproductive caretakers who are most available and most willing to volunteer for such duties. As eager and available as young babysitters are, however, relying on them can be risky. Physically immature and lacking experience, they may endanger an infant through incompetence or poor judgement. Worse, as they reach reproductive age and become more competent, they also become more distractible, focusing more on their own future social status and future reproductive options.

Other mothers and adult males are better bets, although men (except in emergencies) tend to be less eager to babysit unless they happen to have leisure time spent in the vicinity of wives and children (Hewlett 1992), and other mothers may be constrained by the needs of their own infants. Safety concerns (Hames and Draper in press) may forestall mothers from turning over babies to immature child-minders. Once environmental safety and the competence of caretakers and their availability are taken into account, grandmothers—long overlooked by anthropologists—start to look awfully important. Unencumbered by babies of their own, grandmothers are full grown, knowledgeable about their environment, experienced in child care, proficient at foraging, and single-minded, willing to give unstintingly of themselves.

Ever since Hamilton, sociobiologists have recognized that as *reproductive value* (future probability of contributing to the gene pool) declines with age, mothers and other relatives become more altruistic. It is not uncommon for animals approaching the end of their lives to sacrifice themselves for others. Even among insects, conspicuously colored, foul-tasting (aposematic) moths near the end of their lives fly about erratically, calling attention to themselves, actually encouraging predators to eat them and thereby associate their appearance with the repugnant taste of that particular prey so as to spare younger kin a similar fate (Blest 1963). At the end of their reproductive lives, some spider mothers allow their young to eat them (Evans, Wallis, and Elgar 1995). In some primates, females behave more altruistically as they age. Among langurs, decrepit old females at or near the end of their reproductive careers take the lead in defending the troop's feeding territory from encroachment by other groups and hurl themselves against infanticidal males to rescue infants attacked by them (Hrdy and Hrdy 1976). Yet humans appear to be the only extant primates in which the period for such altruistic behavior stretches out for decades after menopause. The most persuasive hypothesis to explain such exceptional longevity is that the beneficial consequences of having postreproductive kin around have been great enough in the human case to favor genetic traits contributing to

longer postmenopausal life spans (Hawkes et al. 1998). But why has this occurred in humans and not among the other species of primates among whom old females help?

Evidently, it takes more than altruistic inclinations. Other conditions have to be met before selection can favor such pronounced postmenopausal longevity. What else besides donative intent is needed? First, there has to be something useful old females can do that offsets costs of having them around, sharing the feeding area. Among langur monkeys, old females spend most of their time peripheralized from other group members. By temperament they avoid competition for food with younger group members. This diminishes the cost of their keep. Alternatively, in the case of food-sharing animals, the increased efficiency and productivity of older females may help to pay their way as among humans (for example, Hawkes, O'Connell, and Blurton Jones 1989, 1997; Bock 1995). Plus, humans can consciously take the future into account. If costs of their keep exceed what the old have to offer, deliberate euthanasia is an option. For example, Hill and Hurtado (1996, 236–37) describe a category of Ache warriors who specialize in executing old women who have outlived their usefulness. Fear of such a fate or of being left behind (for example, abandonment of the old among Eskimos) would provide other incentives for old women to work hard.

In both human and nonhuman primates, old females appear willing to help, so the costs of having them around are offset. But in humans, old women gather food, carry it back to kin, and share it. Food sharing, both uncommon and nutritionally insignificant in most other primates, opened up new possibilities for significant altruism in the hominid case. Especially in hunter-gatherers subjected to recurring famines, foods such as tubers (O'Connell, Hawkes, and Blurton Jones 1999) gathered by old women would have been critical for helping weaned juveniles (in primates always the first to starve) survive when fish and game were scarce.

Aging female primates are not only more altruistic but more experienced and less distracted by other agendas. In human primates, old females have even more to offer. Ivey (1993) describes an old Efé woman who was expert at finding medicinal plants and special foods only used during famine times. Her own children had long since died, but she nevertheless spent hours in the forest collecting fish, shellfish, nuts, fruits, and roots that were too scarce for other women to find at the time of year she managed to. Expert food finders, old women are also more skilled at processing it. Women in Botswana start cracking mongongo nuts in their twenties, and their competence peaks in their mid-thirties (Bock 2002). Prior to the invention of the written word, elders accumulated information that made them unique repositories of knowledge.

# Cooperative Breeding with Long Childhoods and Long-lived Mothers Sets the Stage for Selection to Favor Longer Postmenopausal Life Spans

Bigger mothers, longer childhoods, longer life spans: all seem to crop up in the fossil record at the same time, around 1.7 million years ago with *Homo erectus* (O'Connell, Hawkes, and Blurton Jones 1999). According to Hawkes et al.'s version of the grandmother hypothesis, the catalyst for these life-history changes was the need for provisioning grandmothers to go on living past menopause, whereupon Charnovian life-history rules explain the other changes. Yet as willing and qualified as grandmothers are, it would be unwise to focus exclusively on this one source of allomaternal support. Other cooperatively breeding species exhibit longer adult life spans and longer periods of juvenile dependency without prolonged postreproductive life phases. Selection favoring longevity in postreproductives is not the only route to these life-history changes. The peculiarly cooperative nature of the human species alerts us to consider an evolutionary heritage different from that of other apes.

Grandmothers are helpful in other primates, but (so far as we know) have not been selected to live long past menopause. This implies that something else had to differ, possibly the combination of care from a range of allomothers along with opportunities for significant food sharing. Opportunities for provisioning would not only increase the fitness impact of shared care but also enhance benefits from female philopatry. By remaining among kin, a mother would be more autonomous, and if kin preferentially shared food, she would be better fed. Such a mother would be safer because migrating is dangerous, and because carrying and caring for an infant exposes primate mothers to increased mortality risk from predation and other causes (Altmann 1980). Allomaternal buffering helps explain the greater maternal survivorship described for birds and for cooperatively breeding eusocial insects (ants, bees, termites) as well as naked mole rats (Keller and Genoud 1997). If *Homo erectus* was a cooperative breeder, selection favoring long postmenopausal life spans would have occurred in a context where mothers were already likely to survive longer than in noncooperatively breeding ancestors.

Greater maternal survival accords with the argument that by the Pleistocene, women between the ages of forty and seventy would have been more numerous than most anthropologists and demographers realize (Hawkes this volume). By Hawkes' reckoning, one third of children born could count on a grandmother being present. Her reconstructions are compati-

ble with comparative data from primates indicating that our species evolved to last around seventy-two years (Judge and Carey 2000). But even if we accept these projections, mothers and offspring would have done well to seek a broader base of allomaternal assistance. Consider the twenty infants in Paula Ivey's Efe sample (1993). Only four actually *had* surviving grandmothers. The bulk of allomaternal assistance came from other categories of allomother. Variable sources of allomaternal support are consistent with both the ethnographic evidence and with recent demographic reconstructions for Pleistocene foragers.

Available archeological evidence has been used to construct estimates for nomadic foragers living under a range of conditions. Kurland and Sparks (2003) estimate that under conditions of low mortality, a twenty-year-old primipara would have a roughly 50 percent chance of having a forty-year-old mother alive to help her. If mortality rates were higher, this probability drops to 25 percent. (Hawkes's estimate falls in between). Under either mortality condition, chances of the mother having a five-year-older sibling around would be twice as high as the chance of her children having a grandmother, and the chances of her child having older siblings or cousins around would be higher still. For a woman of reproductive age, there would also be possible or would-be "fathers" around. Precise availabilities of different types of helpers is unknowable, but the relative probabilities of having siblings, sexual partners, co-mothers, cousins, or foster children around to help would have been higher than those for a maternal grandmother. Beyond demographic arguments, the psychobiological evidence from modern humans attests to cooperation involving more than altruistic grandmothers. Markedly different from extant chimps, ours species is predisposed to engage others, to help and share (Tomasello 1999; Fehr and Fischbacher 2003; Hrdy 2004). Human mothers (and their offspring) behave as if they descended from ancestors who elicited support from a fluctuating array of allomothers. Ethnographic evidence suggests these included fathers (as assumed in long-standing Darwinian paradigms), possible or would-be fathers, older offspring, siblings, and other mothers on a reciprocal basis as well as—when available—older matrilineal kinswomen. It seems plausible therefore that selection for long postmenopausal life spans (which the grandmother hypothesis does an elegant job of explaining) only got underway *after* food sharing and shared care by a range of group members—that is, full-fledged cooperative breeding and with it long childhoods and higher maternal survival rates—were already part of the hominid profile.[3] Grandmothers were a critical asset, but only if there was one in the demographic hand a mother was dealt.

How might we test empirically which appears first, cooperative breeding or selection for long postmenopausal life spans? Further work on compara-

tive life histories of cooperative and noncooperative breeders, such as Langen has done for birds, needs to be undertaken for mammals. Special attention should be paid to the role of food sharing. As new paleontological evidence comes in, it may be possible to learn more about the order in which indicators of long childhoods, long postmenopausal life spans, big brains, an so forth first appear in the fossil record. In the meantime, all of us (not just women of a certain age) should be grateful that the long-ignored significance of grandmothers is beginning to be explored.

## Grandmothers as an Ace in the Hole: Summary

According to the cooperative breeding hypothesis, mothers relied on allomaternal assistance from a range of breeding and nonbreeding group members. As in other cooperatively breeding animals, maternal reliance on allomaternal assistance would have been correlated with longer periods of nutritional dependency in offspring and longer maternal life spans, opening our species to a new range of selection pressures, including selection for longer postmenopausal life spans. The hypothesis that cooperative breeding was integral to the evolution of our species derives support from studies of traditional societies in which immatures grow faster, survive better, and their mothers breed faster when older siblings and other kin help care for older infants and especially when allomothers (mother's adult kin and her sexual partners) help to provision nearly weaned and weaned offspring. In these respects, humans resemble other cooperatively breeding species with food sharing. Where humans differ from other cooperative breeders is in the availability of help from postreproductives. Because women live on for several decades after menopause, this particularly helpful type of allomother is potentially available for longer than is the case in other primates. Behaving like suppressed ovulators in other cooperatively breeding animals, these postreproductives help kin rear their young. Due to the demographic hazards of life among nomadic foragers, only some portion of human mothers would have grandmothers still alive and nearby when they gave birth. But for those who did, the availability of this unusually experienced, productive, and motivated allomother served as their ace in the hole, insuring a winning hand in the Darwinian game, helping mothers whose own mothers were around to help, leave more descendants than mothers without.

## Acknowledgments

I am grateful to Eckart Voland, Wulf Schiefenhövel, and Athanasios Chasiotis for their encouragement, suggestions, and patience. This paper benefited from critical review by Kristen Hawkes and Debra Judge.

## Notes

1. Note that primiparous monkey mothers without prior access to infants often mishandle their first infant but improve with practice. Applications of "Hamilton's rule" to allomothers are discussed elsewhere (Hrdy 1999, 2004).

2. Fortuitously, mothers of primipara are more likely to be alive at this vulnerable time than later on, and it is possible that this need for support by vulnerable new mothers encouraged female philopatry in nomadic foragers.

3. Although no other primate is known to have long postmenopausal life spans, we can find shared caretaking and minimal shared suckling correlated with long developmental phases and unusually long life spans (for example, in cebus monkeys, Judge and Carey 2000; personal communication from Joe Manson). Consider this futuristic thought experiment: If allomaternal provisioning in cebus were to become more significant than it currently is, would we find selection for postmenopausal life spans?

## References

Altmann, J. 1980. *Baboon Mothers and Infants*. Cambridge, MA: Harvard University Press.

Alvarez, H. 2004. "Residence groups among hunter-gatherers: A view of the claims and evidence for patrilocal bands." In *Kinship and Social Behaviour in Primates*, ed. B. Chapais and C. Berman. Oxford: Oxford University Press. 420–42.

Arnold, K., and I. Owens. 1999. "Cooperative breeding in birds: The role of ecology." *Behavioral Ecology* 10:465–71.

Beckerman, S. S., R. Lizarralde, C. Ballew, S. Schroeder, C. Fingelton, A. Garrison, and H. Smith. 1998. "The Bari partible paternity project: Preliminary results." *Current Anthropology* 19:164–67.

Beckerman, S., and P. Valentine. 2002. *Cultures of Multiple Fathers: The Theory and Practice of Partible Paternity in Lowland South America*. Gainesville: University Press of Florida.

Beise, J., and E. Voland. 2002. "A multilevel event history analysis of the effects of grandmothers on child mortality in a historical German population (Krummhörn, Ostfriesland, 1720–1874)." *Demographic Research* 7 (article 13): 467–97.

Bird, D., and R. Bliege Bird. In press. "Mardu children's hunting strategies in the western desert, Australia." In *Culture and Ecology of Hunter-Gatherer Childhood*, ed. B. Hewlett and M. Lamb. Hawthorne, NY: Aldine de Gruyter.

Blest, A. D. 1963. "Longevity, palatability, and natural selection in five species of moth." *Nature* 197:1183–86.

Blurton Jones, N. 1993. "The lives of hunter-gatherer children." In *Juvenile Primates*, ed. M. Perreira and L. Fairbanks. New York: Oxford University Press, 69–90.

Blurton Jones, N., F. Marlowe, K. Hawkes, and J. F. O'Connell. 2000. "Paternal investment and hunter gatherer divorce." In *Adaptation and Human Behavior: An*

*Anthropological Perspective,* ed. L. Cronk, N. Chagnon, and W. Irons. New York: Aldine de Gruyter.

Bock, J. 1995. "The determinants of variation in children's activities in a Southern African community." Ph.D. diss., University of New Mexico.

———. 2002. "Learning, life history, and productivity: Children's lives in the Okavango delta, Botswana." *Human Nature* 13:161–97.

Bogin, B. 1996. "Human growth and development from an evolutionary perspective." In *Long-Term Consequences of Early Environment: Growth, Development, and the Lifespan Developmental Perspective,* ed. C. J. K. Henry and S. J. Ulijaszek. Cambridge: Cambridge University Press.

Broude, G. 1994. *Marriage, Family, and Relationships: A Cross-Cultural Encyclopedia.* Santa Barbara, CA: ABC-CLIO.

Cann, R., and A. C. Wilson. 1982. "Letters: Models of human evolution." *Science* 217:303–4.

Cohen, J. E. 2003. "Human population: The next half century." *Science* 302:1172–75.

Creel, S., and N. Creel. 2002. *The African Wild Dog: Behavior, Ecology, and Conservation.* Princeton: Princeton University Press.

Digby, L. 2000. "Infanticide by female mammals: Implications for the evolution of social systems." In *Infanticide by Males and Its Implications,* ed. C. van Schaik and C. Janson. Cambridge: Cambridge University Press, 423–46.

Dunbar, R. 1998. "The social brain hypothesis." *Evolutionary Anthropology* 6:178–90.

Emlen, S. 1995. "An evolutionary theory of the family." *Proceedings of the National Academy of Sciences* 92:8092–99.

Evans, T. A., E. J. Wallis, and M. Elgar. 1995. "Making a meal of mother." *Nature* 376:299.

Fehr, E., and U. Fischbacher. 2003. "The nature of human altruism." *Nature* 425:785–91.

Flinn, M. 1989. "Household composition and female reproductive strategies in a Trinidadian village." In *The Sociobiology of Sexual and Reproductive Strategies,* ed. A. E. Rasa, C. Vogel, and E. Voland. London: Chapman and Hall.

Furstenberg, F. 1976. *Unplanned Parenthood: The Social Consequences of Unplanned Parenthood.* New York: Free Press.

Hames, R., and P. Draper. In press. "Women's work and helpers at the nest in a hunter-gatherer society." In *Culture and Ecology of Hunter-Gatherer Childhood,* ed. B. Hewlett and M. Lamb. Hawthorne, NY: Aldine de Gruyter.

Hamilton, W. D. 1964. "The genetical evolution of social behaviour, 1." *Journal of Theoretical Biology* 7:1–16.

Hart, C. W. M., and A. R. Pilling. 1979. *The Tiwi of Northern Australia.* Fieldwork edition. New York: Holt, Rinehart and Winston.

Hawkes, K. 1991. "Showing off: Tests of an hypothesis about men's foraging goals." *Ethology and Sociobiology* 12:29–54.

———. 2003. "Grandmothers and the evolution of human longevity." *American Journal of Human Biology* 15:380–400.

———. In press. "Mating, parenting, and the evolution of human pair bonds." In *Kinship and Behavior in Primates,* ed. B. Chapais and C. Berman. Oxford: Oxford University Press.

Hawkes, K., J. O'Connell, and N. Blurton Jones. 1989. "Hardworking Hadza grandmothers." In *Comparative Socioecology: The Behavioral Ecology of Humans and Other Mammals,* ed. V. Standen and R. A. Foley. London: Basil Blackwell, 341–66.

———. 1997. "Hadza women's time allocation, offspring provisioning, and the evolution of post-menopausal lifespans." *Current Anthropology* 38:551–77.

———. 2001. "Hunting and nuclear families: Some lessons from the Hadza about men's work." *Current Anthropology* 42:681–709.

Hawkes, K., J. O'Connell, N. Blurton Jones, E. L. Charnov, and H. Alvarez. 1998. "Grandmother, menopause, and the evolution of human life histories." *Proceedings of the National Academy of Sciences* 95:1336–39.

Henry, P. I., G. Morelli, and E. Tronick. 2005. "Child caretakers among Efe foragers of the Ituri forest." In *Culture and Ecology of Hunter-Gatherer Childhood,* ed. B. Hewlett and M. Lamb. Hawthorne, NY: Aldine de Gruyter.

Hewlett, B. 1991. "Demography and childcare in preindustrial societies." *Journal of Anthropological Research* 47:1–23.

———, ed. 1992. *Father-Child Relations: Cultural and Biosocial Contexts.* Hawthorne, NY: Aldine de Gruyter.

Hill, K., and A. M. Hurtado. 1996. *Aché Life History: The Ecology and Demography of a Foraging People.* Hawthorne, NY: Aldine de Gruyter.

Hill, K., and H. Kaplan. 1988. "Tradeoffs in male and female reproductive strategies among the Ache: Part 2." In *Human Reproductive Behaviour: A Darwinian Perspective,* ed. L. Betzig, M. Borgerhoff Mulder, and P. Turke. Cambridge: Cambridge University Press, 292–305.

Hrdy, S. B. 1976. "Care and exploitation of nonhuman primate infants by conspecifics other than the mother." In *Advances in the Study of Behavior VI,* ed. D. S. Lehrman. New York: Academic Press. 101–58.

———. 1999. *Mother Nature: A History of Mothers, Infants, and Natural Selection.* New York: Pantheon.

———. 2002. "On why it takes a village: Cooperative breeders, infant needs, and the future." Part 2 of "The Past, Present, and Future of the Human Family." In *The Tanner Lectures on Human Values,* vol. 23, ed. G. Peterson. Salt Lake City: University of Utah Press, 86–110.

———. 2004. "Evolutionary context of human development: The cooperative breeding model." In *Attachment and Bonding: A New Synthesis,* ed. C. S. Carter and L. Ahnert. Dahlem Workshop No. 92. Cambridge, MA: M.I.T. Press.

Hrdy, S. B., and W. Bennett. 1981. "Lucy's husband: What did he stand for?" *Harvard Magazine,* Jul–Aug., 7–9 and 46.

Hrdy, S. B., and D. B. Hrdy. 1976. "Hierarchical relations among female Hanuman langurs." *Science* 193:913–15.

Hurtado, A. M., K. Hawkes, K. Hill, and H. Kaplan. 1985. "Female subsistence strategies among Ache hunter-gatherers in eastern Paraguay." *Human Ecology* 13:1–28.

Ivey, P. K. 1993. "Life-history theory perspectives on allocaretaking strategies among Efé foragers of the Ituri forest of Zaire." Ph.D. diss., University of New Mexico, Alburquerque.

———. 2000. "Cooperative reproduction in Ituri forest hunter-gatherers: Who cares for Efe infants." *Current Anthropology* 41: 856–66.

Jamison, C. S., L. L. Cornell, P. L. Jamison, and H. Nakazato. 2002. "Are all grandmothers equal? A review and a preliminary test of the 'grandmother hypothesis' in Tokugawa, Japan." *American Journal of Physical Anthropology* 119:67–76.

Judge, D. S., and J. R. Carey. 2000. "Postreproductive life predicted by primate patterns." *Journals of Gerontology: Biological Sciences* 55A:B201–9.

Kaplan, H. 1994. "Evolutionary and wealth flows theories of fertility: Empirical tests and new models." *Population and Development Reviews* 20:753–91.

Kaplan, H., K. Hill, and A. Hurtado. 1984. "Food sharing among the Ache hunter-gatherers of eastern Paraguay." *Current Anthropology* 25:113–15.

Keller, L., and M. Genoud. 1997. "Extraordinary life spans in ants: A test of evolutionary theories of aging." *Nature* 389:958–60.

Kramer, K. 2002. "Variation in juvenile dependence: Helping behavior among Maya children." *Human Nature* 13:299–325.

Kurland, J., and C. Sparks. 2003. "Is there a paleolithic demography? Implications for evolutionary psychology and sociobiology." Paper presented at Fifteenth Annual Meeting of Human Behavior and Evolution Society, June 6, 2003, Lincoln, NE.

Lancaster, C., and J. Lancaster. 1983. "Parental investment: The hominid adaptation." In *How Humans Adapt,* ed. D. J. Ortner. Washington, DC: Smithsonian Institution Press, 33–65.

Langen, T. 1996. "Skill acquisition and the timing of natal dispersal in the white-throated magpie jay, *Calocitta formosa.*" *Animal Behavior* 51:575–88.

———. 2000. "Prolonged offspring dependence and cooperative breeding in birds." *Behavioral Ecology* 11:367–77.

Lawrence, P. R., and N. Nohria. 2002. *Driven: How Human Nature Shapes Our Choices.* San Francisco: Jossey Bass.

Leonetti, D., D. C. Nath, N. S. Hemam, and D. B. Neill. 2002. "Cooperative breeding effects upon the matrilineal Khasi of N.E. India." Paper presented at Human Behavior and Evolution Society Meetings, Rutgers University, New Jersey.

LeVine, R. A., S. Dixon, S. LeVine, A. Richman, P. H. Leiderman, C. Keefer, and T. B. Brazelton. 1996. *Child Care and Culture: Lessons from Africa.* Cambridge: Cambridge University Press.

Lovejoy, O. 1981. "The origin of man." *Science* 211, no. 4480: 341–50.

Marlowe, F. 2001. "Male contribution to diet and female reproductive success among foragers." *Current Anthropology* 42:755–60.

Marshall, L. 1976. *The !Kung of Nyae Nyae.* Cambridge, MA: Harvard University Press.

Mitani, J., and D. Watts. 1997. "The evolution of non-maternal care-taking among anthropoid primates: Do helpers help?" *Behavioral Ecology and Sociobiology* 40:213–20.

O'Connell, J. F., K. Hawkes, and N. G. Blurton Jones. 1999. "Grandmothers and the evolution of *Homo erectus.*" *Journal of Human Evolution* 36:461–85.

Peacock, N. 1985. "Time allocation, work, and fertility among Efe Pygmy women of north-east Zaire." Ph.D. diss., Harvard University, Cambridge.

Rilling, J., D. Gutman, T. Zeh, G. Pagnoni, G. S. Berns, and C. D. Kilts. 2002. "A neural basis for social cooperation." *Neuron* 35:395–405.

Ross, C., and A. MacLarnon. 2000. "The evolution of non-maternal care in anthropoid primates: A test of the hypotheses." *Folia primatologica* 71:93–113.

Rowley, I., and E. Russell. 1990. "Splendid fairy-wrens: Demonstrating the importance of longevity." In *Cooperative Breeding in Birds,* ed. P. Stacey and W. Koenig. Cambridge: Cambridge University Press.

Ruffman, T., J. Perner, M. Naito, L. Parkin, and W. Clements. 1998. "Older (but not younger) siblings facilitate false belief understanding." *Developmental Psychology* 34:161–74.

Sear, R., R. Mace, and I. A. McGregor. 2000. "Maternal grandmothers improve nutritional status and survival of children in rural Gambia." *Proceedings of the Royal Society of London. B* 267: 1641–47.

Sear, R., F. Steele, I. McGregor, and R. Mace. 2002. "The effects of kin on child mortality in rural Gambia." *Demography* 39:43–63.

Shostak, M. 1981. *Nisa: The Life and Words of a !Kung Woman.* Cambridge, MA: Harvard University Press.

Silk, J. B., S. Alberts, and J. Altmann. 2003. "Social bonds of female baboons enhance infant survival." *Science* 302:1231–34.

Snowdon, C. 1996. "Infant care in cooperatively breeding species." *Advances in the Study of Behavior* 25:643–89.

Solomon, N., and J. French. 1997. "The study of mammalian cooperative breeding." In *Cooperative Breeding in Mammals,* ed. N. Solomon and J. French. Cambridge: Cambridge University Press, 1–10.

Spieker, S., and L. Bensley. 1994. "The roles of living arrangements and grandmother social support in adolescent mothering and infant attachment." *Developmental Psychology* 30:102–11.

Stack, C. 1974. *All Our Kin.* New York: Harper and Row.

Tomasello, M. 1999. *The Cultural Origins of Human Cognition.* Cambridge, MA: Harvard University Press.

Turke, P. 1988. "'Helpers at the nest': Childcare networks on Ifaluk." In *Human Reproductive Behaviour: A Darwinian Perspective,* ed. L. Betzig, M. Borgherhoff Mulder, and P. Turke. Cambridge: Cambridge University Press, 173–88.

Weisner, T., and R. Gallimore. 1977. "My brother's keeper: Child and sibling caretaking." *Current Anthropology* 18:169–70.

Werner, E. E. 1984. *Child Care: Kith, Kin, and Hired Hands.* Baltimore: University Park Press.

West Eberhard, M. J. 2003. *Developmental Plasticity and Evolution.* Oxford: Oxford University Press.

Wilson, E. O. 1975. *Sociobiology.* Cambridge, MA: Harvard University Press.

Wilson, M. 1986. "The black extended family: An analytical consideration." *Developmental Psychology* 22:246–258.

Witkowski, S. R., and W. T. Divale. 1996. "Kin groups, residence, and descent." In *Encyclopedia of Cultural Anthropology*, vol. 2, ed. D. Levinson and M. Ember. New York: Henry Holt. 673–80.

# Contributors

*Jan Beise* is currently a scientific researcher at the Max Planck Institute for Demographic Research in Rostock, Germany. He received his Ph.D. in human behavioral ecology from the University of Giessen in 2001. His research interests concern evolutionary explanations of human demographic behavior.

*Athanasios Chasiotis* is currently head of the Cross-cultural Life Span Psychology Research Group at the University of Osnabrück in Germany. He received his Ph.D. in natural sciences from the University of Osnabrück in 1998. His research interests concern the intersection of evolutionary and cross-cultural developmental psychology. His research and publications are in cross-cultural, developmental, evolutionary, and personality psychology and in behavioral ecology.

*Banu Citlak* is a postdoctoral research fellow at Ruhr University in Bochum, Germany. She received her Ph.D. in social sciences from Ruhr University in 1999. Her research interests include the influence of migration on the transformation of social rules within migrant communities and the continuation of these rules among subsequent generations.

*Laurel L. Cornell* received her Ph.D. in sociology from Johns Hopkins University in 1980. Her current research interests include demography and gender studies.

*Leonid A. Gavrilov* works at the Center on Aging, National Organization for Research at the University of Chicago and is a principal investigator of the scientific project Biodemography of Human Longevity funded by the National Institute on Aging (USA). He received his Ph.D. in genetics from Moscow State University in 1980, is coauthor of *The Biology of Life Span* (1991), and author of numerous scientific publications on related topics. His current research interests include genetics of human longevity, heritability of life span, and risk analyses.

*Natalia S. Gavrilova* works at the Center on Aging, NORC at the University of Chicago and was a principal investigator of the research project "Biodemographic Aspects of Longevity Inheritance in Humans" funded by the National Institute on Aging (USA). She received her Ph.D. in anthropology from the Moscow State University in 1982 and is coauthor of *The Biology of Life Span* (1991). Her current research interests include genetics of human longevity, heritability of life span, and risk analyses. She is the author of numerous scientific publications on related topics.

*Andreas Grabolle* studied biology and journalism at the Universities of Mainz, Vienna, and Berlin. His research interests concern adoption among Trobriand Islanders in Papua New Guinea.

*Robin Harwood* is currently an associate professor at the University of Connecticut in the School of Family Studies. She received her Ph.D. from Yale University in 1991. She is the author of *Culture and Attachment: Perceptions of the Child in Context* and of numerous journal articles on the topics of culture, parenting, and early social and emotional development.

*Kristen Hawkes* is a distinguished professor of anthropology at the University of Utah and member of the National Academy of Sciences. Her principal research interests are the evolutionary ecology of hunter-gatherers and human evolution. Drawing on data from fieldwork in Amazonia and East Africa, she has generated, tested, and published explanations for modern hunter-gatherer foraging and for reproductive strategies.

*Natabar S. Hemam* is an academic staff fellow at Gauhati University in Guwahati, Assam, India. He received his Ph.D. in anthropology from the University of Calcutta in 1998. His research has been in tribal and ethnic groups in northeast India with interests in fertility and the nutritional status of women and children.

*Sarah Blaffer Hrdy* is a professor emeritus of anthropology at the University of California–Davis and member of both the National Academy of Sciences and the American Academy of Arts and Sciences. With Glenn Hausfater, she coedited *Infanticide: Comparative and Evolutionary Perspectives* (1984). She is the author of *The Langurs of Abu: Female and Male Strategies of Reproduction* (1978), *The Woman That Never Evolved* (1981), and *Mother Nature: A History of Mothers, Infants, and Natural Selection* (1999; winner of the Howells Prize for best book in biological anthropology). Currently she is exploring the implications for human nature of our long legacy as cooperative breeders.

*Cheryl Sorenson Jamison* is currently an associate scientist in both the anthropology department and the Karl F. Schuessler Institute of Social Research at Indiana University. She received her Ph.D. in anthropology from Indiana University–Bloomington in 1987. Her research interests include human evolution and behavior, dermatoglyphics, and evolutionary medicine.

*Paul L. Jamison* is a professor of anthropology at Indiana University–Bloomington. He received his Ph.D. in physical anthropology from the University of Wisconsin–Madison in 1972. His research interests include physical growth and development of children in circumpolar populations, human adaptation and variation, medical anthropology, the assessment of dysmorphology in the craniofacial complex, and evolutionary medicine.

*Nicholas Blurton Jones* is a professor emeritus in psychological studies in education, and in psychiatry and anthropology. He received his Ph.D. in animal behavior from the University of Oxford in 1964. Research has included longitudinal and

cross-cultural studies of parent-child interaction and application of methods and frameworks from biology in studies of human behavior. His current research includes the behavioral ecology of foraging peoples.

*Chris Knight* is professor of anthropology at the University of East London. He is the author of *Blood Relations: Menstruation and the Origins of Culture* (1991). Recent research focuses on the evolutionary emergence of human kinship, language, and symbolic culture.

*Donna L. Leonetti* is an associate professor at the University of Washington in Seattle. She received her Ph.D. in anthropology from the University of Washington in 1976. Her research has taken her from demographic studies of Japanese Americans to epidemiological studies of aging and chronic disease, and more recently to the discipline of behavioral ecology and studies of reproductive success in Khasi and Bengali ethnic groups in northeast India.

*Birgit Leyendecker* is currently a research fellow at the Ruhr University in Bochum, Germany. She received her Ph.D. in human sciences in 1991 from the University of Osnabrück, Germany. Her research interests include cultural perspectives on child development and parenting and cultural and psychological adaptation of immigrant children and their families, linking qualitative and quantitative research.

*Ruth Mace* is professor of evolutionary anthropology at University College of London. She did her Ph.D. in behavioral ecology at Oxford in 1986. She has since worked on the evolutionary ecology of both subsistence and reproductive strategies of a number of African populations, including the Gabbra in Kenya, the Mandinka in Gambia, and currently the Oromo in Ethiopia. She is interested in aspects of parental investment, life history, and fertility.

*Amy Miller* is currently a congressional fellow in the United States Senate. She received her Ph.D. in 2001 from the University of Connecticut. Her research interests include the cultural coherence between parents' beliefs and behaviors, the intergenerational construction of parenting cognitions, and the adaptation of parenting cognitions and behaviors in the face of rapid societal change or migration.

*Dilip C. Nath* is professor of statistics at the Gauhati University in Guwahati, Assam, India. He received his Ph.D. in statistics and demography from the Banaras Hindu University in 1984. His research has focused on birth spacing, breast-feeding, and demographic aspects of aging.

*Dawn B. Neill* is a graduate research assistant in the department of anthropology at the University of Washington. Her interests are the behavioral ecology of nutrition and growth in Indian populations, both in India and abroad.

*Akiko Nosaka* works as a postdoctoral researcher at the Cross-Cultural Life-Span Psychology Research Group at the University of Osnabrück, Germany, and is interested in family, intergenerational relationships, gender, and life stages. She obtained her Ph.D. degree in anthropology at the Pennsylvania State University in 1997.

*James O'Connell* is professor of anthropology and director of the Archaeological Center at the University of Utah. He received his Ph.D. in anthropology from the University of California–Berkeley in 1971. He has research experience in hunter-gatherer ethnography and archaeology, including fieldwork in western North America (archaeology), Australia (ethnography and archaeology), and East Africa (ethnography).

*Andreas Paul* is currently a lecturer in the Institute of Zoology and Anthropology at the University of Göttingen, Germany. He received his Ph.D. in biology from the University of Kiel in 1984. He has conducted long-term research on the sociobiology and behavior of semi-free-ranging Barbary macaques.

*Jocelyn Scott Peccei* became a research associate in the department of anthropology at the University of California–Los Angeles after receiving her Ph.D. in 1998. Her principal interest is in the origin and maintenance of menopause. Dr. Peccei's most recent work focuses on reevaluating in light of new data the adaptation versus epiphenomenon explanations for menopause.

*Camilla Power* is currently senior lecturer in anthropology at the University of East London. She received her Ph.D. in anthropology from the London University, University College London in 2001. Research interests and publications have focused on the Darwinian models for the evolution of symbolic culture with special attention to language, art, and ritual, and on African hunter-gatherers with special attention to religion and gender rituals.

*Wulf Schiefenhövel* is professor of medical psychology and ethnomedicine at the Ludwig Maximilians University, Munich. He received an M.D. from the University of Erlangen in 1970. He is fellow of the Institutes of Advanced Study in Berlin, Bielefeld, and Budapest. Since 1965, he has been involved in ongoing field studies in Melanesia. He was coeditor of the 1995 recipient of a science book of the year award of the journal *Bild der Wissenschaft* for *Der Mensch in seiner Welt (Humans in Their World)* (3 vols., ed. W. Schiefenhövel, Ch. Vogel, G. Vollmer, and U. Opolka). His research and publications are in human ethology, evolutionary biology, anthropology, medicine, and ethnomedicine.

*Axel Schölmerich* is professor of psychology and head of the developmental psychology section at Ruhr University in Bochum, Germany. He received his Ph.D. in natural sciences from the University of Osnabrück, Germany, in 1990. His main re-

search interests include emotional regulation and reacitivty, cultural factors in human development, and developmental psychobiology.

*Rebecca Sear* is a lecturer in population studies at the London School of Economics. She received her Ph.D. in biological anthropology from University College London in 2001. She is an evolutionary ecologist, interested in explaining human reproductive behavior from an evolutionary perspective. Her research so far has focused on populations in sub-Saharan Africa.

*Eckart Voland* is a professor of biophilosophy at the Center for Philosophy and Foundations of Science, University of Giessen, Germany. He received his Ph.D. in anthropology from the University of Göttingen in 1978. He is the author of *Grundriss der Soziobiologie (Outline of Sociobiology)*, which appeared in the second edition in 2000 and was translated into Portuguese. His research and publications are in Darwinian historical demography, evolutionary reproductive ecology, behavioral ecology, anthropology, evolutionary ethics, and aesthetics.

# Name Index

Abbott, A., 76
Abelson, A., 54
Aberle, D. F., 85, 95
Adams, J. W., 78
Adler, L. L., 240, 253
Agapow, P.-M., 139
Agarwal, R., 259, 273
Ahmad, M., 283, 290
Ahmed, R. A., 240, 253
Ahnert, L., 314
Ahrinter, J., 113
Aiello, L. C., 90, 91, 92, 94, 95, 96, 98
Alberman, E., 213
Alberts, S., 300, 316
Aldrich, J. H. 69, 76
Alexander, R. D., 21, 34, 100, 112, 273
Allal, N., 152, 156
Allison, P. D., 102, 112
Alpert, L., 79, 106, 115
Altermann, J., 300, 316
Altmann, J., 309, 312
Alvarez, H. P., 14, 35, 114, 121, 135, 136, 138, 164, 165, 173, 174, 175, 213, 274, 300, 305, 312, 314
Amoss, P. T., 13, 17, 53, 114, 139, 235
Amundson, D. W., 50, 53
Anderson, J. R., 28, 37, 189, 193
Anderson, K. G., 214
Andresson, J. O., 113
Andreyev, A. Y., 78
Apfel, N. H., 278, 287
Apter, T., 240, 253
Arantes-Oliveira, N., 113
Arnold, K., 302, 303, 312
Ashley Montagu, M. F., 97
Asin-Cayuela, J., 117
Askew, T., 292
Aswad, B. C., 270, 273
Attardi, G., 115, 117
Atzwanger, K., 191
Austad, S. N., 99, 112, 131, 136
Ayzac, L., 76

Bachofen, J. J., 82, 83, 95
Bade, K. J., 275
Baird, D. M., 109, 112
Baker, L., 16
Ballew, C., 312
Baltes, P. B., 278, 287
Barrett, J., 116
Barton, T. S., 138
Bates, J. E., 157
Baumann, O., 174
Baydar, N., 279, 287
Bean, L. L., 79
Beard, R. J., 55
Beck, L., 273, 274
Beckerman, S., 94, 95, 298, 300, 312, 312
Beems, R. B., 113
Beeton, M., 59, 61, 63, 64, 65, 67, 75, 76
Beise, J., 2, 7, 10, 11, 13, 14, 17, 47, 58, 75, 80, 99, 100, 107, 112, 117, 134, 139, 147, 148, 152, 159, 160, 164, 174, 194, 208, 211, 213, 216, 219, 228, 229, 231, 232, 233, 234, 235, 236, 238, 239, 241, 244, 246, 250, 253, 255, 257, 273, 305, 306, 312
Belisle, P., 29, 34
Bell, A. G., 59, 61, 76
Bellamy, R. L., 180
Bellino, F. L., 1, 13
Bell-Krannhals, I., 178, 180, 182, 186, 190, 191, 192
Benefice, E., 17
Bengston, V. L., 258, 275, 288
Benn, R., 290
Bennett, W., 297, 314
Bensley, L., 279, 291, 306, 316
Benson, E., 116
Bentley, G. R., 117
Benzer, S., 116
Bereczkei, T., 11, 13, 151, 156, 239, 253
Berger, C., 191
Berkowitz, G. S., 47, 53
Berman, C. M., 174, 312
Bernier, M. O., 62, 76

**325**

Berns, G. S., 316
Bernstein, G. L., 113, 117
Bernstein, V. J., 279, 292
Betzig, L. L., 55, 58, 177, 191, 213, 314, 316
Beyene, Y., 54
Bhuiya, A., 147, 149, 156
Bideau, A., 59, 63, 65, 75, 76, 236
Biesele, M., 48, 53, 235
Bifano, N. L., 50, 56
Bird, D. W., 133, 136, 161, 175, 304, 312
Black, M. A., 287
Black, M. M., 278, 287
Blest, A. D., 307, 312
Bliege Bird, R., 95, 133, 136, 161, 175, 304, 312
Blikslager, G., 2, 13
Block, E., 49, 54
Blomberg, S. P., 15
Blossfeld, H.-P., 219, 236
Blurton Jones, N. G., 5, 6, 7, 8, 10, 13, 14, 33, 35, 38, 39, 48, 55, 81, 87, 88, 92, 95, 96, 97, 98, 99, 100, 106, 112, 114, 119, 119, 120, 121, 128, 130, 133, 134, 135, 136, 136, 137, 138, 139, 144, 156, 160, 161, 162, 163, 169, 170, 175, 175, 176, 194, 213, 216, 231, 236, 257, 273, 274, 278, 289, 298, 304, 305, 308, 309, 312, 314, 316
Boas, F., 84, 85, 95
Bock, J., 303, 308, 313
Bocquet-Appel, J.-P., 131, 136
Bodyak, N. D., 115
Boerger, R., 284, 289
Boesch, C., 15, 36, 138
Bogan, H., 115
Bogin, B., 39, 41, 54, 100, 101, 113, 313
Bonafe, M., 117
Bongaarts, J., 44, 54
Borgerhoff Mulder, M., 34, 54, 55, 58, 209, 213, 314, 316
Borries, C., 23, 25, 26, 28, 34, 37
Bossard, N., 76
Bossert, W., 118, 137
Bouchard, G., 234, 236
Bovenhuis, H., 14, 113
Bowden, D. M., 35
Bowers, B. F., 282, 287
Bowles, D., 282, 291

Bowman, J. E., 90, 96
Boyd, R., 177, 193
Brady, I., 177, 191, 192
Brakeman-Wartell, S. L., 11, 14, 106, 113
Brand, H., 59, 60, 66, 79
Bräuer, G., 191
Brauer, S., 15, 191, 254
Brazelton, T. B., 315
Breslerman, S., 240, 244, 254
Breslow, N. E., 69, 76
Bresolin, N., 115
Bretscher, J., 2, 16
Brewster, S. J., 116
Bringham, C., 16
Brody, G. H., 278, 287, 290
Brome, D. R., 278, 290
Brooks Gunn, J., 279, 287, 288
Brouard, A., 279, 289
Broude, G., 298, 313
Brown, D. M., 34, 54
Brown, E. J., 279, 287
Brown, J. K., 274
Brownell, R. L. Jr., 56
Bühler, C., 277, 287
Burton, L. M., 258, 273, 278, 282, 287
Buss, D. M., 87, 95
Busse, C. D., 21, 28, 34, 35, 35
Bynum, M. S., 290

Cabera, N., 159
Campbell, J. C., 274
Campbell, K. L., 58
Cann, R., 297, 313
Canning, T., 15
Carey, J. R., 6, 15, 17, 41, 43, 56, 79, 101, 106, 107, 113, 216, 236, 310, 315
Carnes, B. A., 77, 121, 139
Caro, T. M., 24, 25, 26, 27, 29, 34, 42, 43, 54
Carrol, V., 177, 191
Cartner, C. S., 314
Cashdan, E., 157
Cervera, P., 114
Chagnon, N. A., 14, 115, 156, 157, 175, 274, 313
Chance, M. W., 288
Chapais, B., 29, 31, 34, 35, 174, 312
Charbonneau, H., 79, 217, 218, 225, 234, 236

Charlesworth, B., 3, 14, 136
Chase Lansdale, P. L., 279, 288
Chasiotis, A., 1, 10, 12, 75, 190, 246, 310
Chiou, J. M., 79
Chipungu, S. S., 283, 292
Cho, B. H., 289
Chowdhury, M., 147, 149, 156
Christensen, K., 17, 191
Churchill, S. E., 25, 37
Clark, D., 54
Clark, M. C., 280, 290
Clegg, M., 91, 95
Clements, W., 316
Clutton-Brock, T. H., 118, 119, 137, 210, 214
Coale, A. J., 121, 122, 123, 126, 127, 129, 130, 132, 136, 137
Cohen, J. E., 298, 313
Cohen, M., 115
Cole, L. C., 137
Coleman, M., 289
Collard, M., 90, 98, 120, 139
Colligan, R. C., 115
Collins, A., 23, 25, 28, 31, 33, 34, 35, 36, 45, 57, 154, 158, 215, 237, 278, 291
Contreras, J. M., 279, 288
Cook, J. M., 291
Cooley, M., 279, 292
Cooney, T. M., 259, 273
Cornell, L. L., 7, 10, 15, 56, 101, 102, 107, 113, 116, 138, 157, 237, 255, 315
Corp, N., 6, 138
Cosar, F. M., 70, 273
Coskun, P. E., 10, 113
Costa, M. C., 75, 76
Counts, D. A., 274
Cournil, A., 6, 14
Creasey, G. L., 280, 290
Creel, N., 303, 313
Creel, S., 303, 313
Crews, D. E., 117, 121, 132, 137
Crognier, E., 150, 151, 156
Cronk, L., 14, 156, 157, 175, 274, 313
Crow, J. F., 74, 76
Croze, H., 42, 43, 54
Curry El, J., 292
Curtis, S., 287
Curtsinger, J. W., 17
Cutler, R. G., 99, 108, 113

Daling, J., 213
Dalla, R. L., 279, 288
Daly, M. J., 116
Darlington, M. 282, 291
Darwin, C., 85, 95, 297
Das Gupta, M., 210, 213
Day, N. E., 69, 76
Dean, M. C., 91, 95
DeBenedictis, G., 117
De Boer, J., 109, 113
De Bruin, J. P., 4, 14, 108, 113
De Heinzelin, J., 48, 54
Delson, E., 58
De Meeüs, T., 17
deMenocal, P. B., 120, 137
Demeny, P., 121, 122, 123, 126, 127, 129, 130, 132, 137
Dengler, I. C., 270, 273
Deniro, M. J., 144, 159
Denis, H., 236
Denmark, F. L., 240, 253
Dennison, C., 282, 288
Denton, D., 289
Desjardins, B., 79, 158, 217, 218, 236, 237
DeVore, I., 87, 96, 98
De Wit, J., 113
Diamond, J., 38, 41, 42, 54, 106, 113
Dickemann, M., 269, 271, 273
Dickerson, B. J., 278, 288
Dieckmann, A., 236
Diers, C. J., 50, 53
Digby, L., 299, 31
Dillin, A., 109, 113
Dintelman, S. M., 79
Dittus, W. P. J., 21, 35
Divale, W. T., 305
Dixon, S., 315
Doblhammer, G., 7, 14, 59, 63, 64, 65, 75, 76, 153, 156
Donelly, S. M., 108, 116
Doomernik, J., 260, 274
Dorland, M., 14, 113
Dorsey, S., 278, 288
Draper, P., 134, 137, 174, 175, 194, 213, 213, 256, 274, 303, 307, 313
Dribe, M., 64, 76
Drinkwater, M., 115
Dubas, J. S., 258, 274
Du Bois, C., 97

Ducos, B., 114
Duffy, D. L., 15
Dufour, D. L., 198, 213
Dunbar, R. I. M., 7, 11, 13, 16, 59, 63, 69, 71, 72, 79, 237, 239, 253, 255, 276, 300, 313
Dunkel-Schetter, C., 254
Dupâquier, J., 248, 254
Dupont, B., 114
Durant, S. M., 16
Durkheim, E., 81, 85
Dutt, J. S., 54
Dyson, T., 130, 137

Ecochard, R., 49, 55
Eisenberg, A. R., 258, 258, 274
Elgar, M., 307, 313
Ellen, J. M., 280, 288
Ellis, B. J., 87, 95, 151, 157
Ellison, P. T., 40, 57, 101, 113
Emanuel, I., 212, 213
Ember, C. R., 165, 175, 192
Ember, M., 192, 317
Emlen, S., 300, 313
Engel, C., 276
Engels, F., 81, 83, 84, 85, 94, 95, 97
Ensminger, M. E., 279, 289
Euler, H. A., 11, 14, 106, 113, 208, 213, 231, 232, 236, 258, 272, 274, 283, 288
Evans, S. J., 213
Evans, T. A., 307, 313
Evans-Pritchard, E. E., 95
Evdokushkina, G. N., 76, 77, 78
Evdokushkina, N. N., 77, 78
Even, P. C., 114

Fa, J. E., 36
Faddy, M. J., 40, 49, 54, 55
Fairbanks, L. A., 29, 30, 31, 32, 35, 136
Falconer, D. S., 50, 54
Falsetti, A. B., 108, 116
Fea, C. B., 284, 290
Fedigan, L. M., 22, 23, 24, 25, 27, 32, 33, 35, 37, 40, 43, 57, 119, 139
Fehr, E., 310, 313
Feiring, C., 287
Feldman, P. J., 241, 254
Feng, D., 288
Ferguson, A., 82, 95

Fikree, F. F., 157
Filakti, H., 213
Finch, C. E., 16, 48, 54, 55, 56, 112, 113, 114, 136, 237
Fingelton, C., 312
Finkel, T., 109, 113
Fischbacher, U., 310, 313
Fischer, L. R., 258, 274, 283, 288
Fisek, G. O., 259, 274
Fish, J., 117
Fisher, R. A., 118, 137
Fleagle, J. G., 23, 35
Fleury, M., 217, 236
Flinn, M., 304, 313
Flint, M., 1, 14, 24, 35, 50, 54
Flor, D. L., 278, 287
Fogel, R. W., 77
Foley, R. A., 6, 14, 39, 41, 54, 55, 81, 92, 95, 114, 136, 137, 236, 274
Forehand, R., 288
Forlenza, S. G., 288
Forster, J., 191
Fowler, C. W., 54
Franceschi, C., 117
Frank, R., 34, 54
Frankenberg, S. R., 138
Fraser, A. G., 113
Freeman, B. C., 59, 62, 63, 65, 66, 75, 77
French, J., 299, 316
Fretts, R. C., 47, 54, 79, 106, 115
Freud, S., 81, 85
Fricke, T., 116
Frigge, M., 78
Frisch, R. E., 44, 54
Furstenberg, F., 305, 313

Gadgil, M., 118, 137
Gage, T. B., 40, 54, 119, 127, 132, 137
Gagnon, A., 158
Galdikas, B. M. F., 143, 157
Gallimore, R., 304, 316
Gallin, R. S., 240, 254
Gamble, W. C., 279, 288
Garrison, A., 312
Garruto, R. M., 117
Gattai, F. B., 282, 288
Gaulden, M. E., 47, 55
Gaulin, S. J. C., 11, 14, 39, 55, 106, 113
Gauthier, C., 29, 31, 35

Gautier, E., 59, 62, 77
Gavrilov, L. A., 7, 42, 55, 59, 66, 67, 74, 75, 77, 78
Gavrilova, A. L., 77, 78
Gavrilova, N. S., 7, 42, 55, 59, 66, 67, 74, 75, 77, 78
Gehrmann, R., 236
Geloen, A., 114
Genoud, M., 309, 315
George, S. M., 278, 288
Gerber, L. M., 121, 132, 137
Giarrusso, R., 282, 288
Gibson, P. A., 282, 288
Gillespie, B., 210, 214
Glannon, W., 63, 64, 75, 78
Glass, D. V., 60, 66, 78
Glass, J. C. Jr., 283, 289
Godfrey, L. R., 4, 16, 49, 56
Goldin, C., 79
Goldman, M. B., 54
Gontrad, A., 191
Gonzalez-Quinones, F., 147, 148, 158
Good, M. D., 270, 274
Goodall, J., 15, 28, 35, 36, 133, 137, 138
Goodenough, R., 177, 191
Goodman, C. C., 283, 289
Gordon, T. P., 28, 34, 37
Gosden, R. G., 40, 48, 49, 54, 55
Gottschalk-Batschkus, C. E., 192
Gougeon, A., 49, 54, 55
Gough, K., 95
Gould, K. G., 1, 14, 24, 35
Gould, S. J., 6, 14
Gowaty, P. D., 275
Grabolle, A., 10, 11, 182, 191
Graham, C. E., 1, 14, 24, 35, 99, 113
Grahn, D., 121, 139
Grainger, S., 2, 14, 216, 236
Gray, R. H., 50, 55
Greene Bates, C., 292
Greil, H., 191
Grieger, M., 28, 35
Grossmann, K., 182, 190, 191
Grossmann, K. E., 182, 190, 191
Groth, G., 96
Guarente, L., 109, 114
Gudbjartsson, D. F., 78
Gudbjartsson, H., 78
Gudmundsson, H., 75, 78

Guegan, J.-F., 17
Gulcher, J. R., 78
Gustafsson, L., 153, 157
Gutman, D., 316

Haas, J. D., 39, 55, 56
Hackman, E., 212, 213
Haddon, A. C., 81
Hage, P., 9, 14, 252, 254
Haines, R. H., 236
Hall, E. C., 37
Hamai, M., 16, 138
Hames, R. B., 48, 55, 134, 137, 194, 213, 303, 307, 313
Hamilton, W. D., 21, 35, 38, 55, 100, 113, 118, 137, 154, 157, 256, 259, 274, 307, 313
Hamilton, W. J. III, 21, 35
Hammer, M. L. A., 6, 14, 39, 41, 55
Hans, S. L., 279, 282, 292, 292
Harding, D., 289
Harman, S. M., 42, 43, 55, 100, 113
Harpending, H., 127, 130, 139
Harrell, S., 13, 17, 53, 114, 139, 235
Harrigan, A. M., 98
Harriland, W. A., 274
Harris, M., 84, 85, 96
Hart, C. W. M., 295, 313
Hart, N., 20, 236, 241, 248, 254
Hart, W., 54
Hartmann, B., 2, 15
Hartshorne, T. S., 258, 274
Hartung, J., 250, 254
Harvald, B., 15
Harvey, P. H., 118, 119, 137, 139
Hasegawa, T., 16, 28, 31, 32, 35, 138
Hauser, M. D., 27, 35
Hausfater, G., 35
Hawkes, K., 5, 6, 7, 8, 10, 13, 14, 22, 35, 38, 39, 48, 55, 75, 78, 81, 87, 88, 92, 95, 96, 97, 98, 99, 100, 101, 106, 111, 112, 113, 114, 119, 120, 121, 122, 130, 133, 134, 135, 136, 137, 138, 139, 143, 144, 155, 157, 160, 161, 162, 163, 169, 170, 175, 176, 194, 210, 213, 215, 216, 231, 236, 251, 256, 257, 268, 273, 274, 278, 289, 296, 297, 305, 308, 309, 310, 312, 313, 314, 316
Hayami, A., 102, 113, 114

Hayflick, L., 108, 114
Heath, A. C., 15
Heeder, S. D., 283, 289
Heiple, K. G., 138
Helle, S., 7, 12, 14, 15, 79, 115, 138, 237
Hemam, N. S., 315
Henke, W., 191
Henn, B. M., 175
Henripin, J., 225, 236
Henry, C. J. K., 313
Henry, L., 44, 55, 59, 62, 63, 75, 77, 78, 217, 236
Henry, P. I., 304, 306, 314
Hershkind, A. M., 6, 15
Heuch, I., 65, 78
Hewlett, B. S., 145, 157, 175, 298, 303, 307, 313, 314
Hewner, S. J., 231, 236
Heyer, E., 158
Hibben, C. J., 245, 254
Hill, K., 1, 2, 8, 15, 22, 23, 23, 25, 36, 38, 39, 39, 42, 43, 44, 48, 55, 56, 96, 99, 100, 101, 114, 115, 128, 129, 130, 133, 134, 138, 139, 144, 145, 146, 147, 148, 149, 151, 152, 154, 157, 160, 173, 175, 216, 237, 257, 274, 278, 289, 289, 297, 298, 308, 314, 315
Hillman, A. K. K., 42, 43, 54
Hinton, I. D., 292
Hiraiwa, M., 28, 31, 32, 35, 36
Hiraiwa-Hasegawa, M., 16, 138
Hirsch, B. J., 284, 289
Hoeijmakers, J. H. J., 113
Hoffman, E., 274, 284, 289
Hofmann, D., 2, 16
Hoier, S., 11, 14
Holbrook, N. J., 109, 113
Holden, C. J., 9, 15, 85, 94, 96, 97, 209, 213, 252, 254
Holdmann, K., 284, 291
Holladay, S., 284, 289
Holliday, R., 60, 78, 106, 114
Hollingsworth, T. H., 65, 66, 68, 71, 78
Hollweg, W., 246, 254
Holm, N. V., 15, 17
Holman, D. J., 40, 49, 57, 58, 99, 114
Holzenberger, M., 109, 114
Hoppa, R. D., 131, 138
Horrocks, D., 274, 275, 276

Hosaka, K., 16, 138
Hosmer, D. W., 69, 78
Houle, D., 50, 56
Houndoumadi, A., 280, 289
Howard, M., 287
Howell, N., 48, 53, 126, 127, 132, 133, 135, 138, 165, 174, 175, 235
Hrdy, D. B., 307, 314
Hrdy, S. B., 2, 5, 10, 12, 15, 21, 22, 28, 36, 94, 99, 100, 107, 108, 111, 114, 133, 134, 135, 138, 189, 191, 209, 213, 278, 289, 297, 300, 301, 303, 304, 305, 306, 307, 314
Hsin, H., 113
Hsu, A.-L., 109, 113, 114
Huffman, M. A., 27, 36
Huijmans, J., 113
Hunt, K. D., 16, 138
Hunter, A. G., 291
Hurtado, A. M., 2, 8, 15, 22, 23, 36, 38, 39, 42, 43, 44, 48, 55, 56, 96, 99, 100, 101, 106, 114, 115, 128, 130, 134, 138, 144, 145, 146, 148, 149, 151, 152, 154, 157, 160, 173, 175, 216, 237, 257, 274, 278, 289, 289, 297, 298, 306, 308, 314, 315
Hurtado, I., 114
Hyde, R. T., 198, 214
Hyun, O. K., 280, 289

Iachine, I. A., 17
Ialongo, N. S., 291
Ingledew, H., 282, 288
Irons, W., 14, 115, 156, 157, 175, 274, 313
Isaac, N. J. B., 139
Ishikawa, F., 109, 116
Itoh, N., 16, 138
Ivey, P. K., 145, 157, 308, 310

Jacobsen, B. K., 65, 78
Jaeger, U., 191
Jamison, P. L., 7, 10, 15, 56, 116, 138, 157, 237, 255, 315
Janson, C. H., 193, 313
Jarvis, P. A., 280, 290
Johnson, F. B., 109, 114, 139
Johnson, J., 3, 15
Johnson, J. R., 131
Johnson, P. L., 58

Johnson, R. L., 22, 23, 24, 27, 34, 36,
Johnson, T. E., 17
Johnstone, R. C. B., 42, 43, 45, 46, 56
Jokela, J., 7, 12, 14
Jolly, C. J., 35
Jolly, G. R., 283, 289
Jones, K. E., 139
Joslin, D., 279, 289
Joyce, E., 115, 116
Judge, D. S., 6, 15, 41, 43, 56, 101, 106, 107, 113, 114, 216, 236, 310, 315
Junod, H., 85, 96

Käär, P., 12, 14
Kadir, M. M., 157
Kagitcibasi, C., 259, 274, 275
Kahn, R. L., 107, 116
Kamath, R. S., 113
Kamazura, C. L., 136, 175
Kaneko, T., 15
Kang, S., 116
Kannisto, V., 17
Kano, T., 36
Kaplan, H., 5, 7, 8, 12, 15, 40, 48, 56, 81, 89, 92, 96, 101, 106, 111, 114, 115, 144, 155, 157, 158, 214, 216, 237, 277, 278, 289, 296, 297, 298, 314, 315
Kappeler, P. M., 36, 138, 139
Kapsalis, E., 23, 24, 27, 34, 36
Karakasoglu, Y., 270, 274
Kasakoff, A. B., 78
Kasuya, T., 43, 56
Kawanaka, K., 16, 138
Kayser, M., 9, 15, 178, 191, 252, 254
Keddie, N., 273, 274
Keefer, C., 315
Kellam, S. G., 279, 289, 291
Keller, L., 309, 315
Kelley, S. J., 282, 289
Kennedy, G. E., 5, 15, 81, 96, 121, 131, 138, 258, 275, 284, 290
Kenrick, D. T., 87, 96
Kent, S., 112, 273
Kenyon, C., 109, 113, 114, 115
Kenyon, S. M., 240, 254
Keppler, A., 191
Kertzer, D. I., 116
Key, C. A., 90, 91, 92, 96
Khan, A., 157

Khazaeli, A. A., 17
Khraoko, K., 115
Kilts, C. D., 316
Kipling, D., 112
Kirchengast, S., 2, 15
Kirk, K. M., 4, 15
Kirkwood, T. B. L., 2, 17, 59, 60, 63, 68, 69, 71, 72, 75, 78, 80, 99, 108, 116, 134, 139, 153, 154, 155, 158, 158
Kivett, V. R., 282, 290
Klein, R. G., 120, 138
Kling, O. R., 24, 35
Knight, A., 162, 175
Knight, C., 9, 94, 96
Knodel, J. E., 45, 47, 56, 59, 62, 63, 66, 69, 70, 75, 78, 242, 254
Koenig, W., 316
Kohli, M., 12, 15
Kohl-Larsen, L., 161, 163, 175
Kolinsky, E., 274, 275, 276
Kolomer, S. R., 2 2, 290
Kong, A., 78
Konigsberg, L. W., 138
Koray, S., 260, 275
Korpelainen, H., 59, 64, 72, 78
Kotting, D., 138
Koyama, N., 23, 24, 26, 27, 37, 58
Kramer, K., 304, 315
Kraytsbert, Y., 115
Krell, R., 190
Kropf, N. P., 283, 291
Kroutko, V. N., 77, 78
Kruse, E., 79
Kuester, J., 23, 25, 26, 27, 28, 29, 31, 33, 36, 37, 45, 57
Kumle, M., 79
Kummer, H., 87, 96
Kunkel, L. M., 116
Kurland, J. A., 28, 29, 36, 100, 115, 310, 315
Kuro-o, M., 109, 116
Kursat-Ahlers, E., 270, 275
Kushnareva, Y. E., 77, 78
Kuurman, W. W., 14, 113
Kvale, G., 65, 78

Lackovich, R., 289
Ladefoged, P., 175
Lafitau, J. T., 96

Lagefoged, P., 162
Lagunes, I. R., 276
Lahdenperä, M., 7, 15, 75, 79, 115, 134, 138, 216, 231, 237
Lamb, M. E., 145, 157, 175, 313, 314
Lambert, P. M., 131, 139
Lancaster, C., 87, 98, 296, 315
Lancaster, C. S., 38, 39, 56, 256, 275
Lancaster, J. B., 15, 38, 39, 56, 96, 115, 214, 256, 271, 275, 289, 296, 315
Landry Meyer, L., 225, 279, 282, 290
Lang, E. M., 42, 43, 54
Langen, T., 302, 303, 310, 315
Lapinski, R. H., 53
Lapshin, E. V., 77
Lau, S., 289
Lawrence, P. R., 297, 315
Laws, R. M., 42, 43, 45, 46, 56
Leach, E., 179, 191
Leach, J. W., 179, 191
Leadbeater, B. J., 279, 292
Leakey, M. G., 95
LeBouc, Y., 114
Le Bourg, E., 7, 15, 59, 62, 63, 75, 79
Lederer, J., 82, 96
Lee, M., 289
Lee, P. C., 39, 54, 81, 90, 92, 95, 95, 96, 97
Lee, R. B., 87, 96, 98, 135
Lee, R. D., 12, 15, 115, 138, 155, 158, 231, 237, 251, 254
Lee, W., 289
Légaré, J., 79, 218, 236, 237
Legay, J.-M., 6, 14
Legnetti, D. L., 134
LeGrand, T. K., 150, 158
Lehrer-Graiwer, J., 113
Lehrmann, D. S., 314
Leiderman, P. H., 315
Leidy, L. E., 1, 3, 4, 16, 40, 49, 56
Leidy Sievert, L., 4, 16, 108, 115
Lemeshow, S., 69, 78
Leneuve, P., 114
Leonetti, D. L., 10, 147, 152, 158, 198, 199, 214, 239, 246, 315
Lerner, R., 287
Levenson, R., 79, 115
LeVine, R. A., 304, 315
LeVine, S., 315

Levinson, D., 317
Levitt, M. J., 280, 290
Lewis, M., 287
Lewontin, R. C., 6, 14
Liedo, P., 17
Liegel, M., 191
Ligtenberg, T., 59, 60, 66, 79
Lindenberger, U., 278, 287, 290
Lindstrom, J., 209, 210, 214
Linn, R., 240, 244, 254
Little, M. A., 55
Lizarralde, R., 312
Longo, V. D., 17
Lopez, I. R., 288
Loudon, I., 45, 47, 56, 237
Louis, D., 175
Lovejoy, C. O., 129, 131, 138
Lovejoy, O., 315
Lowie, R. H., 83, 84, 85, 97
Lummaa, V., 7, 14, 15, 79, 115, 138, 210, 214, 237
Lund, E., 79
Lupo, K. D., 98
Luzza, F., 75, 76
Lycett, J. E., 7, 16, 59, 63, 69, 71, 72, 79

MacDonald, K. B., 76
Mace, R., 3, 7, 9, 10, 11, 15, 16, 17, 47, 48, 57, 75, 79, 85, 94, 96, 97, 99, 100, 106, 107, 115, 116, 134, 139, 146, 147, 151, 152, 153, 156, 158, 158, 160, 164, 176, 208, 209, 213, 214, 231, 237, 239, 252, 254, 255, 257, 275, 305, 306, 316
MacGregor, A. J., 4, 17, 50, 58, 116
MacGuire, M. T., 30
Mack, A., 116
MacLarnon, A., 31, 37, 302, 316
Maddiosen, I., 162, 175
Magnarella, P. J., 259, 275
Malinchoc, M., 115
Malinowski, B., 84, 97, 178, 179, 187, 191, 192
Manaster, G. L., 258, 274
Manton, K. G., 17
Marck, J., 9, 14, 252, 254
Marcoen, A., 232, 237
Marlowe, F. W., 8, 16, 40, 56, 94, 97, 120, 136, 144, 156, 158, 162, 163, 175, 297, 312, 315

Marsh, H., 43, 56
Marshall, L., 300, 315
Marshall, M., 177, 192
Martin, N. G., 15
Martin, R. D., 39, 56, 96
Martorell, R., 39, 56
Maruta, T., 115
Marx, K., 82, 83, 97
Masset, C., 131, 136
Matise, T. C., 116
Matsumoto-Oda, A., 16, 138
Mattace, R., 75, 76
Matthews, S. H., 258, 275
Maxxucchelli, F., 115
McBurney, D. H., 11, 14, 106, 113
McClure, H. M., 37
McComb, K., 10, 16
McCullough, J. M., 54
McGlade, J., 137
McGrath, S. B., 115
McGregor, I. A., 7, 11, 17, 47, 48, 57, 75, 79, 99, 100, 106, 107, 108, 116, 134, 139, 146, 151, 153, 158, 160, 164, 176, 208, 214, 231, 237, 239, 255, 257, 275, 305, 316
McGue, M., 15
McGuire, M. T., 32, 35
McHenry, H. M., 39, 56, 90, 97
McKenna, J., 16
McKenney, D., 283, 291
McKim, L., 292
McKinlay, J. B., 50, 56
McKinlay, S. M., 50, 56
McLean, F. H., 54
McLennan, J. F., 82, 97
McNamara, R., 220, 224, 231, 237
Medicus, G., 182, 190, 192
Meindl, R. S., 138
Meister, K., 62, 79
Meradji, M., 113
Merchant, K., 39, 56
Michikawa, Y., 109, 115, 117
Mickus, M., 284, 289
Miller, B. C., 289
Mills, T. L., 284, 290
Milton, K., 92, 97
Mineau, G., 79
Minkler, M., 278, 290
Misra, G., 259, 273

Mitani, J. C., 16, 138, 302, 315
Mizroch, S. A., 42, 57
Morelli, G., 304, 306, 314
Morgan, J., 62, 79
Morgan, L. H., 81, 82, 83, 84, 85, 87, 94, 97
Morris, D., 87, 97
Morse, E., 288
Morse, P., 288
Mortensen, H. M., 175
Moss, C., 16
Mountain, J. L., 175
Mueller, U., 236
Muenz, R., 260, 275
Müller, H. G., 59, 65, 75, 79
Münz, R., 275
Muransky, J. M., 284, 290
Murdock, G. P., 83, 84, 85, 85, 94, 97
Murphy, C. T., 109, 114
Murry, V. M., 278, 290
Musatti, T., 282, 288
Musil, C. M., 283, 290
Myers, B. J., 280, 282, 284, 287, 290, 290
Myers, L. L., 283, 291

Naeye, R. L., 47, 57
Naito, M., 316
Nakamichi, M., 8, 16, 27, 36, 16, 138
Nakazato, H., 15, 56, 116, 138, 157, 237, 255, 315
Nath, D. C., 158, 315
Nauck, B., 236
Nault, F., 218, 237
Neill, D. B., 315
Nekhaeva, E., 110, 115
Nelson, F. D., 69, 76
Nelson, J. F., 49, 54, 57
Nesse, R. M., 100, 115, 247, 254
Neubaum, E., 278, 287
Neumann, P., 188
Nicoli, J., 116
Niemitz, C., 191
Nikolaides, K. H., 2, 16
Nishida, T., 1, 16, 21, 22, 23, 24, 26, 27, 36, 57, 99, 115, 119, 133, 138
Nitz, K., 278, 287
Nohria, N., 297, 315
Nolin, D., 213
Norokoshi, K., 16, 138

Nosaka, A., 10, 12, 246
Nozaki, M., 23, 36

Obermeyer, C. M., 4, 16
Obst, E., 162, 176
O'Connell, J. F., 6, 8, 10, 13, 14, 33, 35, 38, 39, 48, 55, 81, 87, 88, 89, 92, 95, 96, 97, 98, 99, 100, 106, 112, 114, 119, 120, 121, 130, 133, 134, 135, 135, 136, 137, 138, 139, 143, 155, 157, 160, 161, 162, 163, 169, 170, 175, 176, 194, 213, 216, 231, 236, 257, 273, 274, 278, 289, 305, 308, 309, 312, 314, 316
O'Connor, K. A., 40, 49, 57, 58
Oefner, P., 15, 254
Oeppen, J., 7, 14, 59, 63, 64, 65, 75, 76, 139, 153, 156
Offord, K. P., 115
Ohling, G. D., 246, 254
Oliviera, F., 117
Olmedo, I. M., 280, 290
Olshansky, S. J., 77, 121, 139
Olson, E. A., 259, 275
Ordner, D., 56
O'Rourke, M. T., 40, 57
Ortner, D., 275, 315
Ott, M. A., 280, 288
Outlaw, F. H., 287
Owens, I. P. F., 15, 303, 312, 302
Owens, M. D., 278, 290
Oyserman, D., 279, 290

Packer, C., 23, 25, 31, 33, 34, 36, 45, 57, 154, 158, 215, 237, 278, 291
Paffenbarger, R. S., 198, 214
Pagnoni, G., 316
Papousek, M., 191
Parish, A., 34, 54
Parker, I. S. C., 42, 43, 45, 46, 56
Parkin, L., 316
Part, T., 153, 157
Partch, J., 21, 22, 28, 36
Pashos, A., 208, 214, 246, 254, 258, 270, 275
Passarino, G., 117
Passman, R. H., 280, 292
Paul, A., 1, 23, 25, 26, 27, 28, 29, 31, 33, 36, 37, 43, 45, 57, 302, 304
Pavard, S., 146, 147, 158

Pavelka, M. S. M., 22, 23, 24, 25, 27, 32, 33, 35, 37, 40, 43, 57, 119, 139
Pawloski, L., 106, 115
Peacock, N., 304, 316
Pearson, J. L., 280, 291
Pearson, K., 59, 61, 63, 64, 65, 67, 75, 76
Pearson, P. L., 14, 113
Peccei, J. S., 3, 4, 5, 7, 9, 16, 22, 34, 37, 38, 39, 40, 41, 44, 50, 57, 99, 101, 108, 115, 154, 158, 215, 237, 272, 273, 275, 278, 291
Peidong, S., 15, 254
Pennington, R., 127, 130, 139
Pennisi, E., 109, 115
Pereira, M. E., 36, 136, 138, 139
Pérez, H. 236
Perls, T. T., 63, 65, 79, 106, 109, 115, 116
Perner, J. 316
Perrin, A. S. 278, 291
Perrin, W. F. 56
Peters, A. 37
Peterson, D. J., 279, 291
Peterson, G., 314
Phillips, D., 283, 292
Phillips, J. F., 150, 158
Pierce, R. A., 287
Pilling, A. R., 313
Plu-Bureau, G., 76
Pluzhinikov, A., 115
Podzuweit, D., 23, 26, 27, 33, 37, 45, 57
Poehlmann, J. A., 279, 291
Poortinga, Y. H., 276
Pope, C. L., 79
Post, J. B., 50, 57
Post, W., 79
Pötter, U., 237
Powell, H. A., 192
Power, C., 9, 94, 96, 98
Powys, A. O., 59, 61, 79
Prentice, A., 156
Promislow, D. E. L., 118, 137
Pru, J. K., 15
Pruchno, R., 283, 291
Pryce, C. R., 96
Pryzbeck, T. R., 138
Pschyremble, W., 2, 16
Puca, A. A., 79, 109, 116
Purvis, A., 118, 137, 139
Pusey, A., 15, 36, 138

Quinlan, R. J., 158

Radcliffe-Brown, A. R., 85, 98
Radin, N., 279, 290
Ragsdale, G., 11, 16, 239, 255
Rasa, A. E., 313
Ratnayeke, S., 27, 28, 37
Raymond Smith, L., 288
Read, A. F., 118, 137
Regan, M., 79
Reher, D. S., 147, 148, 158
Reid, A., 242, 246, 248, 255
Reid, D., 95
Renaud, F., 17
Renne, P., 54
Reynolds, R., 4, 16
Richardson, S. J., 49, 54, 57
Richman, A., 315
Rilling, J., 301, 316
Rivera Mosquera, E. T., 288
Rivers, W. H. R., 81, 177, 192
Robine, J.-M., 79
Robinson, J. G., 21, 26, 37
Robinson, L. H., 283, 291
Robinson, M. M., 283, 291
Robinson, W. C., 45, 57
Robson, A. J., 155, 158
Robson, S., 135
Rockoff, H., 79
Rodseth, L., 81, 98
Roe, K. M., 278, 290
Roewer, L., 191
Roff, D. A., 50, 57
Rogers, A. R., 2, 16, 99, 101, 116, 134, 135, 139, 154, 158
Rohde, P. A., 11, 14
Rohwer, G., 219, 236, 237
Roithmayr, S., 282, 291
Rose, M. R., 153, 158
Ross, C., 31, 37, 302, 316
Rossi, A. S., 258, 275
Rossi, P. H., 258, 275
Roth, G., 76
Rothstein, K., 288
Rowe, J. W., 107, 116
Rowland, S. B., 280, 291
Rowley, I., 302, 316
Rowson, J., 112
Ruffman, T., 305, 316

Ruhlen, M., 175
Ruiz, D. S., 279, 291
Ruiz-Pesini, E., 110, 113
Russel, A. F., 15, 79, 115, 138, 237
Russel, E., 302, 316
Russel, R. J. H., 258, 275

Sabean, D. W., 248, 255
Sadalla, E. K., 96
Saito, R., 102, 116
Sajan, F., 157
Sakamaki, T., 16, 138
Saltz, E., 279, 290
Sandman, C. A., 254
Sands, B., 162, 163, 175, 176
Saraste, M., 116
Savard, L., 29, 31, 35
Sayialel, S., 16
Scarlato, G., 115
Schächter, F., 6, 14
Schaffer, W. M., 136
Scheffler, C., 191
Schiefenhövel, S., 181, 192
Schiefenhövel, W., 1, 6, 10, 11, 15, 17, 75, 178, 180, 181, 182, 186, 187, 191, 192, 254, 310
Schladt, M., 176
Schlegel, A., 271, 275
Schmittdiel, J., 54
Schneider, D. M., 95, 98
Schneider, E. L., 55, 113
Schölmerich, A., 10, 12
Schrenk, F., 95
Schröder, I., 191
Schroeder, S., 312
Schuck, P. H., 275
Schuler, J., 192
Schultz, M., 191
Schvaneveldt, J. D., 289
Schwartz, G. T., 95
Schwarz, D. F., 280, 288
Sear, R., 7, 10, 11, 17, 47, 48, 57, 75, 79, 85, 94, 96, 99, 100, 106, 107, 116, 134, 139, 146, 147, 148, 149, 150, 151, 152, 153, 156, 158, 160, 164, 176, 208, 209, 213, 214, 216, 219, 229, 231, 232, 237, 239, 252, 254, 255, 257, 275, 296, 298, 305, 306, 316
Sebire, N. J., 2, 16

See, L. A., 282, 291, 291
Segal, N., 136, 175
Seifert, W., 260, 275
Seitz, V., 278, 287
Sellen, D. W., 34, 54
Semyonova, V. G., 76, 77, 78
Senft, G., 192
Senikas, V., 49, 57
Service, E. R., 98
Sexton, P., 16
Shanley, D. P., 2, 17, 99, 108, 116, 134, 139, 154, 155, 158
Sharma, D., 280, 291
Shea-Drinkwater, M., 116
Sherman, P. W., 5, 7, 17, 32, 37, 100, 116
Shih, C., 116
Shimuzu, K., 23, 36
Shipman, P., 91, 98
Shostak, M., 300, 316
Sieff, D. F., 228, 237
Siegmund, R., 181, 192
Sikes, N. E. ,39, 57
Silk, J. B., 177, 183, 185, 187, 192, 193, 300, 316
Silldorff, A., 16
Silverstein, M., 258, 275, 283, 288, 289
Simmons, F., 292
Simon, A. F., 109, 116
Sinclair, D. A., 109, 114
Sinha, J. B. P., 259, 276
Sipe, T. A., 289
Skinner, G. W., 107, 116, 243, 255
Skovron, M. L., 53, 79
Skuse, D., 96
Smith, B. H., 39, 41, 54, 91, 98, 101, 113, 120, 139
Smith, E. A., 161, 175
Smith, E. O., 16
Smith, F. J., 108, 116
Smith, H., 312
Smith, K. S., 21, 35
Smith, L. C., 130, 136, 163, 175
Smith, M. S., 258, 276, 284, 291
Smith, P. K., 291
Smith, T. D., 54
Smuts, B. B., 98, 271, 276
Snieder, H., 4, 17, 50, 58, 108, 116
Snijders, R. J. M., 2, 16

Snowdon, C., 302, 316
Solomon, N., 299, 316
Sommer, V., 23, 25, 26, 37
Sorensen Jamison, C., 7, 10, 11, 15, 47, 56, 99, 100, 101, 103, 107, 116, 134, 138, 147, 149, 157, 216, 231, 237, 239, 255, 306, 315
Sorenson, T. I. A., 15
Southwick, C. H., 36
Sparks, C., 310, 315
Spears, N., 49, 55
Spector, T. D., 4, 17, 50, 58, 108, 116
Spieker, S. J., 279, 291, 306, 316
Sprey, J., 258, 275
Srivastava, A., 23, 25, 26, 37
Stacey, P., 316
Stack, C., 305, 316
Standen, V., 14, 55, 114, 136, 137, 236, 274
Staudinger, U., 278, 287
Stearns, S. C., 40, 41, 58, 139
Steckel, R. H., 236
Steele, F., 17, 116, 147, 158, 214, 237, 255, 316
Stefansson, K., 78
Stein, H., 248, 249, 255
Steiner, R. A., 24, 35
Stephan, P., 187, 193, 276
Stephens, D., 290
Sticker, E. J., 284, 291
Stoneking, M., 15, 254
Straka-Geiersbach, S., 250, 255
Strassmann, B. I., 210, 214
Stringer, C., 95
Sugar, M., 278, 292
Sutherland, M. R., 4, 16, 49, 56
Suzuki, S., 23, 24, 26, 27, 37, 58
Swanton, J., 85, 98
Sweet Jemmott, L., 287
Symons, D., 87, 95

Takahashi, Y., 109, 116
Takahata, Y., 21, 23, 24, 26, 27, 36, 37, 57, 58, 99, 115
Takasaki, H., 21, 23, 24, 26, 27, 36, 57, 99, 115
Talbert, G. B., 43, 55, 100, 113
Tamis-LeMonda, C. S., 159
Tan, D., 276

Tatar, M., 23, 25, 31, 33, 34, 36, 45, 57, 109, 116, 154, 158, 215, 237, 278, 291
Telfer, E., 40, 48, 55
Te Velde, E. R., 14, 113
Thalabard, J. C., 49, 55, 76
Themmen, A. P. N., 113
Thierry, B., 28, 37, 189, 193
Thomas, F., 4, 17
Thon, B., 79
Tigges, J., 23, 37
Tilly, J. L., 15
Timberlake, E. M., 283, 292
Timur, S., 259, 276
Tinkle, D. W., 273
Tittel, M., 181, 192
Tomasello, M., 301, 310, 316
Tomlin, A. M., 280, 292
Tommaseo-Ponzetta, M., 15, 252
Tompkins, R. L., 120, 139
Ton, D., 270
Toulemon, L., 60, 66, 71, 80
Tremblay, M., 15, 79, 115, 138, 237
Trevathan, W. R., 16, 38, 39, 58
Trinkaus, E., 121, 131, 139
Trivers, R., 89, 98, 210, 214
Tronick, E., 304, 306, 314
Trost, M. R., 96
Trussel, T. J., 122, 137
Tucker, W. T., 214
Turke, P. W., 55, 58, 99, 116, 213, 304, 314, 316
Turner, L., 16, 138
Turner, R. J., 279, 289
Tylor, E. B., 81
Tyrrell, G.,T., 27, 35

Uehara, S., 16, 138
Uhlenberg, P., 259, 273
Ulijaszek, S. J., 313
Ulrich, R., 260, 275
Underhill, P. A., 15, 175, 191, 254
Unger, D. G., 279, 292
Uno, K. S., 107, 117
Usher, R. H., 54
Uygur, E., 260, 276

Valentine, P., 94, 95, 298, 300, 312
Van Arendonk, J. A. M., 14, 113
Van Belle, G., 213

Van der Horst, G. T. J., 113
Van Hueck, W., 67, 80
Van Imhoff, E., 79
Van Leeuwen, W., 113
Van Noord, P. A. H., 14, 113
Van Orsouw, N. J., 115
Van Poppel, F., 79
Van Ranst, N., 232, 237
Van Schaik, C. P., 193, 313
Van Steeg, H., 113
Van Vleet, K. E., 240, 255
Vargas, E., 156
Vaupel, J. W., 6, 15, 17, 131, 138, 139
Verschueren, K., 232, 237
Villena, M., 156
Vogel, C., 313
Voight, J. D., 279, 292
Voland, E., 1, 7, 11, 13, 16, 17, 34, 47, 54, 58, 59, 63, 69, 71, 72, 75, 79, 80, 99, 100, 107, 112, 117, 134, 139, 147, 152, 159, 160, 164, 174, 187, 190, 193, 194, 208, 211, 213, 216, 217, 219, 228, 229, 231, 232, 233, 234, 235, 237, 238, 239, 241, 246, 250, 253, 255, 257, 271, 273, 276, 305, 306, 310, 312, 313
Voran, M., 292, 283
Vrba, E. S., 39, 54, 58

Wachter, K. W., 16, 56, 112, 114, 136, 237
Wadhwa, P. D., 254
Wagner, A., 163
Wakeman, M. A., 284, 290
Wakschlag, L. S., 282, 292
Waldhoff, H., 270, 276
Walker, A., 91, 95, 98
Walker, M. L., 23, 37
Walker, P. L., 131, 139, 144, 159
Walker, R., 139
Wallace, D., 109, 110, 113, 117
Wallis, E. J., 307, 313
Wang, A. L., 198, 214
Wang, J. L., 79
Waser, P. M., 21, 37
Washburn, S. L., 40, 58, 87, 89, 98, 121, 131, 139
Watts, D., 302, 315
Watts, I., 94, 96
Way, N., 279, 292
Waynforth, D., 152, 159

Weber, R. A., 280, 290
Webster, A. J., 139
Weeda, G., 113
Weeks, S. C., 117
Weiner, A. B., 178, 193
Weiner, M., 275
Weinstein, M., 44, 58
Weiser, T., 316
Weisfeld, C. C., 136, 175
Weisfeld, G. E., 136, 175
Weisner, T., 304
Weiss, G., 15, 191
Weiss, K. M., 5, 17, 40, 58, 117, 121, 126, 130, 131, 139
Weiss, S., 254
Weitz, C. A., 54
Weitzel, B., 106, 113, 208, 213, 231, 232, 236, 258, 272, 274, 283, 288
Wells, P. A., 258, 275
Werner, E. E., 305, 316
West Eberhard, M. J., 303, 316
Westendorp, R. G., 59, 60, 63, 68, 69, 71, 72, 74, 75, 80
Westermarck, R., 84
Wheeler, P., 90, 95
White, F. J., 25, 37
White, J. B., 270, 276
White, L. A., 87
White, T., 54
Whitehead, P. F., 35
Whitley, D., 289
Wie, J. Y., 115
Wiechmann, I., 191
Willard, D. E., 210, 214
Willert, A., 290
William, T. D., 317
Williams, G. C., 2, 3, 5, 17, 21, 32, 37, 38, 40, 41, 58, 62, 80, 99, 100, 115, 117, 118, 119, 139, 154, 159, 238, 256, 259, 276, 278, 292
Williams, J., 15, 36, 138, 115
Williams Petersen, M. G., 290, 284
Wilson, A. C., 297, 313
Wilson, E. O., 58, 299, 316
Wilson, G., 287
Wilson, M., 305, 317
Wilson, M. N., 279, 292
Winston, C. A., 282, 292
Wise, P. M., 1, 13
Witkowski, S. R., 305, 317
WoldeGabriel, G., 54
Wood, B. A., 90, 98, 120, 139
Wood, J. W., 1, 3, 4, 5, 6, 17, 40, 43, 44, 47, 49, 57, 58, 100, 108, 117, 143, 157
Woodburn, J. C., 87, 130, 161, 162, 164, 173, 176
Wrangham, R. W., 15, 36, 98, 138
Wynford-Thomas, D., 112

Yamashita, K., 23, 36
Yashin, A. I., 17
Yoo, A. J., 289
Yoo, K. H., 289
Yorker, B. C., 289
Yule, G. U., 59, 61, 63, 64, 65, 75, 76

Zamma, K., 16, 138
Zamsky, E. S., 279, 288
Zeanah, C. H. J., 292
Zeh, T., 316
Zeng, Y., 17
Zhang, J., 110, 117
Zohar, S., 23, 32, 37

# Subject Index

ache, 5, 8, 13, 43, 44, 48, 128, 130, 144, 147–149, 152, 210, 216, 257, 300, 308
adoption, 177, 182, 183, 184, 187, 188, 189; by maternal grandmother, 184, 185, 188–190; in nonhuman primates, 28, 301
age at maturity, relationship with life span, 118, 119, 135
age structure, 121–135
aging: evolutionary models, 135; factors leading to, 109, 110; human vs. chimpanzee, 133, 135; increase of altruistic behavior, 307; shift in rates, 119
allomothers/allomaternal care: availability, 303, 307, 309–311; benefits for allomothers, 300; communal breeding, 299; compensating compromised maternal competence, 305; correlation with life history traits, 302, 303, 309, 311; cost/benefit balance, 308; daughters, 304; female philopatry, 309; food sharing, 309–311; grandmothers/old females, 92, 305–311; impact on child survival and development, 305, 306, 311; impact on maternal reproduction, 304–306, 311; impact on maternal survivorship, 309; juvenile females, 304; and maternal commitment, 306; in nonhuman primates, 28–31, 300–308; novel opportunities for selection, 302, 303; role in evolution, 299, 301, 308–311; role in weaning, 302; selection for allomothers, 303; suppressed ovulation, 299; variation according to local ecology, 300
altriciality life span hypothesis, 5, 7, 9
amenorrhea, lactational, 8
antagonistic pleiotropy, 3, 40, 42, 44, 62, 63
anti-aging hormone, 109
australopithecines, 39, 90, 91, 120, 132

avunculate, 85
Aymara, 150

Bengali, 147, 152, 194–213, 246
Berbers, 150
bipedal locomotion, 39, 90, 120
birth order, 204, 207
breast cancer, 62
by-product hypothesis, 5, 6, 40

Charnov's model, 118–121, 135, 309
child care, from serial to overlapping, 40, 42, 51, 296
chromosomal aberrations, 2, 43, 47
cooperative breeding, 5, 8, 133, 134, 143, 144, 189, 190, 209, 286, 287, 299–304, 309–311
cost/benefit matrix, of the elderly, 12, 13, 107, 108, 308
costs of reproduction: and cooperation, 93; differences between matrilinear and patrilinear kin, 153; increase with body size, 90–93; increase with prolonged fertility 39, 46, 47, 50, 51; longevity, 7, 63, 74, 75, 154; metabolic costs, 39, 90; reduced somatic maintenance and repair, 60; sex differences, 93; sibling competition, 2; trade-off between high fertility and child and maternal mortality, 153

demography: anthropological, 126; paleodemography, 131, 134
dependency ratio, 124, 132
disposable soma theory, 63, 64
division of labor, 90, 94, 143, 297, 298
divorce, 147, 149, 183, 188, 249
DNA repair mechanism, 109

economic exploitation, 246, 248–250, 253
Efé, 308, 310
Eipo, 6

339

embodied capital hypothesis, 5
encephalization, 89–93, 303
environment of evolutionary adaptedness (EEA), 10, 12, 50, 51
Eurocentrism, 87
eusociality, 299
euthanasia, 308
exogamy, 85, 86, 252
expensive tissue hypothesis, 90

family: origins, 82–90, 94, 296; relationships, 11, 247–249, 258, 259, 263–273, 279, 281–287; values, 87, 297, 298
fertility: age-specific fertility, 44, 46, 53; costs and risks of prolonged fertility, 2, 4, 42, 45, 47, 215; decrease with age, 1–3, 23, 41–45; effect on age structures, 122–135; evolutionary constraint, 3, 4, 41; grandmother/kin effects, 151–154, 173, 200, 201, 210–212; human vs. chimpanzee, 4, 43, 119; male fertility, 43, 74; in nonhuman primates, 23–27, 42–46; selection for early fertility, 44, 45, 52, 53; trade-off between early fertility and late infertility, 3, 40, 44, 154; trade-off with longevity, 7, 42, 61–66, 71, 72, 74
fly-by phenomenon, 6
follicle atresia/depletion, 3, 4, 23, 48, 49, 51
food sharing, 120, 143, 144, 300, 301, 308–311

Gainj, 53
Gambia, 146–154, 208, 216, 232, 257, 298
genes for longevity, 109, 110
genetic conflicts, 251, 252
gerontocide, 13
good mother hypothesis, 5, 7, 32, 33, 39, 51, 100, 101, 106–108, 111, 154, 272, 273, 278;
grandfathers: and adoption, 185, 186, 189; grandpaternal solicitude, 283; impact on child survival and development, 147, 150, 216, 227–231, 234; impact on female fertility, 152, 208; impact on stillbirth incidence, 242; impact on wellbeing of teenagers, 279; residence patterns, 170–174
grandmother hypothesis, 5, 7, 21–23, 28, 29, 33, 34, 39, 48, 51, 81, 87–91, 94, 99–101, 106, 108, 112, 118, 119, 121, 133, 135, 149, 154, 173, 251, 256–260, 268, 272, 273, 278, 287, 309, 310
grandmothers: acceptance of grandmaternal support, 279; contact with grandoffspring, 281, 285, 286; differing opportunities for kin support, 12, 165, 166, 194, 239, 258; distribution of help according to need, 134, 160, 161, 173; emotional ties to grandoffspring, 282, 284, 285; help according to age of daughter, 230, 231; help according to sex of grandoffspring, 228, 229, 280; help during pregnancy, 228, 231, 233–235; impact on child nutritional status/growth, 47, 48, 160, 206–212, 216, 231, 257; impact on child psychological development, 279, 280, 305, 306; impact on child survival, 47, 145–150, 154, 194, 200–211, 216, 222–227, 230, 231, 241, 246, 257; impact on daughter's fertility, 8, 48, 92, 120, 151–154, 188, 200, 201, 208, 210, 231; impact on stillbirth mortality, 241–245; impact on teenage wellbeing and education, 279; interests in daughters-in-law, 10, 195, 196, 209, 233, 234, 239, 240; intrafamilial allocation conflicts, 12; kin support through birth attendance, 8; kin support through child care/adoption, 8, 106, 184–189, 208, 212, 228, 279–282, 285, 308; kin support through domestic work activities, 212, 282; kin support through food supply, 8, 48, 93, 106, 120, 133, 160, 216; kin support through medical or ecological knowledge, 8, 106; kin support through teaching maternal care, 8; life expectancy, 101, 104–106; maternal vs. paternal, 11, 12, 47, 100, 147, 149, 150, 152, 153, 156, 184, 185, 188, 189, 194–196, 208–212, 216, 222–

234, 239–245, 251, 257, 258, 280, 283, 285, 286; motivation for kin support, 12, 234; in nonhuman primates 22, 27–34; role in weaning, 181, 225, 229, 232; self-concept and role satisfaction, 282, 283
grandmother's clock hypothesis, 100, 101, 106–108, 111
Gusii, 304
gyneocracy, 82

Hadza/Hadzabe, 5, 8, 13, 48, 87, 88, 92, 119, 120, 128, 130, 133, 144, 160–174, 216, 257, 296, 305
Herero, 127, 130
Hiwi, 8, 48
*Homo erectus/ergaster*, 39, 89–94, 299, 301, 309
*Homo heidelbergensis*, 89, 93, 94

Ifaluk, 304
inclusive fitness, 39, 215, 216, 256, 269, 272, 273, 277, 296
interbirth intervals: as affected by grandmothers/allomothers, 31, 88, 120, 135, 152, 184, 188, 256; humans vs. great apes, 7, 134, 143; and infant mortality, 204, 211; and prolonged offspring dependence, 39; and reproductive costs, 90–93; and reproductive success, 151
intergenerational transfers, 12, 13, 107, 135, 155, 216, 251, 259
intrafamilial conflicts of interest, 12, 13, 239, 240, 246–251
Inuit, 13, 144, 177, 183, 187, 308

Khasi, 147, 152, 194–213
kin effects: on fitness, infant survival or female fertility, 145, 147–156; matrilineal vs. patrilineal, 147–151, 153, 156, 184
kin selection, 100, 154, 168, 172, 216, 303
kin support, 6–13, 92, 133, 135, 143, 145, 146, 148, 150, 155, 188, 258, 259, 270, 299, 300, 302, 304, 310, 311; in nonhuman primates, 21, 22, 28–31, 34, 305
Kipsigis, 209

Krummhörn, 64, 147, 149, 152, 216, 232–234, 240–253, 257
!Kung, 6, 13, 126–128, 130, 166, 174, 210, 300
Kwakiutl, 85

Libben, 129–133
life expectancy, 38, 40–42, 51, 52, 68, 118, 121–135, 243, 278; grandmothers vs. nongrandmothers, 102–106, 111
life history, 6, 134, 143, 210, 215; comparative perspective, 22–24, 33, 43–45; evolution, 39, 81, 88–93, 118, 120, 121, 127, 129, 132–135, 174, 278, 309, 303, 309, 311; theory, 89, 118, 119, 121, 153
life-history trade-offs. *See* trade-off
life span, 1, 4, 6, 7, 38, 52, 88, 89, 92, 100, 119, 135, 154, 189, 215, 216, 225, 251, 256, 272, 278, 303, 309–311; altricial life span hypothesis, 9; and mtDNA mutation, 110; in nonhuman primates, 23–27, 33; postreproductive and number of children, 61–67, 70–75; relation with body size and supply with oocytes, 48; reproductive vs. nonreproductive, 40–43
life span artifact hypothesis, 278
life tables, 103, 121–132, 135, 220, 224
longevity: diet, intelligence, and longevity model, 81, 89, 92, 93; heritability, 6; and reproduction/number of children, 7, 59–66, 71–75; spandrel, 6

males: father's impact on child survival, 147; male care/provisioning in cooperative breeding systems, 8, 143, 144, 150, 153, 156, 173, 297–301; male competition 92, 93; male mating effort, 92, 93, 195; male parental investment, 89, 92, 148, 250
Mandinka, 149, 296
mate-guarding, 246, 247, 250, 253
maternal risks from advanced age, 2, 39, 45, 47
mating enhancement, 247, 248, 250, 253
matriarchy, 9, 179

matrilineality, 9, 10, 81–89, 94, 151, 153, 179, 186, 189, 190, 194, 195, 209–212, 295, 304–306
matrilocality, 9, 87, 94, 164, 165, 252, 253, 304, 305
menopause: adaptation explanations, 2, 4, 21, 38–42, 48, 49, 52, 53, 94, 99, 100, 135, 143, 154, 155, 215; artifact/by product explanations, 6, 34, 38, 40–42; and costs of early reproduction, 41; environmental factors, 4; evolutionary legacy, 4, 21, 41; heritability of age of, 4, 48, 49, 50, 51, 108; in nonhuman primates, 1, 21–24, 33, 43; stabilizing selection, 50; variation in age, 4, 49, 50
mitochondrial inheritance, 110, 112
modern artifact hypothesis, 5, 118
monogamy, 84, 195, 248, 297, 300
mortality schedules, 121–127, 130
mother hypothesis. *See* good mother hypothesis
mother-in-law: effect on parity progression 152, 153; relationship with daughter-in-law, 10, 11, 195—197, 210, 211, 212, 233, 234, 235, 240–253, 282–286
mother-right, 81–83
multiple paternity, 188, 298
mutation load, and age-related infertility, 74

Neanderthals, 89, 93
Neolithic revolution, 5, 10
nutrition/nutritional status, 4, 8, 44, 67, 145, 153, 179, 197, 208, 216, 257

pair bonds, 87–89, 143, 297
paternity (un)certainty, 11, 83, 86, 94, 100, 149, 153, 168, 173, 177, 188 190, 195, 209, 211, 212, 232, 246, 247, 250, 253, 256, 257, 268–272
patriarchy, 9, 270, 305
patrilineality, 10, 81, 83–87, 148, 149, 153, 156, 179, 185, 189, 194, 209–212, 259, 270
patrilocality, 9, 87, 153, 164, 165, 195, 246, 250–253, 270, 271, 305

phenotypic associations, 231, 232
philopatry: female, 309; male, 9, 22; male vs. female, 81, 94
polyandry, 300
polygyny, 148, 300

ostreproductive survival in nonhuman primates, 21, 24, 25

Québec, 62, 146–148, 216–235

reasonable mother hypothesis. *See* good mother hypothesis
reciprocal altruism, 146
replacement strategy, 249, 250
reproductive fitness/success, 3, 7, 8, 12, 22, 23, 30–32, 38, 40, 48, 51, 60, 75, 89, 118, 121, 134, 144–146, 153–155, 161, 168–170, 173, 177, 184, 186, 188, 194, 200, 210, 216, 251, 252, 296, 304, 305
reproductive/social manipulation, 251–253
residence patterns, 9, 164–174, 195, 197, 198, 208, 210, 211, 241, 244, 245, 267
respect for elders, 12, 282, 285, 286, 308

Sami, 12
semelgametogenesis, 3, 40
senescence, 3, 38, 48, 62, 109, 215; changes in rates of, 121; reproductive, 22, 27, 41–43, 154, 155, 272
showing off through big-game hunting, 93, 297
sibling competition, 2, 155
sibling effects: on infant survival, 147, 150; on maternal fertility, 151, 152
sibling solidarity, 85, 86
smoke detector principle, 247
social Darwinism, 84
socioeconomic conditions, 50, 59, 148, 210, 248, 260, 263, 283
stepparenthood, 150, 298
stopping-early hypothesis, 2, 5, 7, 40, 215

Thonga, 85, 86
Tiwi, 295, 296

Tokugawa, Japan, 101, 107, 111, 147, 149, 216
trade-off: between fertility and mortality, 153; between longevity and fertility/reproduction, 7, 42, 62–66, 71, 72, 74; favoring early reproduction, 40, 42; between female mate value and maternal investment, 187; for mother-in-law dominance, 249, 250; between male mating effort and kin support, 169; quality vs. quantity in reproduction, 38; in parental investment, 133; in sexual strategies, 94

Trinidad, 304
Trobriand, 177–190

uterus, problems with high fertility, 2

virilocality, 9

wife-sharing, 298